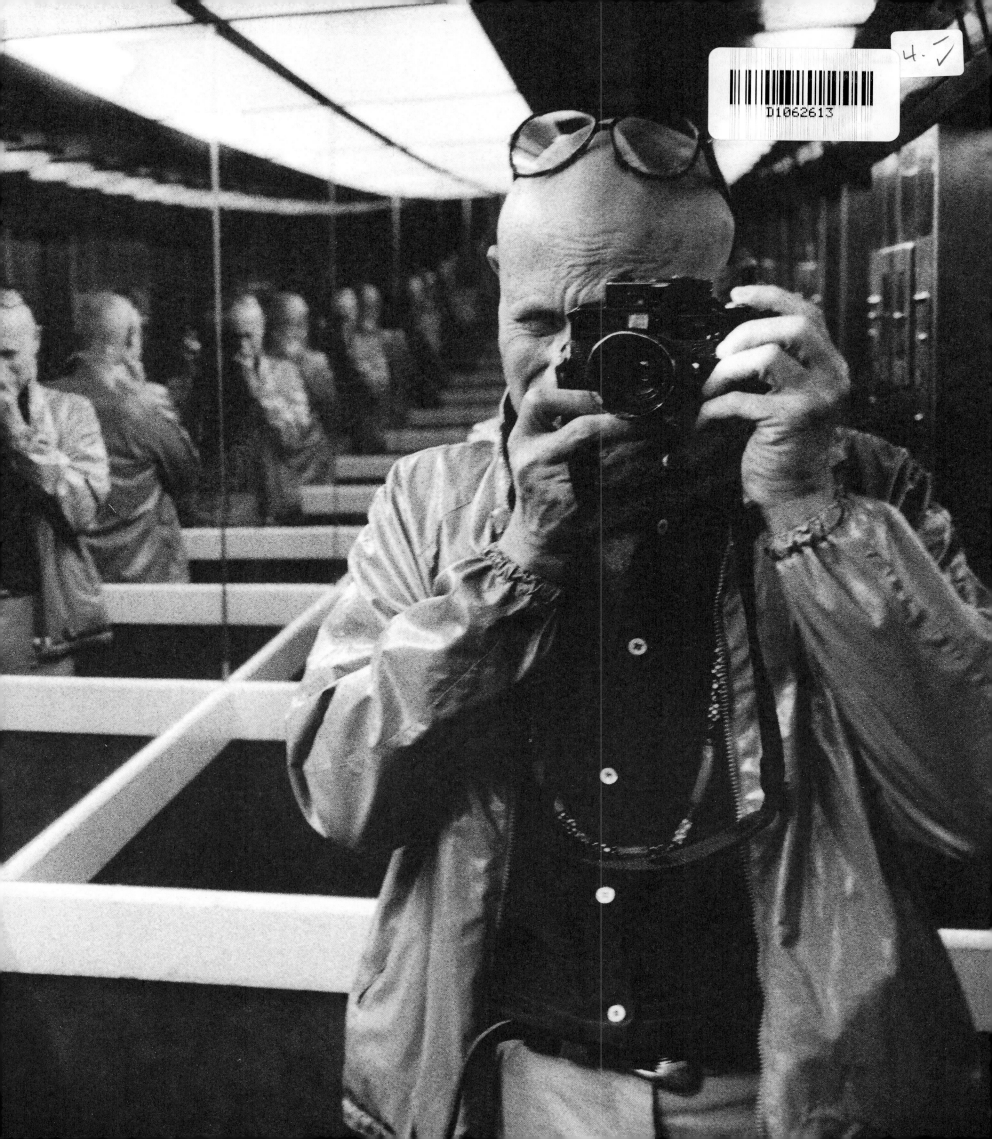

On the
Other Side
of the
CAMERA

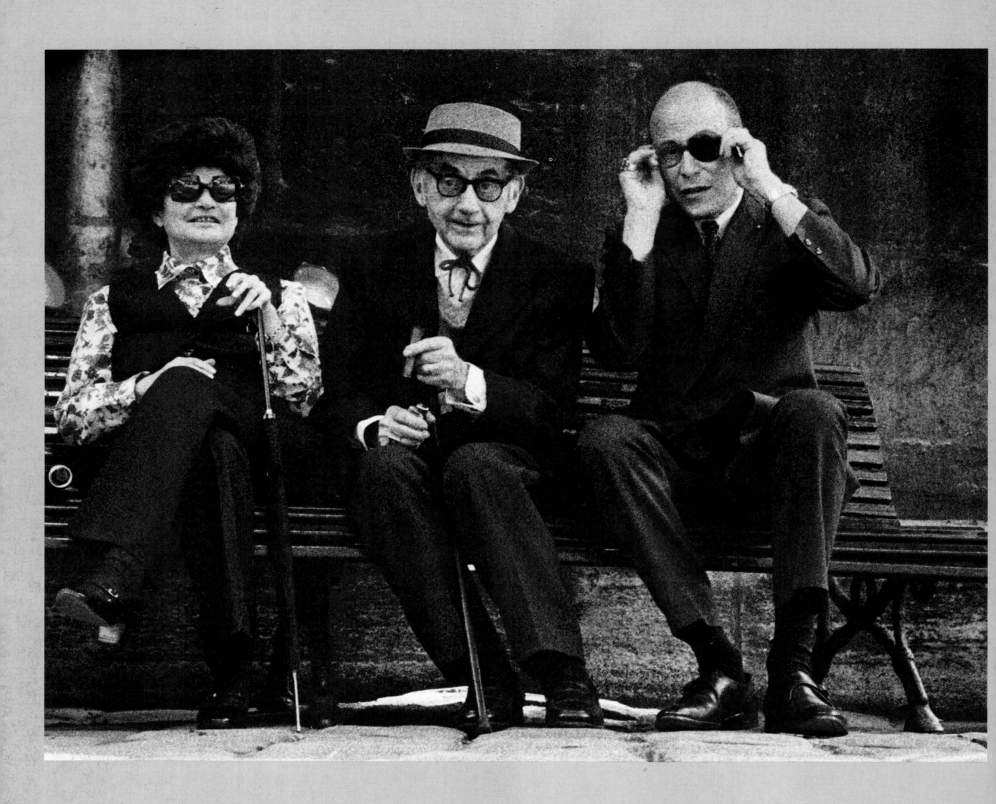

ARNOLD CRANE

On the Other Side of the CAMERA

KÖNEMANN

To »Dave«, David Gomberg, my grandfather, whose creative spirit has given me whatever vision I might possess. I shall never forget you.

Man Ray sitting between his wife and Arnold Crane.

Man Ray zwischen seiner Frau und Arnold Crane.

Man Ray assis entre sa femme et Arnold Crane.

© 1995 Könemann Verlagsgesellschaft mbH
Bonner Str. 126, D-50968 Köln

© Photos and text: Arnold Crane

Design: Peter Feierabend, Berlin
Graphic assistants: Sonja Latsch, Cologne; Jennifer Levy, Cologne
German translation: Andreas Heering, Cologne; Ulrike Bischoff, Schwalmtal
French translation: Martine de Boisgrollier, Cologne
Editor: Mike Johnston, Niles
Contributing editors: Daniela Kumor, Cologne; Kristina Meier, Cologne
Production manager: Detlev Schaper, Cologne
Colour separation: Imago Publishing Ltd., Thame; Reproservice W. Pees, Essen
Printing and binding: Amilcare Pizzi, Cinisello B. (MI)
Printed in Italy
ISBN 3-89508-093-4

Contents · Inhalt · Sommaire

Foreword · Introduction 6

Vorwort · Einleitung 8

Préface · Introduction 10

Man Ray 12

Ansel Adams 32

Imogen Cunningham 44

André Kertész 50

Paul Strand 56

Walker Evans 70

Brassaï 90

Bill Brandt 98

Robert Doisneau 110

Edward Steichen 120

W. Eugene Smith 132

Robert Frank 142

Berenice Abbott 148

Manuel Alvarez Bravo 154

Harry Callahan 158

Aaron Siskind 170

Arthur Siegel 182

Beaumont Newhall 192

Minor White 204

Arthur Rothstein 216

Arnold Newman 224

Lee Friedlander 230

Garry Winogrand 240

Henri Cartier-Bresson 256

Epilogue · Epilog 258

Acknowledgements · Danksagung · Remerciements 260

Foreword

When photographers take an image, they are expressing an emotion or presenting a certain point of view. Most are separated from their subject by the lens itself. However, when making an image of a person who creates images, something entirely different is taking place. The image maker is acutely aware of the fact that there is nowhere to hide. The spirit of the photographer is laid naked before the subject, who has an intimate knowledge of both the process and the intention. What a daunting yet thrilling task it is to photograph a photographer. I know very few that actually enjoy being subjects.

My friend Arnold Crane has taken upon himself this difficult assignment with dignity and humor. For several decades he has been acquainted with the finest photographers in the world, individuals who have taught us new ways of seeing and who have brought us closer to one another by revealing to us our common humanity.

The images in this book present these individuals as they would choose to be seen. They most likely did not have the luxury of being able to refuse Arnold, for his friendly demeanor and style of working is instantly disarming. As the images show, he makes one feel extremely comfortable and in doing so is able to penetrate the psyche of the subject and remove the veil of »the mask«.

Much has been written about the men and women whose faces grace these pages. Now we have a remarkable window into their souls. With this exceptional book, Arnold Crane has greatly expanded our insight into the vision and the art of some of the greatest photographers of the twentieth century.

Graham Nash

Introduction

This book is the culmination of my life-long love affair with photography and everything related to it.

I was four years old when I became fascinated with a camera for the first time. My father, a pharmacist, had accepted as security for a customer's debt to him a lensless hand-cranked Pathé 16mm amateur motion picture camera. That camera, which was kept in a desk drawer in our living room, was the genesis of my passion for photography: I vividly remember spending long periods of time peering through the tiny viewfinder and cranking the handle, listening to the empty film reel turning, and imagining myself as a filmmaker . . . which, incidentally, I still hope to be someday!

Later, when I was about five or six, I received a Kodak Brownie box camera. I used it quite a bit and even when the film would run out, I would endlessly click the shutter, only pretending to take photographs. Thus it began . . . !

A lot has happened in the more than 50 years since then. I went from the Brownie to a Kodak Monitor 616, to a 4x5 Anniversary Speed graphic and a Bolsey BL, to Leica III's and a Linhof Master Technica, to Hasselblad, Pentax, Canon, and Nikon. Nowadays I do a great deal of my work with Contaxes and Hasselblads.

When I was young I freelanced, and experienced a lot of adventures. I photographed funerals, murders, earthquakes, and did annual reports and more than 600 weddings. I broke my leg while photographing a fire. Once I answered a police call of a shooting and, arriving on the scene before the police did, I got shot at by a murderer who was shortly thereafter killed in a gun battle with the police. Needless to say, I am grateful that in my case he was a bad shot.

I eventually passed the bar and became a litigator. Throughout my Law School years, my photographs appeared in publications ranging from local Chicago newspapers to national magazines, and I continued taking pictures during the first three years of my practice of law. Finally, however, I realized that I could not serve two masters, and I put my cameras away for the next ten years or so. During those years, though, when I had a spare moment, I would sometimes get them back out, and look through the viewfinders and click the shutters as I had done when I was a child – always feeling that I had taken a wrong turn in my road.

Then, on 23 October 1967, I attended the opening of an exhibition of the photography of Edward Steichen at what is now the LaSalle National Bank of Chicago, with Steichen himself in attendance. I was just beginning to use my cameras again at the time, so I took them along, and ended up exposing a couple of rolls of the famous Steichen.

Not long afterward, in New York, I visited Peter Bunnell, then at the Museum of Modern Art. I showed Peter my contact sheets of Steichen. He immediately called in Grace Mayer, a former assistant of Steichen's from the years when Steichen had been in charge of Photography at the Museum. When she saw the contacts, she requested a set for the Steichen archives which she was curating, and I delivered them to her shortly thereafter.

The next summer I met Jean Petitory at the sale of the Tristan Tzara library and collection at the auction house of Kornfeld and Klipstein in Berne, Switzerland. Jean, who developed into a wonderful friend, introduced me to Man Ray via telephone from Berne, and soon I was off to Man's studio at 2 bis rue Ferou in Paris, camera and tape recorder in hand. That's when my passionate odyssey really began; it has lasted for many years.

My selection of subjects was not often so simple. To prepare, I had to frequent museums, speak with curators, be familiar with all of the existing histories of photography (notably Pollack, Newhall, and Gernsheim), read books and magazines about photography, and attend exhibits in New York and Chicago. Fortunately, I also possessed a very selective eye, which helped me to determine who was significant.

By now, I have photographed many of the most important photographers to have emerged since the 19th century. I have concentrated on those who made an aesthetic contribution to the medium – missing only Henri Cartier-Bresson, who would not permit me to photograph him (but who is included in this book anyway), and Margaret Bourke-White, who, when I met her, was sadly so overtaken by Parkinson's disease that I could not photograph her. Also, unfortunately, my project got started too late for me to have photographed Edward Weston, László Moholy-Nagy, and Alfred Stieglitz.

As I photographed, I also made audio tapes of a number of my subjects, and have used some of the quotes from those tapes in several of the vignettes in this book.

Peter Bunnell was the real catalyst for this project. After seeing my photographs of Man Ray and Steichen, it was he who suggested that I photograph the other »giants« then living.

With his encouragement I proceeded, and this book is the result of those efforts.

Arnold Crane, New York 1995

Vorwort

Wenn Fotografen ein Bild aufnehmen, bringen sie ein Gefühl zum Ausdruck oder stellen eine bestimmte Sichtweise vor. Die meisten sind von ihrem Sujet durch das Objektiv getrennt. Wenn ein Fotograf allerdings ein Porträt von einem Menschen macht, der selbst Bilder schafft, so findet etwas völlig anderes statt. Der Macher des Bildes ist sich deutlich der Tatsache bewußt, daß er sich nicht verstecken kann. Der Geist des Fotografen ist vor dem Fotografierten bloßgelegt, der ein intimer Kenner sowohl des Prozesses als auch der Intention ist. Was für eine erschreckende und dennoch spannende Aufgabe, einen Fotografen zu fotografieren. Ich kenne nur sehr wenige, denen es wirklich Spaß macht, vor der Kamera zu stehen.

Mein Freund Arnold Crane hat diese schwierige Aufgabe mit Würde und Humor auf sich genommen. Über mehrere Jahrzehnte hinweg hat er Bekanntschaft mit den besten Fotografen der Welt gemacht, Persönlichkeiten, die uns neue Arten des Sehens gelehrt und uns einander nähergebracht haben, indem sie uns das Gemeinsame unseres Menschseins offenbart haben.

Die Porträts dieses Buches stellen diese Persönlichkeiten vor, wie sie gern gesehen werden wollten. Höchstwahrscheinlich konnten sie sich nicht den Luxus leisten, Arnold zu widerstehen, da seine freundliche Art und Arbeitsweise auf Anhieb entwaffnend wirken. Wie die Fotos zeigen, gelingt es ihm, eine Atmosphäre zu schaffen, in der sein Gegenüber sich ungemein wohl fühlt, und so zu seiner Seele durchzudringen und die verschleiernde ›Maske‹ zu lüften.

Über die Männer und Frauen, deren Porträts in diesem Buch vorgestellt werden, ist viel geschrieben worden. Hier haben wir nun ein Fenster zu ihrer Seele. Mit diesem außergewöhnlichen Buch vermittelt Arnold Crane uns einen tieferen Einblick in die Sichtweise und das Schaffen einiger der größten Fotografen des zwanzigsten Jahrhunderts.

Graham Nash

Einleitung

Dieses Buch ist die Frucht meiner lebenslangen Liebe zur Fotografie.

Ich war vier Jahre alt, als ich mich zum ersten Mal von einer Kamera faszinieren ließ. Mein Vater, Apotheker, hatte als Pfand für die Schulden, die ein Kunde bei ihm hatte, eine handbetriebene 16-mm Schmalfilmkamera ohne Objektiv bekommen. Mit dieser Kamera, die mein Vater in einer Schreibtischschublade in unserem Wohnzimmer verwahrte, begann meine lebenslange Leidenschaft für die Fotografie: Ich erinnere mich lebhaft, daß ich oft stundenlang durch den winzigen Sucher sah, an der Kurbel drehte, auf das Rattern der leeren Filmspule lauschte und davon träumte, Filmemacher zu sein – noch heute hoffe ich, diesen Traum eines Tages zu verwirklichen.

Später, ich muß wohl fünf oder sechs Jahre alt gewesen sein, bekam ich einen einfachen Fotoapparat, eine Kodak »Brownie«. Ich habe sehr viel mit dieser Kamera gespielt – sogar wenn ich keinen Film mehr hatte, saß ich oft stundenlang da und betätigte den Auslöser, als würde ich fotografieren. So fing alles an.

Seitdem sind mehr als fünfzig Jahre vergangen. Nach der »Brownie« bekam ich eine Kodak »Monitor« 616, dann eine 4 x 5-»Anniversary Speed Graphic« und eine »Bolsey BL«; später hatte ich eine »Leica III« und eine »Linhof Master Technica«, dann eine Hasselblad, eine Pentax, eine Canon, eine Nikon. Heute verwende ich hauptsächlich Contax- und Hasselblad-Kameras.

In meiner Jugend arbeitete ich als freier Journalist, was recht abenteuerlich war. Ich fotografierte Beerdigungen, Schwerverbrechen, Erdbeben und über 600 Hochzeiten. Als ich einen Brand fotografieren wollte, brach ich mir ein Bein. Einmal hörte ich über Funk einen Polizeiruf wegen einer Schießerei, ich raste hin und traf noch vor der Polizei ein; der Mörder schoß auch auf mich, knapp vorbei, und kam wenig später in einer Schießerei mit der Polizei ums Leben. Natürlich bin ich froh, daß der Mörder in meinem Fall ein schlechter Schütze war.

Ich machte schließlich mein Examen in Jura und wurde Rechtsanwalt. Schon als Student veröffentlichte ich Fotos in verschiedenen Magazinen – von den Chicagoer Tageszeitungen bis zu Illustrierten, die in ganz Amerika erschienen. Auch während meiner ersten drei Jahre als Rechtsanwalt fotografierte ich weiter. Schließlich mußte ich allerdings einsehen, daß ich nicht auf zwei Hochzeiten zugleich tanzen konnte, und hängte meine Kameras für etwa zehn Jahre an den Nagel. Doch ab und an, wenn ich in diesen Jahren etwas Zeit hatte, holte ich sie heraus, sah durch den Sucher und drückte auf den Auslöser, wie ich es als Kind getan hatte – und jedesmal beschlich mich das Gefühl, den falschen Weg eingeschlagen zu haben.

Am 23. Oktober 1967 besuchte ich die Eröffnung einer Ausstellung mit Arbeiten des Fotografen Edward Steichen – sie fand in den Räumen der heutigen LaSalle Bank of Chicago statt, und Steichen selbst war anwesend. Damals fing ich gerade wieder an, ein bißchen zu fotografieren, also nahm ich meine Kameras mit und verschoß einige Filme mit Aufnahmen des berühmten Edward Steichen.

Wenig später besuchte ich Peter Bunnell in New York, der damals am Museum of Modern Art arbeitete. Ich zeigte ihm meine Kontaktabzüge von Steichen. Bunnell rief sofort Grace Mayer hinzu, eine frühere Assistentin von Steichen, als er noch Chef der Abteilung für Fotografie am Museum war. Sie schaute sich die Fotos an und bat mich sofort um einen Satz Abzüge für die Steichen-Archive, die sie als Kuratorin verwaltete.

Im nächsten Sommer traf ich Jean Petitory beim Verkauf der Tristan-Tzara-Bibliothek und -Sammlung im Auktionshaus Kornfeld und Klipstein in Bern. Jean, der mir ein wunderbarer Freund wurde, führte mich telefonisch bei Man Ray ein, und schon bald machte ich mich mit Kamera und Tonbandgerät auf den Weg zu Mans Pariser Atelier. Das war der eigentliche Beginn meiner leidenschaftlichen fotografischen Odyssee, die jetzt schon viele Jahre dauert.

Nicht immer gestaltete sich die Wahl meiner Sujets so einfach. Zur Vorbereitung mußte ich Museen besuchen, mit Kuratoren sprechen, mich mit allen Büchern zur Geschichte der Fotografie vertraut machen (vor allem mit Pollack, Newhall und Gernsheim), Bücher und Zeitschriften über Fotografie lesen und Ausstellungen in New York und Chicago besuchen. Glücklicherweise besitze ich einen Blick für das Wesentliche, der mir half zu entscheiden, wer wichtig war.

Inzwischen habe ich manche der bedeutendsten Fotografen des 20. Jahrhunderts fotografiert. Ich habe mich dabei auf diejenigen konzentriert, die die Möglichkeiten der Fotografie ästhetisch erweitert haben – nur Henri Cartier-Bresson und Margaret Bourke-White fehlen leider in meiner Sammlung. (Cartier-Bresson wollte sich nicht fotografieren lassen, aber ich habe ihn trotzdem in dieses Buch aufgenommen). Bourke-White litt so schwer an der Parkinsonschen Krankheit, als ich sie traf, daß ich sie nicht fotografieren konnte. Leider begann ich mit der Arbeit für dieses Buch zu spät, um Edward Weston, László Moholy-Nagy und Alfred Stieglitz noch portraitieren zu können.

Zu einigen meiner Fototermine nahm ich auch ein Tonbandgerät mit, und an mehreren Stellen in diesem Buch zitiere ich nach diesen Originalaufnahmen.

Peter Bunnell ist der Initiator dieses Projekts. Nachdem er meine Fotos von Man Ray und Steichen gesehen hatte, ermutigte er mich, auch die anderen großen Fotografen auf Film zu bannen.

Peter habe ich dieses Buch mit zu verdanken.

Arnold Crane, New York, 1995

Préface

Quand les photographes prennent une image, ils expriment une émotion ou donnent un point de vue. La plupart sont séparés de leur sujet par leur propre objectif. Cependant, lorsque l'on photographie quelqu'un qui crée lui-même des images, ce qui se produit est complètement différent. Celui qui tient alors l'appareil sait parfaitement qu'il n'y a nulle part où se cacher. Son esprit est mis à nu devant l'autre qui connaît si bien l'intention et le processus. Photographier un photographe est intimidant et émouvant. J'en connais peu qui aiment devenir sujets eux-mêmes.

Mon ami Arnold Crane a pris cette difficulté sur lui avec dignité et humour. Des décennies durant, il a rencontré les plus grands photographes du monde, ceux qui nous ont appris à voir différemment et qui nous ont rapprochés de l'autre en nous révélant notre nature commune.

Les images de ce livre montrent ces personnages comme ils voudraient être regardés. Ils n'ont vraisemblablement pas eu la possibilité d'être capables de repousser Arnold, tant sa manière de travailler et son air amical sont désarmants. Comme ces photographies en témoignent, il sait mettre à l'aise pour pénétrer l'esprit de son sujet et faire tomber le voile du « masque ».

On a beaucoup écrit à propos des hommes et des femmes dont les visages ornent ces pages. Nous possédons maintenant une remarquable ouverture sur leurs âmes. Avec ce livre exceptionnel, Arnold Crane a réellement développé notre idée de l'art et du regard de quelques-uns des plus grands photographes du vingtième siècle.

Graham Nash

Introduction

Ce livre est l'apogée de ma longue histoire d'amour avec la photographie et de tout ce qui lui est lié.

J'avais quatre ans quand, pour la première fois, je fus fasciné par une caméra. Mon père, pharmacien de son métier, avait accepté d'un client, en garantie du paiement de sa dette, une caméra-amateur privée d'objectif, une Pathé 16mm à manivelle. La caméra, conservée dans le tiroir du bureau de notre salon, fut à l'origine de ma passion pour la photographie. Je me souviens avoir passé des heures à scruter au travers du minuscule viseur en tournant la manivelle, écoutant la bobine tourner à vide et m'imaginant cinéaste... ce que j'espère toujours devenir un de ces jours, soit dit en passant !

Plus tard, alors âgé de cinq ou six ans, je reçus un appareil-photo Kodak Brownie que j'utilisai sans arrêt. Après que la pellicule fut épuisée, je continuai inlassablement d'appuyer sur le déclencheur, feignant de photographier.

C'est ainsi que tout a commencé...

Il s'est passé bien des choses durant ces cinquante années. J'allai d'un Brownie à un Kodak Monitor 616, d'un 4x5 Anniversary Speed graphic et un Bolsey BL à un Leica III et d'un Linhof Master Technica à Hasselblad, Pentax, Canon et Nikon. Actuellement, je réalise la plus grande partie de mon travail avec des Contax et des Hasselblad.

Jeune homme, j'étais photographe indépendant et il m'arriva bien des aventures. J'ai photographié des enterrements, des malfaiteurs, des tremblements de terre, fait des reportages annuels et pris plus de 600 mariages ! Une fois, je me cassai la jambe en prenant un incendie. Une autre fois, répondant à un appel de la police à propos d'une fusillade, j'arrivai avant elle sur les lieux et devins la cible du malfaiteur, abattu peu après au cours d'un échange de balles avec les policiers. Inutile de préciser que je me réjouis qu'il fût piètre tireur.

Je fus reçu au Barreau et devins avocat. Pendant mes années de droit, mes photographies furent publiées dans des parutions allant de journaux locaux de Chicago à des magazines nationaux, et je continuai la photo pendant les trois premières années de ma carrière d'homme de Loi. Finalement, je compris que je ne pouvais pas « servir deux maîtres » à la fois et mis mon appareil de côté pendant les dix années qui suivirent. Bien qu'à mes moments perdus je le sortis parfois et regardai à travers le viseur, appuyant sur le déclencheur comme lorsque j'étais enfant, avec toujours au fond de moi ce sentiment d'avoir fait fausse route.

Puis, le 23 octobre 1967, j'assistai au vernissage d'une exposition des photographies d'Edward Steichen dans ce qui est maintenant la LaSalle National Bank de Chicago, en présence de Steichen lui-même. Je recommençais juste à me servir de mes appareils, et j'en pris alors quelques-uns pour bombarder le fameux Steichen, utilisant une pellicule après l'autre.

Peu de temps après, je rendis visite à Peter Bunnell, au Museum of Modern Art de New York. Je lui montrai mes planches contact. Il appela immédiatement Grace Meyer, l'ancienne assistante de Steichen à l'époque où il était à la tête du département Photo du musée. Quand elle les vit, elle me demanda un jeu destiné aux archives concernant Steichen dont elle était la conservatrice. Je le lui remis peu de temps après.

L'été suivant, je rencontrai Jean Petitory à la salle des ventes Kornfeld et Klipstein à Berne, lors de la vente de la bibliothèque et collection de Tristan Tzara. Jean, qui allait devenir un merveilleux ami, m'introduisit auprès de Man Ray, via téléphone de Berne, et je courus bientôt à l'atelier de Man au 2 bis de la rue Férou à Paris, appareil-photo et magnétophone en mains. Ce fut là que commença vraiment cette passionnante odyssée ; elle allait se poursuivre pendant des années.

Sélectionner des sujets était rarement une simple affaire.

Pour les préparer, je devais fréquenter les musées, parler avec les conservateurs, être familier avec l'histoire de la photographie (notamment par Pollak, Newhall et Gernsheim), lire magazines et livres sur le sujet, me rendre aux expositions à New York et Chicago. Par chance, je possède un regard très sélectif qui m'aida à choisir ce qui en valait la peine.

A ce jour, j'ai photographié la plupart des grands noms de la photographie qui se sont révélés depuis le XIXe siècle.

Je me suis attaché à ceux qui ont apporté une contribution esthétique à cet art, même s'il me manque Cartier-Bresson, qui ne m'a pas permis de le photographier, et Margaret Bourke-White, qui était déjà atteinte de la maladie de Parkinson quand je la rencontrai, ce qui exclut toute idée de photographie. Mon projet a malheureusement aussi démarrer trop tard pour que j'aie eu l'occasion de prendre Edward Weston, Moholy-Nagy et Stieglitz.

Pendant mes séances de photo, j'enregistrai également des cassettes et me suis servi, dans ce livre, de plusieurs extraits de celles-ci pour étayer mes portraits.

Peter Bunnell servit de catalyseur à ce projet. Après avoir vu mes photos de Man Ray et Steichen, ce fut lui qui me suggéra de photographier les autres « géants » encore vivants.

Avec ses encouragements, j'ai poursuivi ma route, et ce livre est le résultat de ces efforts.

Arnold Crane, New York, 1995

Man Ray

Emanuel Rudnitzky; 1890–1976. American.
Photographer, painter, sculptor, film maker, Dadaist and
Surrealist. Innovator who broke away from traditional
»objective« photography. He is known for his Rayographs
(negativeless images on photographic paper, reflecting the
shadows of opaque, transparent and translucent objects placed
upon sensitized paper) and portraits of the painters, poets,
writers and composers who lived in Paris in the 1920s and
1930s.

Emanuel Rudnitzky; 1890–1976. Amerikaner.
Er war Fotograf, Maler, Bildhauer, Filmemacher, Dadaist und
Surrealist. Ein Neuerer, der die Abhängigkeit der Fotografie von
der »objektiven Realität« durchbrach. Er ist berühmt für seine
Porträts von Malern, Dichtern und Komponisten des Paris der
zwanziger und dreißiger Jahre und für seine Rayographien,
ungegenständliche Foto-Graphiken, die er auf Fotopapier
erzeugte, indem er räumliche Objekte darauf legte und sie
mehrmals, die Lampe bewegend belichtete. Er malte sogar mit
Entwickler.

Emanuel Rudnitzky; 1890–1976. Américain.
Photographe, peintre, sculpteur, cinéaste, dadaïste et surréaliste.
Innovateur, il se distancia de la photographie traditionnelle
objective. Il est connu pour ses Rayographes (images sans négatif
sur papier photographique, reflétant les ombres d'objets
opaques, transparents et translucides placés sur du papier
sensible) et ses portraits de peintres, de poètes, d'écrivains et
compositeurs qui vécurent à Paris au cours des années vingt et
trente.

Man Ray with his magnifying glass »verre Laurent« in his studio in Paris, 1969–74.

Man Ray mit seinem Vergrößerungsglas »Verre Laurent« in seinem Atelier in Paris, 1969–1974.

Man Ray avec sa loupe « Verre Laurent » dans son atelier à Paris, 1969–1974.

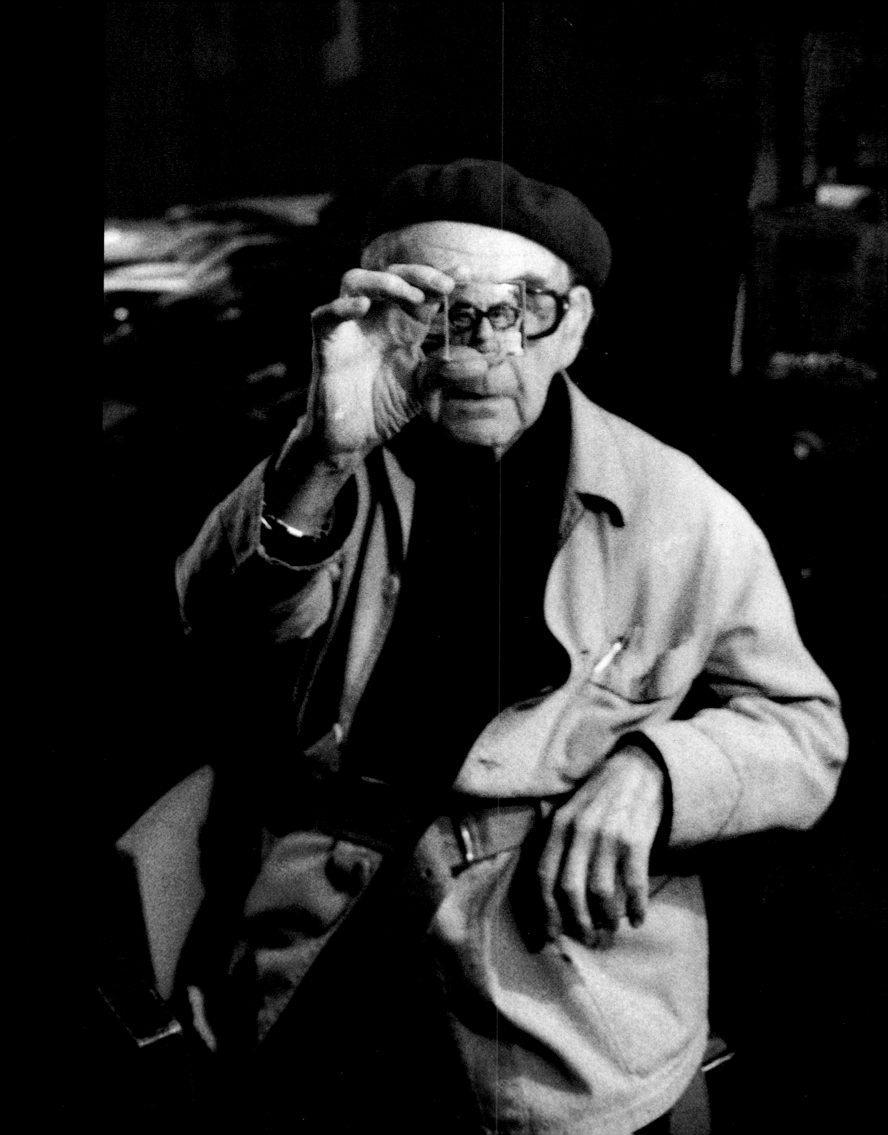

Photographer, painter, Dadaïst, Surrealist, genius: I first met him in Paris in June of 1968, with the smell of tear gas still hanging in the air, just one day after the student demonstrations during the spring of that year. I took many photographs of him over the years we were friends.

Always brilliant and funny, Man was a persistent joker, constantly making puns. Though he had enjoyed a great deal of artistic success by the late 1960s, he rightly felt he had not received the public recognition to which he was entitled. He was a real breakaway force in the 20th century, who took the photographic image beyond the bounds of the pure pictorial or objective print. He expanded the expressive limits of the medium, and it is partly due to him that photographic prints now hang in art museums all over the world.

According to legend, the tiny atelier where Man Ray lived and worked in Paris, 2 bis rue Ferou, was once the home of one of the original Three Musketeers. One day in 1971 I took my friend Nia Janis to meet him there. Nia, then a professor of art history at Wellesly college, would later do a book on the calotype in collaboration with my friend André Jammes of Paris (another introduction I'm proud to have made).

Juliet, Man's wife, greeted Nia and myself at the door and ushered us into the tiny bedroom with a huge bed located at the back of the studio, just across from a tiny bathroom and next to the darkroom, which housed all of Man's precious negatives.

Man was there, sitting propped up on his bed watching a television set hung from the ceiling. He was viewing a program showing the paintings of Hieronymous Bosch. Man invited us both to sit on the bed with him. Then he proceeded to get up and adjust the color of the set to a bizarre hue, stating: »I really want to see what Bosch looks like in different colors.«

One day I came into the studio and found one of the photographs I had done of him all cut up. He laughed and apologized, saying: »I had an emergency. My passport expired and I had no recent picture of myself. So I used one of the ones you took of me.« In my career as a photographer, that was the only time I'm aware of that I ever made a »passport photo«!

Another time as I was photographing him he said: »try this,« and stuffed his index finger into his nose. This was his own favorite of all the pictures I made of him. He said he wanted it to be the frontispiece of a future catalogue of his works.

As I went out for a copy of the French daily France Soir one morning in Paris, I read a headline »Duchamp est mort.« I immediately returned to my hotel and called Man's studio. Man answered, but I asked to speak to Juliet, as Man's heart was weak and I did not want to break the news to him of the death of his best friend. When Juliet came to the phone, I told her what had happened. »We just had dinner with Marcel and Teenie [his wife] last night,« she gasped.

Der Fotograf, Maler, Dadaist, Surrealist, das Genie: Zum ersten Mal begegnete ich ihm in Paris im Juni 1968; es hing noch der Geruch von Tränengas in der Luft, denn am Tag zuvor hatte es, wie an vielen Tagen in diesem Frühjahr, Studentendemonstrationen gegeben. In den langen Jahren unserer Freundschaft habe ich viele Fotos von Man Ray gemacht.

Er war ein brillanter, witziger Kopf, immer zu einem Scherz aufgelegt und ein Freund von Wortspielen. Obwohl er zu dieser Zeit schon recht erfolgreich war, hatte er immer noch das berechtigte Gefühl, nicht die Anerkennung erfahren zu haben, die er eigentlich verdiente. Ray verhalf der Kunst des 20. Jahrhunderts zu einem wahren Durchbruch, indem er der Fotografie eine neue Dimension verlieh, die über das rein illustrative oder objektive Abbild der Wirklichkeit hinausging. Er erweiterte die Ausdrucksmöglichkeiten des Mediums, und es ist nicht zuletzt sein Verdienst, daß heute in Kunstmuseen der ganzen Welt auch Fotos zu sehen sind.

Einer Legende zufolge war das kleine Pariser Atelier, 2 bis Rue Férou, in dem Man lebte und arbeitete, einst die Wohnung eines der »Drei Musketiere«. 1971 stellte ich ihm dort meine Freundin »Nia« Janis vor. Nia, die damals eine Professur für Kunstgeschichte am Wellesley College innehatte, hat später mit meinem Freund André Jammes – auch eine Verbindung, die ich geknüpft habe – ein Buch über Kalotypie geschrieben.

Mans Frau Juliet begrüßte Nia und mich an der Tür und führte uns in das kleine Schlafzimmer mit seinem riesigen Bett, das im hinteren Teil des Ateliers lag, gleich neben der Dunkelkammer, in der sich all die kostbaren Negative befanden.

Man Ray saß im Bett und sah fern; das Fernsehgerät hing von der Decke herunter. Es lief gerade eine Sendung über die Gemälde von Hieronymus Bosch. Wir sollten uns zu ihm setzen. Dann stand er auf und verstellte die Farben des Fernsehers zu einer bizarren Komposition. Er meinte dazu: »Ich wollte immer schon mal sehen, wie Boschs Gemälde aussehen, wenn sie andere Farben haben.«

Einmal kam ich in sein Atelier und fand eins der Fotos, die ich von ihm gemacht hatte, zerschnitten auf dem Tisch. Er lachte und entschuldigte sich mit den Worten: »Es war ein Notfall; mein Paß war abgelaufen, und ich hatte kein Paßbild. Also habe ich eins von deinen Fotos genommen.« Soweit ich weiß, ist dies das einzige Paßbild, das ich in meiner ganzen Karriere als Fotograf gemacht habe.

Als ich ihn bei einer anderen Gelegenheit fotografierte, sagte er: »Probier's doch mal so«, und steckte sich den Finger in die Nase. Es wurde sein persönliches Lieblingsbild aus der ganzen Bilderserie, die ich von ihm gemacht habe. Er sagte, er wolle es als Frontispiz für seinen nächsten Katalog nehmen.

Als ich eines Morgens in Paris den France Soir las, fiel mir die Schlagzeile »Duchamp est mort« (»Duchamp gestorben«) ins Auge. Ich lief sofort ins Hotel zurück und rief Man in seinem Atelier an. Er kam an den Apparat, aber ich sagte, ich wolle mit Juliet

Photographe, peintre, dadaïste, surréaliste, génie : je le rencontrai pour la première fois à Paris en juin 1968. L'odeur des gaz lacrymogènes flottait encore dans l'air : la veille, des étudiants avaient manifesté, comme de nombreuses fois ce printemps-là. Je le photographiai souvent pendant toutes ces années où nous fûmes amis.

Drôle, brillant, Man était très farceur, toujours prêt à faire des calembours. Bien qu'il connût un grand nombre de succès artistiques vers la fin des années soixante, il estimait à juste titre ne pas avoir reçu du public la reconnaissance qu'il était en droit d'attendre. Il fut un vrai innovateur du XXᵉ siècle et permit à la photographie d'être plus que la représentation objective de la réalité. Il élargit les limites d'expression de ce média, et c'est en partie grâce à lui si des photographies sont aujourd'hui accrochées dans les musées du monde entier.

La légende veut que le petit atelier où vécut et travailla Man Ray, 2 bis rue Férou à Paris, ait été autrefois la demeure de l'un des trois mousquetaires. Un jour de 1971, j'emmenai là mon amie « Nia » Janis. Nia, alors professeur d'histoire de l'art au Wellesley College, allait devenir plus tard l'auteur d'un ouvrage sur la calotypie, en collaboration avec mon ami André Jammes de Paris, une autre personnalité que je suis fier d'avoir rencontrée.

Juliet, la femme de Man, nous accueillit et nous mena dans la minuscule chambre occupée par un lit immense placé au fond de la pièce, coincé entre une petite salle de bains et la chambre noire, matrice de tant de précieux négatifs.

Man était là, assis sur son lit à regarder la télévision suspendue au plafond. Le programme portait sur des peintures de Jérôme Bosch. Man nous invita à nous asseoir en sa compagnie sur le lit, puis il procéda à un réglage de la couleur dans une teinte particulière et ajouta : « J'ai toujours voulu savoir à quoi ressemble Bosch dans des couleurs différentes. »

Un jour j'arrivai dans son atelier et trouvai, en morceaux, une des photos que j'avais faites de lui. Il rit et s'excusa en ajoutant : « C'est un cas d'urgence. Mon passeport arrive à expiration et je n'ai pas de photo récente. Je suis donc forcé de prendre une de celles que tu as faites. » Autant que je sache, c'est la seule « photo d'identité » que j'aie jamais réalisée de toute ma carrière de photographe !

Une autre fois, alors que je le photographiais, il me dit : « essaie cela », et se mit l'index dans le nez. Elle devint sa photo préférée parmi toutes celles que je fis de lui. Il dit qu'il la voulait en couverture du futur catalogue de son œuvre.

Alors que j'étais allé chercher France Soir un matin à Paris, je lus en première page « Duchamp est mort ». Je retournai immédiatement à mon hôtel et appelai le studio de Man. Celui-ci décrocha mais je demandai à parler à Juliet. Son cœur était fragile et je ne voulus pas lui annoncer aussi brutalement le décès de son meilleur ami. J'appris la terrible nouvelle à Juliet. « Nous avons dîné avec Marcel et Teenie (sa femme) hier soir », dit-elle d'une voix entrecoupée. Man avait prévu de me présenter

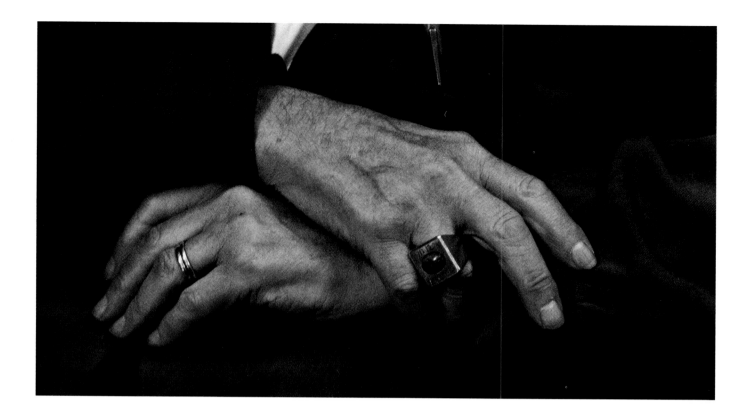

Man Ray's hands and ring, bearing his initials, 1969–74.

Die Hände von Man Ray; der Ring mit seinen Initialen, 1969–1974.

Les mains de Man Ray et sa chevalière portant ses initiales, 1969–1974.

Man had arranged for me to meet Duchamp for the first time the next day – a meeting fate did not allow to happen.

When I went over to the studio later that morning, Man, at the request of *France Soir*, was writing Duchamp's obituary. He reminisced to me about their lifelong friendship – chess, vacations, »The Large Glass.« Duchamp's »The Bride Stripped Bare . . .« Their friends, lovers, collaborations such as the »Boîte-en-Valise«.

And then Man said: »Arnold, I want you to have this,« handing me a slipcased Time-Life book entitled *Marcel Duchamp.* I asked: »Man, would you please inscribe it for me?«

He replied, as only he could have: »Ask Marcel to do it!«

I received a call at my Paris hotel one day from Joe Hirshhorn the collector, founder of the Hirshhorn Museum in Washington D.C. Knowing of my friendship with Man, Joe wanted me to sell him some photographs for his museum. When I relayed his request to Man, Man responded: »Why that son-of-a-bitch! He spent all week here trying to buy my paintings for no money. He's too goddam cheap to buy my paintings – so he doesn't get any photographs!«

I relayed the message to Joe, but put it a little more diplomatically.

Several years later I organized a show of works of

sprechen, denn ich wußte von Mans Herzschwäche, und wollte ihn vorsichtshalber nicht mit der Nachricht vom Tode seines besten Freundes konfrontieren. Als Juliet an den Apparat kam, erzählte ich ihr von Duchamps Tod: »Wir haben doch gestern noch mit Marcel und Teenie [seiner Frau] zu Abend gegessen«, sagte sie bestürzt.

Für den nächsten Tag hatte ich einen Termin bei Duchamp – das Schicksal verhinderte dieses Treffen.

Als ich am späteren Vormittag zu Man ins Atelier kam, schrieb er gerade den Nachruf auf Duchamp für den *France Soir.* Er erzählte mir von seiner lebenslangen Freundschaft mit Duchamp – Schach, Ferien, Duchamps »Das große Glas«, »The Bride Stripped Bare«, ihre Freunde, Lieben, Mitarbeiter, sowie die »Boîte en Valise«.

Schließlich sagte Man: »Arnold, ich möchte dir das hier schenken«, und gab mir ein Time-Life Book im Schuber mit dem Titel *Marcel Duchamp.* Ich bat ihn: »Man, würdest du mir das Buch bitte signieren?«

Er antwortete auf seine unvergleichliche Weise: »Frag doch Marcel!«

Einmal rief mich Joe Hirshhorn, Kunstsammler und Gründer des Hirshhorn Museums in Washington, in meinem Hotel in Paris an. Joe, der wußte, daß ich mit Man befreundet war, wollte, daß ich ihm beim Kauf einiger Fotos von Man für sein Museum behilflich war. Als ich Man von Joes Anliegen erzählte, sagte er nur: »Der alte Geizkragen! Der hat hier eine Woche zugebracht und versucht, mir meine Gemälde für ein paar Groschen abzuschwatzen. Wenn er zu geizig ist, meine Gemälde zu kaufen, soll er meine Fotos auch nicht kriegen!«

Ich erzählte Joe davon, formulierte es aber natürlich viel diplomatischer.

à Duchamp le lendemain. Le destin en décida autrement.

Quand je passai au studio à la fin de cette matinée-là, Man, sur la demande de *France Soir*, rédigeait un article à la mémoire de Duchamp. Il évoqua devant moi leur longue amitié, les parties d'échecs, les vacances, le *Grand Verre, La mariée mise à nu par ses célibataires* de Duchamp, leurs amis, leurs amours, les collaborateurs ainsi que *La boîte en valise.*

Puis il me dit : « Arnold, je veux que tu prennes cela » et me tendit un étui contenant un livre *Time Life* intitulé *Marcel Duchamp.* Je demandai : « Man, peux-tu le dédicacer pour moi ? ». Il me répondit comme lui seul pouvait le faire : « Demande donc à Marcel de le faire ! »

Je reçus un appel à mon hôtel à Paris de Jœ Hirshhorn, le collectionneur, fondateur du musée Hirshhorn à Washington D.C. Connaissant mon amitié pour Man, Jœ désirait que je lui vendis quelques photos pour son musée. Quand je rapportai cette conversation à Man, il s'exclama : « Quoi, ce fils de chienne ! Il a essayé toute la semaine d'acheter mes peintures pour rien. Il est bien trop radin pour acheter mes peintures, il n'aura aucune photo ! ».

Je transmis le message à Jœ, mais avec bien entendu un peu plus de diplomatie !

Quelques années plus tard, j'organisai une exposition de l'œuvre de Man avec un catalogue, au musée d'Art de Milwaukee. Cette exposition parcourut tout le pays, du Metropolitan de New York aux musées du Texas et de San Francisco. Mais jamais mention ne fut faite de cette exposition parfaitement documentée, dans aucune bibliographie ou chronologie publiées par la suite.

Quand j'appris le décès de Man, le 19 novembre

Man in an exhibition, with a catalogue, at the Milwaukee Museum of Art. This exhibition traveled all over the United States to the Metropolitan in New York and the museums in Texas and San Francisco. But mention of this fully documented show has never appeared in any bibliographies or chronologies that have since been published.

When I learned of Man's death in Paris, on 19 November 1976, I immediately called Juliet from the kitchen of my Chicago apartment and said: »Please say goodbye to Man for me.«

She responded: »I'll do more than that – I'll kiss him for you.«

I had first met Man after Jean Petitory, Man Ray's publisher, telephoned him from the auction house of Kornfeld and Klipstein in Berne, Switzerland. Jean, with whom I later was to become friendly, learned of my interest in Man during the sale of the collection of the Dada poet Tristan Tzara. Jean had

Einige Jahre später organisierte ich eine Ausstellung von Mans Werken – mit Ausstellungskatalog – am Milwaukee Museum of Art. Diese Ausstellung wanderte dann durch die ganzen USA, zum Metropolitan Museum in New York und zu Museen in Texas und San Francisco. Leider ist diese große, gut dokumentierte Ausstellung seither in keiner Bibliographie oder Chronologie mehr erwähnt worden.

Als ich am 19. November 1976 von Mans Tod in Paris erfuhr, griff ich in der Küche meines Chicagoer Apartments sofort zum Telefonhörer und rief Juliet an. »Sag ihm bitte auf Wiedersehen von mir«, bat ich sie. »Ich werde noch etwas mehr tun«, antwortete sie, »ich werde ihm einen Kuß von dir geben.«

Kennengelernt habe ich Man Ray auf Vermittlung seines Verlegers, Jean Petitory, mit dem ich später Freundschaft schloß. Jean erfuhr von meinem Interesse an Man während der Versteigerung der Sammlung des DADA-Poeten Tristan Tzara. Er rief Man noch vom Auktionshaus Kornfeld und Klipstein in Bern an und schlug ihm vor, sich mit mir zu treffen. Aus dieser Begegnung erwuchs eine langjährige Freundschaft.

Ganz nebenbei: Jean und ich fuhren bei einer anderen Gelegenheit mit dem Wagen zu einer Auktion in die Schweiz. Jean, der Ende der siebziger Jahre an der Hodgkinschen Krankheit gestorben ist, war ein großartiger Reisebegleiter – wenn man einmal davon absieht, daß wir immer eine Vorliebe für die gleichen Frauen hegten! Jedenfalls werde ich mich bis an mein Lebensende darüber amüsieren, daß sowohl seine Frau als auch seine Geliebte Chantal hießen. Er mußte sich wohl nie Sorgen darüber

1976, j'appelai immédiatement Juliet de la cuisine de mon appartement à Chicago et lui dit : « S'il te plaît, dis lui au revoir de ma part ». Elle me répondit : « Je vais faire plus que cela, je vais l'embrasser pour toi. »

Jean Petitory, l'éditeur de Man Ray (désormais « Man », comme il voulait que ses amis l'appellent), qui allait devenir un ami, apprit mon intérêt pour Man durant une vente aux enchères de la collection du poète dada Tristan Tzara à la Salle des ventes de Kornfeld et Klipstein à Berne. Il organisa alors les présentations entre Man et moi par téléphone.

Jean mourut à la fin de l'année 1970 de la maladie d'Hodgkin. C'était un compagnon de voyage fantastique, mis à part le fait que nous tombions toujours amoureux des mêmes femmes ! Un détail cocasse le concernant est que sa femme et sa maîtresse portaient le même prénom, Chantal. Je suppose qu'il n'eut jamais à s'inquiéter de se tromper de prénom durant son sommeil.

Man, citoyen américain, né à Philadelphie (Pennsylvanie) en 1890, fut d'abord dessinateur puis peintre. Il arriva à Paris en 1921 et devint membre d'un groupe d'artistes, écrivains, poètes,

Man Ray's enlarger – note objects on bottom which he used to make some of his Rayographs (negativeless photographic images), 1969–74.

Man Rays Vergrößerer – man beachte die Gegenstände unten, die er für einige seiner Rayographien (ohne Negativ direkt auf Fotopapier entstehende Bilder) benutzte. 1969–1974.

L'agrandisseur de Man Ray. On remarque dans le fond les objets dont il se servait pour exécuter quelques-uns de ses Rayographes (images photographiques sans négatif). 1969–1974.

Man Ray giving my son David sunglasses with battery-powered windshield wipers, c. 1972.

Man Ray reicht meinem Sohn David eine Sonnenbrille mit batteriebetriebenen Scheibenwischern, um 1972.

Man Ray offrant à mon fils David des lunettes de soleil avec un essuie-glace activé par des piles. Vers 1972.

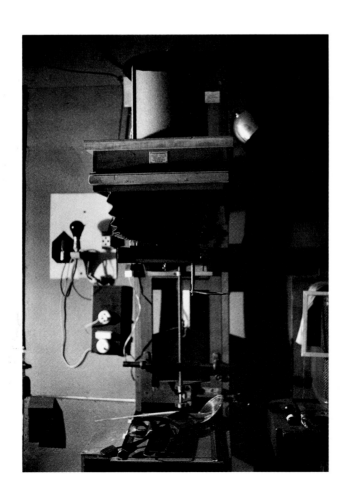

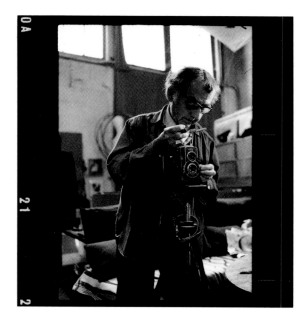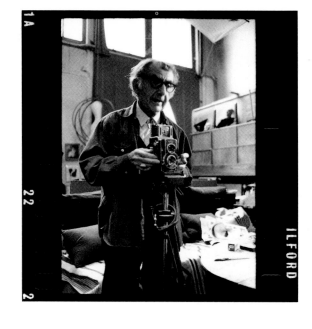

suggested Man meet with me. That meeting between Man and myself led to a lasting friendship.

Jean and I motored from Paris to Switzerland to attend a subsequent Kornfeld auction. Jean, who died in the late 1970s from Hodgkin's disease, was a great travel companion – except for the fact that we both liked the same women that we met! One thing I shall never forget about him was that both his wife and mistress were named Chantal. I guess he never did have to worry about saying the wrong name in his sleep.

Man, an American, was born in Philadelphia, Pennsylvania, in 1890. He was first a draughtsman, then a painter. He went to Paris in 1921 where he became a member of the group of practicing artists, writers, poets, and composers later described as Dadaists – although Man said Dada was never a movement, but rather an anti-movement. He partied with them and photographed them and became one of them. Dadaism continued into the 1930s and '40s as part of the larger movement now known as Surrealism.

Man and I frequently lunched at a small Bistro called Chez Alexander on the rue des Trois Canettes on the left bank.

Near the end of his life, Man needed to lean on his cane for support. He had developed a neurological condition that was gradually interfering with his ability to walk. He also wore a pair of sunglasses with one lens completely gone from the frame. When I asked him about them, he responded: »Oh, they are very useful! I never have to worry whether it's a sunny or a dark day. They're useful for both. You see, I never have to change them!«

Man Ray told me that he took up photography in order to support himself as a painter, but as fate would have it, aside from his airbrush drawing or his fantastic painting of the floating lips, »Observatory Time,« he'll best be remembered – ironically, but true to Dada form – as a photographer.

machen, im Schlaf einmal den falschen Namen zu sagen.

Man war Amerikaner. Er wurde 1890 in Philadelphia geboren. Er zeichnete zuerst, dann wurde er Maler. 1921 ging er nach Paris, wurde Mitglied einer Gruppe von bildenden Künstlern, Schriftstellern, Dichtern und Komponisten, die sich später Dadaisten nannten – Man Ray sagte mir einmal, daß DADA niemals eine Bewegung war, sondern eher eine Anti-Bewegung. Er ging zu den Parties der Gruppe, fotografierte sie und gehörte mit der Zeit dazu. Der Dadaismus setzte sich bis in die dreißiger und vierziger Jahre als Teil des Surrealismus fort.

Man und ich gingen oft in einem kleinen Bistro namens Chez Alexandre in der Rue des Trois Canettes am linken Seineufer Mittag essen.

Gegen Ende seines Lebens war Man beim Gehen auf einen Stock angewiesen. Er litt an einer Nervenkrankheit, die seine Gehfähigkeit mit der Zeit immer stärker einschränkte. Er trug eine Sonnenbrille, der ein Glas fehlte. Als ich ihn fragte, was es mit dieser Sonnenbrille auf sich hätte, sagte er: »Die ist sehr praktisch! Es ist nämlich bei diesem Modell ganz egal, ob der Tag sonnig ist oder düster. Ich habe für beides vorgesorgt. So muß ich nie die Brille wechseln.«

Man Ray erzählte mir, daß er nur angefangen habe zu fotografieren, weil er glaubte, damit seinen Lebensunterhalt verdienen und nebenher malen zu können. Aber das Schicksal wollte es anders. Sieht man von seinen Airbrush-Zeichnungen und seinem fantastischen Gemälde von den schwebenden Lippen, »Observatory Time«, einmal ab, so wird wohl am ehesten sein fotografisches Werk die Zeit überdauern – das ist eine Ironie des Schicksals, aber auch wieder wahrhafter DADA.

Man Ray using his camera in his studio in Paris, 1970.

Man Ray mit seiner Kamera in seinem Atielier in Paris, 1970.

Man Ray avec son appareil-photo dans son atelier à Paris, 1970.

appartenant tous au mouvement dada, bien que Man ait toujours déclaré qu'il s'agissait non d'un mouvement mais d'un anti-mouvement. Il se mêla à ces artistes, les photographia, et finalement devint l'un d'entre eux. Le dadaïsme se développa dans les années 1930 à 1940, s'inscrivant dans un large mouvement connu plus tard sous le nom de surréalisme. Man et moi-même déjeunions très souvent « Chez Alexandre », un petit bistrot de la rive gauche, rue des Trois Canettes.

Vers la fin de sa vie, Man ne se déplaça plus qu'à l'aide de sa canne. Il était atteint d'une maladie du système nerveux qui affectait ses facultés motrices. Il portait toujours des lunettes de soleil avec un seul verre. Lorsque je lui en demandai la raison, il me fit cette réponse : « Oh, c'est très pratique! Je n'ai jamais à me demander s'il fait beau ou mauvais. Ça marche dans les deux cas ! Tu vois, je n'ai jamais besoin de changer. »

Man me dit un jour être devenu photographe pour assurer sa survie de peintre, mais, ironie du sort, mis à part ses dessins à l'aérographe, ou bien encore sa fantastique toile de lèvres flottantes *Observatory Time*, on se souvient plus du photographe que du peintre.

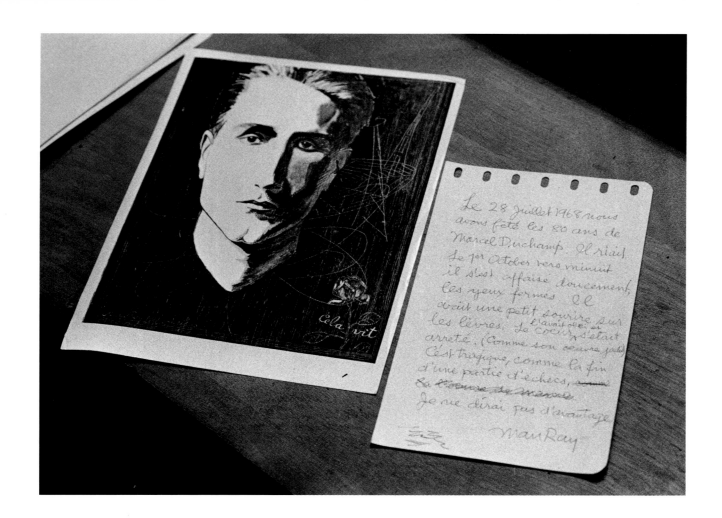

Man's handwritten obituary for his friend Marcel Duchamp, as it appeared on his desk – with Man's etching of Duchamp, the morning after Duchamp's death. 1968.

Mans handgeschriebener Nachruf auf seinen Freund Marcel Duchamp, auf seinem Schreibtisch am Morgen nach Duchamps Tod. Daneben Mans Radierung von Duchamp. 1968.

L'article rédigé à la main à la mémoire de son ami Marcel Duchamp posé sur le bureau avec une eau-forte de celui-ci, le matin qui suivit sa mort. 1968.

Close-up of obituary, 1968.

Nahaufnahme des Nachrufs, 1968.

Gros plan de l'article à la mémoire de Duchamp, 1968.

18

His darkroom shelf with some of his negative boxes –
containing early glass negatives of some of his most
famous subjects, 1969–74.

Regalausschnitt in Man Rays Dunkelkammer mit etlichen
Negativkisten, in denen er frühe Glasnegative mit einigen
seiner berühmtesten Aufnahmen aufbewahrt. 1969–1974.

L'étagère de sa chambre noire avec quelques boîtes,
renfermant les négatifs en verre de quelques-uns de ses
plus célèbres sujets. 1969–1974.

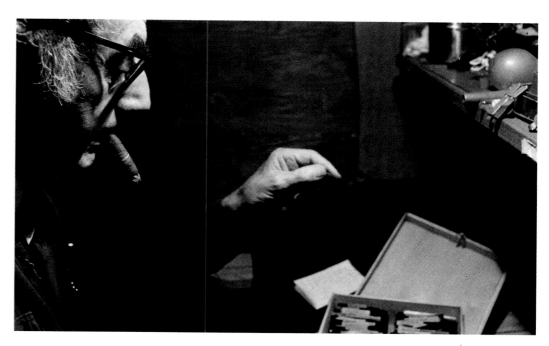

Examining one of his negatives, 1974.

Bei der Betrachtung eines Negativs, 1974.

En train d'examiner l'un de ses négatifs, 1974.

A negative file, 1971.

Eine Box mit Negativen, 1971.

Un classeur contenant des négatifs, 1971.

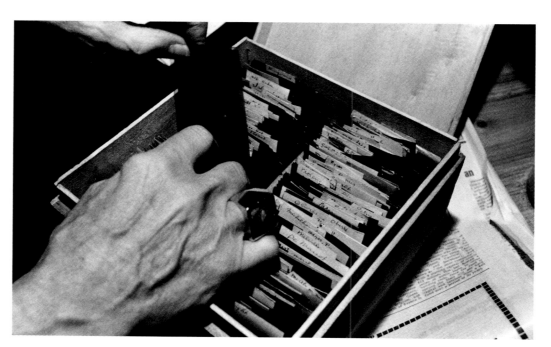

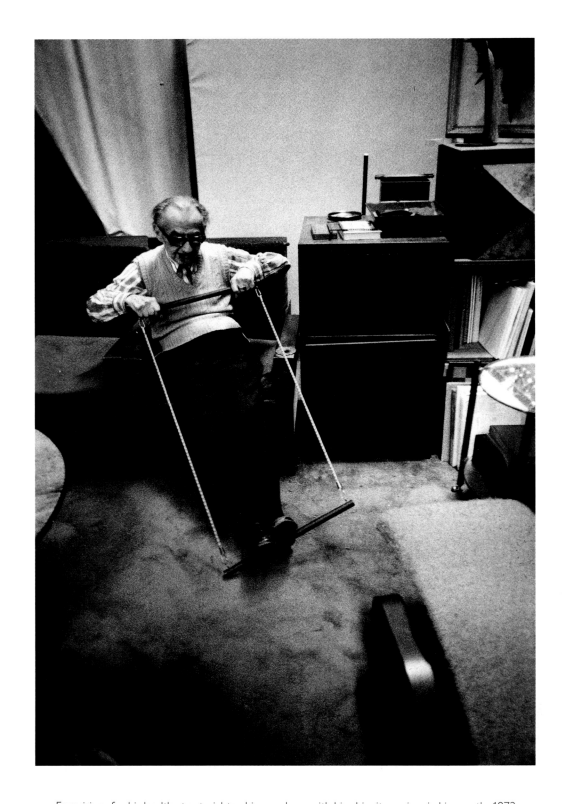

Exercising »for his health« to straighten his muscles – with his ubiquitous cigar in his mouth, 1972.

Beim Gesundheitstraining für die Muskeln – mit Zigarre – wie immer, 1972.

En train de s'exercer « pour sa santé » à étirer ses muscles, son éternel cigare entre les lèvres. 1972.

Emerging from the rear of his studio (bedroom and darkroom) to studio area, 2 bis rue Férou, 1972.

Man Ray betritt sein Atelier. Hinter dem Vorhang befinden sich Schlafzimmer und Dunkelkammer, 2 bis rue Férou, 1972.

Il entre dans son atelier (derrière le rideau se trouvent la chambre à coucher et la chambre noire), 2 bis rue Férou, 1972.

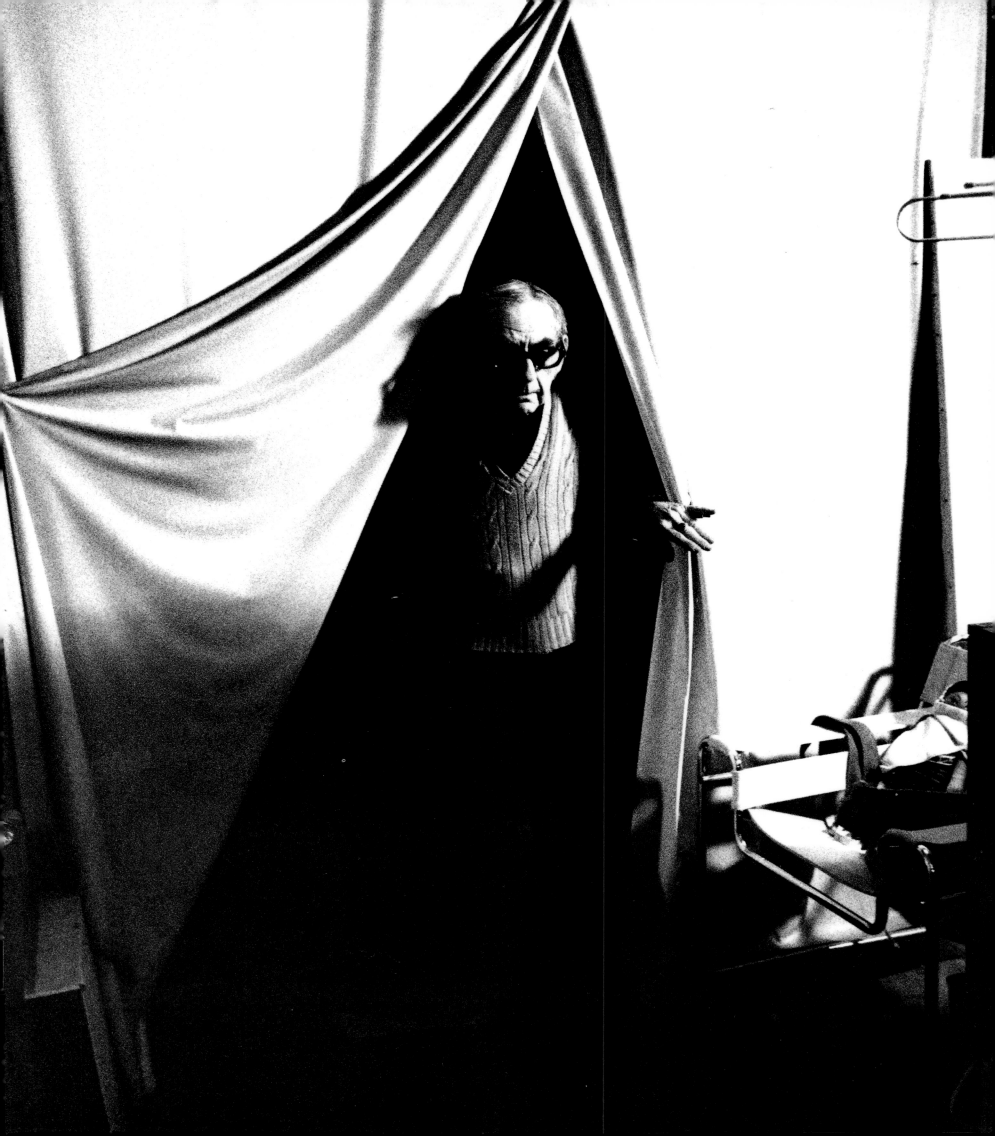

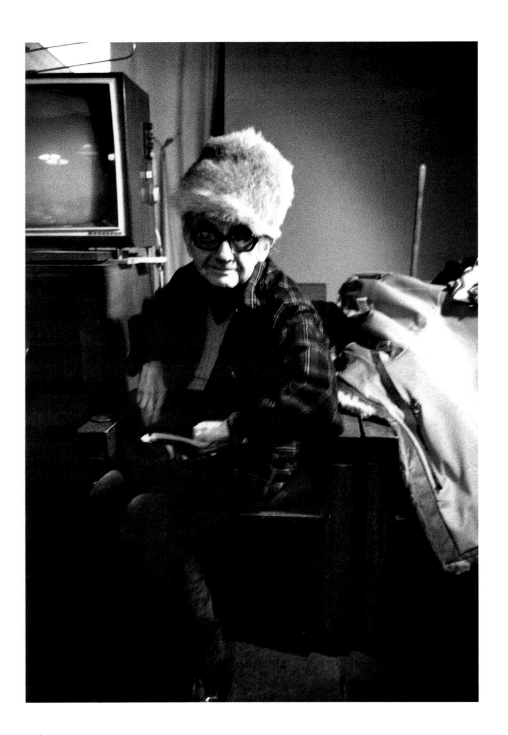

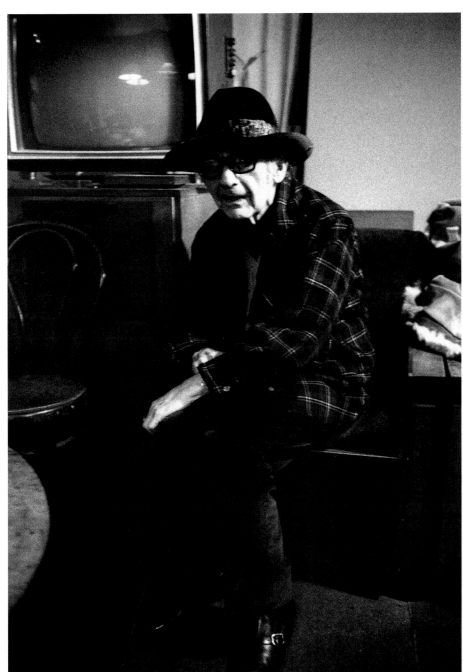

Man loved hats and masks. Wearing one of his fur hats, 1969.

Man war ein Liebhaber von Hüten und Masken. Hier trägt er eine seiner Pelzmützen. 1969.

Man aimait les chapeaux et les masques. Il porte ici l'un de ses chapeaux de fourrure. 1969.

Man Ray wearing my hat, 1972.

Man Ray mit meinem Hut, 1972.

Man Ray portant mon chapeau, 1972.

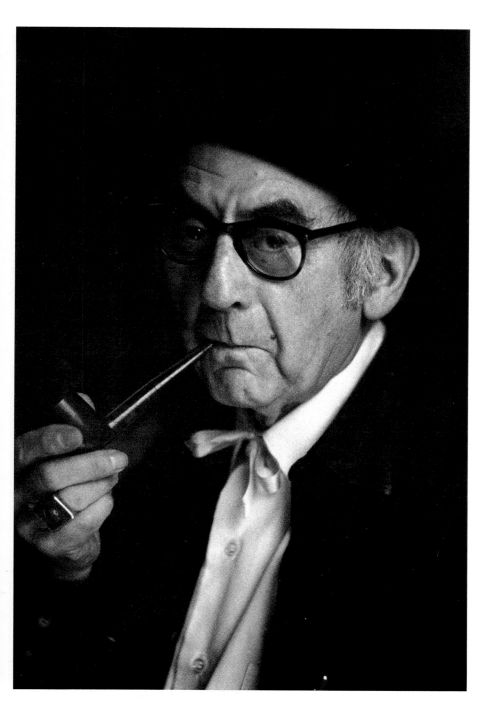

Portrait, 1971.

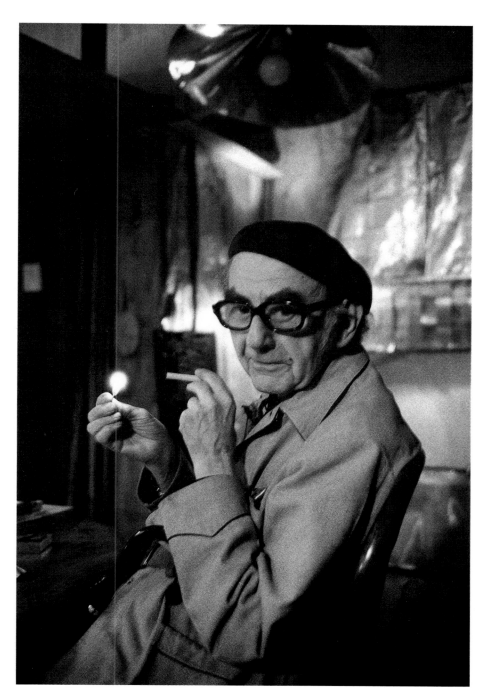

Man Ray lighting a cigarette, 1971.

Man Ray zündet sich eine Zigarette an, 1971.

Man Ray en train de s'allumer une cigarette, 1971.

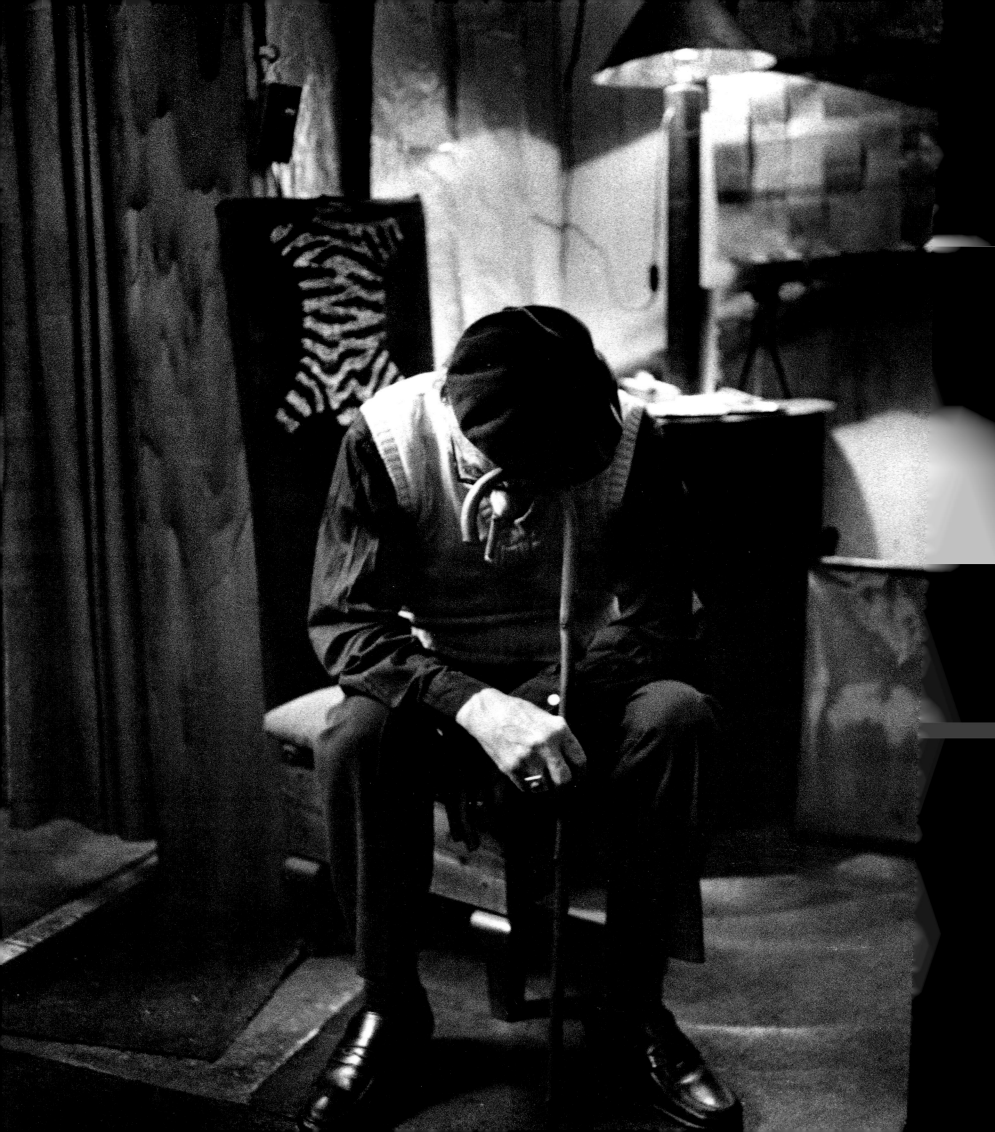

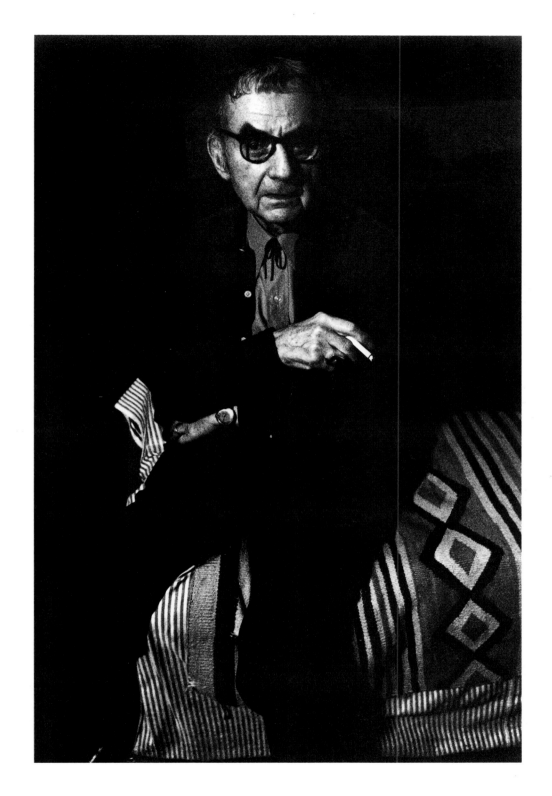

My very first photograph of Man Ray, 2 bis rue Férou, 1968.

Das erste Bild, das ich von Man Ray machte. Entstanden bei der ersten Begegnung in Rays Atelier, 2 bis Rue Férou, 1968.

Ma première photographie de Man Ray prise durant notre première rencontre, 2 bis, rue Férou, 1968.

In studio, 2 bis rue Férou, 1973.

Im Atelier, 2 bis Rue Férou, 1973.

Dans l'atelier, 2 bis, rue Férou. 1973.

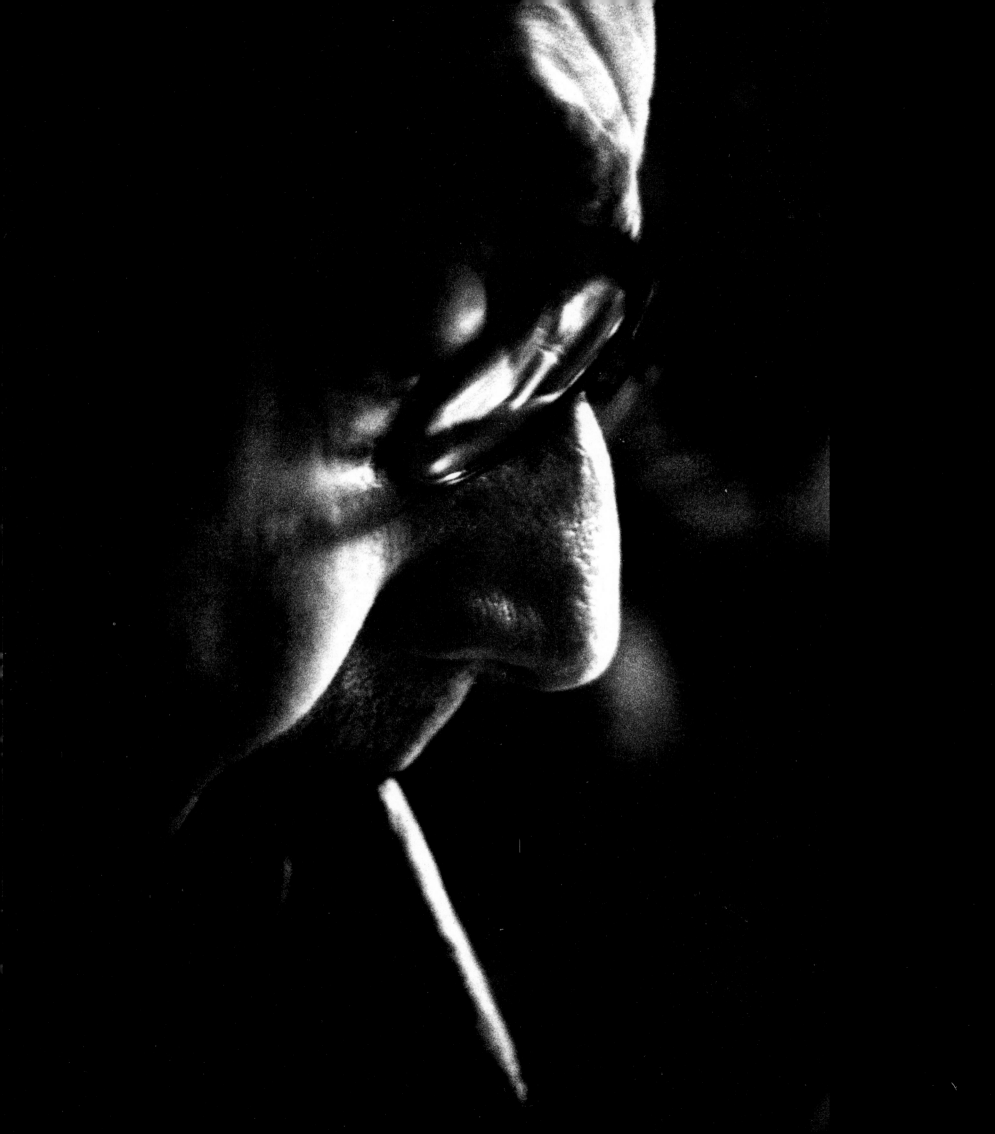

Portrait, 1970.

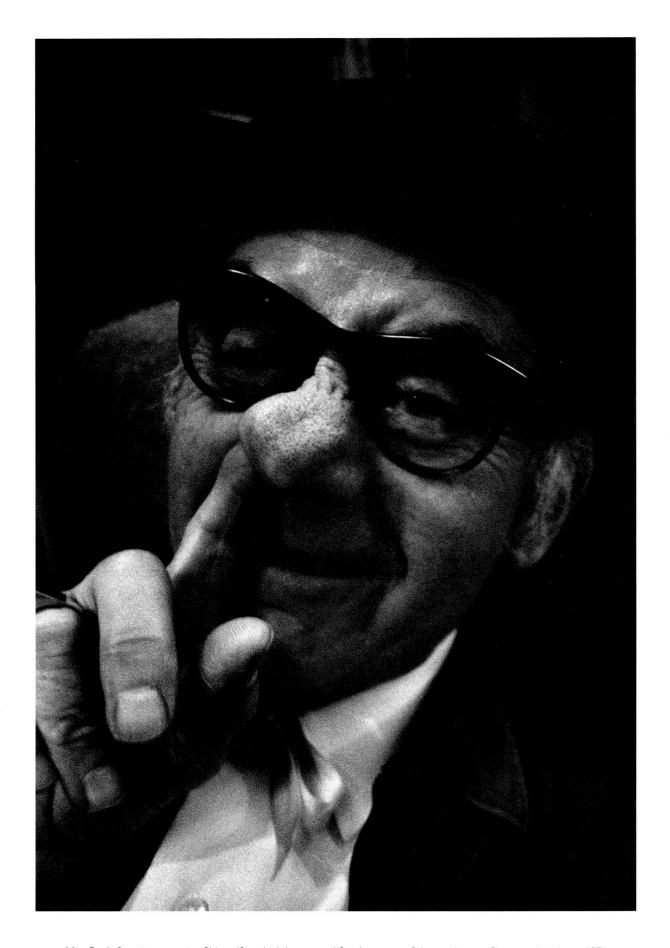

Man Ray's favorite portrait of himself – which he wanted for the cover of the catalogue of his next big show. 1974.

Man Rays Lieblingsporträt aus meiner Serie – er wünschte es als Titelbild für den Katalog seiner nächsten großen Ausstellung. 1974.

L'autoportrait préféré de Man Ray qu'il voulait en couverture du catalogue de sa prochaine importante exposition. 1974.

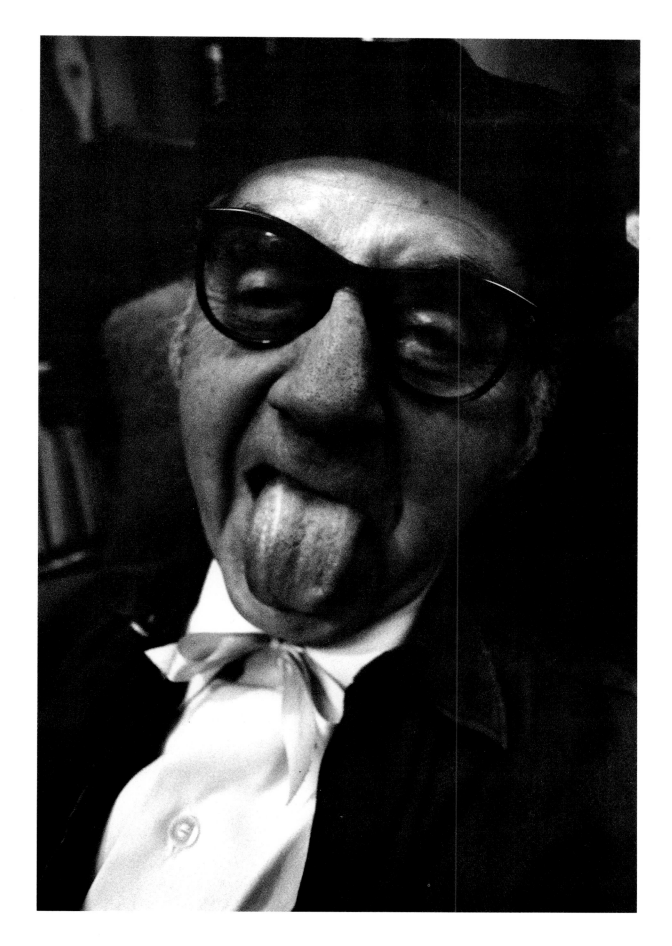

»Playing with author«, 1971.

Man Ray albern, 1971.

« En train de jouer avec l'auteur », 1971.

Man Ray being Man Ray,
1972.

Man Ray dreht mir eine
Nase. 1972.

Man Ray tel qu'en
lui-même, 1972.

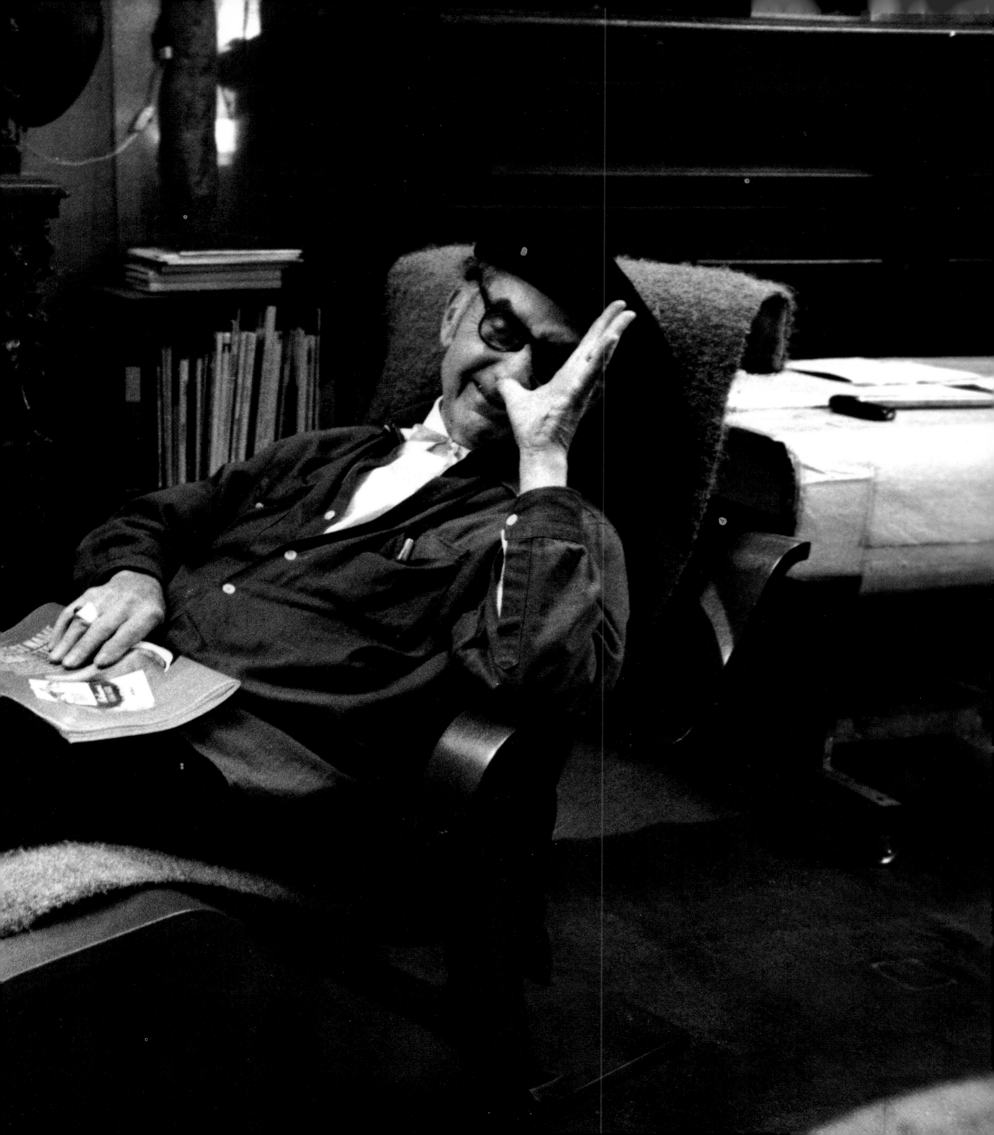

Ansel Adams

1902–1984. American.
Photographer, author and environmentalist. Best known for his
landscape photographs of the National Parks. Wrote numerous
books on the technique of photography and for many years
conducted photography workshops.

1902–1984. Amerikaner.
Adams war Fotograf, Autor und engagierter Umweltschützer.
Berühmt für seine Landschaftsfotografien der amerikanischen
Nationalparks. Er schrieb zahlreiche Bücher über
Fotografietechnik und lehrte in vielen Foto-Workshops.

1902–1984. Américain.
Photographe, auteur et spécialiste de l'environnement. Il est très
connu pour ses photos prises dans les parc nationaux. Il écrivit un
grand nombre d'ouvrages techniques sur la photographie et
anima de nombreux ateliers consacrés à cette dernière.

Ansel Adams at Point Lobos, California, 1969.

Ansel Adams am Point Lobos in Kalifornien, 1969.

Ansel Adams à Point Lobos, Californie, 1969.

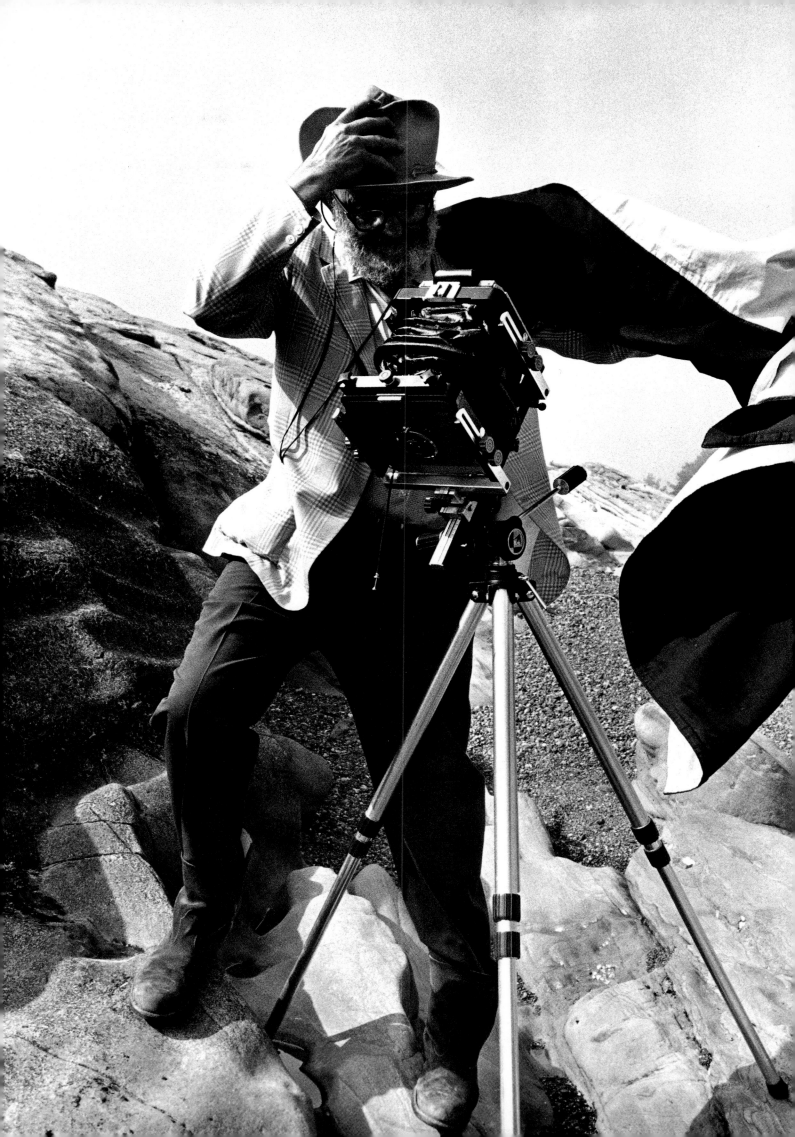

It would be redundant to write an essay chronicling the accomplishments or the life of Ansel Adams, so I shall devote this chapter to some reminiscences.

He gave an overall impression of being *big* – warm and open. When we flew to Carmel, my wife and I found Ansel and Virginia waiting for us at their home high on a hill overlooking the ocean. With a handshake, Ansel broadly welcomed us inside.

Ansel's home had a prominently placed grand piano and a darkroom that would have been the envy of any photographer in the world fortunate enough to see it. Among the expected accoutrements in his darkroom was a very sophisticated timer for »repeatability of results,« as Ansel said, and a horizontal enlarger for Ansel's larger prints, such as those we sometimes see of his famous »Moonrise Over Hernandez«.

Ansel was photographing the day I arrived – he said he photographed almost every day – and he suggested that I accompany him to Point Lobos. It was really a magical moment for me to be with one of photography's great heroes at one of the medium's most important locations, the place where Ansel and his friend Edward Weston had made some of their most remarkable photographic masterpieces.

Ansel set up his camera, an Arca-Swiss 4x5-inch view camera, on his tripod. He made some Polaroids and exposed some negatives. With only a 35mm in hand, I photographed him at Point Lobos. I remember him asking me about the film I was using and commenting about my lens settings.

On our first night there, we sat around a candlelit dinner table, and Ansel was his warm, charming self. At the end of dinner, he proceeded to the piano and played some Brahms and Bach, to my great enjoyment. He then proceeded to tell me that his real love was music, and that early in his career he had wanted to become a concert pianist. In fact, he ob-

Leben und Werk dieses Giganten der Fotografie brauche ich hier wohl nicht vorzustellen, aber ich möchte gerne von meinen Erinnerungen an ihn erzählen.

Wenn ich Ansel traf, hatte ich stets das Gefühl, eine große Persönlichkeit zu erleben – voller Wärme und Offenherzigkeit. Als ich mit meiner Frau nach Carmel flog, erwarteten uns Ansel und Virginia in ihrem Haus hoch auf einem Berg mit Meerblick. Ansel hieß uns aufs herzlichste willkommen.

Imposant an diesem Haus war schon der Flügel, aber Ansels Dunkelkammer würde sicher jeden Fotografen vor Neid erblassen lassen.

Zur Ausrüstung des Labors gehörte auch eine hochkomplizierte Zeitschaltuhr, die, wie Ansel es ausdrückte, »die Wiederholbarkeit der Ergebnisse garantierte«; außerdem ein horizontal montierter Vergrößerer für übergroße Abzüge, wie wir sie manchmal von seinem berühmten »Moonrise over Hernandez« sehen.

Am Tag unserer Ankunft fotografierte Ansel gerade – er sagte, daß er praktisch jeden Tag Aufnahmen mache –, und er schlug vor, daß ich ihn zum Point Lobos begleiten solle. Es war ein geradezu magischer Moment für mich, mit einem der Großen der Fotografie dort zu sein, wo Ansel und sein Freund Edward Weston einige ihrer Meisterwerke geschaffen hatten.

Ansel baute seine Arca-Swiss 4 x 5-Zoll-Sucherkamera auf einem Stativ auf. Er machte ein paar Polaroidbilder und einige Negative. Ich hatte nur eine 35 mm-Kamera ohne Stativ dabei; mit der fotografierte ich Ansel am Point Lobos. Er erkundigte sich nach dem Film, den ich benutzte und machte Bemerkungen zu meiner Kameraeinstellung.

An unserem ersten Abend in Carmel saßen wir alle um einen kerzenbeschienenen Eßtisch, und Ansel war in seinem Element – charmant und warmherzig. Nach dem Essen setzte er sich an den Flügel und spielte Brahms und Bach – ein Genuß! Später erzählte er uns, daß seine wahre Liebe eigentlich die Musik sei und er in seiner Jugend davon geträumt habe, Konzertpianist zu werden – das Talent dazu besaß er zweifellos. Leider war er aber schon in seinem zweiten Lebensjahr an einer Arthritis erkrankt, und die Ärzte prophezeiten ihm, daß seine

Il serait superflu d'écrire un ouvrage sur la vie d'Ansel Adams et je me contenterai ici de quelques souvenirs.

Il se dégageait de sa personne une impression de chaleur humaine et d'ouverture sur les autres. Lorsque nous nous étions envolés pour Carmel, ma femme et moi avions trouvé Ansel et Virginia qui nous attendaient dans leur maison perchée sur la colline, dominant l'océan. Ansel nous accueillit d'une poignée de main chaleureuse.

On trouvait dans la maison, bien en évidence, un grand piano, ainsi qu'une chambre noire qui aurait fait envie à n'importe quel photographe du monde. Parmi le matériel habituel, il y avait un chronomètre très perfectionné pour répéter les résultats, comme me l'expliqua Ansel, et un agrandisseur horizontal pour les épreuves plus grandes, comme celles que nous voyons quelquefois dans son célèbre *Moonrise Over Hernandez*.

Le jour de mon arrivée, Ansel était en train de photographier. Il me dit le faire presque tous les jours et me proposa de l'accompagner à Point Lobos. Ce moment fut vraiment magique. J'étais dans l'un des sites les plus photographiés avec l'un des grands noms de cet art, l'endroit où Ansel et son ami Edward Weston avaient réalisé la plupart de leurs chefs-d'oeuvre. Ansel fixa son appareil, un Arca-Swiss 4x5 sur un trépied. Il fit quelques polaroïds et exposa des négatifs. Je n'avais qu'un 35mm dans les mains et le photographiai à Point Lobos. Je me rappelle qu'il me posa des questions sur les films que j'utilisais et commenta le réglage de mes lentilles.

Notre première soirée, nous la passâmes assis autour d'une table dressée pour un dîner aux chandelles avec un Ansel totalement fidèle à lui-même, charmant et chaleureux. A la fin du dîner, il se mit au piano et interpréta Brahms et Bach pour mon plus grand plaisir. Il me confia qu'il était amoureux de la musique et qu'il avait souhaité devenir pianiste

Adams on his property with friend, 1969.

Adams mit einem Freund im Garten seines Hauses, 1969.

Adams dans sa propriété avec un ami, 1969.

Music area, Adams' home, 1969.

Das Musikzimmer in Adams' Haus, 1969.

Le coin musique chez les Adams, 1969.

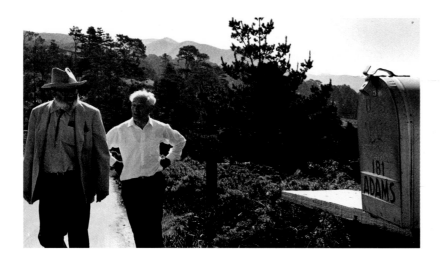

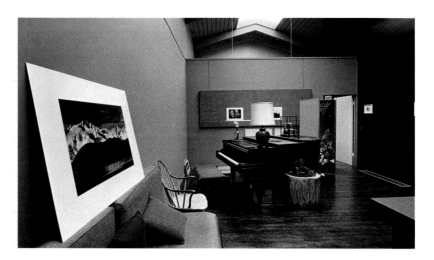

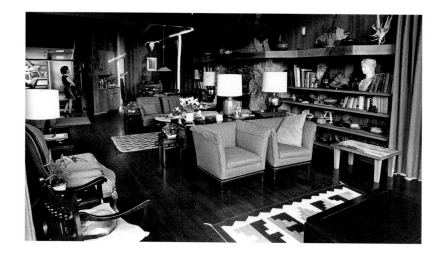
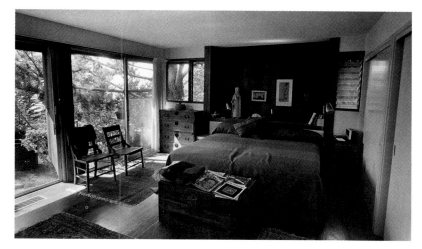

Interior of Adams' home, 1969.

Blick in Adams' Hause, 1969.

L'intérieur de la maison des Adams, 1969.

Ansel and Virginia's bedroom, 1969.

Das Schlafzimmer von Ansel und Virginia, 1969.

Chambre à coucher de Virginia et Ansel Adams, 1969.

viously had the talent to do so. But he had developed an arthritic condition in his twenties, and was told by his doctors that if his dream did happen it would be short-lived because his fingers would stiffen. Thus he came to his second love: photography.

When we returned to the Adams' home the next morning, Virginia had prepared breakfast. We had bacon and eggs and some wonderful muffins that she had fixed. Later that morning Ansel took me in his car to Wildcat Hill, the former home of Edward Weston, where Edward's son Neil was now living with his family. When we visited Neil, a number of cats were scurrying underfoot.

We went back to the house that afternoon so Ansel could meet a young photographer who had brought a portfolio for Ansel to review. Ansel gave generously of his time to the young man and offered gentle encouragement.

We then drove to another of Ansel's friends, Rosario Mazzeo, a classical clarinetist formerly with the Boston Symphony Orchestra. They played some music together, Ansel on the piano, and Rosario the clarinet. Since I also play the clarinet (although not nearly to the same high standard of musicianship), Rosario handed me a clarinet, and for a brief moment we were a trio playing at the Mazzeo home.

During our wide-ranging discussions I mentioned to Ansel that I had some relatives living in Kentucky. He confided to me that he had always wanted to become a »Kentucky Colonel,« an honorary title conferred by the governor of Kentucky. When I told him that I could make it happen, he said: »If you do, I'll give you one of my photographs.«

To make a long story short, I did make it happen, and Ansel kept his word without having to be reminded – so now I have a wonderful Adams portrait of Stieglitz, which was sent to me by the newly commissioned »Colonel« himself.

Finger steif werden würden. So traf er seine zweite Liebe: die Fotografie.

Als wir am nächsten Morgen zum Haus der Adams zurückkehrten, hatte Virginia das Frühstück schon fertig. Es gab Schinken und Rührei und ganz wunderbare Muffins, die Virginia selbst gebacken hatte. Anschließend fuhr Ansel mit mir nach Wildcat Hill, dem Haus von Edward Weston, das jetzt sein Sohn Neil mit seiner Familie bewohnte. Überall liefen Katzen herum!

Nachmittags fuhren wir wieder zurück, weil Ansel sich mit einem jungen Fotografen treffen wollte, der ihn gebeten hatte, seine Mappe zu begutachten. Ansel war sehr freigebig mit seiner Zeit und machte dem jungen Mann auf sehr einfühlsame Weise Mut.

Später besuchten wir einen anderen Freund von Ansel, Rosario Mazzeo, einen Klarinettisten, der im Boston Symphony Orchestra gespielt hatte. Sie musizierten eine Zeitlang gemeinsam, Ansel auf dem Piano und Rosario auf der Klarinette. Da ich auch ein bißchen Klarinette spiele (wenn auch nicht annähernd so gut), reichte mir Rosario eine Klarinette, und ein Weilchen bildeten wir ein Trio.

Im Verlauf unserer Gespräche über Gott und die Welt erwähnte ich, daß ich Verwandte in Kentucky habe. Ansel vertraute mir an, daß er sich schon immer gewünscht habe »Kentucky Colonel« zu werden, ein Ehrentitel, den nur der Gouverneur von Kentucky verleihen kann. Ich versprach ihm meine Hilfe, den Titel zu bekommen – und er sagte: »Wenn es klappt, schenke ich dir ein Foto von mir.«

Wir hatten Glück, Ansel bekam den Titel – und ich ein wunderschönes Adams-Porträt von Alfred Stieglitz, das mir der frischgebackene Colonel zuschickte.

de concert. Il était évident qu'il en possédait le talent. Mais il avait développé une arthrite à vingt ans, et ses médecins lui avaient dit que si ce rêve se réalisait, il devrait l'abandonner très vite parce que ses doigts enfleraient. C'est ainsi qu'il en arriva à son second amour, la photographie.

Le matin suivant, lorsque nous arrivâmes chez les Adams, Virginia avait préparé le petit déjeuner. Des œufs, du bacon et quelques délicieux *muffins*. Plus tard dans la matinée, Ansel me conduisit à Wildcat Hill (« la colline des chats sauvages ») où Edward Weston avait vécu et où son fils Neil habitait maintenant avec sa famille. Nous nous promenâmes avec Neil, les chats détalant à notre approche.

Nous regagnâmes la maison dans l'après-midi où l'attendait un jeune photographe venu recueillir les critiques d'Ansel sur son travail. Ansel fut généreux de son temps et l'encouragea gentiment.

Nous rendîmes ensuite visite à un autre de ses amis, Rosario Mazzeo, un clarinettiste classique qui avait appartenu dans le temps à l'orchestre symphonique de Boston. Il se mirent à jouer, Ansel au piano, Rosario à la clarinette. Jouant aussi de la clarinette en amateur, Rosario me tendit un instrument et, pour un court moment, nous devînmes un trio improvisé.

A la faveur d'une de nos nombreuses conversations, je rapportai à Ansel que j'avais de la famille dans le Kentucky. Il me confia alors qu'il avait toujours voulu devenir un « Colonel du Kentucky », titre honorifique conféré par le gouverneur de cet État. Quand je lui dis que je pouvais arranger cela pour lui, il répondit : « Si tu fais cela, je t'offrirai une de mes photos. »

J'obtins cette faveur et je possède donc à présent un merveilleux portrait de Stieglitz réalisé par Ansel, qui me fut envoyé par notre frais émoulu « Colonel » lui-même.

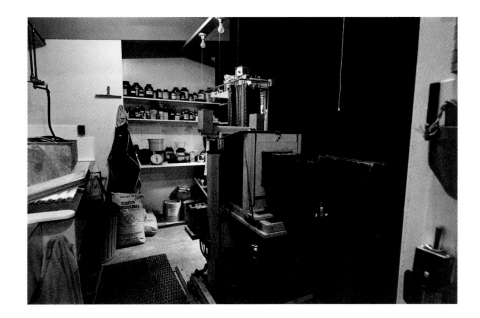

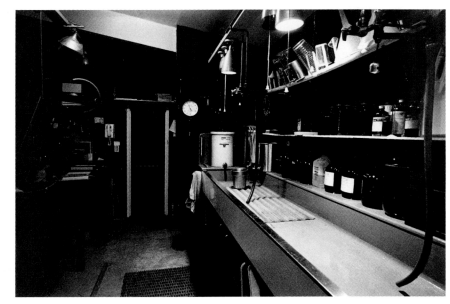

Portion of Ansel Adams' darkroom with enlarger for horizontal projection. This unit was used to produce the very large prints (over 20x24 inches) that Ansel often made. 1969.

In Ansel Adams Dunkelkammer: das Vergrößerungsgerät für horizontale Projektion. Dieses Gerät benutzte er für großformatige Abzüge (über 50 x 60 cm), von denen er sehr viele anfertigte. 1969.

Dans la chambre noire d'Ansel : un agrandisseur à projection horizontale. Cette installation était utilisée pour exécuter des épreuves de grande largeur (au-delà de 50x60 cm) qu'Ansel réalisait souvent. 1969.

Archival print drying frames – made of mesh which allowed the photographs to air-dry free of chemical contamination, 1969.

Vorrichtung zum Trocknen von Abzügen, 1969.

Cadre pour sécher les épreuves et les conserver, muni d'un filet recevant les épreuves fraîchement développées, 1969.

Part of Ansel Adams' darkroom. Note vertical enlarger on far left for Ansel's enlargements. 1969.

In Ansel Adams Dunkelkammer: ein vertikal gestellter Vergrößerer für normale Vergrößerungen, 1969.

Dans la chambre noire d'Ansel. Sur la gauche, l'agrandisseur vertical pour les agrandissements ordinaires, 1969.

Boxes of photographic prints, kept in the print finishing room at his home in Carmel, 1969.

Kartons mit Abzügen in seinem Trockenraum in Carmel, 1969.

Boîtes d'épreuves conservées dans la pièce de séchage chez lui, à Carmel, 1969.

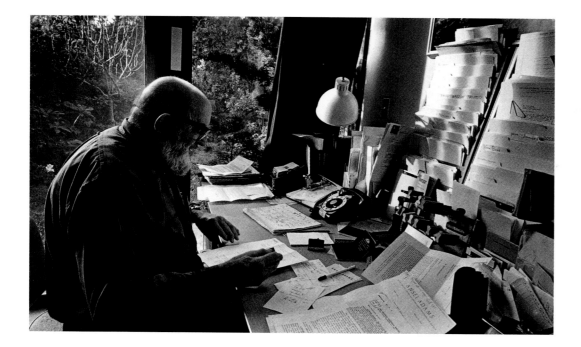

Ansel at his work desk at home, 1969.

Ansel zu Hause an seinem Schreibtisch, 1969.

Ansel chez lui à son bureau, 1969.

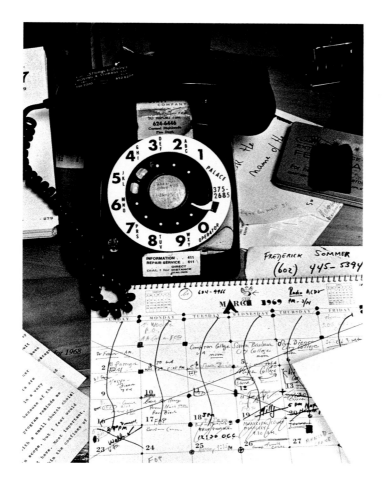

Ansel inspecting a zone system set of control negatives in his home, 1969.

Ansel betrachtet zu Hause ein Set von Testnegativen, 1969.

Ansel inspectant une série de négatifs de contrôle chez lui, 1969.

Ansel's desk calendar of March 1969. Note my appointment appearing on the 26th and 27th. (This calendar also appears in the top photograph.)

Ansels Tischkalender vom März 1969: Der Termin mit mir ist für den 26. und 27. März vorgemerkt. (Dieser Kalender ist auch auf dem oberen Foto zu sehen.)

Le calendrier de bureau d'Ansel daté de mars 1969. Mes rendez-vous apparaissent le 26 et le 27. (On peut voir ce calendrier sur la photographie de dessus).

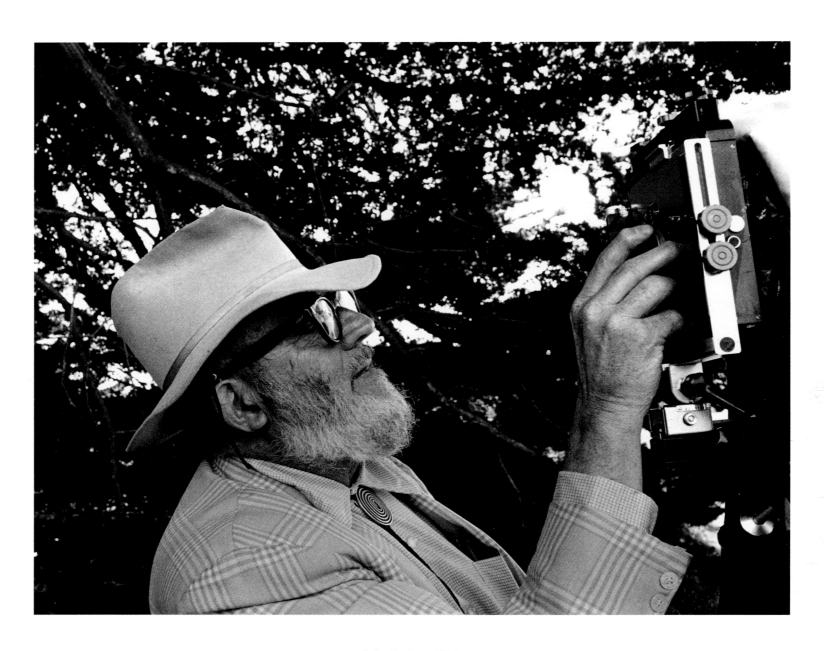

Adjusting lens, 1969.

Beim Einstellen der Kamera, 1969.

Réglage des lentilles, 1969.

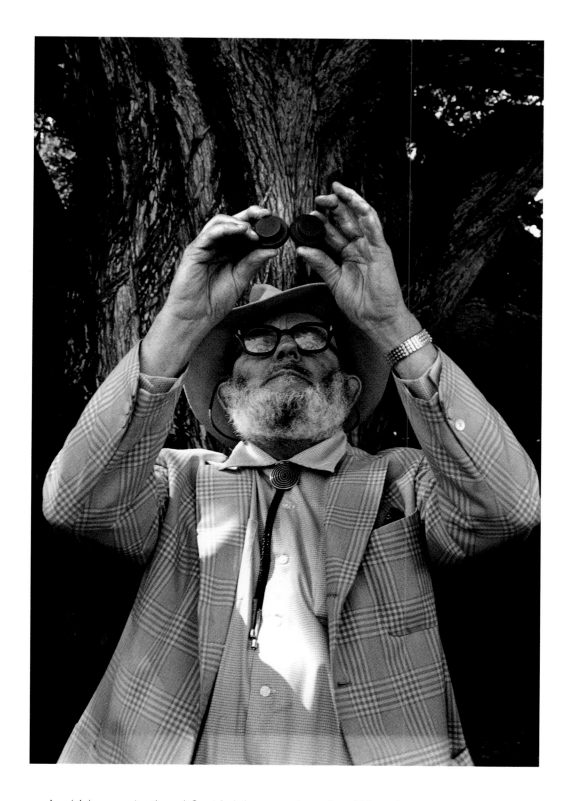

Ansel Adams peering through 2 »pinhole lenses« to determine which size he wished to use that day. (A pinhole lens – exactly that! – is an opaque surface with a tiny hole but no optical glass that acts as a lens as in a pinhole camera. The pinhole creates a small image opening, permitting the objects at which the camera is aimed to form an acceptably in focus image on the film plane.) 1969.

Ansel Adams schaut durch zwei »Sucherobjektive«, um festzustellen, welche Größe er benutzen soll. Ein solcher Sucher besteht aus einer opaken Fläche mit einem kleinen Loch, das nach dem Prinzip der Camera obscura als Linse dient. Die kleine Öffnung fungiert als Lochblende, die die Gegenstände, auf die die Kamera gerichtet ist, auf der Filmebene als einigermaßen scharfes Bild erscheinen läßt. 1969.

Ansel Adams scrutant deux « lentilles-trous d'aiguille » afin de choisir la taille qu'il désirait pour la journée. Un trou d'aiguille (c'est exactement cela !), est une surface opaque avec un trou minuscule, et non un verre optique fonctionnant comme la lentille d'un d'appareil-photo. Le trou crée une ouverture qui permet aux objets visés par l'appareil d'être mis au point sur la surface de la pellicule. 1969.

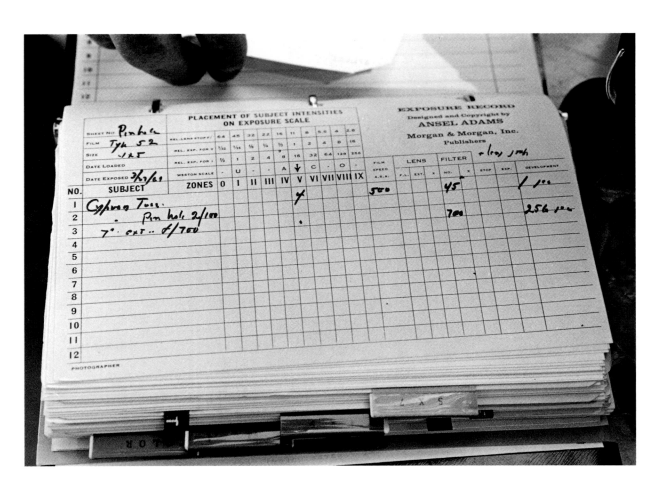

Ansel's exposure record – which he kept for every negative which he exposed – so that he maintained consistency in his use of his zone system. 1969.

Ansels Belichtungsliste – er machte sich Notizen über jedes einzelne Negativ, das er entwickelte; er bevorzugte mehrere Aufnahmen vom selben Motiv mit unterschiedlichen Belichtungswerten und führte Buch darüber. 1969.

Classement des prises de vue d'Ansel, qu'il tenait pour chacun des négatifs développés, afin de maintenir une cohérence lors de l'utilisation de son système de zone. 1969.

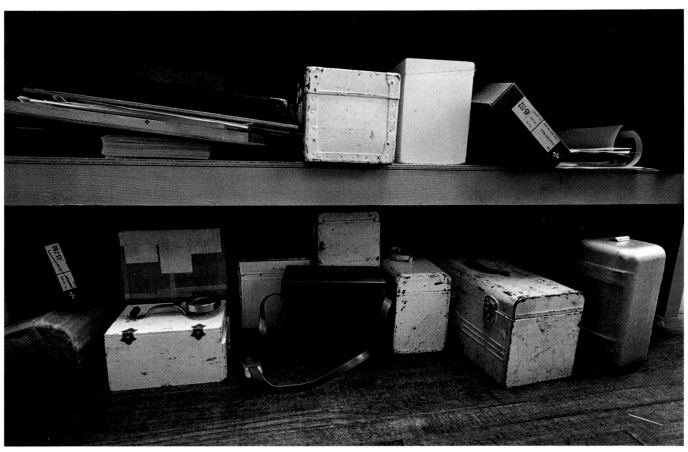

Ansel Adams' camera cases, 1969.

Ansel Adams Kamerataschen, 1969.

Boîtes d'appareils photographiques appartenant à Ansel Adams, 1969.

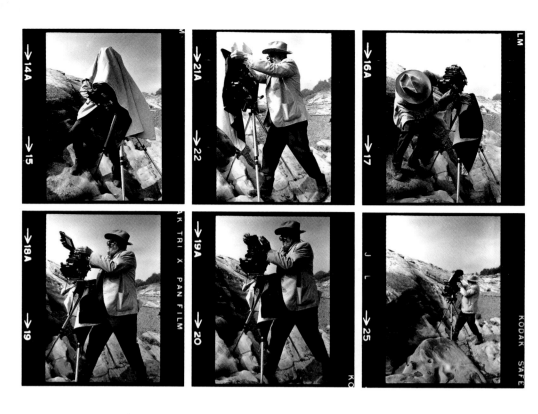

Ansel Adams photographing with Polaroid materials,
Point Lobos, 1969.

Ansel Adams bei der Arbeit mit einer Polaroid-Kamera
am Point Lobos, 1969.

Ansel Adams en train de photographier avec un polaroïd
à Point Lobos, 1969.

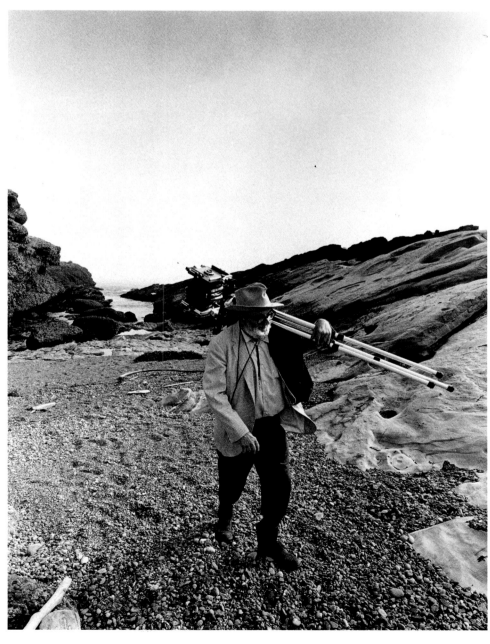

Photographing, Point Lobos, 1969.

Beim Fotografieren am Point Lobos, 1969.

En train de photographier à Point Lobos, 1969.

Ansel on Point Lobos, 1969.

Ansel am Point Lobos, 1969.

Ansel à Point Lobos, 1969.

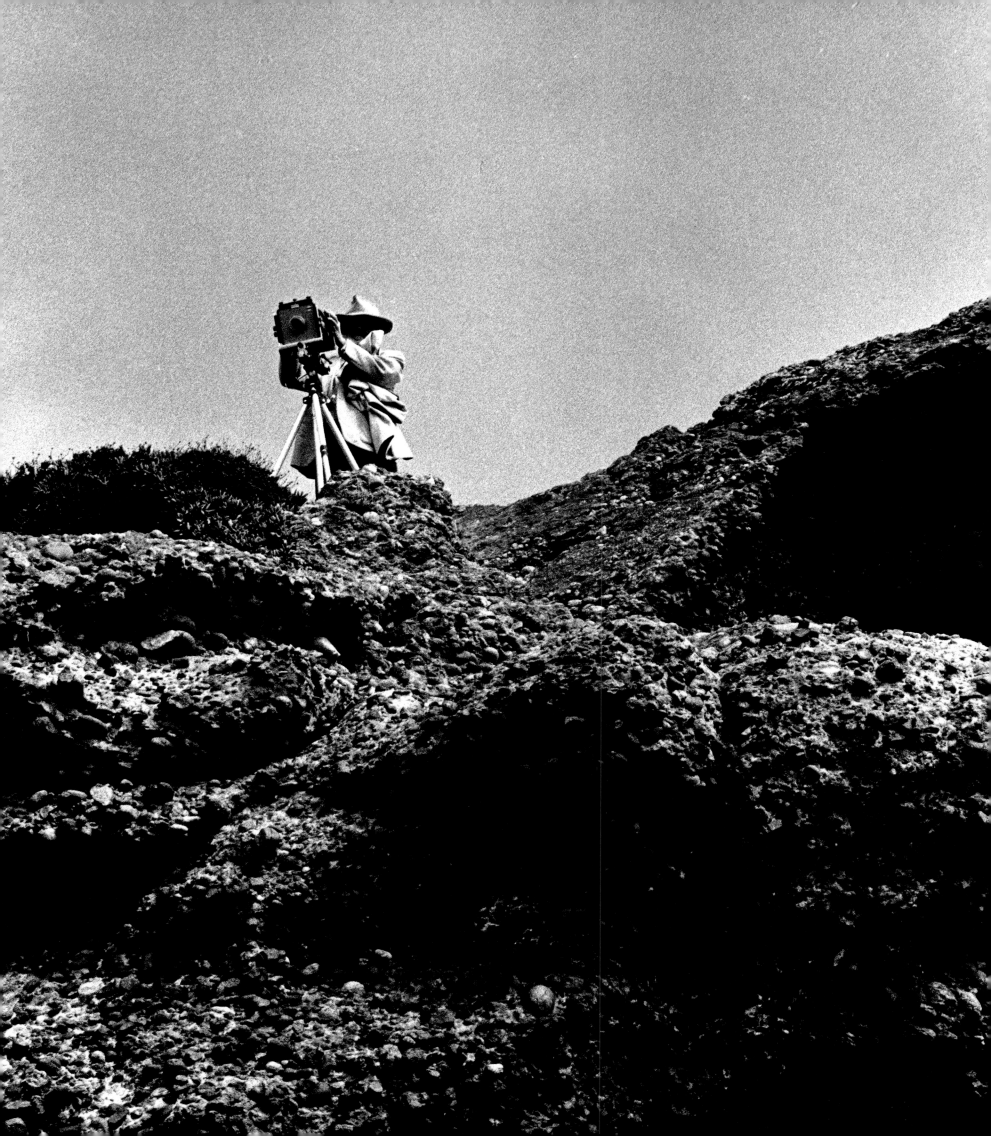

Imogen Cunningham

1883–1976. American.
Photographer and teacher. Photographed nudes, flowers and portraits. With Edward Weston, Ansel Adams and several others, she helped found an early group entitled F/64, the members of which devoted themselves to achieving precise detail in their photographs.

1883–1976. Amerikanerin.
Sie war Fotografin und Dozentin. Berühmt für ihre Aktaufnahmen, Blumen- und Porträtfotos. Zusammen mit Edward Weston, Ansel Adams und anderen gründete sie einen Zirkel von gleichgesinnten Fotografen – die Gruppe F/64 – die um besonders präzise Details in der Fotografie bemüht war.

1883–1976. Américaine.
Photographe et chargée de cours. Elle photographia des nus, des fleurs et des portraits. Avec Edward Weston, Ansel Adams et bien d'autres, elle fut à l'origine de la création d'un groupe appelé F/64, dont les membres s'attachaient à parachever les détails les plus précis de leurs photographies.

Imogen at the gate to her yard, 1969.

Imogen an ihrem Gartentor, 1969.

Imogen devant le portail de sa cour, 1969.

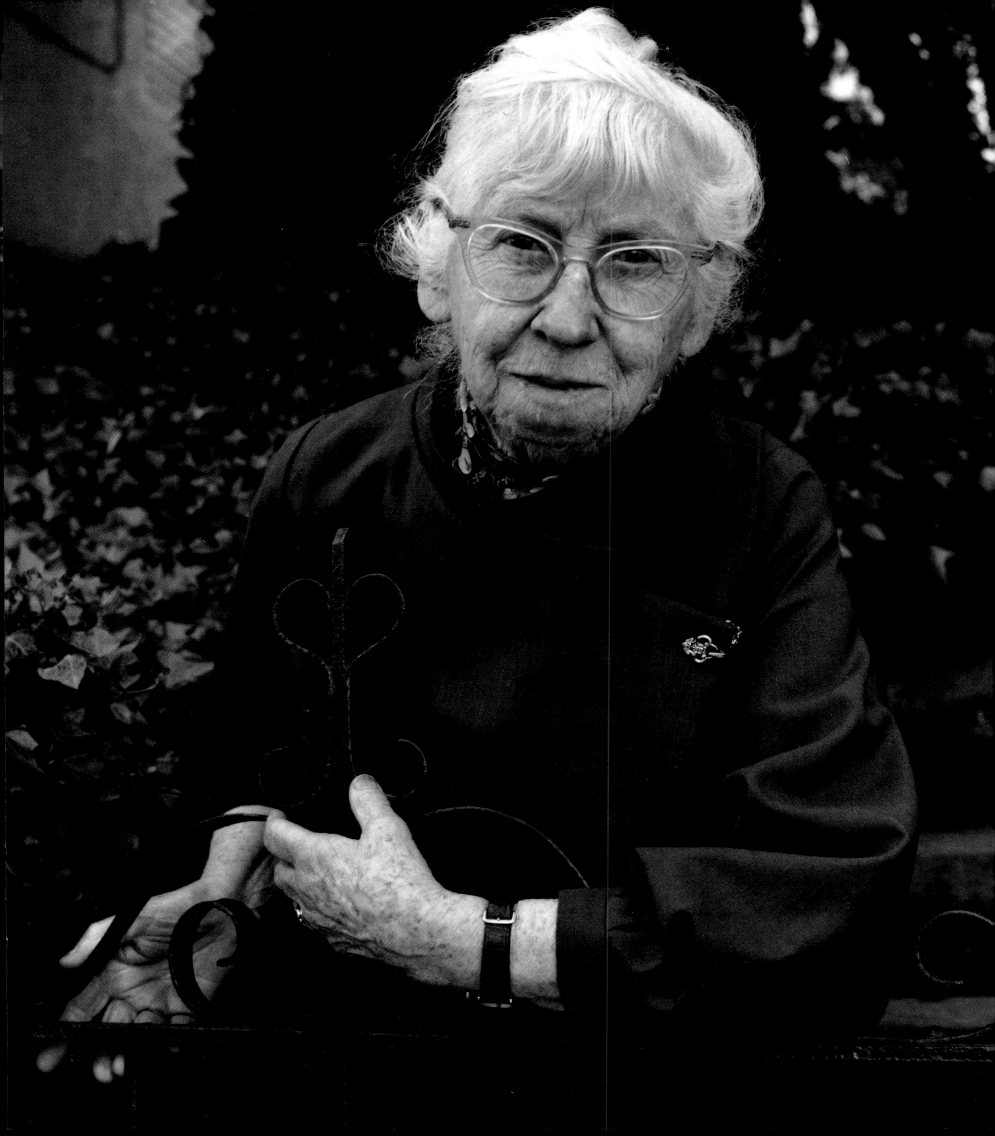

Ansel Adams called Imogen for me while I was visiting him in Big Sur, and Martha and I went on to San Francisco to meet her per Ansel's arrangement.

She was in her eighties at the time – cute and »feisty as the devil.« I believe that she took an instant dislike to me, but it was obvious she liked Martha because she told me so about half a dozen times; yet she criticized everything about me.

I must have eventually managed to convince her that I was okay, however, because, as we talked about pictures, she finally warmed up to me. She showed me her early work – flowers, nudes and portraits, in wonderful vintage prints which she had never sold.

I took a number of shots of her while she was sitting on her couch, but she was very self-conscious and I didn't feel that that part of our morning session yielded any good images. As a photographer, most of us know when we »have it in the can,« so to speak, and I realized that had had still not really »captured« my subject.

As she made us breakfast, we spoke of Edward Weston, Group F/64, Dorothea Lange, the current state of photography, and the California School. It was a most entertaining morning.

She was so at ease in her kitchen that I made my warmest and most favorite image of her there. Whenever I show that particular photograph of Imogen to anyone, I always mention that I felt she looked the part of a »little imp.«

I am always amazed at the »magic box,« the camera. If one knows how to use it, it can give back so many gifts. I feel I've been blessed so many times by

Ansel Adams bat Imogen telefonisch um einen Termin für mich, als ich bei ihm in Big Sur zu Besuch war; Martha und ich fuhren dann nach San Francisco weiter und konnten uns, dank Ansels Hilfe, dort treffen.

Imogen war damals schon über achtzig Jahre alt – sie sah gut aus und war putzmunter. Ich glaube, daß sie mich auf den ersten Blick nicht ausstehen konnte. Aber offensichtlich mochte sie Martha, denn das sagte sie mir ungefähr ein dutzendmal; mich aber kritisierte sie unentwegt.

Es muß mir schließlich doch gelungen sein, ihr ein klein wenig Sympathie abzuringen. Als wir über Fotografie zu reden begannen, wurde sie jedenfalls wesentlich umgänglicher. Sie zeigte mir ihre frühen Arbeiten – Blumen, Akte und Porträts, alles Vintage Prints, die sie nie verkauft hatte.

Als sie sich schließlich für ein paar Porträtaufnahmen aufs Sofa setzte, war sie so befangen, daß diese Phase unserer Morgensitzung mir keine guten Aufnahmen brachte. Wir Fotografen wissen meist, wann wir etwas »im Kasten haben« und wann nicht, und ich merkte sofort, daß ich mein Gegenüber noch nicht richtig »eingefangen« hatte.

Während sie uns Frühstück machte, sprachen wir über Edward Weston, die Gruppe F/64, Dorothea Lange, über zeitgenössische Fotografie und die »California School«. Es wurde ein sehr interessanter Vormittag.

Living room of Imogen's apartment, 1969.

Wohnzimmer in Imogens Apartment, 1969.

Le salon de l'appartement d'Imogen, 1969.

Ansel Adams se chargea d'organiser une rencontre entre Imogen et moi lors d'une visite que je lui rendis à Big Sur, et c'est ainsi que Martha et moi-même allâmes à San Francisco.

Elle était dans sa quatre-vingtième année à cette époque, coquette et « séductrice en diable ». Je crois vraiment qu'il lui a suffi d'un instant pour me prendre en grippe. Il était évident qu'elle aimait Martha parce qu'elle le répéta une demi-douzaine de fois ; elle critiqua par contre tout ce qui me concernait.

Je parvins en fin de compte à la convaincre que j'étais acceptable et lorsque nous parlâmes photo, elle se montra mieux disposée à mon égard. Elle me montra ses premiers travaux, fleurs, nus et portraits, épreuves uniques et magnifiques qu'elle n'avait jamais vendues.

Je pris plusieurs photos d'elle alors qu'elle était assise sur son divan, mais elle était embarrassée et je sentis que cette séance du matin ne produirait pas de bonnes images. Les photographes sentent mieux le moment où c'est « dans la boîte », si je puis dire, et je remarquai qu'elle avait posé d'une façon contrôlée.

Pendant qu'elle préparait le petit déjeuner, nous parlâmes de Edward Weston, du groupe F/64, de Dorothea Lange, de la situation actuelle de la photographie et de la California School. Ce fut vraiment une matinée très divertissante.

Elle était tellement à l'aise dans sa cuisine que ce fut là que je réalisai ma plus tendre et la préférée de mes photos la concernant. Elle me fait songer à un petit lutin.

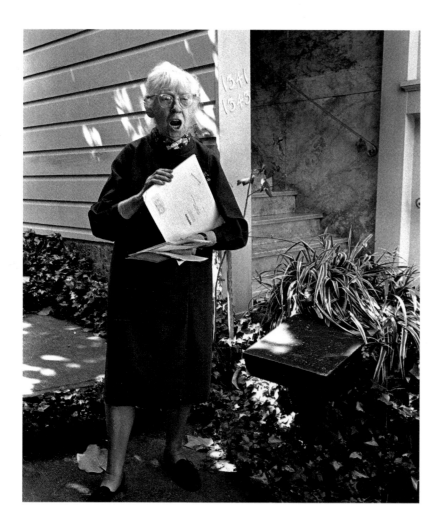

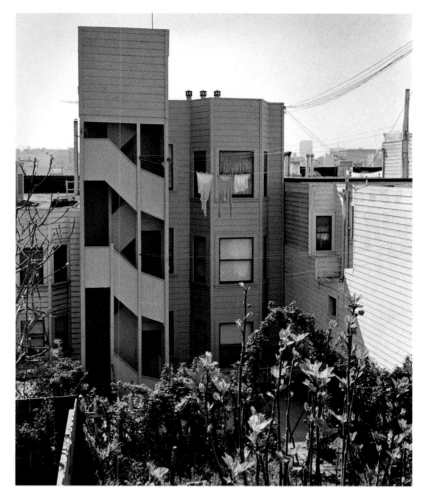

After having just picked up her mail. Note the copy of *Aperture*, which she was complaining always came two months late. 1969.

Imogen mit ihrer Post. Man beachte die Ausgabe von *Aperture*, von der sie sagte, sie komme immer zwei Monate zu spät. 1969.

Après être allée chercher le courrier. On aperçoit un exemplaire de *Aperture* – elle se plaignait qu'il arrivait toujours avec deux mois de retard. 1969.

my cameras. Magic happens! I photographed Imogen retrieving her mail – her tough side coming through, I felt – but it was not until I looked at an 11×14 print I had made of that image that I discovered a copy of *Aperture* magazine was prominently showing amongst her mail.

She was teaching a photography class that day, and Martha and I accompanied her to see the school where she taught.

I regret not having had more time with Imogen as she presented a real challenge. In a sense, she dared me to photograph her. In retrospect, I believe that I managed to meet her challenge.

In ihrer Küche wirkte sie völlig entspannt, und dort machte ich auch meine liebenswürdigste Aufnahme von ihr, mein Lieblingsfoto. Sie wirkt darauf wie ein kleiner Kobold.

Ich bin doch immer wieder überrascht über die kleine Wunderkiste, die wir Kamera nennen. Wenn man sie zu bedienen weiß, kann sie einem so viele wunderschöne Geschenke machen. Ich habe schon so viel Glück mit meinen Kameras erfahren. Wunder gibt es doch! Ich machte ein Foto von Imogen, als sie ihre Post aus dem Briefkasten holte – ich fand, daß dabei ihre strenge Seite zum Vorschein kam – doch erst als ich einen 28 × 35-cm-Abzug davon studierte, entdeckte ich bei der Post in ihrer Hand die Fotozeitschrift *Aperture*.

Am Tag unseres Besuchs gab sie Fotounterricht; Martha und ich begleiteten sie zu der Schule, wo sie ihren Kurs abhielt.

Ich finde es schade, daß ich nicht mehr Zeit mit Imogen verbringen konnte, denn sie war eine echte Herausforderung für mich. Ihre ganze Haltung schien gewissermaßen zu sagen: Wage es ja nicht, mich zu fotografieren. Im nachhinein glaube ich, daß ich ihrer Herausforderung gerecht geworden bin.

Imogen's San Francisco residence, 1969.

Außenansicht von Imogens Apartment in San Francisco, 1969.

Imogen dans sa résidence à San Francisco, Californie, 1969.

Je suis toujours stupéfié par cette boîte magique que nous appelons appareil-photo. Celui qui sait s'en servir peut offrir tant de cadeaux ! J'ai vraiment connu des instants de béatitude grâce à mon appareil. La magie opère. Je photographiai Imogen alors qu'elle rapportait son courrier, percevant le côté dur de sa personne, mais ce ne fut que lorsque je regardai l'image en 28×35 cm que je découvris un exemplaire du magazine *Aperture* bien en évidence dans la pile de courrier.

Elle donnait un cours de photographie ce jour-là, et Martha et moi l'accompagnâmes pour voir l'école où elle enseignait.

Je regrette de n'avoir pu passer davantage de temps avec Imogen dans la mesure où elle représentait une véritable prouesse : elle avait, dans un certain sens, daigné que je la prenne en photo. Avec le recul, je crois avoir relevé son défi.

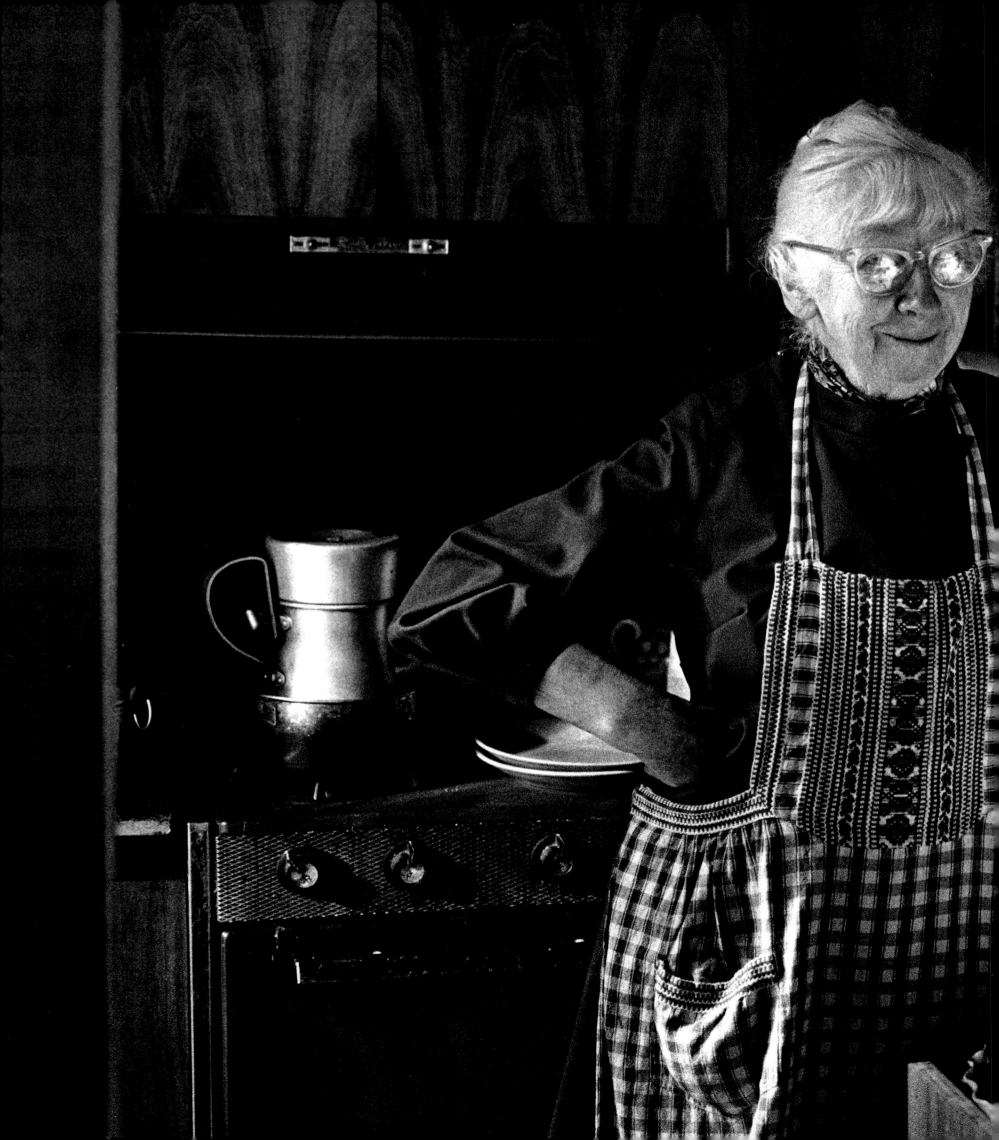

Imogen in her kitchen. I describe this photograph as Imogen looking like an »imp«. March 1969.

Imogen in der Küche. Hier, meine ich, sieht Imogen aus wie ein Kobold. März 1969.

Imogen dans sa cuisine. Ici, je trouve qu'elle ressemble à un « lutin ». Mars 1969.

André Kertész

1894–1985. Hungarian.
Worked in Hungary as a photojournalist. Emigrated to the
United States in 1936. Photographed still lifes, people and nude
distortions.

1894–1985. Ungar.
Kertész arbeitete zunächst in Ungarn als Fotojournalist.
Emigrierte 1936 in die USA. Bekannt für seine Stilleben, Porträts
und Aktaufnahmen.

1894–1985. Hongrois.
Il fut reporter photographe en Hongrie. Il émigra aux États-Unis
en 1936. Il photographia des natures mortes, les gens et des nus
déformés.

My favorite photograph of Kertész, taken on a cold rainy day in New York, 1968.

Kertész an einem kalten, regnerischen Tag in New York, mein Lieblingsbild von ihm, 1968.

Ma photo préférée de Kertész, prise au cours d'une froide journée de pluie à New York, 1968.

Warm – kind – sad – regretful . . . Those are the words that to me best describe my late friend André Kertész.

1, Park Avenue in New York City was where he lived. I remember the apartment, on the west side of the Avenue, in a substantial elevator building. We spoke of many things during our first meeting – mutual friends, his projects, how he had struggled to make a living as a photographer and of his feeling that the »art world« had not given him the recognition he deserved.

I photographed him at his home at first, but didn't really feel I was getting his »spirit« onto the film. So I suggested we go out for coffee. We walked to a local café. It was raining that day. It was during that walk in the rain that I made my favorite image of Kertész.

As I was photographing him at the table having coffee that first day, he took the camera from my hands and photographed me. Before I left I promised him copies of the photographs I had made of him that day. Several months were to pass before I returned to New York to deliver two prints, one the »rain« photograph. He looked at them and said, »Now which photograph of mine would you like?«

I was flabbergasted. I said I couldn't take his print because the exchange would be completely unfair to him. He insisted, saying: »We photographers always must trade photographs when they are worthy.« That day, early on, for a brief moment, my photographs became »worthy!«

André in his living room, 1968.

André in seinem Wohnzimmer, 1968.

André dans son salon, 1968.

Warmherzig, gütig, melancholisch, zweiflerisch. So könnte man meinen Freund André Kertész am treffendsten charakterisieren.

Er lebte in dem Haus Nummer 1 an der Park Avenue in New York City. Ich kann mich noch gut an seine Wohnung erinnern; sie lag in einem massiven Gebäude mit Fahrstuhl auf der Westseite der Avenue.

Als wir uns das erste Mal trafen, sprachen wir über vielerlei – gemeinsame Freunde, seine weiteren Vorhaben, wir sprachen auch davon, wie schwierig es für ihn gewesen war, sein Brot als Fotograf zu verdienen, und darüber, daß er sich von der Kunstszene noch nicht genügend gewürdigt fühlte.

Zuerst fotografierte ich ihn zu Hause, aber ich hatte das Gefühl, sein eigentliches Wesen nicht zu erfassen. Also schlug ich vor, irgendwo eine Tasse Kaffee zu trinken. Wir gingen in ein Café in der Nähe. Während unseres Spaziergangs durch den Regen gelang mir dann mein Lieblingsbild von Kertész.

Als ich die Aufnahmen von ihm am Kaffeetisch machte, nahm er mir die Kamera aus der Hand und fotografierte mich. Natürlich sollte er Abzüge von den Porträts bekommen, die ich von ihm gemacht hatte. Es vergingen mehrere Monate, ehe ich wieder nach New York zurückkehrte und ihm zwei Bilder brachte; eins davon war das Foto von ihm im Regen. Er schaute sie sich an und sagte: »So, und jetzt darfst du dir eins von meinen Bildern aussuchen.«

Ich war völlig baff. Ich beteuerte, daß ich kein Foto von ihm annehmen könne, weil seine Fotos so ungleich viel wertvoller seien als meine. Er insistierte aber und sagte nur: »Wir Fotografen tauschen im-

Chaleureux, bon, mélancolique, plein de regrets... Ce sont quelques mots qui résument le mieux mon ami André Kertész, rencontré sur le tard.

Il habitait 1, Park Avenue à New York. Je me souviens de son appartement situé dans un immeuble important à l'ouest de l'avenue. Nous parlâmes de beaucoup de choses lors de cette première rencontre, d'amis communs, de ses projets, de ses efforts pour vivre de sa profession, de son sentiment de frustration de n'avoir pas reçu du « milieu de l'art » la reconnaissance qu'il méritait. Je le photographiai chez lui, dès cette première rencontre, mais j'avais le sentiment de n'avoir pas vraiment capté son « âme ». Je lui proposai alors d'aller boire quelque chose dehors. Nous nous dirigeâmes vers un café – c'était un jour de pluie – et c'est durant cette promenade que je pris ma photo préférée de Kertész.

Alors que nous étions assis à boire notre café, je le photographiai à table, puis il me prit l'appareil des mains et me photographia à son tour. Avant de le quitter, je lui promis une copie des clichés que j'avais faits ce jour-là. Plusieurs mois s'écoulèrent avant que je ne retourne à New York et lui remette les deux épreuves, dont l'une prise sous la pluie. Il les regarda et me dit : « Maintenant, regarde les miennes et choisis en une . » J'étais complètement abasourdi. Je lui dis que je ne pouvais accepter un tel échange qui serait trop à son désavantage. Il insista et poursuivit : « Nous, photographes, devons toujours négocier nos photos quand elles en valent la peine. » Ce jour là, pour un bref instant, mes épreuves « valurent la peine » !

Une histoire amusante me fut rapportée par David Travis, Conservateur du département Photographie à l'institut d'Art de Chicago, à propos

An amusing story was told to me about André by David Travis, the Curator of Photography at the Art Institute of Chicago. David said the story came to him directly from André. There was a well-known and well-respected Manhattan art dealer, who we will refer to as Mrs. X. She suffered from a speech impediment, so it was her practice to have her assistant make all her telephone calls for her. But when her assistant called Kertész to arrange an exhibition of his photographs, André insisted that Mrs. X call him herself if she wanted to show his work. She did, and the show happened. But, with great delight he explained his behavior saying. »I'm very hard of hearing, and Mrs. X knows I am. So I wanted to see what it would be like for someone who can't speak to try to talk to someone who can't hear!«

André also permitted me to look at his wonderful tiny vintage prints, and now I feel some regret about them. Most photographers and painters I have known are collectors of some sort: Picasso collected hats, amongst other things; Tzara collected books and the artwork of his friends. At the time, I was collecting photographs. Some of my regrets in life concern things I wanted, and could have afforded to buy, but didn't. André's vintage prints were among the things I should never have let get away.

mer Bilder, wenn sie es wert sind.« An diesem Tag wurden meine Fotos, wenn auch nur für einen kurzen Augenblick, »wertvoll«.

David Travis, Curator of Photography beim Art Institute of Chicago, trug mir eine amüsante Anekdote zu, die er von André selbst gehört hatte. Eine der involvierten Persönlichkeiten ist eine allseits bekannte und geachtete Kunsthändlerin in Manhattan, die wir »Mrs. X« nennen wollen. Sie litt unter einer Sprachstörung, weshalb sie Telefonate gewöhnlich von einer Assistentin erledigen ließ. Als ihre Assistentin aber Kertész anrief, um eine Ausstellung seiner Arbeiten zu arrangieren, ließ er wissen, daß Mrs. X ihn selbst anrufen solle, wenn sie seine Arbeiten der Öffentlichkeit präsentieren wolle. Sie rief an, und die Ausstellung kam zustande. Später erklärte er sein Verhalten mit vergnügtem Grinsen: »Ich bin sehr schwerhörig, und Mrs. X weiß das auch. Ich wollte einfach einmal sehen, was passiert, wenn jemand, der nicht sprechen kann, versucht, mit jemand zu telefonieren, der nicht hören kann!«

André zeigte mir auch einige von seinen herrlichen, kleinformatigen Vintage Points; heute denke ich mit etwas Wehmut daran zurück. Die meisten Fotografen und Maler, die ich kenne, sind und waren Sammler: Picasso sammelte unter anderem Hüte, Tristan Tzara sammelte Bücher und Kunstwerke von Freunden. Ich sammelte damals Fotos. Heute bereue ich gelegentlich, daß ich mir einige Aufnahmen nicht gekauft habe, obwohl ich das Geld dafür hatte. Andrés Vintage Points zählen dazu. Ich hätte sie mir nicht durch die Lappen gehen lassen dürfen.

Living room of his apartment at 1, Park Avenue, New York, 1968.

André Kertész' Wohnzimmer an der Park Avenue in New York, 1968.

Le salon de son appartement au 1, Park Avenue, à New York, 1968.

d'André. David me dit qu'il tenait cette histoire d'André lui-même. Il s'agissait d'un marchand d'art connu et respecté à Manhattan que nous appellerons Madame X. Elle souffrait d'un trouble de la parole et chargeait toujours ses assistants de téléphoner à sa place. Un jour qu'un assistant appelait Kertész pour mettre au point une exposition de ses photos, André insista pour que Madame X téléphonât en personne si elle désirait montrer son travail. Elle le fit et l'événement eut lieu. André s'était fort amusé de cette anecdote et avait ajouté: « Je suis dur d'oreille et Madame X le sait. J'étais simplement curieux de savoir ce qui se passerait quand l'un ne peut pas parler et que l'autre ne peut pas entendre ! »

André m'avait autorisé à regarder sa merveilleuse collection de photos miniatures originales et, maintenant, j'y repense avec quelque nostalgie. La plupart des photographes et peintres que j'ai connus sont des collectionneurs. Picasso collectionnait les chapeaux entre autres choses, Tzara les livres et œuvres de ses amis. A cette époque, je collectionnais les photos. Un des regrets de ma vie concerne ces choses que j'aurais pu acheter sans l'avoir fait. Les photographies d'André font partie de celles que je n'aurais jamais dû laisser échapper.

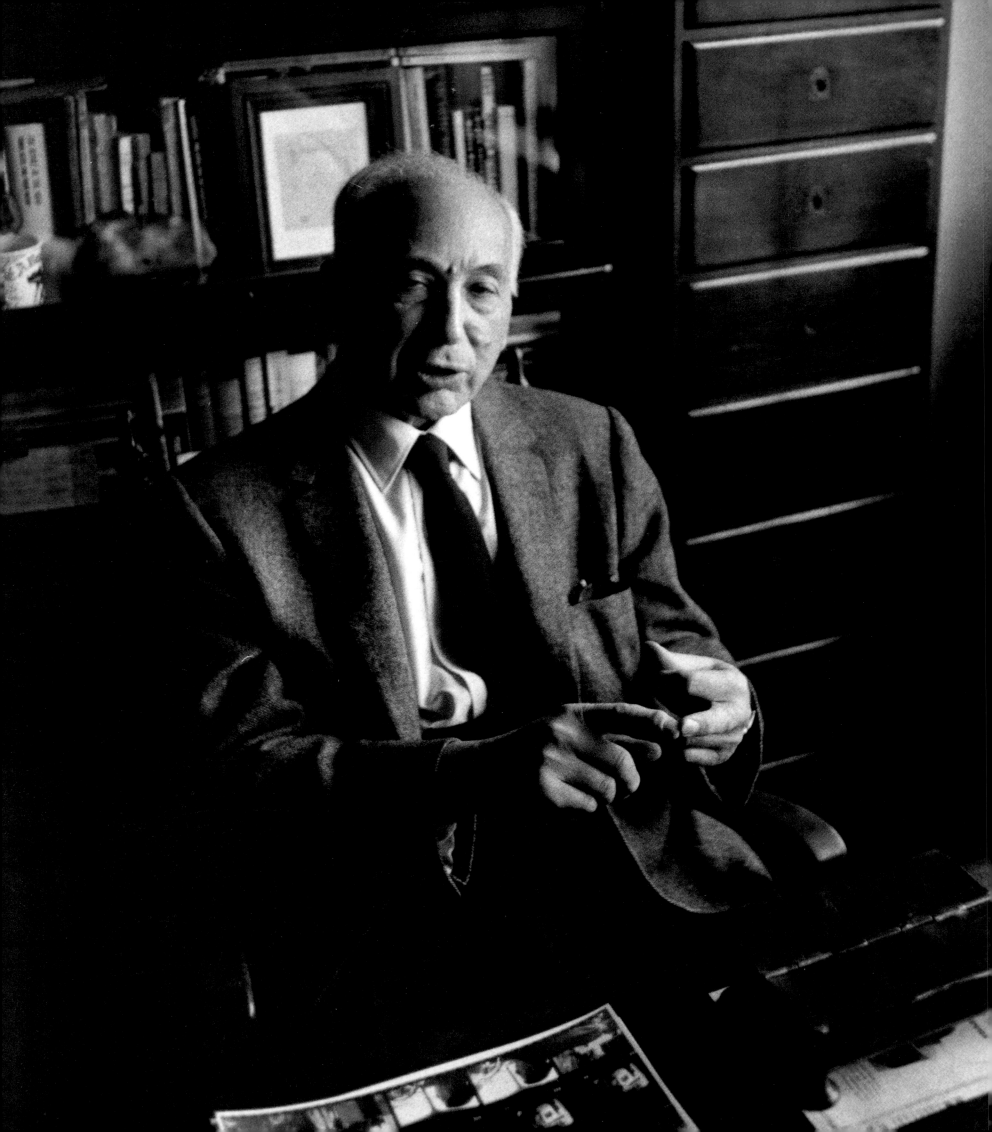

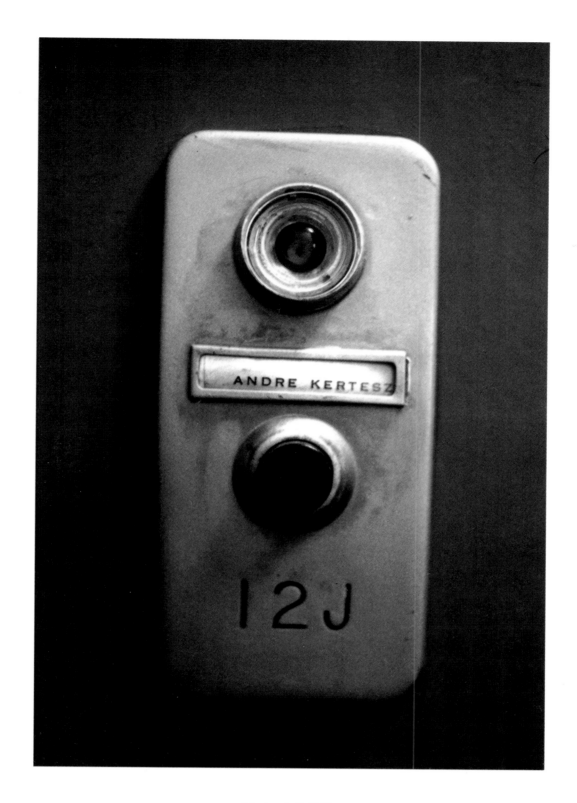

His doorbell, 1968.

Andrés Klingel, 1968.

La sonnette d'entrée, 1968.

In his living room. Note the contact sheet of my photographs of Paul Strand on desk. 1968

In seinem Wohnzimmer. Auf dem Schreibtisch ein Bogen mit Kontaktabzügen meiner Porträts von Paul Strand. 1968.

Dans son salon. Sur le bureau, les planches contact de mes photographies de Paul Strand. 1968.

Paul Strand

1890–1976. American.
One of the first photographers to reject the »pictorialism« of the late 19th and early 20th centuries. His photographs, including *Blind Woman* and *White Fence* appeared in Stieglitz's *Camera Work* and remain landmarks of purity and objectivity in photography even today. Published *Mexican Portfolio* and numerous other books. Also a film maker. Left the United States to live in France in the early 1950s. His works appear in many museums and have been the subject of many solo exhibitions.

1890–1976. Amerikaner.
Er war einer der ersten Fotografen, der gegen die Ende des 19. und Anfang des 20. Jahrhunderts vorherrschende Ausrichtung der Fotografie an der Malerei rebellierte. Seine Aufnahmen, z.B. *Blind Woman* und *White Fence*, erschienen in Stieglitz' *Camera Work*. Diese Arbeiten setzen noch heute Standards für Klarheit und Objektivität in der Fotografie. Strand veröffentlichte zahlreiche Bücher, darunter *Mexican Portfolio*. Er war auch Filmemacher. Anfang der fünfziger Jahre ließ er sich in Frankreich nieder. Seine Arbeiten finden sich in vielen Museen der Welt; er hatte zahlreiche Einzelausstellungen.

1890–1976. Américain.
L'un des premiers photographes à rejeter la photographie pittoresque de la fin du XIXe et du début du XXe siècle. Ses œuvres, y compris *Blind Woman* et *White Fence*, apparaissent dans la revue de Stieglitz *Camera Work*, et constituent encore de nos jours un point marquant dans l'histoire de la photographie en raison de leur pureté et de leur objectivité. Il publia le *Mexican Portfolio* et un grand nombre d'autres livres. Il était aussi cinéaste. Il quitta les États-Unis pour la France au début de l'année 1950. Son travail est montré dans de nombreux musées et a fait l'objet d'expositions particulières.

Portrait, 1968.

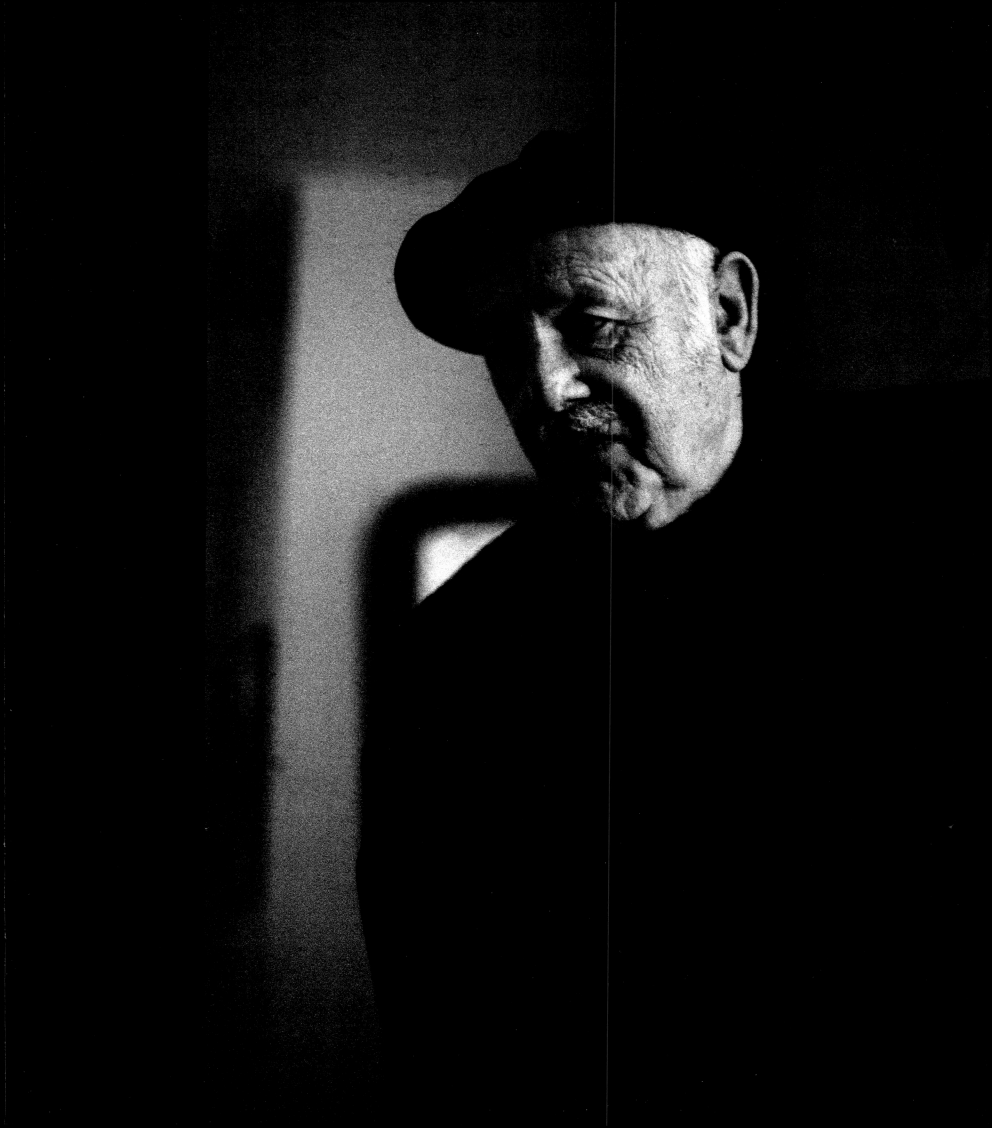

I first met Paul Strand when he picked me up at the Verneuil-sur-Seine train station in France. After a brief correspondence, he had agreed to meet me. Accompanied by Martha, my wife at that time, I spent an afternoon with Paul and his wife Hazel at their home in Orgeval.

I was always curious about the fact that he often photographed people in an apparently direct manner – facing the camera, but never really looking at it. When I inquired about this, he became quite open and said that from very early on as a photographer he was wary of approaching people directly. He therefore devised a system whereby it would appear the camera was pointed away from the subject – first by screwing a false lens to the side of his camera and later by using a periscope-like attachment that would permit him to face 90 degrees away from the subject being photographed – the reason for the many photographs of people facing him, but not looking directly into the lens.

He was very clear about his abilities both as a cinematographer and as a still photographer.

He stated to me that he felt that fine photogra-

Strand's left hand: his finger nails are stained by print developer, a common occurrence with photographers who print their own negatives. 1968.

Strands linke Hand: Seine Fingernägel sind fleckig vom Entwickler. Das kommt bei Fotografen, die ihre Abzüge selber machen, häufig vor. 1968.

La main gauche de Strand : ses ongles sont tachés par le produit utilisé pour le développement, ce qui est courant chez les photographes qui développent eux-mêmes leurs clichés. 1968.

Paul Strand traf ich zum ersten Mal, als er mich am Bahnhof von Verneuil-sur-Seine in Frankreich abholte. Nach kurzer Korrespondenz hatte er sich bereitgefunden, mich zu empfangen. Ich kam in Begleitung meiner damaligen Frau Martha und verbrachte einen Nachmittag mit Paul und seiner Frau Hazel in ihrem Haus in Orgeval.

Es war mir schon lange aufgefallen, daß er häufig Menschen scheinbar direkt fotografierte, die Fotografierten aber nie in die Kamera schauten. Als ich ihn danach fragte, sagte er mir ganz offen, daß er schon früh versucht habe zu vermeiden, Menschen direkt und mit ihrem Wissen zu fotografieren. Deshalb dachte er sich ein System aus, mit dessen Hilfe es so aussah, als ob die Kamera gar nicht auf den Fotografierten gerichtet sei – zuerst, indem er eine Objektivattrappe an eine Kameraseite montierte, später mit einer Art Periskop, das es ihm erlaubte, sich um 90 Grad von der von ihm fotografierten Person abzuwenden. Das war also der Grund, warum er so viele Aufnahmen gemacht hatte, bei denen die Porträtierten unmittelbar vor der Kamera zu stehen scheinen und trotzdem nicht ins Objektiv schauen.

Paul war sich seiner Begabung als Kameramann für den Film und als Fotograf sehr wohl bewußt.

Er sagte mir, daß seiner Meinung nach die guten Photogravüren – wie zum Beispiel die Arbeiten, die in Stieglitz' Zeitschrift *Camera Work* erschienen waren, (darunter auch »Weißer Zaun« und »Blinde Frau«), und die Fotos, die als Photogravüren in seiner »Mexikanischen Mappe« enthalten waren – seinen Negativabzügen an visueller Kraft in nichts nachstünden.

Heute, nach 24 Jahren, kann ich mich leider nicht

Je rencontrai Paul Strand pour la première fois quand il vint me chercher à la gare de Verneuil-sur-Seine. Après quelques échanges épistolaires, il avait accepté de me rencontrer. Accompagné de Martha, ma femme à cette époque, nous passâmes l'après-midi en compagnie de Paul et Hazel dans leur maison d'Orgeval.

Bien que nous ayons parlé sans discontinuer, je n'ai retenu de lui, lors de cette rencontre, que peu d'impressions.

Je m'étais toujours étonné du fait qu'il photographiait apparemment les gens directement, face à l'objectif, sans que toutefois ceux-ci le regardent vraiment. Quand je lui en parlai, il me répondit très ouvertement et m'expliqua que, dès le début de sa carrière, il s'était montré réticent à photographier quelqu'un de face. Il développa donc un système grâce auquel il semblait diriger l'objectif ailleurs que sur le sujet à prendre. D'abord en vissant un objectif factice sur le côté de l'appareil, puis plus tard en utilisant un genre de périscope fixé à l'engin, il pouvait voir son sujet dans un angle de vue à 90°.

Paul était très conscient de ses capacités de cinéaste et de photographe.

Il m'affirma que les fines photogravures qu'il réalisa, comme celles parues dans le périodique de Stieglitz *Camera Work* (y compris la barrière blanche et la femme aveugle) et les photographies présentées comme photogravures dans son *Mexican Portfolio* étaient égales en qualité visuelle à n'importe lesquelles de ses épreuves.

Vingt-quatre années se sont écoulées depuis cette rencontre : c'est bien long pour se souvenir de détails. Mais il y a une histoire que je n'oublierai jamais. Quand je lui parlai de la vente de ses travaux

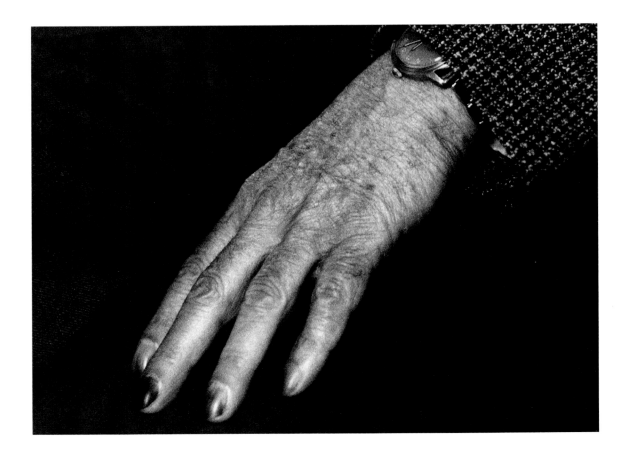

vures of his work, such as those which had appeared in Stieglitz's periodical *Camera Work* (including »Blind Woman« and »White Fence«) and those photographs presented as photogravures in his »Mexican Portfolio«, were equal in visual value to any of his prints.

Twenty-four years are a very long time for me to remember many details of my day with this master, although I recall I accompanied him to his local pharmacy. But there's one story I won't forget. When I asked him about selling his work (that was still in the early days of photographic collecting) he related a story about a young student in France who wished to purchase a certain one of his photographs. Strand told him the price was $500; the student said all he had was $100, so Strand offered time installments, and the student accepted. I remember feeling privately critical of Strand for this when he told me the story, thinking perhaps that he could have been more generous and reduced his price. But as I mature in years, I have come to realize that money is easier to make than pictures are. As Man Ray once said to a wealthy collector who wanted to buy one of his early paintings: »You can always make more money! I can only make one of these paintings.«

My afternoon with Strand ended after he brought out numerous 5x5-inch maquettes of his books to show me – books already finished, and some which were still in the works. He told me he was always ready to do another book, provided he could get sufficient financial support and time to do enough research. His enthusiasm for talking about photography never waned that afternoon. I got the impression that he was one of the more well-balanced and happy photographers I've met.

mehr an alle Details dieses Besuchs bei Paul Strand erinnern, allerdings weiß ich noch, daß ich ihn in die Apotheke des Ortes begleitet habe. Eine Geschichte werde ich jedoch nie vergessen: Als ich ihn fragte, wie es mit dem Verkauf seiner Werke stünde – der Aufbau fotografischer Sammlungen steckte damals erst in den Anfängen –, erzählte er mir von einem jungen Studenten aus Frankreich, der Strand ein bestimmtes Foto habe abkaufen wollen. Strand sagte ihm, es koste 500 Dollar. Der Student hatte aber nur 100 Dollar; Strand schlug ihm deshalb vor, das Bild in Raten zu bezahlen, und der Student nahm den Vorschlag an. Damals dachte ich eher kritisch über diese Geschichte. Meiner Meinung nach hätte er dem Studenten mit dem Preis ruhig etwas mehr entgegenkommen können. Doch je älter ich werde, desto klarer wird mir, daß es viel leichter ist, Geld zu verdienen, als gute Bilder zu machen. Man Ray sagte einmal zu einem wohlhabenden Kunstsammler: »Sie können jederzeit mehr Geld machen; so ein Bild kann ich aber nur einmal machen.«

Mein Nachmittag bei Strand endete damit, daß er mir zahlreiche 10 x 10 cm große Entwürfe seiner Bücher zeigte – von bereits fertigen Büchern, aber auch von einigen, an denen er noch arbeitete. Er sagte mir, daß er jederzeit bereit sei, ein neues Buch herauszugeben, wenn er nur genug finanzielle Unterstützung dafür bekomme und genug Zeit für die Recherchen habe.

Paul sprach an jenem Nachmittag mit unermüdlichem Eifer über die Fotografie. Meiner Meinung nach ist er einer der ausgeglicheneren und glücklicheren Charaktere unter den Fotografen, die ich kenne.

Maquettes of Strand's books, 1968.

Vorlagen zu Strands Büchern, 1968.

Les maquettes des livres de Strand, 1968.

(c'était encore le début des collections de photos), il me rapporta une anecdote à propos d'un jeune étudiant en France qui désirait lui acheter une photo particulière. Il lui indiqua le prix qui était de 500 dollars ; l'étudiant lui dit qu'il ne possédait en tout et pour tout que 100 dollars. Strand lui offrit alors de payer en plusieurs fois et l'étudiant accepta.

Je me souviens avoir éprouvé de la réprobation en écoutant cette histoire, me disant qu'il aurait pu se montrer plus généreux et réduire le prix. Mais les années passant, je réalisai qu'il est plus facile de « faire de l'argent » que des photos. Comme répondit un jour Man Ray à un riche collectionneur qui voulait acheter une de ses premières peintures : « Vous pouvez toujours gagner plus d'argent ! Je ne peux faire qu'une fois chacune de ces peintures. »

Notre après-midi prit fin après qu'il m'eût montré de nombreuses maquettes de ses livres. Certains étaient déjà finis et d'autres encore en chantier. Il me dit qu'il était toujours prêt à faire des livres, à la condition toutefois d'être suffisamment soutenu et d'avoir assez de temps pour ses recherches. Plus tard, je lui envoyai quelques photos que j'avais prises de lui et qui figurent dans ce livre.

Son enthousiasme à parler photographie ne faiblit pas un instant ce jour- là. J'eus l'impression qu'il était le photographe le mieux équilibré et le plus joyeux qu'il m'ait été donné de rencontrer.

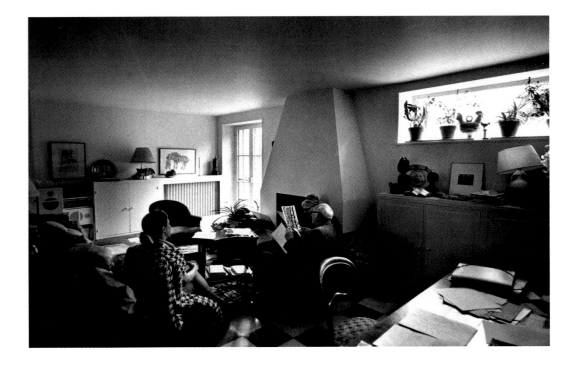

The Strand living room. Left to right: Martha Crane (my former wife), Paul and Hazel Strand, 1968.

Das Wohnzimmer der Strands. Von links nach rechts: Martha Crane (meine damalige Ehefrau), Paul und Hazel Strand, 1968.

Le salon des Strand. De gauche à droite : Martha Crane (mon ex-épouse), Paul et Hazel Strand, 1968.

Purchasing medicine at his local pharmacy, 1968.

Arzneikauf in der Apotheke, 1968.

Un achat de médicaments à la pharmacie locale, 1968.

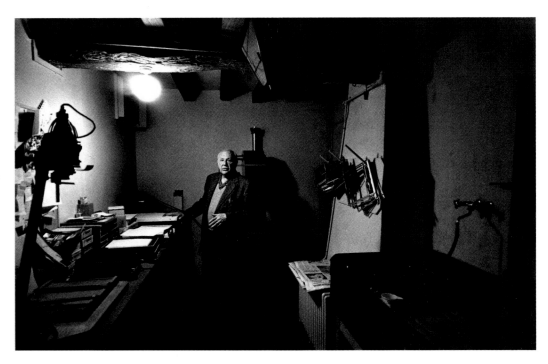

Strand's darkroom. The enlarger on the left is for smaller format negatives, the enlarger behind Strand for his larger view camera negatives. 1968.

Strands Dunkelkammer. Das Vergrößerungsgerät links benutzte er für kleinformatige Negative, das Gerät hinter ihm für Mittel- und Großformate. 1968.

Chambre noire de Strand. L'agrandisseur à gauche est pour les négatifs de petit format, celui derrière Strand pour ses négatifs plus grands. 1968.

Strand's bulletin board, 1968.

Strands Pinnwand, 1968.

Le tableau d'affichage de Strand, 1968.

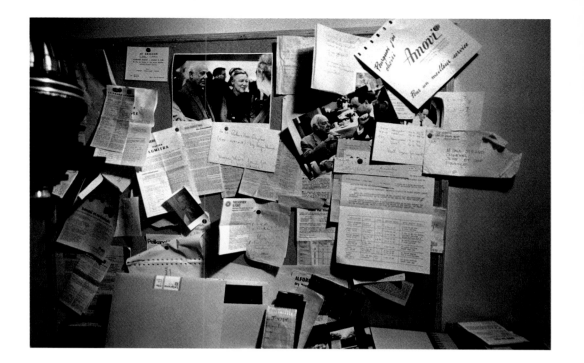

Shopping at the »general store« in Orgeval, 1968.

Beim Einkaufen in der »Alimentation Générale« in Orgeval, 1968.

Les courses à l'alimentation générale d'Orgeval, 1968.

Hazel »fixing« her husband's collar, 1968. I was given the feeling that she adored her husband and was extremely loving and protective of him.

Hazel nestelt am Kragen ihres Mannes. Ich hatte das Gefühl, daß sie ihren Mann vergötterte, sie war ständig um ihn besorgt. 1968.

Hazel en train d'arranger le col de son mari. J'ai eu le sentiment qu'elle adorait son mari et se montrait extrêmement tendre et protectrice à son égard. 1968.

Viewing a vintage print of one of his most famous images, »Blind Woman«, 1968.

Beim Betrachten eines Vintage Print eines seiner berühmtesten Bilder: »Blinde Frau«, 1968.

Examen de l'épreuve originale de l'une de ses plus célèbres photos; « Femme aveugle », 1968.

Looking at his negative envelopes. Left to right: Martha Crane, Hazel and Paul Strand, 1968.

Bei der Durchsicht von Negativen – von links nach rechts: Martha Crane, Hazel und Paul Strand, 1968.

En train de regarder ses négatifs. De gauche à droite : Martha Crane, Hazel et Paul Strand, 1968.

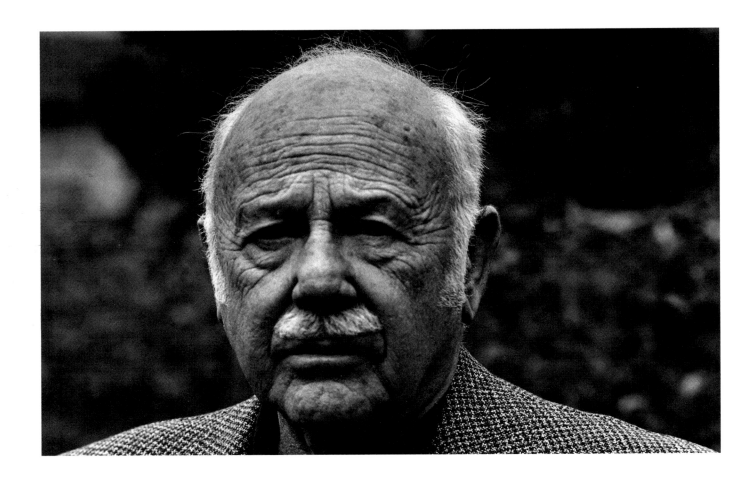

Portrait, 1968.

Strand seated in his garden, 1968.

Paul Strand in seinem Garten, 1968.

Strand assis dans son jardin, 1968.

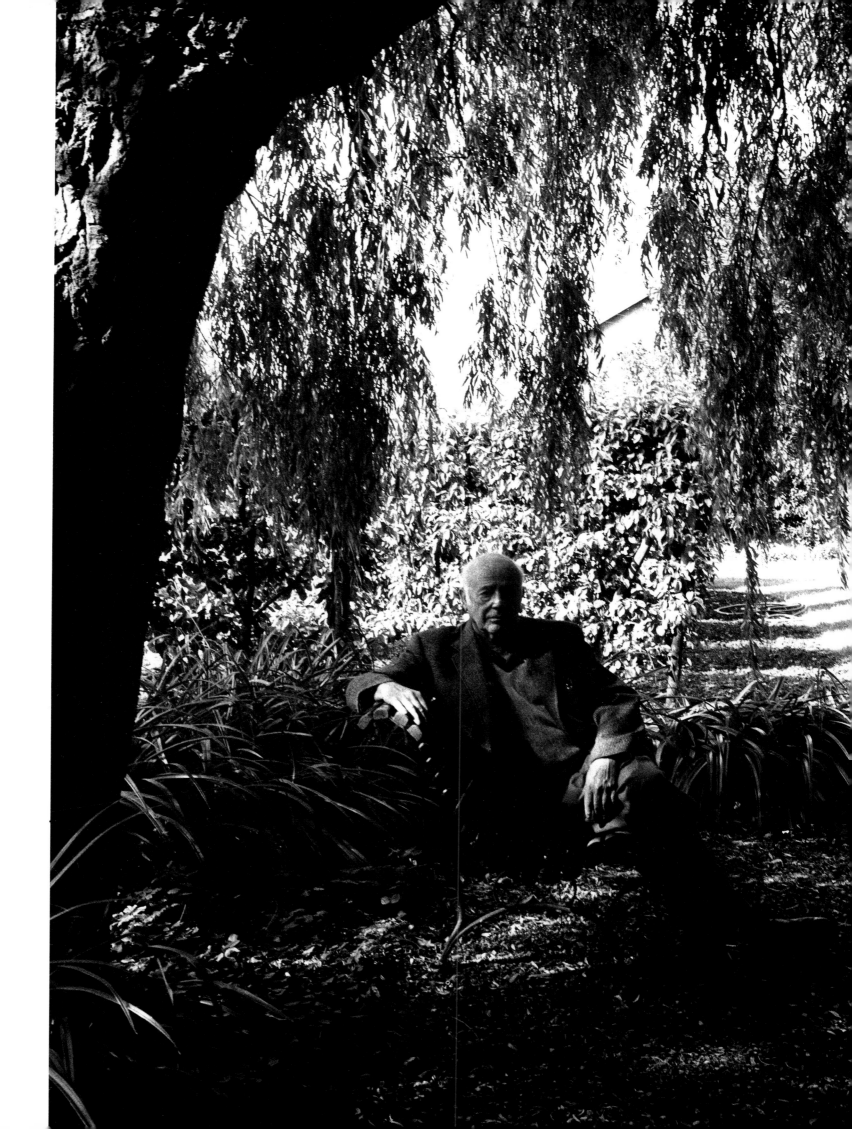

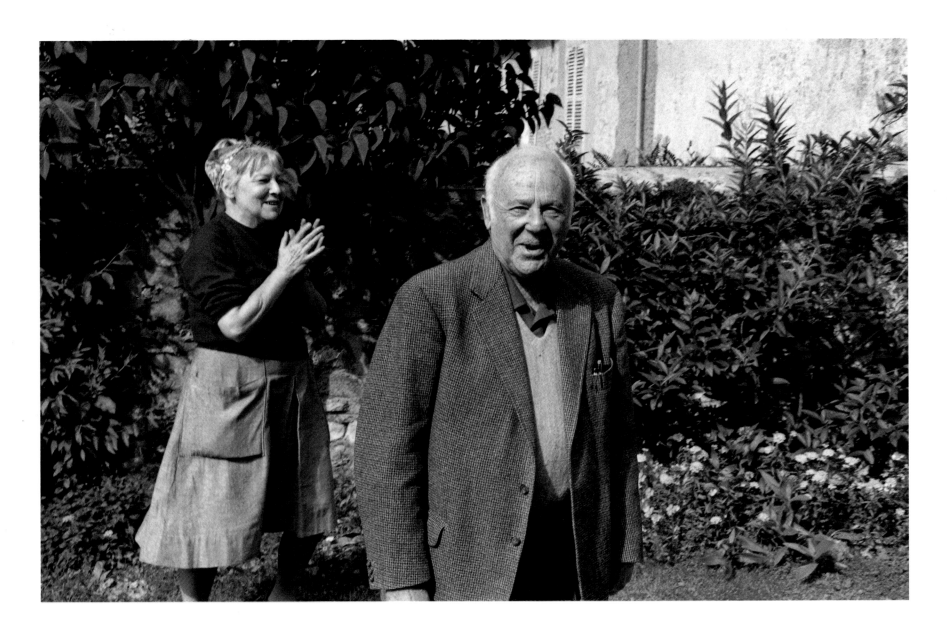

In the garden with his wife, 1968.

Im Garten mit seiner Frau, 1968.

Dans le jardin avec sa femme, 1968.

Lawn bowling in his garden, 1968.

Beim Boulespiel im Garten, 1968.

Jeu de boules sur la pelouse du jardin, 1968.

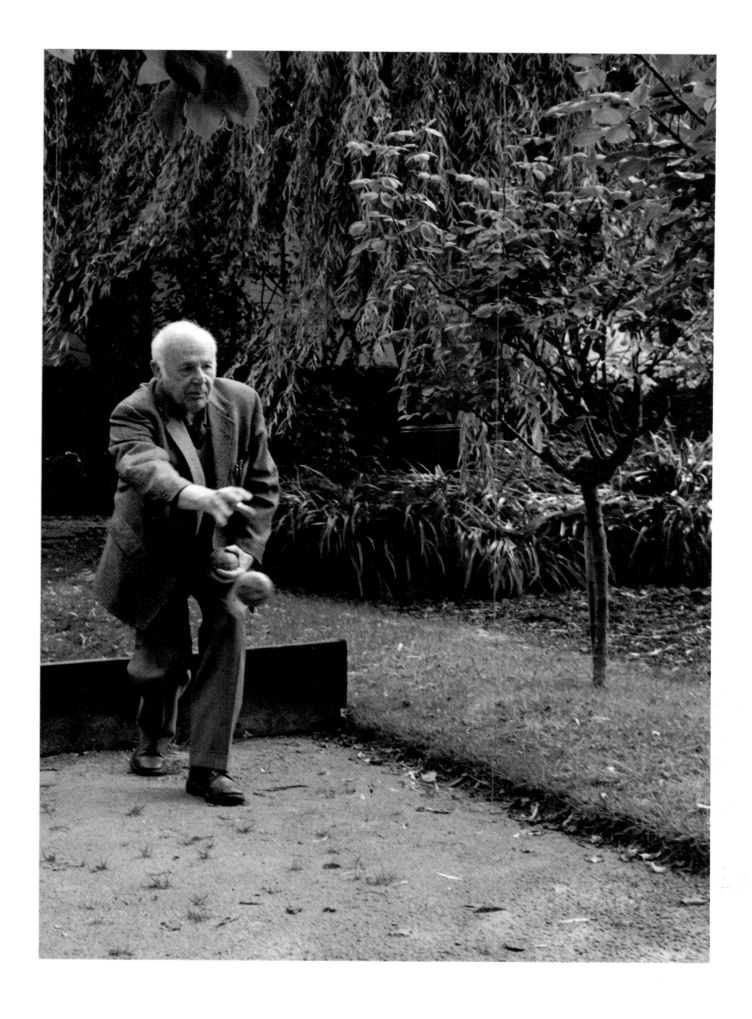

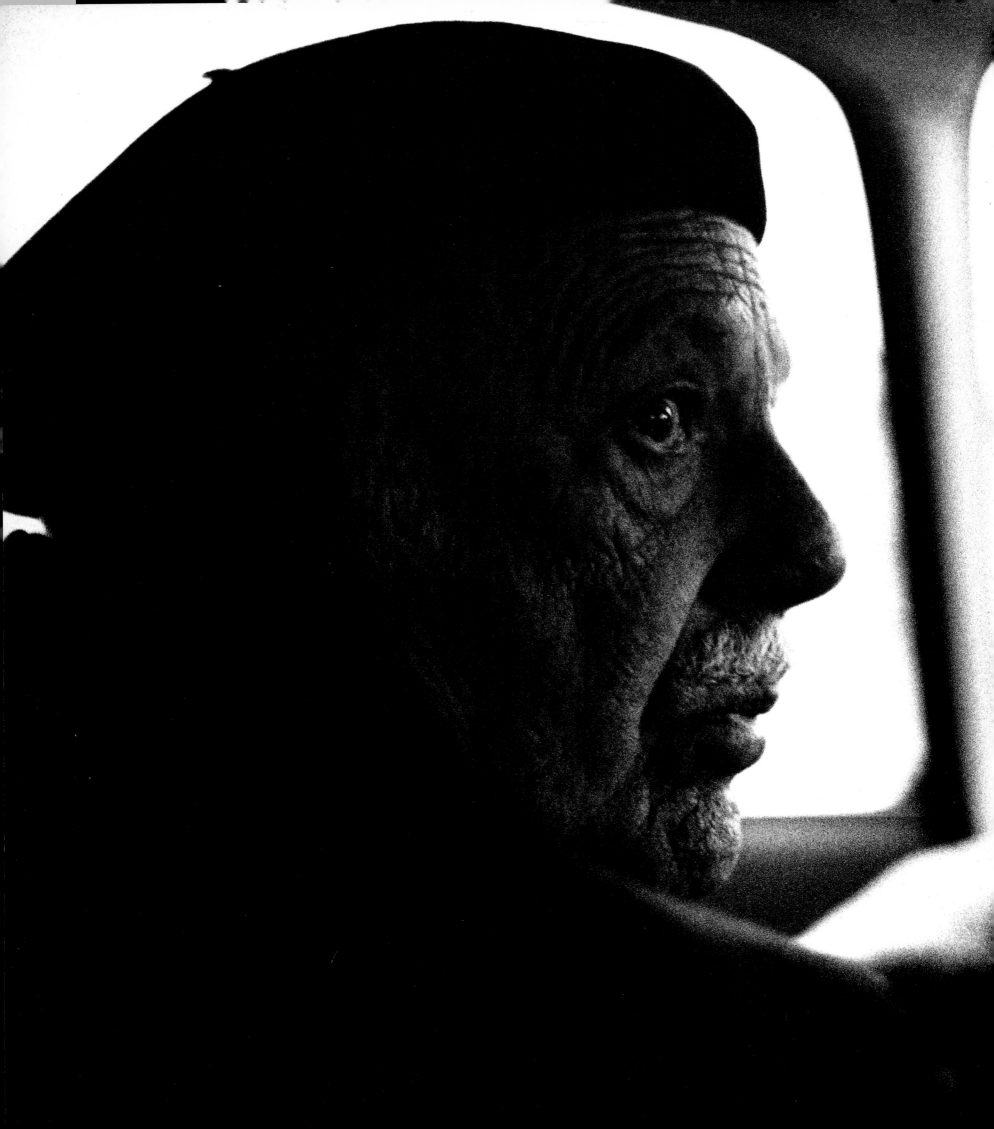

Walker Evans

1903–1975. American, born St. Louis, Missouri.
One of the United States' most important social documentarians.
Photographed the poverty of the Depression of 1929–31 for the
Farm Security Administration. His photographs are direct, having
a purity of content that is often emulated. Evans' photographs
illustrate a number of books i.e., *Let Us Now Praise Famous
Men* (1941) by James Agee and Hart Crane's *The Bridge*. His
photographs have been the subject of many solo exhibitions. A
number of books have been written about him since his death.

1903–1975. Amerikaner. Geboren in St. Louis, Missouri.
Er leistete mit seinem Werk einen bedeutenden Beitrag zur
sozialdokumentarischen Fotografie der Vereinigten Staaten.
Fotografierte die Armut in Amerika während der
Weltwirtschaftskrise für die Farm Security Administration. Seine
Fotos sind von besonderer Direktheit und von einer Klarheit, die
man oft nachgeahmt hat. Evans illustrierte auch einige
bedeutende Bücher mit seinen Fotos – James Agees *Let Us Now
Praise Famous Men* (1941) und Hart Cranes *The Bridge* sind
zwei besonders herausragende Beispiele. Seinem Werk sind
zahlreiche Einzelausstellungen und Bücher gewidmet.

1903–1975. Américain. Né à St. Louis, Missouri.
L'un des grands noms américains de la photo à caractère social. Il
a photographié la pauvreté lors de la Crise de 1929 à 1931 pour
la Farm Security Administration. Son art est direct, le contenu
dépouillé, pur, et il sera souvent imité. Les photographies d'Evans
illustrent de nombreux livres comme *Let Us Now Praise
Famous Men* (1941), texte de James Agee ou *The Bridge*, texte
de Hart Crane. De nombreuses expositions particulières et bien
des livres lui ont été consacrés.

Portrait, 1969.

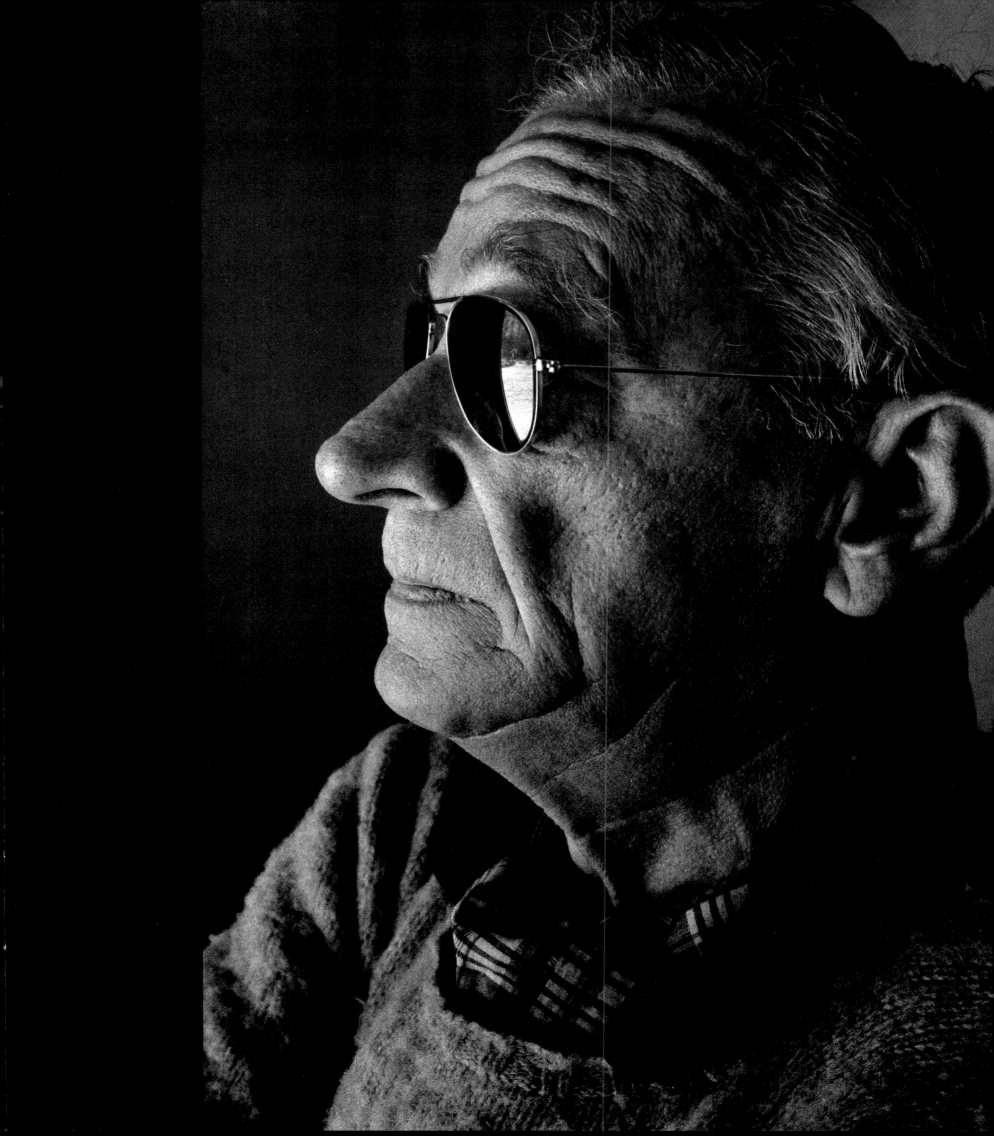

Beginning in the late 1920s, working in and around New York City with his »vest pocket« camera, Walker Evans photographed the waterfront, skyscrapers, and, most importantly, the Brooklyn Bridge, in a style that was his alone: clean, uncluttered, immediate, and direct.

Walker went on to photograph Tahiti, Florida, Cuba, and of course the poverty and the hopelessness of the Depression during the 1930s for the Farm Security Administration; he also photographed in Chicago and later did photo-essays for *Fortune* magazine; he photographed interiors, people, landscapes and objects with the coolness and detachment of a surgeon, wielding his camera not unlike a scalpel, cutting away the surface to get to the visceral content of the subject at hand. He photographed in black-and-white, not turning to color until he went on staff at *Fortune* in the 1950s.

I first met him after phoning him with a description of my project. I remember him being both curious about my undertaking and agreeable to my proposal. He suggested that I come in on a Saturday morning and spend the day and night as his house guest in Old Lyme, Connecticut. So I flew to New York and took a train to Lyme, according to his directions. He identified himself at the station, and proceeded to drive me to his home in Old

Evans' mailbox, Old Lyme, Connecticut, 1969.

Evans Briefkasten, Old Lyme, Connecticut, 1969.

La boîte à lettres de Walker Evans, Old Lyme, Connecticut, 1969.

Walker Evans begann seine Karriere Ende der zwanziger Jahre in der Metropole New York, die er mit seiner Pocketkamera durchstreifte; dabei gelangen ihm Aufnahmen von Wolkenkratzern und insbesondere von der Brooklyn Bridge, die schon ganz von seinem persönlichen fotografischen Stil geprägt waren: klar, weiträumig, hautnah.

Walker fotografierte später Tahiti, Florida, Kuba – und natürlich für die Farm Security Administration die Armut und Hoffnungslosigkeit im Amerika der Weltwirtschaftskrise; er fotografierte auch in Chicago und gestaltete später auch Foto-Essays für *Fortune*; er machte Aufnahmen von Wohnungen, Menschen, Landschaften und Objekten mit der Abgeklärtheit und Nüchternheit eines Chirurgen. Die Kamera wurde ihm zu einer Art Skalpell, mit dem er die Oberflächen aufschnitt, um das lebendige Innere seiner Motive freizulegen. Er fotografierte lange Zeit schwarzweiß und begann erst in den fünfziger Jahren mit der Farbe, als er für *Fortune* arbeitete.

Ich traf ihn, kurz nachdem ich ihn wegen meines Projekts angerufen hatte. Er war neugierig und hilfsbereit zugleich. Er lud mich übers Wochenende zu sich nach Old Lyme, Connecticut, ein.

Ich flog also nach New York und nahm den Zug nach Lyme. Er holte mich am Bahnhof ab, und wir fuhren nach Old Lyme, das nur ein paar Meilen entfernt liegt; seine Frau Isabelle erwartete uns zu Hause. Auf der Fahrt sprachen wir über meine Idee, eine Fotodokumentation mit den Porträts und dem Umfeld der großen zeitgenössischen Fotografen

Walker Evans débuta fin 1920 en travaillant à New York et ses environs avec son appareil de poche, photographiant les quais, les gratte-ciel et, plus important, le pont de Brooklyn dans un style unique : pur, dépouillé, direct. Walker poursuivit en photographiant Tahiti, la Floride, Cuba et bien sûr la misère, le désespoir durant la grande dépression des années trente pour la Farm Security Administration ; il photographia aussi Chicago et fit plus tard de la photographie d'essai pour *Fortune Magazine*. Il prit les intérieurs, les gens, les paysages et les objets avec le calme et le détachement d'un chirurgien, ne manipulant pas son appareil différemment d'un scalpel, coupant la surface pour atteindre les viscères du sujet. Il photographia en noir et blanc, refusant la couleur jusqu'à ce qu'il intègre une équipe à *Fortune* en 1950.

Je le rencontrai pour la première fois après lui avoir expliqué mon projet au téléphone. Je me souviens de lui comme s'étant montré à la fois curieux de mon entreprise et ouvert à ma proposition. Il me suggéra de venir un samedi matin et m'invita pour le week-end dans sa maison d'Old Lyme, dans le Connecticut. Il me dit que sa femme, Isabelle, et lui-même prendraient soin de moi.

With one of his several Rolleiflexes – the case in the foreground contained several additional cameras, 1969.

Mit einer seiner Rolleiflex-Kameras. Der Koffer im Vordergrund enthält weitere Kameras. 1969.

Avec l'un de ses nombreux Rolleiflex. Le coffre au premier plan contient plusieurs autres appareils. 1969.

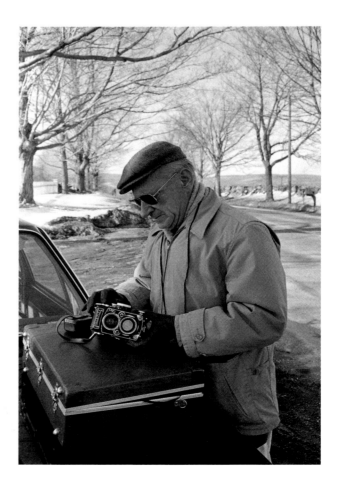

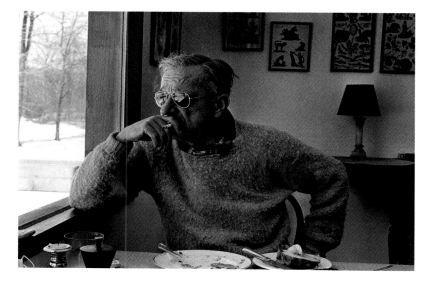

Lyme, just a few miles away. His wife Isabelle was waiting for us. As we drove we spoke of my self-assigned project of documenting the faces and environments of the great living photographers. He was quite interested and agreed to let me taperecord our conversations as well as photograph him.

Only later did I come to feel that part of his willingness to co-operate had to do with an awareness of his own mortality, and his need to share his experiences as a photographer with an acolyte who would record some of the details of his life.

As I looked around his home I observed that Walker Evans lived as he photographed. In his home, all areas (but one) were totally organized and uncluttered. He told me that he alone was responsible for the order of the house. Each surface, whether table, windowsill, or wall, and even inside his closets, was ruled by a very strict sense of organization.

But, alas, chaos did abound in one area – his photographic archives. When I asked to see his pictures, Walker directed me to several files which were stored under a worktable in his workroom.

There, bent, folded, torn, mixed up and in total disarray were the masterpieces of his life's work: work prints, finished prints, and negatives.

Only one group in that room was organized, and that one was the collection of pictures that made up the book *American Photographs*. Those were kept in indexed order in a small grey metal upright file about 9x10x12 inches in size.

That first weekend, Walker and I pored over what probably were thousands of images. We talked about literature, smoked some very fine cigars, and went to a local eatery for some good hamburgers.

Walker was always taking a pill for some ailment – afterwards clearing his throat of the »foul taste of water« by sipping on a glass of Scotch, all the time complaining that no one was buying his photographs (even though he was then a famous photographer) and that the Museum of Modern Art had only given him a minimal budget to print the retrospective of his life's work which was to open on 27 January 1971. This entire exhibition was being prin-

herauszugeben. Er fand die Sache sehr interessant und gestattete mir sogar, unsere Gespräche auf Band mitzuschneiden.

Erst viel später merkte ich, daß sein bereitwilliges Entgegenkommen teils mit einem Wissen um seine Sterblichkeit und dem Bedürfnis zusammenhing, seine Erfahrungen als Fotograf an einen Schüler weiterzugeben, der sein Leben dokumentarisch festhielt.

Schon beim ersten Gang durch sein Haus fiel mir auf, daß er lebte, wie er fotografierte. Jeder Winkel (außer einem) war peinlich sauber und aufgeräumt. Er erzählte mir, daß er die Inneneinrichtung des Hauses selbst gestaltet hatte. Ob Fensterbänke, Tische, Wände: Sogar seine Schränke vermittelten den Eindruck von symmetrischer Ordnung.

Nur in einem Raum in diesem wohlorganisierten Haus herrschte Chaos: In der Dunkelkammer mit seinen Fotoarchiven. Als ich seine Bilder sehen wollte, führte mich Walker zu einigen Dokumentenordnern, die unter einem Arbeitstisch in seiner Dunkelkammer lagen.

Ein Sammelsurium von verknickten, zerrissenen, und völlig zerwühlten Meisterwerken – Kontaktabzüge, Probebelichtungen, fertige Abzüge und Negative.

Nur eine einzige Serie von Aufnahmen war geordnet, und zwar die Bilder, die er für das Buch *American Photographs* zusammengestellt hatte. Diese Bilder waren in einer kleinen Metalldose verstaut.

An jenem ersten Wochenende schaute ich mir wohl einige tausend Bilder mit Walker an. Wir redeten über Literatur, rauchten einige ausgezeichnete Zigarren und verzehrten in der Nähe einige köstliche Hamburger.

Walker nahm beständig Tabletten gegen diese oder jene Beschwerde, und anschließend spülte er sich – »um den ekligen Wassergeschmack wegzukriegen« – immer den Mund mit einem Glas Scotch aus; er beklagte sich ausgiebig darüber, daß niemand seine Fotos kaufen wollte (obwohl er damals schon ein berühmter Fotograf war) und daß das Museum of Modern Art in New York ihm nur ein winziges Budget bewilligt hatte, um Abzüge für die Retro-

Je pris l'avion de New York puis le train en direction de Lyme. Il vint me chercher, puis me conduisit à Old Lyme à quelques kilomètres de là. Sa femme nous attendait. Tout en conduisant, nous parlâmes de la tâche que je m'étais assignée de collectionner, de leur vivant, les visages et aussi l'environnement des grands noms de la photographie. Il se montra très intéressé et fut d'accord pour que j'enregistre nos conversations et fasse des photographies.

Ce fut plus tard que je réalisai que sa volonté de coopérer était liée à la conscience de sa propre mortalité et à son besoin de partager quelques détails de sa vie avec un complice qui les consignerait.

Comme je regardais autour de moi, je remarquai qu'il vivait comme il photographiait. Chez lui, toutes les pièces (sauf une) étaient fonctionnelles et dépouillées. Il me dit que lui seul était responsable et de l'ordre dans la maison. Toutes les surfaces, aussi bien les tables, les rebords des fenêtres, que les murs et même l'intérieur des toilettes faisaient l'objet de règles strictes concernant l'ordre.

Mais, hélas, le désordre foisonnait dans un domaine : ses archives photographiques. Quand je lui demandai de voir ses images, Walker me montra un amoncellement de piles entassées sous une table dans son atelier. Là, froissés, pliés, tordus, mélangés dans un désordre total, se trouvaient les chefs-d'œuvre de sa vie de photographe : épreuves achevées ou non, négatifs.

Seule une partie de l'atelier échappait au chaos. C'était celle consacrée à la collection de photos utilisées pour l'ouvrage *American Photograph* : celles-ci étaient classées et indexées dans un petit classeur vertical en métal.

Ce premier week-end, Walker et moi étudiâmes probablement près de mille photos. Nous parlâmes littérature, appréciâmes quelques fins cigares et allâmes dans un snack déguster quelques bons

ted by one person in Texas in order that »the prints might have a uniformity.« Although Walker was a professor and taught at Yale (this was the late 1960s), he was always short of funds; so I was able to acquire a very important group of his photographs, including a maquette of an unpublished book of photographs containing seventy contact prints in a thirty-page book. The title page in Evans' hand reads, »Faulkner Country: Tennessee and Mississippi, June 1948.« This unpublished and unknown work was later acquired from me by the Getty Museum in Malibu, California.

At my request, as another souvenir, Walker also gave me an empty medication bottle – as I said before, he was always taking something. This one was from the »Old Lyme Pharmacy« – Prescription #46508 – Compazine 5 mg., dated 4/14/66. I always kept this bottle as a very personal memento of a great man.

Walker's wife, Isabelle, was a soft-spoken, mature person who made me feel welcome as their house guest. During my numerous visits, I was given complete access to Walker, and was able to photograph him even as he was shaving and dressing.

Sometime later, when I returned to the Museum of Modern Art and showed those photographs to John Szarkowski, then Director of the Department of Photography, John exclaimed, »Arnold, these pictures are invalid!«

When I asked why, he responded: »No one gets this close to Walker!«

I replied: »You forget, John – I did!«

Walker asked me to accompany him wherever he went during my visits to Old Lyme. Whether it was to cocktail parties, dinners, or just a visit to a local hardware store, I'd go along. I remember he was al-

spektive seines Lebenswerks zu machen, die am 27. Januar 1971 in New York eröffnet werden sollte. Er ließ alle Abzüge für die Ausstellung von jemandem in Texas machen, damit »die Abzüge eine gewisse Gleichmäßigkeit haben«. Obwohl Walker damals, Ende der sechziger Jahre, eine Professur an der Yale University innehatte, war er immer knapp bei Kasse; deshalb verkaufte er mir eine sehr bedeutende Serie von Fotos sowie eine Vorlage für einen geplanten Bildband, der auf dreißig Seiten etwa siebzig Kontaktabzüge enthielt. Auf dem Umschlag dieses Entwurfs stand handschriftlich: »Faulkner Country: Tennessee and Mississippi, June 1948«. Später kaufte mir das Getty-Museum in Malibu dieses unveröffentlichte und noch unbekannte Werk von Walker Evans ab.

Walker nahm, wie bereits gesagt, ständig Medikamente. So bat ich ihn um ein Arzneifläschchen als Souvenir, und er gab mir eins von der »Old Lyme Pharmacy«; darauf steht: »Prescription #46508 – Compazine 5 mg. 14/4/66«. Ich werde sie immer als meine ganz persönliche Erinnerung an diesen bedeutenden Mann aufbewahren.

Walkers Frau Isabelle war eine ruhige, intelligente Frau, die mir immer das Gefühl gab, willkommen zu sein. Ich war oft bei ihnen zu Gast und hatte engsten Kontakt mit Walker, ich durfte ihn sogar beim Ankleiden und Rasieren fotografieren.

Als ich einige Zeit später dem damaligen Direktor des Department of Photography im Museum of Modern Art, John Szarkowski, diese Bilder vorlegte, kommentierte er trocken: »Arnold, diese Bilder sind gefälscht!«

Auf meine Frage, wie er das meine, sagte er: »Walker läßt niemanden so nah an sich ran.«

»Mich schon«, antwortete ich.

Walker bat mich, ihn überallhin zu begleiten, wenn ich bei ihm in Old Lyme zu Besuch war. Wir gingen zu Cocktailparties, Soireen – oder einfach nur zum Haushaltswarenladen um die Ecke. Ich erinnere mich, daß er ständig ans Fotografieren dachte. Wir kamen oft an einem Kornsilo vorbei, und jedesmal sagte Walker: »Eines Tages werde ich das Ding fotografieren, wenn wir das richtige Licht

hamburgers. Walker se gavait de pilules pour toutes sortes de « maladies », puis après cela, pour se débarrasser de cet « infect goût d'eau », il sirotait un verre de Scotch, se plaignant sans arrêt que personne n'achetât ses photos (bien qu'il fût déjà un photographe très connu), et que le Museum of Modern Art ne lui ait accordé qu'un budget minimum pour éditer une rétrospective de son travail qui devait avoir lieu le 27 janvier 1971. L'exposition toute entière devait être développée par une personne au Texas parce que le tirage devait être « parfaitement uniforme ».

Bien que Walker fût professeur et enseigna à Yale (à la fin des années soixante), il était toujours à court d'argent ; j'acquis ainsi une série importante de photos, dont la maquette d'un album de photographies de trente pages non publié contenant soixante-dix planches contact. Evans lut le titre « Faulkner Country : Tennessee et Mississippi, juin 1948 ». Le Getty Museum à Malibu Californie me racheta plus tard ce travail inconnu.

Comme nous l'avons déjà dit, Walker ingurgitait toutes sortes de remèdes. A ma demande, il me donna en souvenir un flacon vide de la « Old Lyme Pharmacy » avec cette prescription : #46508-Compazine 5mg, datée du 14/4/66. Je l'ai toujours gardé précieusement en souvenir de ce grand homme.

Isabelle, l'épouse de Walker, était une femme intelligente à la voix douce qui me mit parfaitement à l'aise dans la maison. Durant mes nombreuses visites, je pus approcher Walker à ma guise et le photographier même quand il se rasait ou s'habillait. Quelque temps après, comme je retournais au Museum of Modern Art et montrais ces photos à John Szarkowski, alors directeur du département Photo, celui-ci s'exclama : « Arnold, ces photos sont truquées ! ». Je lui demandai ce qu'il voulait dire, il répondit : « Personne n'approche Walker de si

Table in Evans' garden apartment on the Upper East side in New York City. He kept this small pied-à-terre for his Manhattan visits. Note the open copy of *The New York Social Register*. This photograph was made the evening of the opening of his retrospective. 1971.

Tisch in Evans Gartenapartment auf der Upper East Side in New York. Er hielt sich diese kleine Zweitwohnung für seine Aufenthalte in Manhattan.
Man beachte das aufgeschlagene *New York Social Register*. Das Foto wurde am Abend der Eröffnung seiner Retrospektive gemacht. 1971.

Une table dans le jardin d'hiver de l'appartement de Walker Evans situé à Upper West side. Il gardait ce petit pied-à-terre pour ses visites à Manhattan. On note la présence du *New York Social Register* ouvert. Cette photo fut faite au cours de la soirée d'inauguration de la rétrospective de Walker, 1971.

Evans at the opening of his retrospective at the New York Museum of Modern Art, 1971.

Evans bei der Eröffnung seiner großen Retrospektive im Museum of Modern Art, New York, 1971.

Walker Evans au vernissage de sa rétrospective au Museum of Modern Art de New York, 1971.

ways thinking about photographing. We often would pass a certain grain elevator and he would say: »Someday I shall photograph this, when the light is right.«

One of my last memories of him is a book Walker gave me as a gift during one of my final visits. I had seen his closet filled with suits from J. Press; his shoes, made by the finest of English custom shoemakers; his camera cases filled with the finest equipment and the best German optics; and his sturdy Swedish automobile. That book is still on my shelf. It is a compendium of essays, one of which Walker himself had written. The title of the book is *Quality*. His love of quality seemed to sum up an important aspect of the man.

In 1969 I asked Walker who or what had influenced him as a photographer. He searched for a way to reply. He responded that in the '30s he had not seen much photography but was addicted to newsreels, which were very graphic in their method of reportage. He acknowledged to me that perhaps he was most influenced by those newsreels.

He added: »When you get a project, the pictures find you. You become a kind of medium – you think things are done *through* you somehow. You are the agent. A lot of art is that way.«

dafür haben.« Ich besitze ein Andenken an Walker, ein Buch, das er mir bei einem meiner letzten Besuche geschenkt hat. Seine Schränke waren voll mit den besten Anzügen von J. Press, seine Schuhe kamen von den besten englischen Schuhmachern, seine Kirschenschachten waren mit der besten Ausrüstung und allerbester deutscher Optik bestückt, und er fuhr einen unverwüstlichen schwedischen Wagen. Das Buch, das er mir damals gab, steht noch heute in meinem Bücherregal. Ein Essay-Sammelband, darunter auch ein Essay von Walker selbst. Der Titel dieses Bandes lautet *Quality*. Die Liebe zur Qualität war bezeichnend für diesen Mann.

1969 fragte ich Walker einmal, wer oder was ihn als Fotograf besonders beeinflußt habe. Er überlegte lange. Schließlich sagte er, daß er in den dreißiger Jahren zwar nicht viele Fotos gesehen habe, dafür aber geradezu süchtig nach Wochenschauen gewesen sei; die Reporter bei Wochenschauen seien immer um höchstmögliche Anschaulichkeit bemüht gewesen. Diese Wochenschauen, vertraute er mir an, hätten vermutlich den größten Einfluß auf sein Werk gehabt.

»Wenn man eine größere Reportage macht, finden einen die Bilder. Man wird zu einer Art Medium – man bekommt das Gefühl, daß man die Dinge nur sichtbar macht. Man ist wie ein Katalysator. Das kommt in der Kunst ganz häufig vor.«

près ». Je répliquai : « John, vous oubliez que je l'ai fait ! ».

Walker me demanda de l'accompagner partout où il allait pendant mes visites à Old Lyme. Qu'il s'agisse d'un cocktail, d'un dîner ou d'une visite dans une quincaillerie du coin, j'étais là. Je me souviens qu'il pensait sans arrêt à photographier. Nous passions souvent devant un élévateur à grains et il répétait à chaque fois: « Un de ces jours, il faudra que je prenne ça, quand l'éclairage sera bon. » Walker Evans réalisa des photos au contenu d'un naturel et d'une clarté inimitables.

L'un de mes derniers souvenirs de lui est un livre qu'il m'offrit en cadeau, lors d'une de mes dernières visites. J'avais vu ses armoires remplies de costumes de J. Press, ses chaussures faites sur mesure par le plus raffiné des chausseurs, ses boîtes d'appareils-photo équipées du meilleur matériel et de la meilleure optique allemande et sa robuste automobile suédoise. Ce livre est toujours sur mon étagère. C'est un recueil d'essais, l'un d'eux écrit par Walker lui-même. Le titre du livre est *Quality*. L'amour de la qualité semble avoir été un aspect important de cet homme.

En 1969, je demandai à Walker par qui ou par quoi il avait été influencé en tant que photographe. Il réfléchit un moment avant de répondre et me dit que dans les années trente, il n'avait pas tellement vu de photographies, mais qu'il était un « mordu » des actualités dont le style de reportages était très vivant. Il reconnut que c'était peut-être les actualités qui l'avaient le plus marqué.

Il ajouta : « Quand vous avez un projet, les images vous trouvent. Vous devenez un médium, vous pensez que les choses sont faites *à travers* vous en quelque sorte. Vous êtes le transporteur d'images. C'est ainsi que naît la création artistique ».

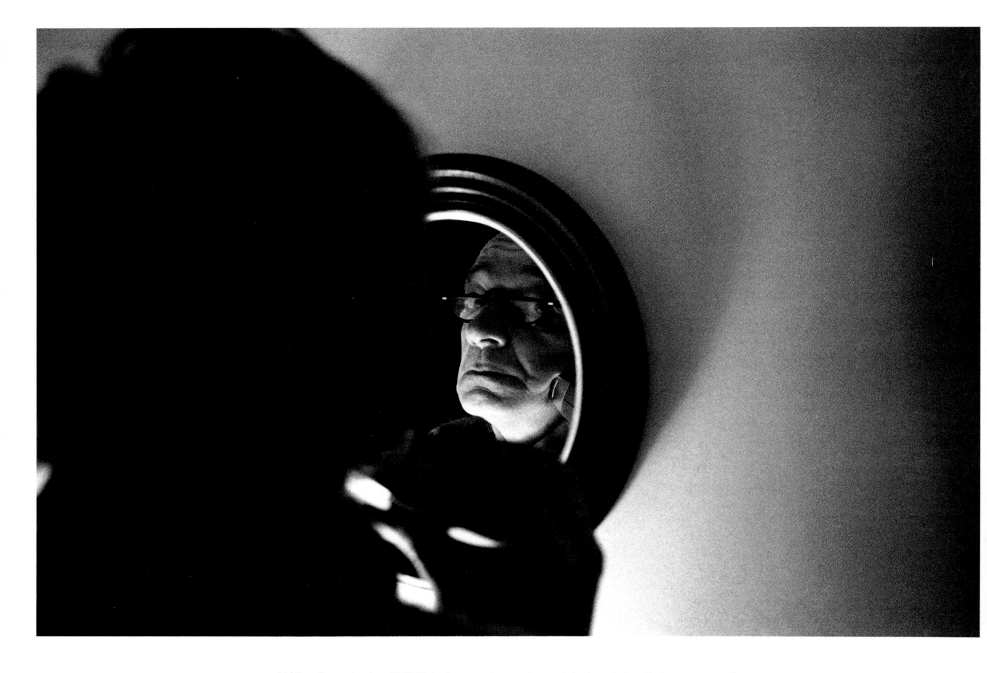

Walker Evans shaving, 1969. This photograph caused a strain in the relationship between myself
and John Szarkowski, then Curator of Photography at New York's Museum of Modern Art, who said
to me, »These pictures are invalid, no one gets this close to Walker!« But of course I did.

Walker Evans beim Rasieren, 1969. Dieses Foto belastete die Beziehungen zwischen mir und John Szarkowski,
der damals Curator of Photography am New Yorker Museum of Modern Art war. Er sagte mir damals:
»Arnold, diese Bilder sind gefälscht; Walker läßt niemanden so nah an sich ran!« Mir war es aber gelungen.

Walker Evans en train de se raser, 1969. Cette photo est à l'origine de la tension qui s'installa entre
John Szarkowski et moi, alors conservateur de la photographie au Museum of Modern Art de New York.
Il me dit :« Ces photos sont truquées! Personne n'approche Walker de si près ! » Je l'ai pourtant fait.

White table in living room. This table and the previous photograph of the tabletop were included
in this book by me during my final edit. Both images — especially the white table —
kept coming up in my mind as typical examples of Evans' eye for organization. 1969.

Weißer Tisch im Wohnzimmer. Ich habe mich erst im letzten Augenblick
entschlossen, dieses und das vorhergehende Foto mit Tischmotiv mit in dieses Buch aufzunehmen,
weil mir die beiden als besonders gute Beispiele für Evans Liebe zur Klarheit erscheinen. 1969.

La table blanche de la salle de séjour. J'ai inclu cette photo dans
l'édition finale. Elles revenaient sans cesse dans ma mémoire comme
exemple typique du sens de l'organisation de Walker. 1969.

Wall and table in Evans' dining room, 1969.

Wand und Tisch in Evans Eßzimmer, 1969.

Mur et table dans la salle de séjour des Evans, 1969.

Evans in living room in front of Ben Shahn painting, 1969.

Evans im Wohnzimmer vor einem Gemälde von Ben Shahn, 1969.

Walker dans la salle de séjour face à une peinture de Ben Shahn, 1969.

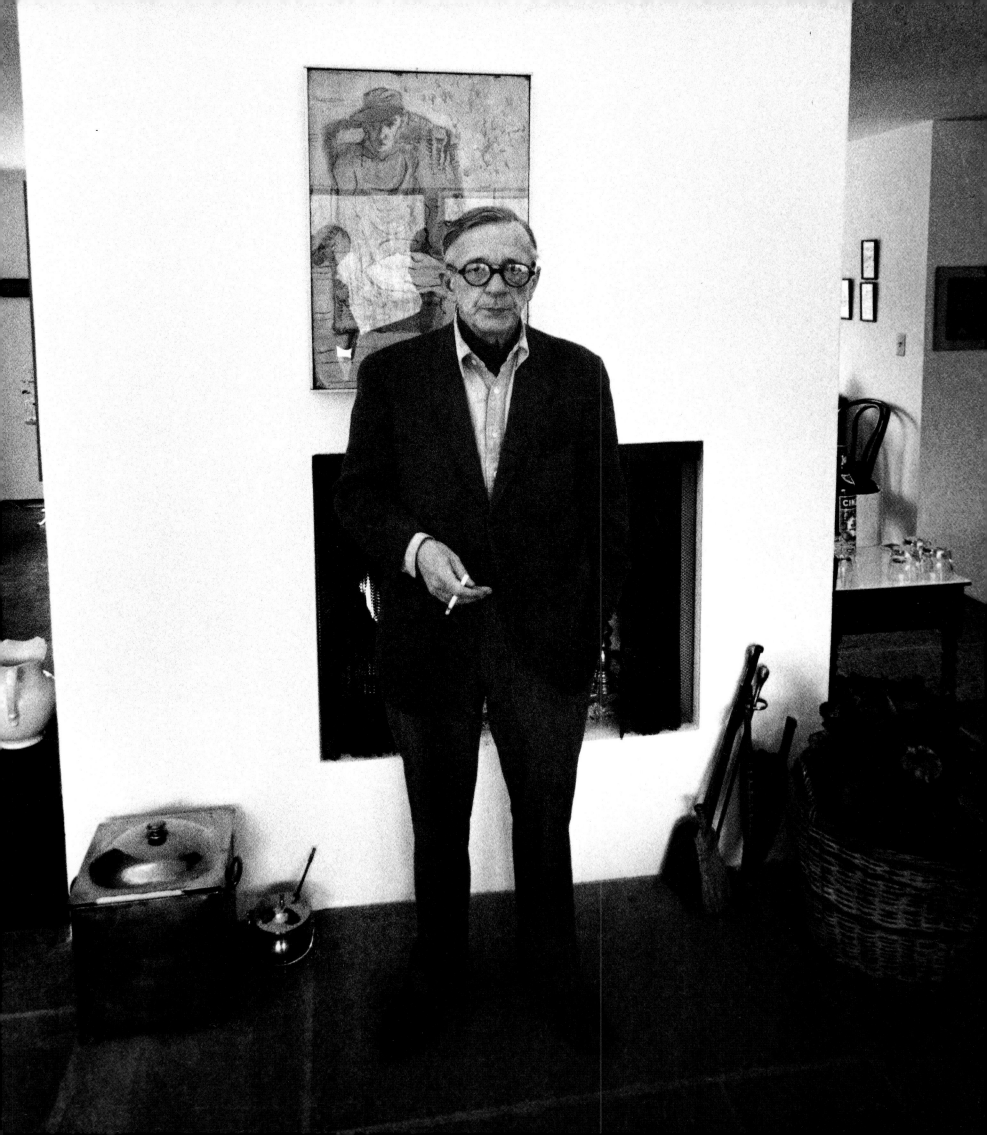

Walker's chaotic work room. His negatives and paints were kept in cardboard box files
on the floor under the prints and just to the right of the chair in the foreground. 1969.

Walkers chaotischer Arbeitsraum. Seine Negative und Abzüge befanden sich in Kartons
auf dem Fußboden unter den Abzügen, gleich rechts neben dem Stuhl im Vordergrund. 1969.

L'atelier désordonné de Walker. Les peintures et les négatifs sont conservés dans
des cartons posés à même le sol sous les épreuves, à droite de la chaise au premier plan. 1969.

Walker talking with me in his work room, 1969.

Walker und ich im Gespräch, 1969.

Walker en train de parler avec moi dans l'atelier, 1969.

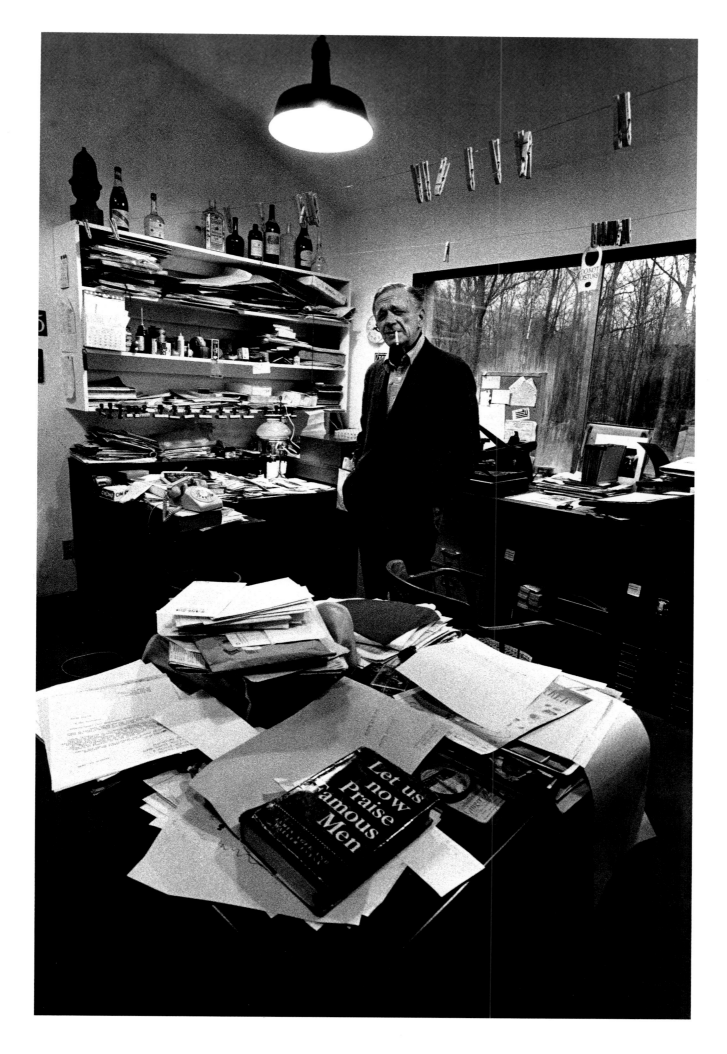

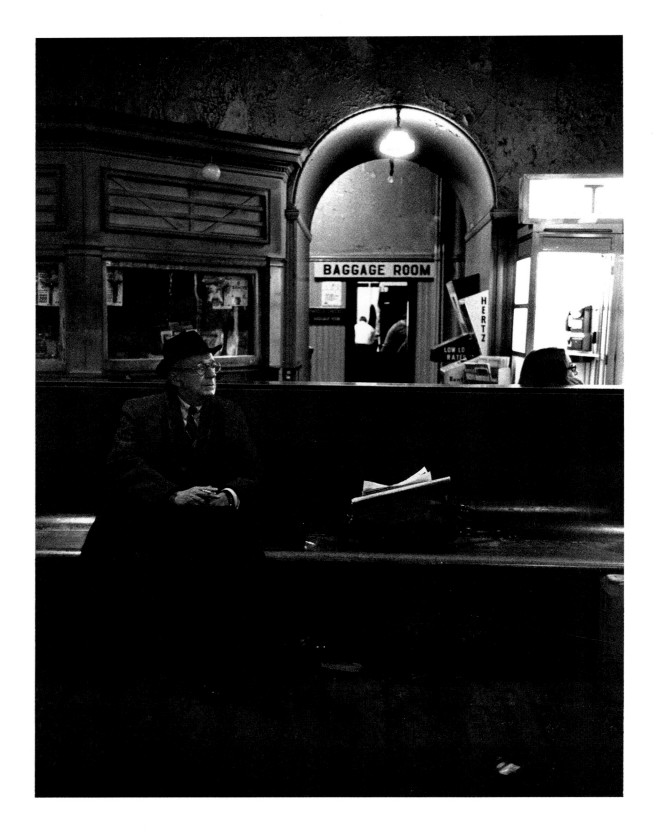

△ ▷ In the waiting room at the station in Lyme, Connecticut, 1969.

Im Wartesaal am Bahnhof von Lyme, 1969.

Dans la salle d'attente à la gare de Lyme, Connecticut, 1969.

Evans (hand over his eyes) on train between Lyme and New York City, 1969.
Evans had a fear of airplanes and would only travel by train, car or ship.

Evans (mit der Hand vor den Augen) im Zug von Lyme nach New York City, 1969.
Evans hatte Angst vorm Fliegen und reiste deshalb nur mit dem Zug, Auto oder Schiff.

Walker (la main en visière) dans le train entre Lyme et New York City, 1969.
Il avait peur de prendre l'avion et ne se déplaçait qu'en train, en voiture ou en bateau.

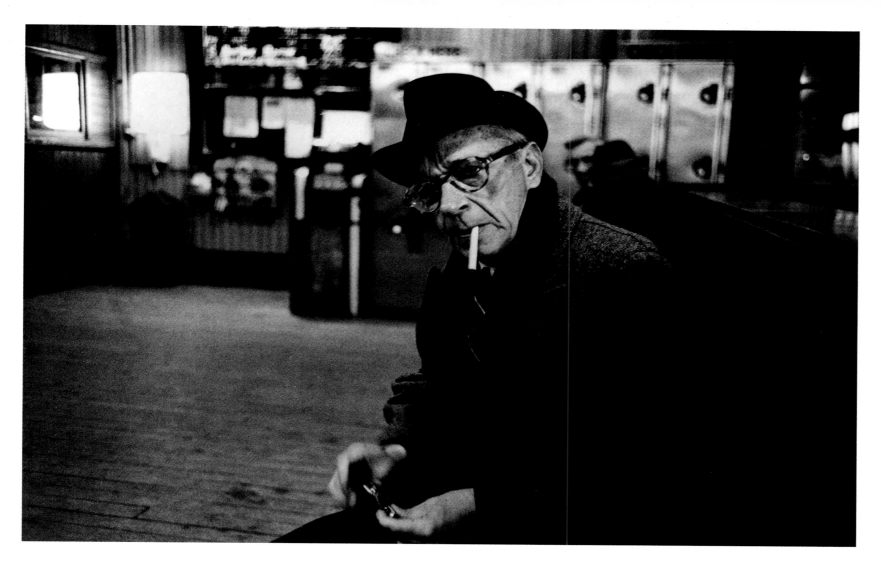

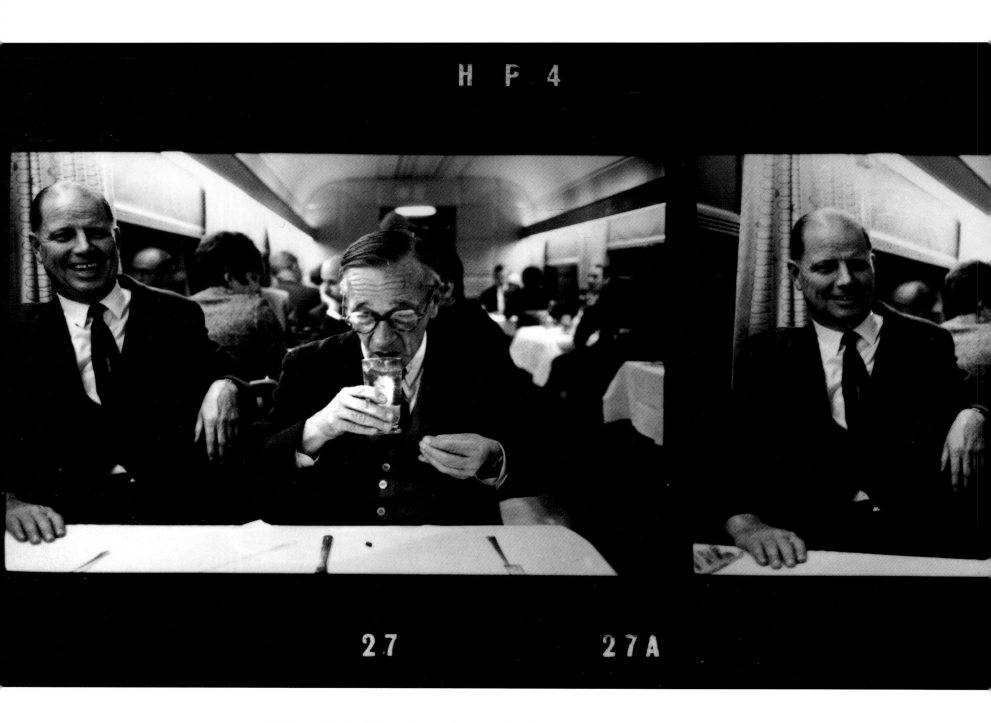

Taking a pill in the dining car between Lyme and New York. The gentleman on Evan's left appeared at
Wellesley University during a speech I was delivering at an opening of an exhibition of my
photographic portraits at their Art Museum. Regretfully the record of his name has been lost. 1969.

Evans nimmt eine Tablette im Speisewagen auf der Fahrt von Lyme nach New York. Den Mann links
von ihm sah ich bei meinem Vortrag wieder, den ich bei der Eröffnung einer Ausstellung meiner Porträts
am Wellesley College gehalten habe. Leider fällt mir sein Name nicht mehr ein. 1969.

Walker Evans en train de prendre une pilule dans le wagon restaurant entre Lyme et New York. L'homme qui se
tient à sa gauche était présent à l'université de Wellesley pendant le discours d'inauguration de l'exposition de portraits
photographiques ayant lieu dans le musée d'Art de l'université. Malheureusement, j'ai oublié son nom. 1969.

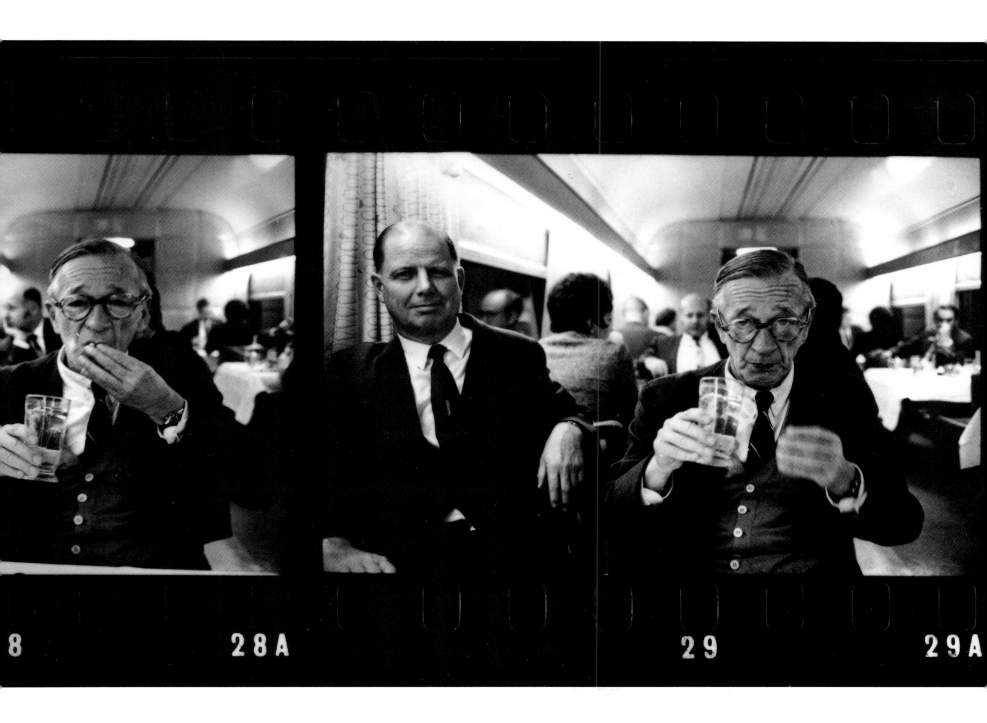

8　　　　　　28A　　　　　　　　　　29　　　　　29A

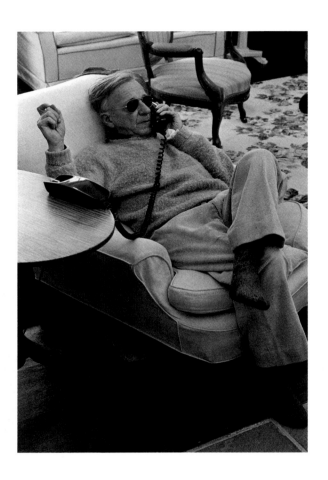 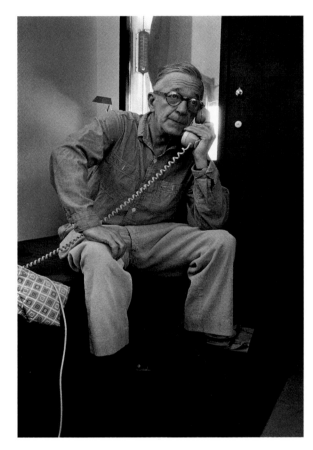 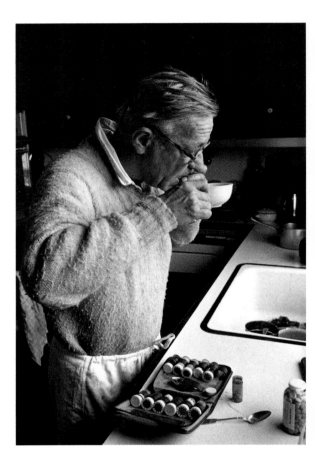

On the phone and in the kitchen taking a pill. Note the medicine case in foreground. 1969.

Am Telefon und in der Küche, um eine Tablette zu schlucken. Man beachte das Etui mit diversen Medizinfläschchen im Vordergrund. 1969.

Au téléphone et dans la cuisine en train d'avaler une pilule. Au premier plan, l'armoire à pharmacie. 1969.

His »wrecked car garden« in the lot across from his home in Old Lyme. He had junk cars brought to the lot in order to »add character« to the lot and to photograph them. He was very proud of this venture. 1969.

Sein »Schrottgarten« auf dem Grundstück gegenüber, 1969. Dort hatte er eine Reihe von Schrottautos abstellen lassen, weil das dem Grundstück »Charakter« verleihe – er fotografierte dort auch und war sehr stolz auf das ganze.

Un « jardin d'épaves » sur son terrain, de l'autre côté de sa maison à Old Lyme, 1969. Il avait amené ces épaves de voitures pour « donner du caractère » au terrain et pour les photographier. Il était très fier de son audace.

My favorite photograph of Evans, 1969.

Mein Lieblingsfoto von Evans, 1969.

La photo de Evans que je préfère, 1969.

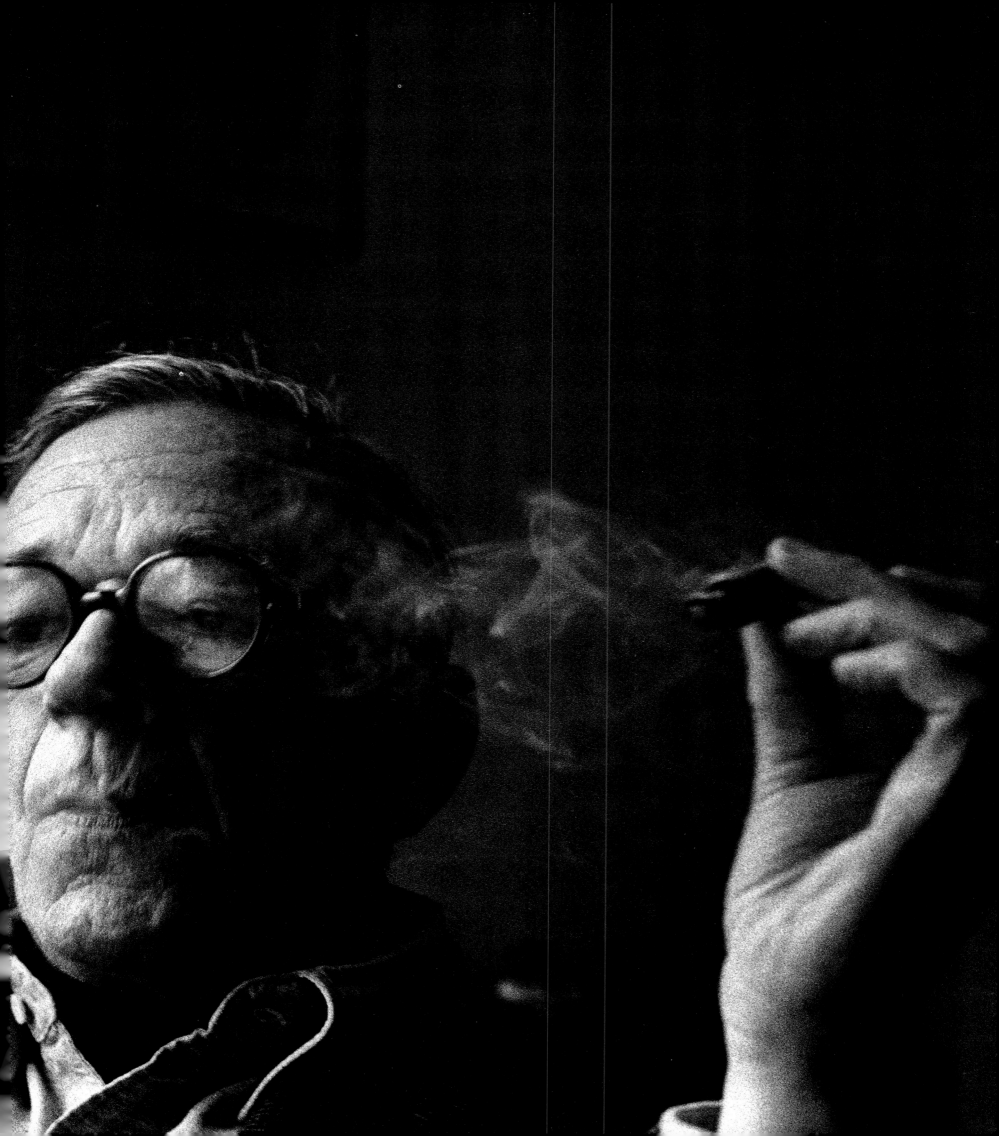

Brassaï

Gyula Halász; 1899–1984. Born in Hungary.
Photographed in Paris from early 1920s. Frequently worked at
night, photographing bar girls, dock-workers, prostitutes,
transvestites – all of the life that gave Paris the excitement for
which it was famous. Photographed graffiti and later turned to
making sculpture. His photographs appeared in Surrealist
magazines, and were collected in a number of books.

Gyula Halász; 1899–1984. Ungar.
Er arbeitete seit Anfang der zwanziger Jahre als Fotograf in Paris
und machte hauptsächlich Fotos von Menschen, die nachts auf
den Straßen unterwegs waren: Bardamen, Dockarbeiter,
Prostituierte und Transvestiten – er fotografierte das Leben, für
das Paris berühmt war. Er machte auch Aufnahmen von Graffiti
und arbeitete als Bildhauer. Seine Fotos erschienen häufig in
surrealistischen Magazinen und Büchern.

Gyula Halász; 1899–1984. Français d'origine hongroise.
Il photographia Paris au début des années vingt. Il travaillait
souvent la nuit, photographiant filles de bars, dockers,
prostituées, travestis – toute cette vie nocturne si fascinante qui
a donné à Paris sa réputation. Il photographia aussi des graffitis
puis, plus tard, devint sculpteur. Ses photographies apparaissent
très souvent dans les magazines consacrés au surréalisme et dans
de nombreux livres.

At the opening of an exhibition of his sculptures and tapestries made after his
graffiti series of photographs; held at the La Boëtie Gallery, New York. 1968–70.

In der La Boëtie Gallery, New York, bei der Eröffnung einer Ausstellung seiner Skulpturen und
Wandteppiche, die nach seiner Serie von Graffiti-Fotos angefertigt worden waren. 1968–1970.

Au vernissage de son exposition de sculptures et tapisseries, réalisées d'après une
série de photographies de graffitis, tenue à La Boëtie Gallery, New York. 1968–1970.

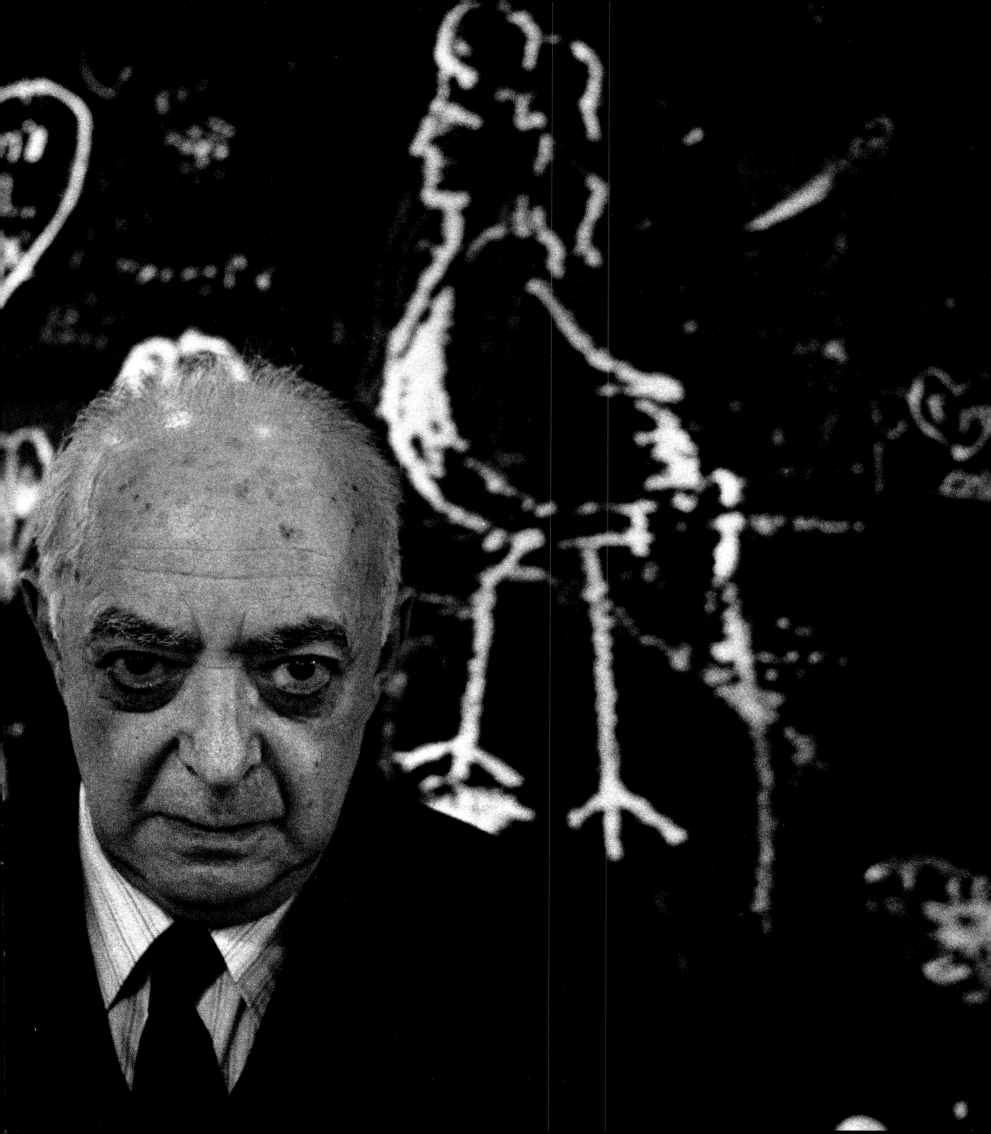

Brassaï was one of the warmest and least self-absorbed of any person I have ever met – or photographed.

When I arrived for my meeting with him one spring day in 1968, his wife Gilberte rushed me into their interesting and very organized apartment.

I have never seen such enthusiasm and joy as Brassaï showed as he opened box after box of beautiful prints – his photographs of nudes, graffiti, Paris street scenes, street people, transvestites, and on and on, the results of his life's work.

I made no audio tape of him; I felt it was futile due to the language differential. I regret that choice now! However, I did photograph him and he was very co-operative.

He was fluent in both Hungarian and French, and I speak only English and some German. It was fortunate for me that Beatrice Yaborg, a very fine sculptor who was visiting Madame Brassaï at the time, offered to act as my interpreter. She saved the day!

As I worked my lens closer and closer to Brassaï's face he fully understood my goal and froze, permitting me to make the intimate images I wanted.

I was using a Nikon F and 55mm f/3.5 Micro-Nikkor at the time. Brassaï took the camera from me and began to point it at objects close up. He was amazed at how near he was able to focus that lens. He told me he wished he had had such equipment in his earlier days

As we were going through his prints, I expressed a desire to acquire some. He was generous with me in that regard too. Two of my prized possessions are prints he gave to me as gifts, with personal dedications.

I learned that day that Brassaï had a new love – he was sculpting. He wanted to show me his sculpture studio and I enthusiastically accompanied him there.

Gilberte referred to us as »boys,« which seemed

Living room/library, 1968–70.

Das Wohnzimmer mit Bücherregalen, 1968–1970.

Salle de séjour, bibliothèque, 1968–1970.

Brassaï war einer der freundlichsten Menschen, die ich je getroffen und fotografiert habe. Kein bißchen egoistisch!

Als ich ihn an einem Frühlingstag im Jahre 1968 traf, führte mich Gilberte, seine Frau, in ihr ausgefallen eingerichtetes und sehr ordentliches Apartment.

Niemals habe ich einen Menschen mit solchem Enthusiasmus und solcher Freude bei der Sache gesehen wie Brassaï, als wir Kiste um Kiste voller wunderbarer Fotos durchgingen – seine Aktaufnahmen, die Fotos von Graffiti, Straßenszenen in Paris, Obdachlose, Transvestiten – die Früchte eines langen Arbeitslebens.

Ich zeichnete unser Gespräch nicht auf Band auf, weil ich dachte, das sei wegen der Sprachbarriere zwischen uns nutzlos – er sprach fließend Ungarisch und Französisch. Heute bereue ich das. Aber ich habe ihn fotografiert, und dabei war er sehr kooperativ.

Leider spreche ich nur Englisch und ein wenig Deutsch. Zum Glück war Beatrice Yaborg, eine sehr gute Bildhauerin, zu Besuch bei Madame Brassaï, und bot sich bei Gesprächen als Dolmetscherin an. Sie machte eine Unterhaltung erst möglich.

Als ich mit meiner Kamera näher und näher an Brassaïs Gesicht herankam, verstand er sofort, was ich wollte, und »gefror« – so daß ich die intimen Aufnahmen machen konnte, die ich mir gewünscht hatte.

Ich arbeitete damals mit einer Nikon F und einem 55-mm/3,5-Nikkor-Mikro-Objektiv. Brassaï nahm meine Kamera und richtete sie auf verschiedene Ge-

Detail of his living room/library shelves; the print boxes lower right contain some of his most famous images, 1968–70.

Detail der Bibliothek in seinem Wohnzimmer; die Archivkästen unten rechts enthalten einige seiner berühmtesten Aufnahmen. 1968–1970.

Des détails de la salle de séjour : étagères de bibliothèque, boîtes d'épreuves en bas à droite contenant quelques-unes de ses plus célèbres photographies. 1968–1970.

Brassaï fut la personne la plus chaleureuse et la moins égoïste qu'il m'ait été donné de rencontrer.

Quand je me présentai, un jour de printemps en 1968, pour notre première rencontre, sa femme, Gilberte, m'entraîna dans leur appartement à la fois curieux et très fonctionnel.

Je n'ai jamais vu autant de joie et d'enthousiasme que chez Brassaï me montrant, au fur et à mesure qu'il ouvrait ses boîtes de photos, des nus, des graffitis, des scènes de rue à Paris, des gens de la rue, des travestis... etc, l'aboutissement de sa vie de photographe.

Je n'ai pas fait d'enregistrement de lui ; je pensais que c'était vain en raison de la différence de langue. Je le regrette maintenant ! Néanmoins, je le photographiai, et il se montra très coopératif.

Brassaï offrit son temps avec chaleur et générosité. Il parlait couramment hongrois et français et je ne parlais qu'anglais et un peu allemand. Par bonheur, Béatrice Yaborg, un fin sculpteur, rendit visite ce jour-là à Madame Brassaï et put me servir d'interprète. Ce fut elle qui sauva cette journée !

Comme j'approchais l'objectif de plus en plus près de son visage, il comprit parfaitement mon but et se figea, me permettant de faire les photos intimistes que je souhaitais.

J'utilisai un Nikon F et 55mm f/3.5 Micro-Nikkor à cette époque. Brassaï me prit l'appareil des mains et commença à pointer les objets de près. Il se montra très surpris de pouvoir régler la lentille et focaliser un objet d'aussi près. Il me dit qu'il aurait aimé avoir un tel équipement à ses débuts.

Comme nous regardions plus avant ses photos, je lui fis part de mon désir d'en acheter quelques-unes. Il se montra incroyablement généreux avec moi à cet égard et m'offrit les deux photos dédicacées que j'aime le plus.

J'appris ce jour-là que Brassaï avait un nouvel amour, la sculpture. Il voulut me montrer son atelier et j'acceptai avec enthousiasme de l'accompagner.

Gilberte nous appelait les « garçons », ce qui me semble approprié. La plupart de mes amis artistes photographes ont conservé une jeunesse d'esprit,

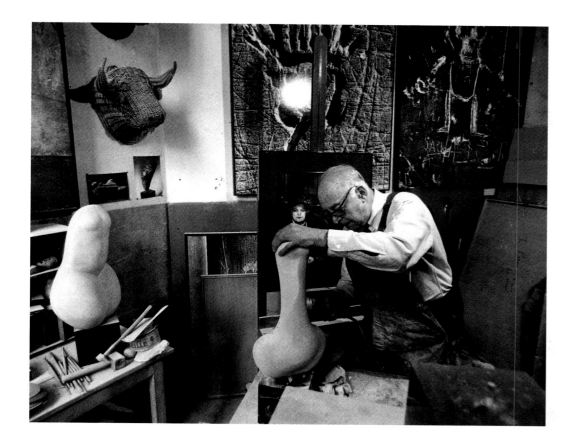

Working on one of his pieces in the studio, 1968–70.

Im Atelier, bei der Arbeit an einer seiner Skulpturen, 1968–1970.

En train de sculpter, 1968–1970.

apropos. Most of my artist and photographer friends have managed to maintain a youthfulness, a wonderful childlike quality, which perhaps helps set them apart from the rest of this overly serious world. Perhaps it is because of their eternally youthful souls that the genius of creativity is able to emerge.

When we arrived at the studio, Brassaï almost jumped into his overalls, grabbed his chisel and mallet and proceeded to demonstrate to me how he worked. I can tell you, he was one very happy man!

I last saw him when he invited me to the opening of an exhibition of sculptures and tapestries he made from his photographs of graffiti, at La Boëtie Gallery in New York.

I was sad to read of his death in the *New York Times*, and was quite moved and honored when I later received a note from Gilberte informing me that she had given a copy of my photograph of Brassaï to the newspapers to use in his memorial piece.

genstände in der Nähe. Er war erstaunt, wie nah man mit diesem Objektiv an Motive herangehen konnte. Er bedauerte, daß es solch ein Objektiv nicht schon zu Beginn seiner Karriere gegeben habe.

Bei der Durchsicht seiner Aufnahmen sagte ich ihm, daß ich gerne ein paar davon kaufen würde. Er erwies sich als unglaublich generös: Zwei Juwelen in meiner Sammlung sind Fotos, die er mir schenkte und mit einer Widmung versah.

An jenem Tag erfuhr ich, daß Brassaï eine neue Liebe entdeckt hatte – die Bildhauerei. Er wollte mir sein Bildhaueratelier zeigen, und voller Neugier begleitete ich ihn.

Gilberte nannte uns »Jungs«, und das war treffend. Die meisten Künstler und Fotografen unter meinen Freunden sind jung geblieben und haben sich eine wunderbare Kindlichkeit erhalten, was sie vielleicht vom Rest dieser viel zu ernsten Welt unterscheidet. Vermutlich liegt es an ihrer jung gebliebenen Seele, daß sie ihre Kreativität frei entfalten können.

Als wir im Studio eintrafen, sprang Brassaï in einen seiner Overalls, nahm Hammer und Meißel in die Hand und zeigte mir seine Arbeitsweise – ein glücklicher Mann!

Das letzte Mal sah ich ihn in der La Boëtie Gallery in New York bei der Eröffnung einer Ausstellung von Skulpturen und Wandteppichen, die nach seinen Fotos bemalt worden waren.

Es stimmte mich tieftraurig, in der *New York Times* von seinem Tod zu erfahren; ich war gleichermaßen gerührt und geehrt, als mir Gilberte mitteilte, daß sie mein Foto von Brassaï als Pressefoto für seine Nachrufe verschickt habe.

Playing with a pinball machine (unidentified man at left was friend of Brassaï). Toward the end of the evening I discovered the film was not winding through my camera and finally threaded the take-up spool properly so the events of the evening were not totally lost. 1968–70.

Beim Flippern, 1968–1970. (Der Mann neben Brassaï war ein Freund von ihm.) Gegen Ende des Abends stellte ich fest, daß mein Film nicht richtig eingelegt war und nicht weitergespult wurde. Also habe ich den Fehler behoben und doch noch ein paar Bilder von dem Abend machen können.

Partie de billard (à gauche de Brassaï, un de ses amis), 1968–1970. Cette photo fut prise en fin de soirée. Je découvris que la pellicule ne se dévidait pas dans l'appareil. J'enfilai finalement la bobine réceptrice correctement, de façon à ce que les événements de la soirée ne soient pas complètement perdus.

une âme d'enfant, qui les aide peut-être à se maintenir en retrait de cette société sérieuse à l'excès.

Quand nous arrivâmes à l'atelier, Brassaï enfila son bleu de travail, empoigna burin et maillet et se mit à me montrer comment il travaillait. Je peux vous dire qu'il était le plus heureux des hommes !

Je le vis pour la dernière fois lorsqu'il me convia au vernissage d'une exposition de sculptures et de tapisseries réalisées à partir de graffitis, à La Boëtie Gallery à New York.

Je fus triste d'apprendre son décès dans le New York Times et fus touché et honoré quand, plus tard, je reçus une lettre de Gilberte m'informant qu'elle avait donné copie de ma photographie de Brassaï aux journaux pour l'article à sa mémoire.

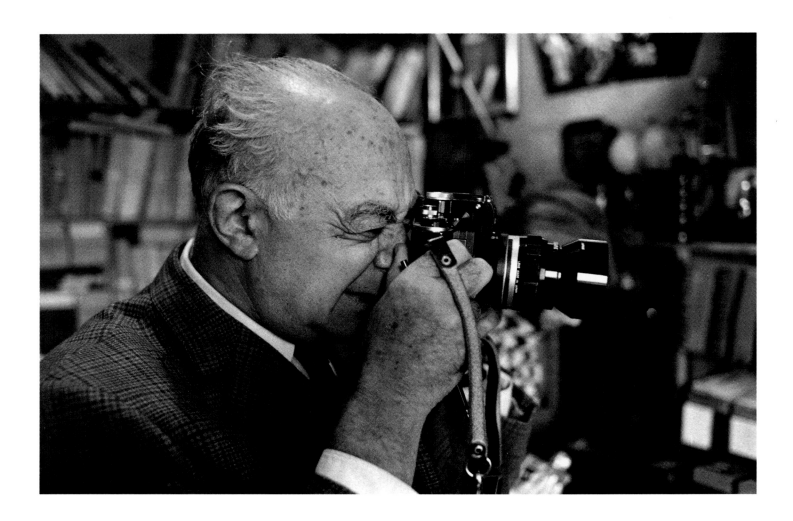

Brassaï viewing through the lens of one of my cameras, 1968–70.

Brassaï schaut durch das Objektiv einer meiner Kameras, 1968–1970.

Brassaï scrutant la lentille d'un de mes appareils, 1968–1970.

Portrait, 1968–70.

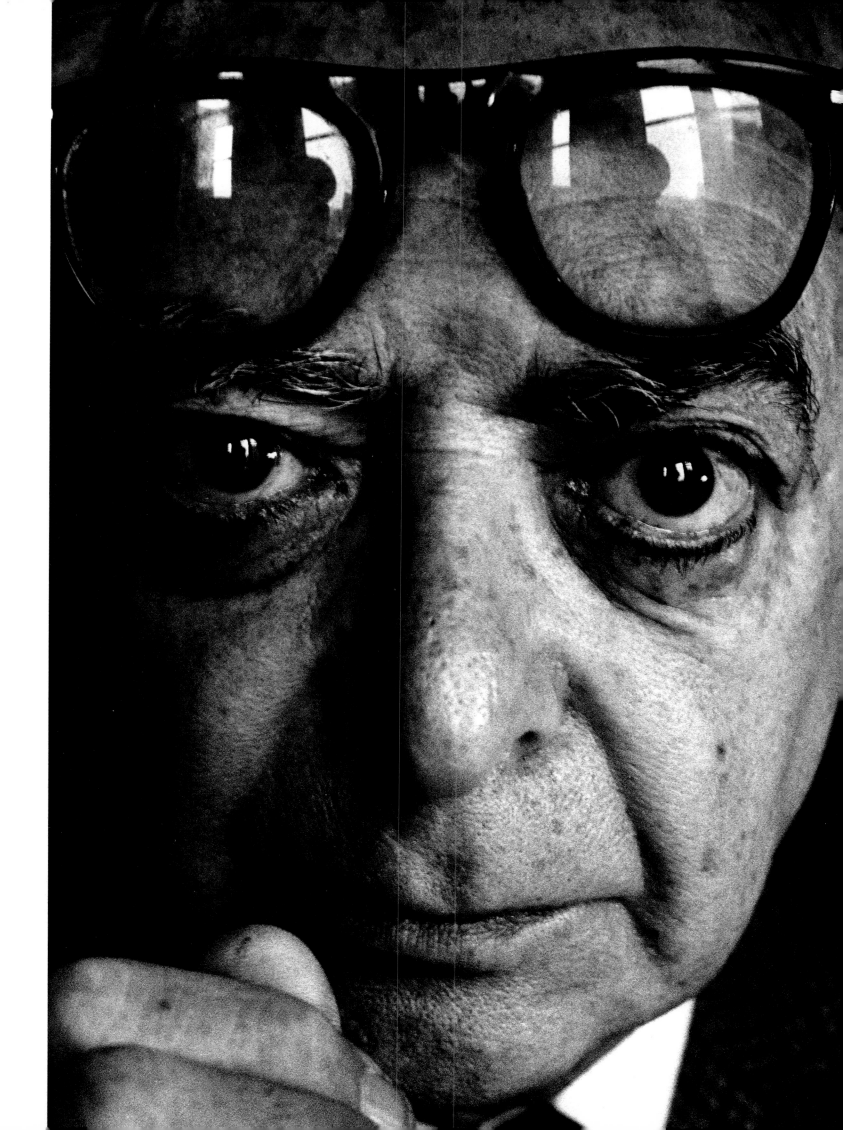

Bill Brandt

1904–1983. British.
Photographed people, nude distortions and landscapes.

1904–1983. Engländer.
Berühmt für seine Porträts, Akt- und Landschaftsaufnahmen.

1904–1983. Anglais.
Il photographia les gens, des nus déformés et la nature.

Portrait, 1968.

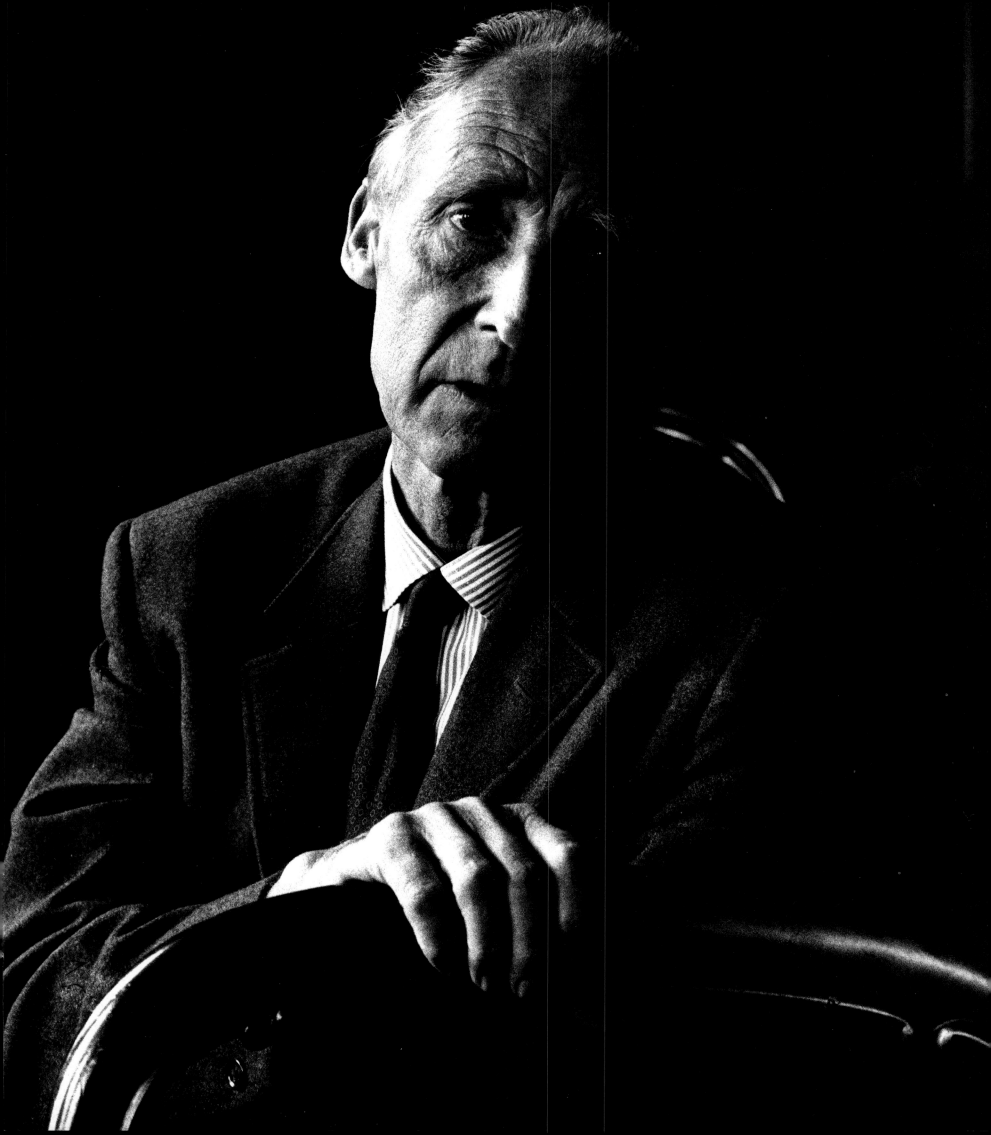

The first thing Bill Brandt told me was that he really loved photography.

When I'd arrived at his flat in London with my cameras and tape machine I had been greeted by a tall, thin, very private man, with a soulful face. He welcomed me into his living room, and immediately informed me that he did not wish to have his voice recorded. Despite this, he was very open with me, allowing me to quiz him about his life's work.

I noticed a beautiful 8x10-inch wooden camera on a table. He called my attention to the lens, an amazing wide angle, and proudly placed his tiny hands over the front of the camera and told me: »This is the camera I used for my series of photographs of women that ultimately became *Perspectives of Nudes*« – his famous book.

I said: »Don't move.«

I then proceeded to make a number of exposures of him, using a Pentax with a 16mm Takumar lens. This was a special camera and lens I carried with me, in addition to my Nikon F's and Leica M's, for just such an opportunity. For me, a camera is a specific tool that is required for a specific job. This particular job called for a distorting lens to photograph the distorting camera and its grand master.

I spent some time looking around his living room and what has really stuck in my memory were a number of shadow boxes on the wall, each containing a collage consisting, among other things, of

Das erste, was Bill Brandt mir bei einem Besuch anvertraute, war, daß die Fotografie seine große Liebe sei.

Als ich an seiner Wohnungstür in London klingelte, öffnete mir ein großer, schlanker, sehr zurückhaltender Mann mit einem seelenvollen Gesicht. Er bat mich in sein Wohnzimmer und sagte mir sofort, daß er keinen Tonbandmitschnitt wünsche. Dennoch war er sehr offen und gab mir Gelegenheit, ihn über sein Lebenswerk zu befragen.

Auf dem Tisch lag eine wunderschöne Holzkamera von 8 × 10 Zoll. Er machte mich auf das erstaunliche Weitwinkelobjektiv dieser Kamera aufmerksam, faltete stolz seine sehr kleinen Hände über der Kamera und erklärte mir: »Mit dieser Kamera habe ich meine Serie von Aktaufnahmen gemacht, die ich in *Perspectives of Nudes* versammelt habe« – in seinem berühmten Buch.

Ich sagte: »Bleiben Sie so sitzen!«

Dann machte ich eine Reihe von Aufnahmen mit einer Pentax mit 16-mm-Takumar-Objektiv. Diese Kamera mit ihrer Speziallinse hatte ich, neben meinen Nikons und Leicas, eigens für solche Gelegenheiten bei mir. Für mich ist eine Kamera ein Werkzeug, und für jede Arbeit sollte man das richtige Werkzeug auswählen. Für die Aufnahmen bei Bill brauchte ich ein Verzerrer-Objektiv, um den großen Meister der verzerrenden Kamera auf Film zu bannen.

La première chose que me dit Bill Brandt fut qu'il était un amoureux de la photographie.

Quand j'arrivai dans son appartement londonien avec mes appareils et mon magnétophone, je fus accueilli par un homme mince, grand, très singulier, au visage expressif. Il me conduisit au salon et m'informa immédiatement qu'il ne souhaitait pas être enregistré. En dépit de cela, il se montra très ouvert, m'autorisant à le questionner à propos de son travail.

Je remarquai un bel appareil 8x10 pouces en bois posé sur la table. Il attira mon attention sur l'objectif, un étonnant grand angle, et posa fièrement ses mains fines sur le dessus de l'appareil en me disant : « Voici l'appareil dont je me suis servi pour ma série de photos de femmes », qui sont devenues *Perspectives of Nudes*, son célèbre ouvrage.

Je dis : « Ne bougez pas. »

Et je me mis à prendre un certain nombre de poses, utilisant un Pentax avec un objectif Takumar 16 mm, appareil et objectif spéciaux que j'avais justement pris, en plus de mon Nikon F et du Leica M, pour ce genre de situation précise. Un appareil-photo représente pour moi un outil bien spécifique qui doit répondre à un besoin tout aussi spécifique. Mon travail nécessitait donc une lentille déformante pour un appareil déformant et son grand maître.

Je passai quelque temps à regarder autour de moi et ce qui frappa ma mémoire fut le nombre de vitri-

Doorbell to his apartment, 1968.

Brandts Türklingel, 1968.

La sonnette de son appartement, 1968.

The living-room wall in Brandt's London apartment featuring collages made by Brandt using animal skeletons, feathers, etc. 1968.

Das Wohnzimmer in Brandts Londoner Apartment mit den Collagen aus Tierskeletten, Federn und anderen Materialien. 1968.

Mur de la salle de séjour de l'appartement londonien. On y voit les collages réalisés par Bill à partir de squelettes d'animaux, de plumes, etc.. 1968.

bones of reptiles and birds, and feathers. He told me that he was the artist who had created these constructions – which would clearly be described as Surrealist.

Brandt agreed with me that he could be classified as a Surrealist.

During our meeting, a tall, beautiful woman entered the room – his wife. When she came into the room he changed into a happier man – as if by magic. It was evident that they were a very happy couple.

Bill then suggested that we take a walk in one of the nearby parks so that he could show me some »wonderful women.« We did! It was a sunny summer day in London and there, sunning themselves, were some women, with Rubenesque bodies, clad in bathing suits, the type he so enjoyed photographing. He gleefully stood near a few of these »wonderful women« of his, posing – he wanted to be photographed near them.

Ich sah mich eine ganze Weile in Bills Wohnzimmer um – besonders fielen mir einige Schaukästen an den Wänden mit jeweils einer Collage auf, die unter anderem aus Reptilien- und Vogelknochen und Federn bestanden. Wie er mir sagte, hatte er diese Gebilde, die eindeutig surrealistisch wirkten, selbst geschaffen.

Brandt stimmte mir zu, daß man ihn als Surrealisten einstufen könne.

Im Verlauf unseres Gesprächs betrat eine großgewachsene, schöne Frau den Raum – seine Frau. Als sie hereinkam, wirkte Bill sofort glücklicher und gelöster, sie war wie ein Zauber, der ihn einhüllte. Ganz offensichtlich waren sie ein sehr glückliches Paar.

Dann schlug Bill vor, einen kleinen Spaziergang in einem Park in der Nähe zu machen, weil er mir ein paar »wunderbare Frauen« zeigen wollte. Es war ein heiterer Londoner Sommertag, und im Park sonnten sich einige Frauen mit Rubensformen in Badeanzügen, also so, wie er die Frauen am liebsten fotografierte. Voller Freude nahm er in der Nähe einiger dieser wunderbaren Frauen Aufstellung, und posierte für mich – er wollte, daß ich ihn in ihrer Nähe fotografierte.

nes sombres sur le mur, chacune renfermant un collage comportant des ossements de reptiles et d'oiseaux, ainsi que des plumes. Il me dit qu'il était l'auteur de ces créations, qui pourraient être définies sans hésitation comme surréalistes.

Brandt convint d'ailleurs avec moi qu'on pouvait l'assimiler à ce groupe.

Durant notre rencontre, une grande et belle femme entra dans la pièce – sa femme. Dès l'instant où elle fut là il devint, comme par magie, le plus joyeux des hommes. Il était évident que c'était un couple très heureux.

Bill proposa ensuite une promenade dans un parc des environs, pour qu'il puisse ainsi me montrer quelques « femmes merveilleuses ». Et nous le fîmes ! C'était un jour d'été londonien ensoleillé, et là, s'offrant un bain de soleil, se trouvaient quelques femmes avec des corps à la Rubens, en costume de bain, le genre de femmes qu'il aimait photographier.

Il se campa, plein d'allégresse, à proximité de ces « femmes merveilleuses », et voulut être photographié à leur côté.

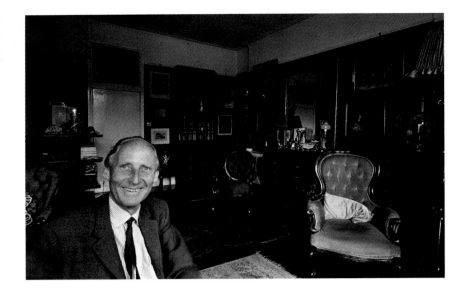

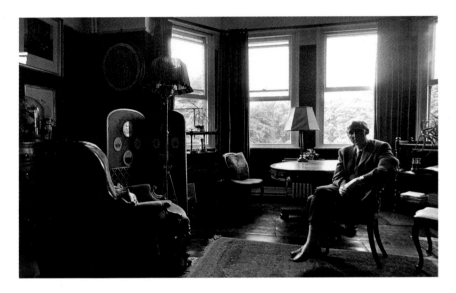

Brandt's living room, 1968.

Brandts Wohnzimmer, 1968.

La salle de séjour des Brandt, 1968.

Brandt at the entrance to his London flat, 1968.

Brandt an der Eingangstür zu seiner Londoner Wohnung, 1968.

Bill à l'entrée de son appartement londonien, 1968.

Brandt took me on a walk to a park near by his London flat
in order to share his views of the women he so loved to see. 1968.

Brandt ging mit mir in einem Park unweit von seinem Apartment
spazieren, um mir Frauen zu zeigen, die ihm gefielen. 1968.

Brandt et moi faisons une promenade dans un parc des
environs afin qu'il me montre les femmes qu'il aime voir. 1968.

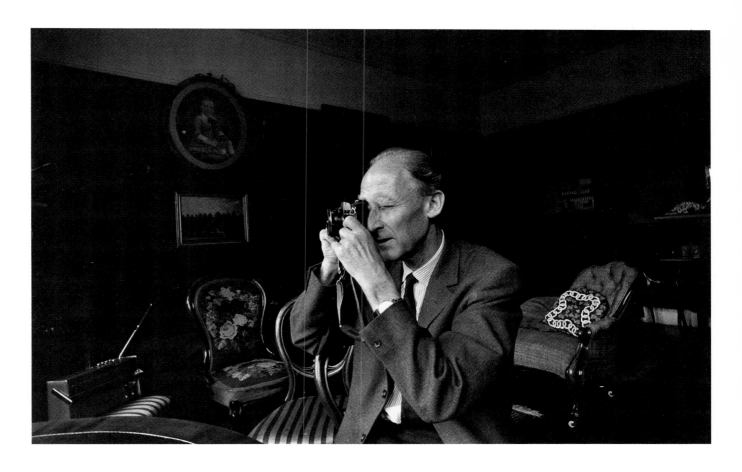

Brandt inspecting my camera with its 17mm
fish-eye lens, 1968.

Brandt begutachtet meine Kamera mit dem
17-mm-Fischauge-Objektiv, 1968.

Brandt en train d'inspecter mon appareil et ses lentilles
fish-eye de 17mm, 1968.

Portrait, 1968.

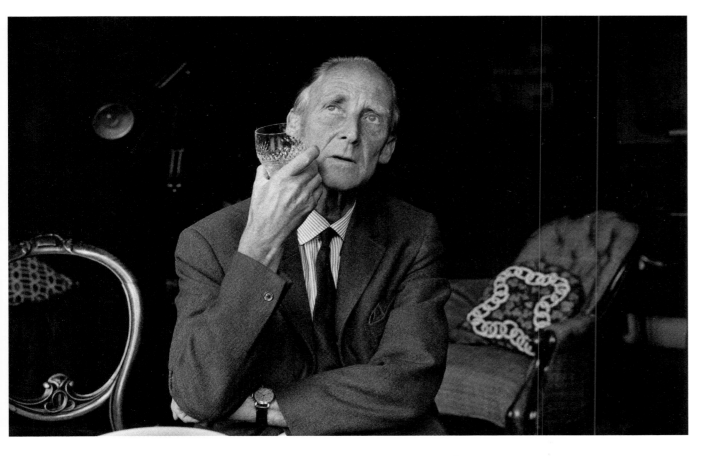

▷ Brandt and his wife at home, 1968.

Brandt mit seiner Frau zu Hause, 1968.

Bill et sa femme à la maison, 1968.

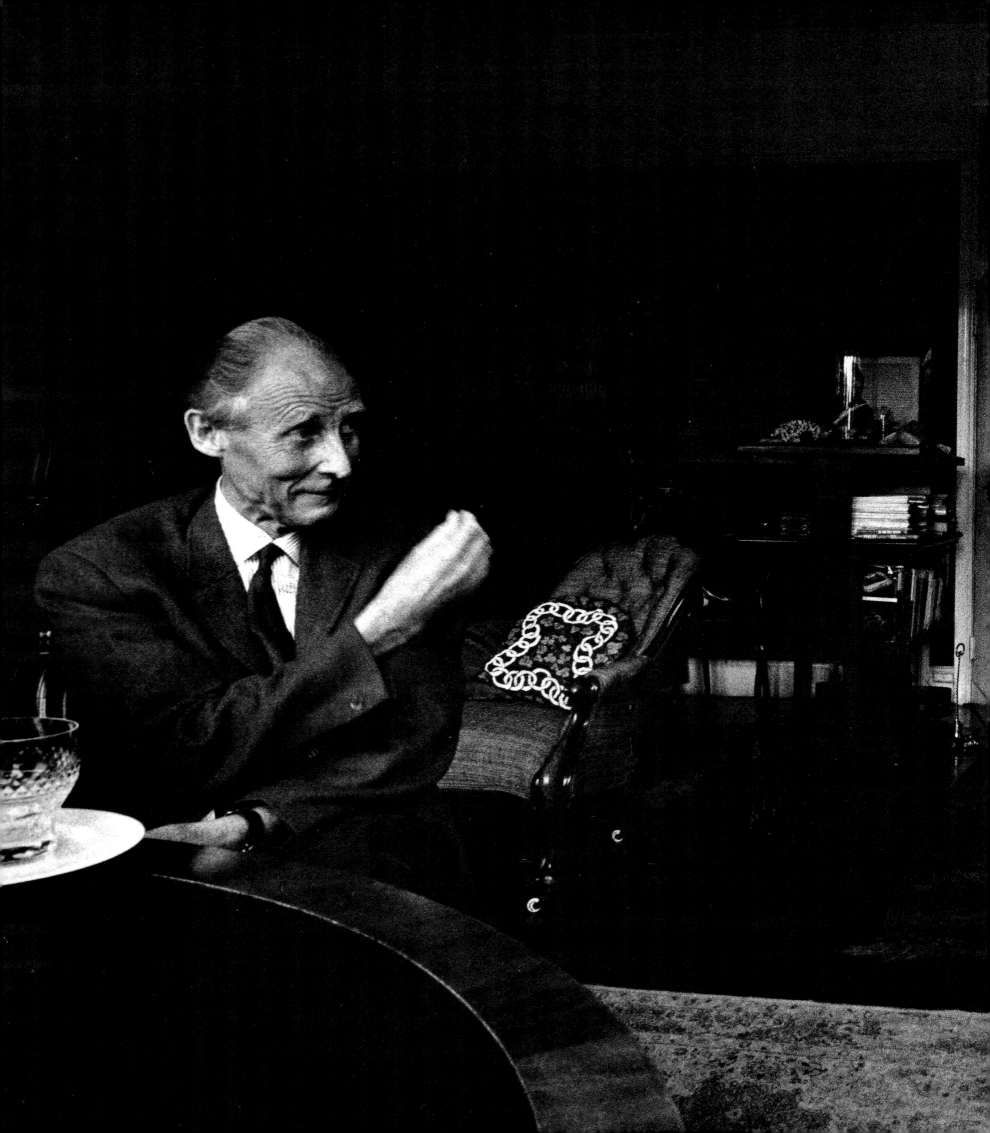

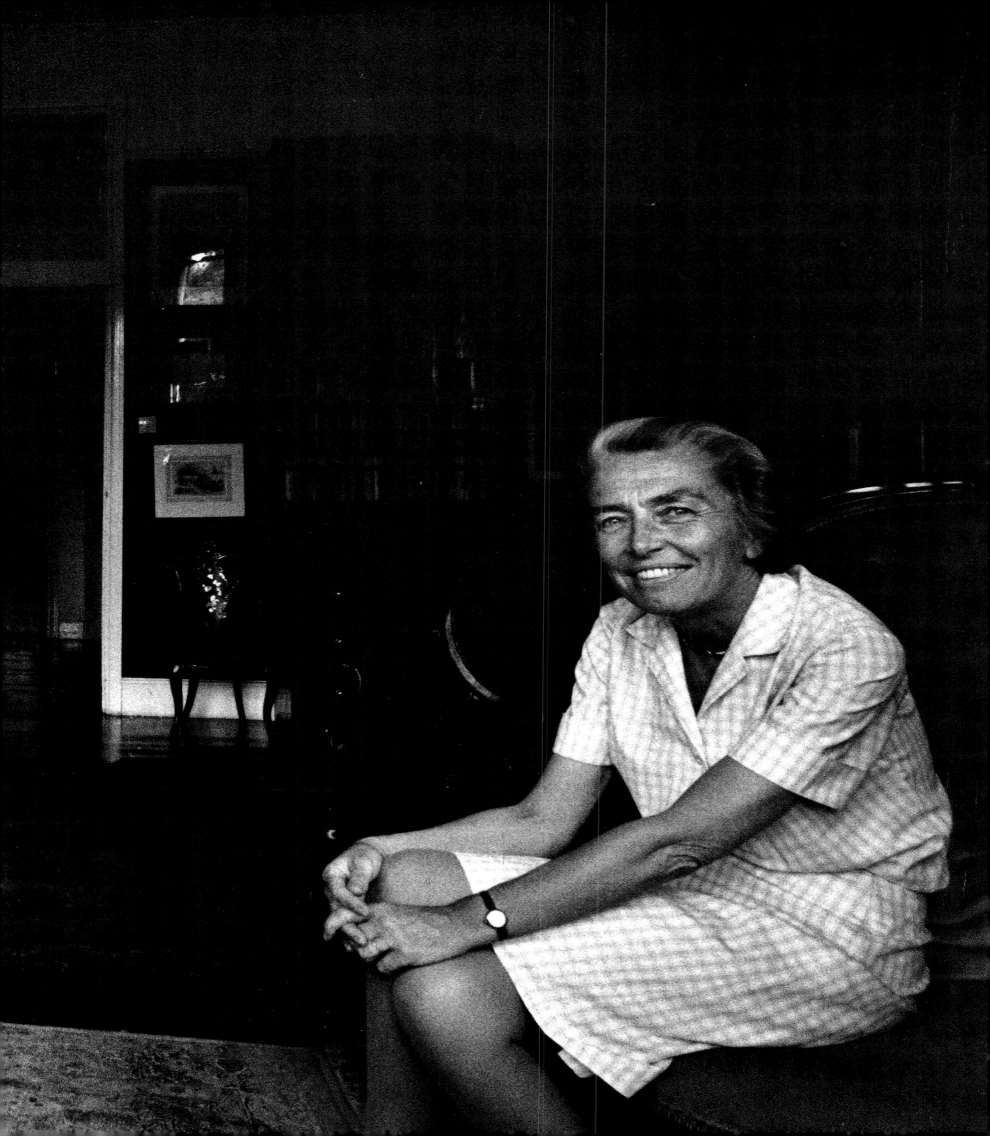

△ ▷ Brandt with the 8×10-inch camera and its wide-angle Zeiss Protar lens which he used to make the famous photographs of female nudes later published in his book *Perspective of Nudes*. 1968.

Brandt mit der 8 × 10-Zoll-Kamera. Mit dem dazugehörigen Weitwinkelobjektiv machte er die berühmten weiblichen Aktaufnahmen, die in sein Buch *Perspective of Nudes* eingingen. 1968.

Bill Brandt tenant son appareil 8×10 pouces avec son grand angle Zeiss Protar dont il se servit pour photographier les nus de femmes du fameux livre *Perspective of Nudes*. 1968.

Robert Doisneau

1912–1994. French.
Photojournalist – street photographer who photographed the
humor and sweetness of the French.

1912–1994. Franzose.
Fotojournalist und Straßenfotograf, der die sonnigeren und
vergnügteren Seiten des französischen Lebens fotografierte.

1912–1994. Français.
Reporter, photographe des rues, il immortalisa l'humour et le
charme des français.

Portrait, 1968.

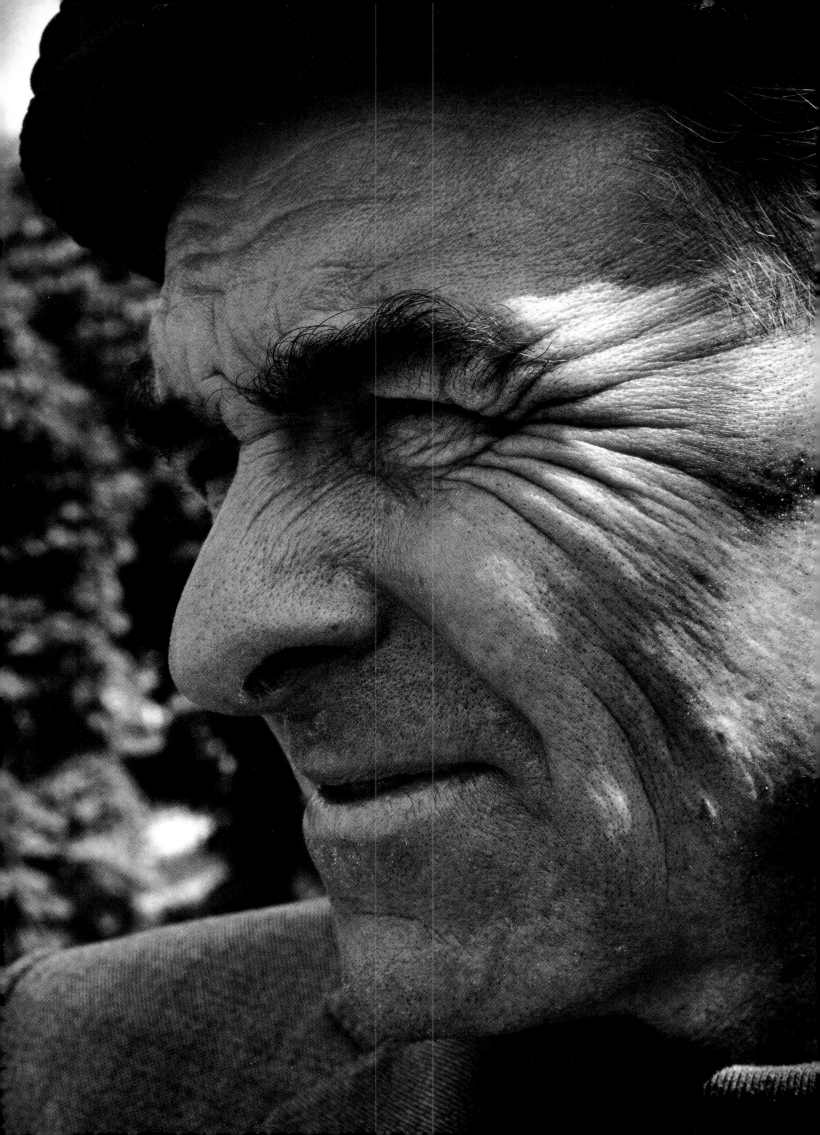

The mention of Robert Doisneau's name brings a smile to the face of anyone who knew him, or who knows his work. I am often asked to describe him, and I respond, as if he were still alive, by saying he is a humorist; his photographs are happy, sometimes funny. Robert Doisneau always brings to my mind a line from the movie *Sabrina*. Sabrina, played by Audrey Hepburn, is asked »What do you do?« She responds by saying: »I am having an affair with the World.« Monsieur Doisneau had an affair with the world; he was in love with life.

When I phoned him in Paris to set a time for our meeting, I learned he spoke absolutely no English. My French at that time was restaurant French. Fortunately, I had phoned while I was visiting Brassaï and Gilberte. Their friend, Beatrice Yaboury, who was also there at the time, could hear my linguistic terror. Beatrice was kind enough to rescue me from the need to resort to sign language, which, after all, is rather ineffective over the phone lines. My meeting with Robert was set for the following day, and Beatrice, a wonderful sculptor who has since gained much recognition, offered to be my interpreter.

Robert welcomed Beatrice and myself with a broad beaming smile. He said that the day was »a good picture day!« Beatrice spoke French, German, Italian and English, but at the time English was not her strength. But my second language is German, so

Doisneau with a local, 1968.

Doisneau auf der Straße mit einem Fremden, 1968.

Doisneau avec un habitant du quartier, 1968.

Die bloße Erwähnung seines Namens bringt Menschen, die ihn oder sein Werk kannten, zum Lächeln. Oft bittet man mich, von ihm zu erzählen; ich antworte dann immer, so als wäre er noch am Leben: »Er ist ein Humorist; seine Fotos sind fröhlich, manchmal sogar witzig.« Wenn ich an Robert Doisneau denke, fällt mir immer ein Dialog aus Billy Wilders Film »Sabrina« ein. Audrey Hepburn spielt darin Sabrina, die auf die Frage »Was machen Sie so?« antwortet: ›Ich habe eine Affäre mit der Welt.‹ Monsieur Doisneau hatte auch eine Affäre mit der Welt; er war verliebt in das Leben.

Als ich ihn in Paris anrief, um ein Treffen auszumachen, war ich überrascht, daß er kein Wort Englisch konnte. Ich sprach damals aber nur »Restaurant-Französisch«. Zum Glück hatte ich ihn von Brassaï und Gilberte aus angerufen; deren Freundin, Beatrice Yaboury, bemerkte meine schweißtreibenden Sprachprobleme und war so freundlich, mich aus der Verlegenheit zu befreien, meine Bitte in Zeichensprache vorbringen zu müssen, was am Telefon ja nur selten gelingt. Wir vereinbarten ein Treffen für den folgenden Tag, und Beatrice, übrigens eine angesehene Bildhauerin, bot uns ihre Hilfe als Dolmetscherin an. Robert begrüßte Beatrice und mich mit einem strahlenden Lächeln und erklärte den Tag zum »ausgezeichneten Foto-Tag«!

Beatrice sprach Französisch, Deutsch, Italienisch und Englisch, doch war Englisch damals nicht gerade ihre Stärke. Zum Glück spreche ich auch Deutsch, so daß ich Deutsch mit ihr redete und sie dann meine Worte für Doisneau ins Französische übersetzte.

Robert Doisneau in Paris, 1968.

Robert Doisneau in Paris, 1968.

Robert Doisneau à Paris, 1968.

Le simple fait de prononcer son nom amène le sourire sur les lèvres de quiconque l'a connu, ou connaît son travail. On me demande souvent de le décrire, et je réponds, comme s'il était encore vivant, que c'est un humoriste. Ses photos sont joyeuses, parfois drôles. Robert Doisneau me remet toujours en mémoire une scène du film *Sabrina* de Billy Wilder. On demande à Sabrina, interprétée par Audrey Hepburn, « Que faites-vous ? » et elle répond : « J'ai une affaire avec le monde. » Monsieur Doisneau avait une affaire avec le monde ! Il était un amoureux de la vie.

Quand je l'appelai à Paris pour préparer notre rencontre, j'appris qu'il ne parlait pas un mot d'anglais. Mon français, à cette époque, était un « français de cuisine » : heureusement je l'avais appelé lors de ma visite chez Brassaï et Gilberte. Leur amie Béatrice Yaboury qui se trouvait là put se rendre compte de mon terrible problème de langue. Gentiment, elle vint à ma rescousse, le langage des signes n'étant pas d'un grand secours au téléphone ! Ma rencontre avec Robert fut fixée au jour suivant et Béatrice, merveilleux sculpteur reconnue depuis, se proposa d'en être l'interprète.

Robert nous accueillit d'un sourire radieux. Il nous dit que cette journée était une « bonne journée pour la photo ». Béatrice parlait français, allemand, italien et anglais, mais à cette époque l'anglais n'était pas son fort. Ma seconde langue étant l'allemand, je

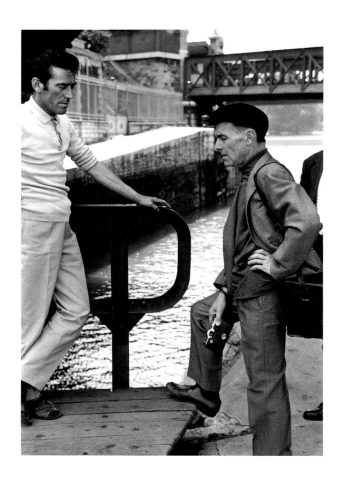

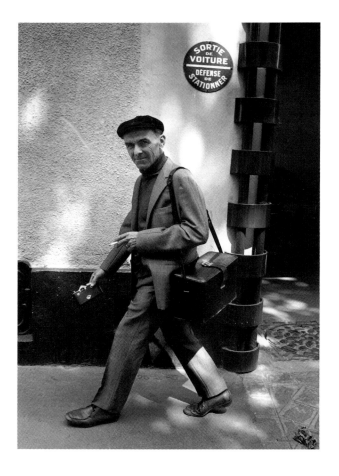

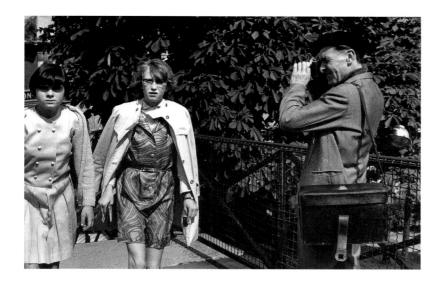

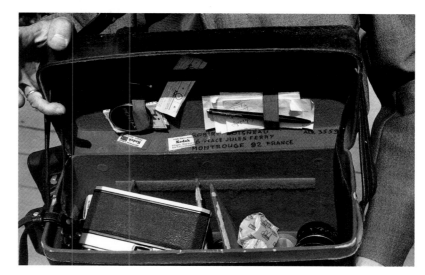

Doisneau working, 1968.

Doisneau bei der Arbeit, 1968.

Doisneau en train de travailler, 1968.

Interior of Doisneau's camera bag, 1968.

Das Innenleben von Doisneaus Kameratasche, 1968.

L'intérieur du sac-photo de Robert Doisneau, 1968.

I spoke to her in German and she translated my words into French for Doisneau.

Robert responded positively to any request I made of him. He gave me the run of his house, allowing me to photograph anything I desired.

I photographed him at his home, but I felt that it just wasn't happening, so to speak, so, knowing Doisneau was a street photographer, I suggested we leave the apartment and go wherever he was most comfortable.

Doisneau drove us down to one of his favorite canals, where some men were fishing. We worked together for a while there – Doisneau photographing, and me photographing him photographing. And then he would turn his camera on me. On the bridge over the canal, I began to work closer and closer to his face, using my macro lens, when he jokingly crossed his eyes. I knew I had my picture!

Then we went off to the Seine and began the process all over again.

I last saw my friend 3 years ago at the opening of the »Magnum« Photography Exhibition.

Though much older and in failing health by then, he was just as warm, his smile was just as broad, and he was just as tall as he ever had been – at 6'5", a real giant, whose pictures will endure to enrich the annals of the history of photography.

Robert ging bereitwillig auf alle meine Bitten ein. Er zeigte mir seine ganze Wohnung und ließ mich alles fotografieren.

Ich fotografierte ihn bei sich zu Hause, doch hatte ich das Gefühl, daß dabei nichts Vernünftiges herauskam; da Doisneau selbst viel auf der Straße fotografiert hat, schlug ich vor, hinaus an einen Ort zu gehen, an dem er sich wohl fühlte.

Doisneau fuhr uns zu einem seiner Lieblingskanäle; nur ein paar Angler saßen dort. Wir arbeiteten eine Weile gleichzeitig; Doisneau machte Aufnahmen, und ich fotografierte ihn beim Fotografieren. Nach einer Weile richtete er seine Kamera auf mich. Auf der Brücke über dem Kanal ging ich mit der Kamera immer näher auf ihn zu – ich hatte ein Makroobjektiv. Schließlich schnitt er Grimassen und begann zu schielen. Ich wußte, daß ich mein Bild im Kasten hatte!

Dann gingen wir an die Seine und fotografierten dort weiter.

Das letzte Mal sah ich meinen Freund vor 3 Jahren anläßlich der Eröffnung der Fotoausstellung »Magnum«.

Obwohl er schon recht alt war und nicht mehr bei bester Gesundheit, war er immer noch so liebenswürdig wie in jüngeren Jahren, sein Lächeln noch immer so breit wie ehedem und die Statur mit 1,95 Meter so imposant wie früher: ein Gigant, dessen Bilder die Annalen der Fotografiegeschichte für immer bereichern werden.

m'exprimai dans cette langue et elle traduisit en français pour Doisneau. Et ça a marché !

Robert répondit oui à toutes mes demandes. Il me donna carte blanche pour photographier tout ce que je voulais dans toute la maison. Je le photographiai chez lui, mais je sentis que « ça n'était pas ça ». Aussi, sachant que Doisneau était un photographe des rues, je suggérai de quitter l'appartement pour un lieu plus favorable, où il se sentirait à l'aise.

Doisneau nous conduisit à l'un de ses canaux préférés, où se trouvaient quelques pêcheurs. Nous travaillâmes un moment tous les deux, lui photographiant et moi le photographiant en train de photographier ! Puis il dirigea l'appareil vers moi. Sur le pont qui traversait le canal, je commençai à travailler de plus en plus près de son visage, utilisant ma lentille grossissante, quand il se mit à loucher pour faire le pitre. Je sus que je tenais ma photo !

Puis nous nous dirigeâmes vers la Seine et recommençâmes la même chose un peu partout.

Je vis mon ami pour la dernière fois il y a trois ans lors de l'exposition « Magnum ».

Bien que déjà âgé à cette époque et d'une santé délicate, il était aussi chaleureux, son sourire était aussi large et aussi grand qu'il ne l'avait jamais été. Il était un géant d'un mètre quatre-vingt-quinze dont l'œuvre est venue enrichir les annales de l'histoire de la photographie.

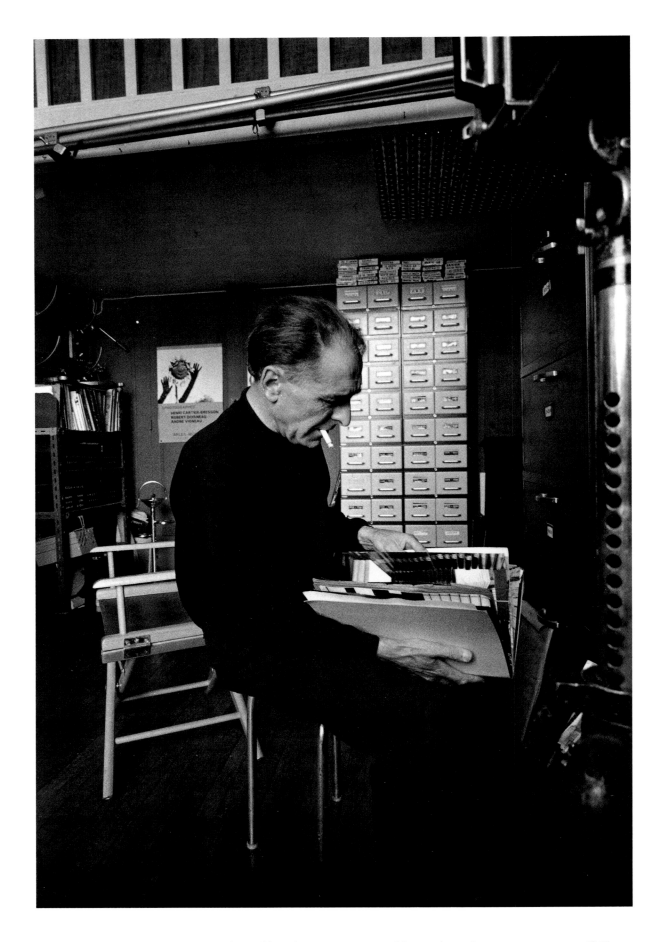

His equipment and storage room at home. Note the camera at upper right – and negative storage center rear. 1968.

Der Raum, in dem er seine Ausrüstung und Fotos aufbewahrte. Hinten die Schubladen für Negative. 1968.

La pièce où il rangeait son équipement et ses photos: en haut à droite, l'appareil, au fond, les tiroirs pour les négatifs. 1968.

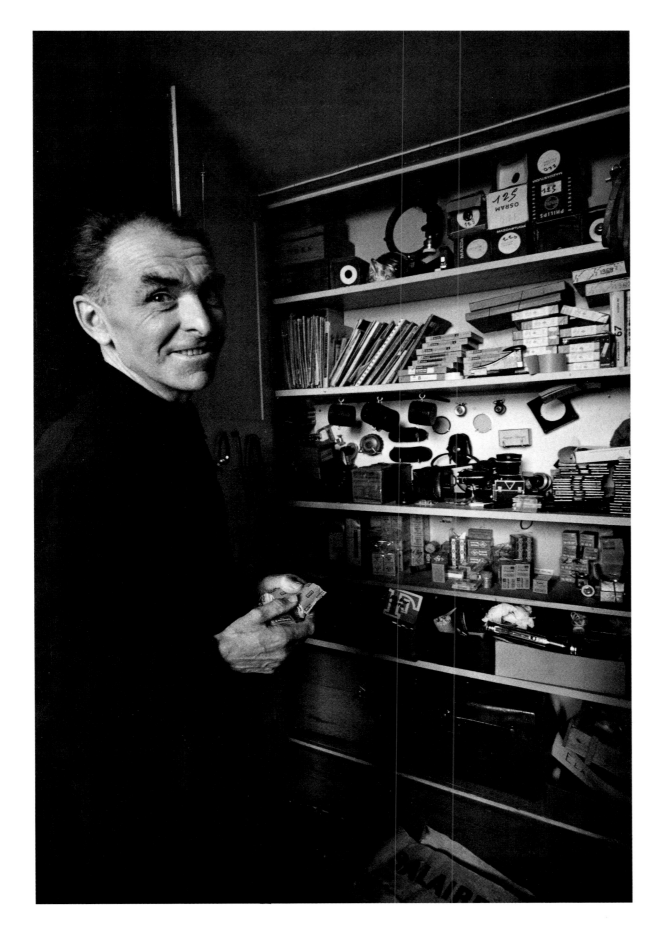

The equipment cabinet in his home, 1968.

Der Fotoschrank in seiner Wohnung, 1968.

Une armoire à photos de l'appartement, 1968.

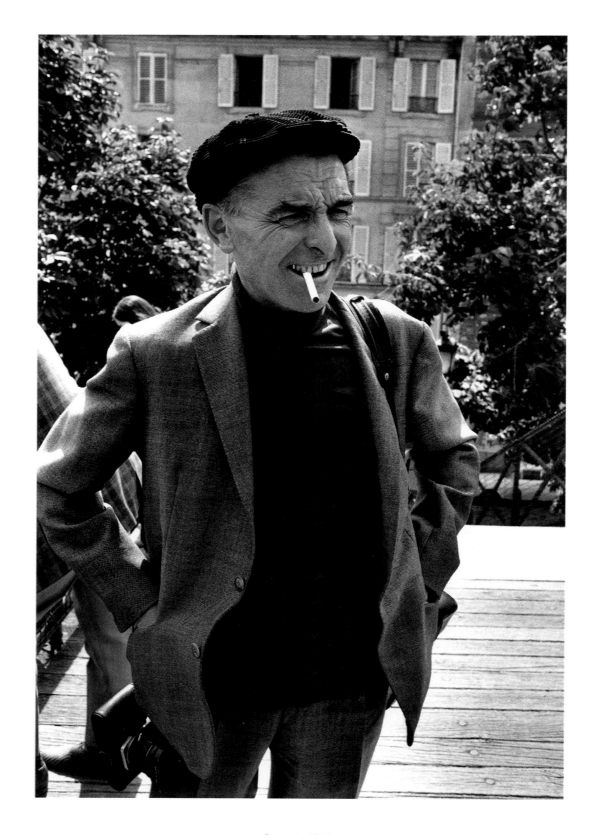

Portrait, 1968.

Speaking with local who was fishing, 1968.

Im Gespräch mit einem Angler, 1968.

Doisneau en train de parler avec un pêcheur du quartier, 1968.

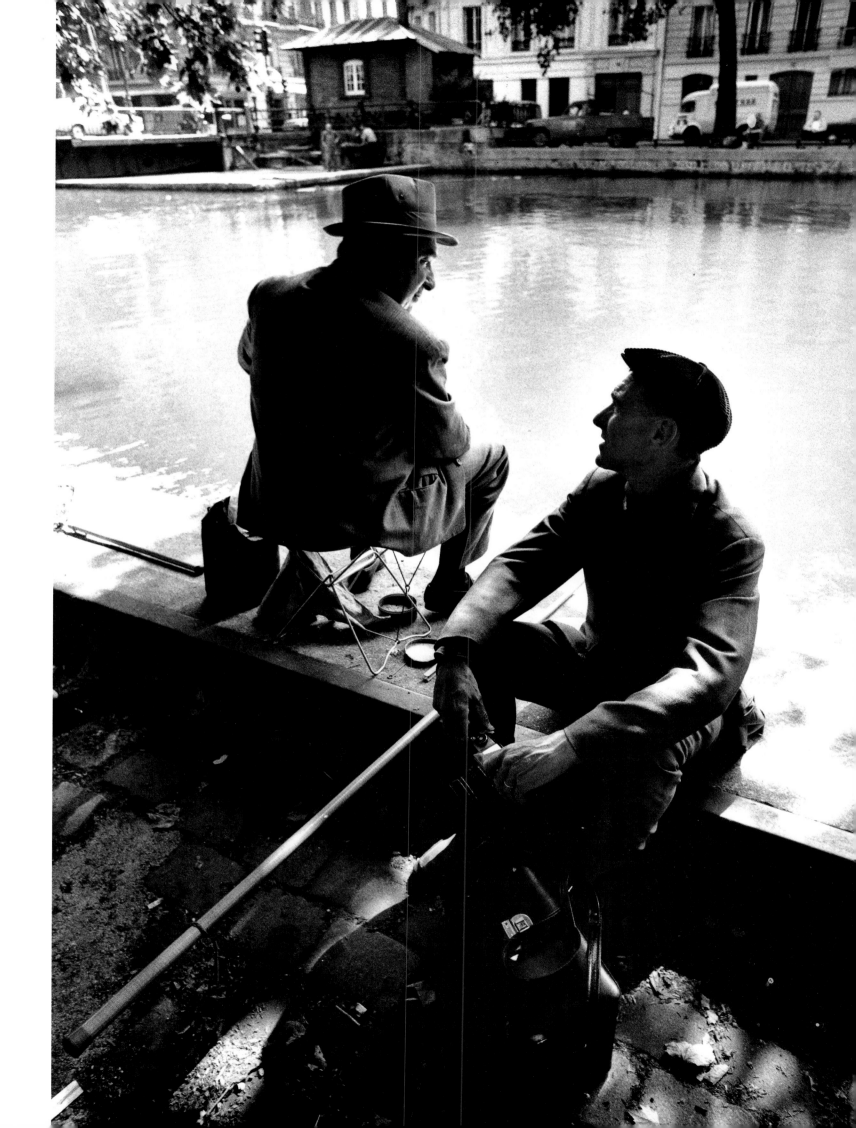

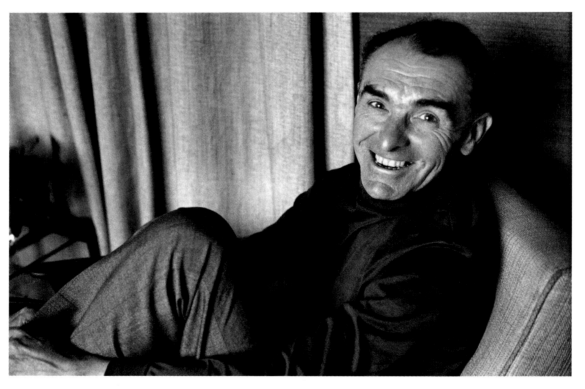

Doisneau at home, 1968.

Doisneau in seiner Wohnung, 1968.

Doisneau à l'entrée de l'appartement, 1968.

Portrait, 1968.

Edward Steichen

1879–1973. American.
Early pictorialist photographer. Published in Stieglitz' *Camera Work*. Fashion photographer in the 1920s and 1930s for *Vogue*. Became Director of Photography for the United States Navy during World War II. Curator of Photography, Museum of Modern Art, New York (1947–62). Curated The Family of Man photography exhibition at the museum, the catalogue for which has become an essential in every photographic library.

1879–1973. Amerikaner.
Steichen gilt als Pionier der malerischen Fotografie. Veröffentlichte in Stieglitz' Zeitschrift *Camera Work*. Während der zwanziger und dreißiger Jahre arbeitete er als Modefotograf für *Vogue*. Während des Zweiten Weltkriegs war er Director of Photography in der United States Navy. Von 1947 bis 1962 war er Curator of Photography am New Yorker Museum of Modern Art (MOMA). Unter seiner Ägide entstand die Ausstellung »The Family of Man« am MOMA; der Katalog dieser Ausstellung gilt heute als unentbehrlich für jede Fotobibliothek.

1879–1973. Américain.
Il fut à ses débuts photographe pictorialiste. Ses travaux furent publiés dans la revue de Stieglitz *Camera Work*. Photographe de mode dans les années vingt et trente pour *Vogue*, il devint Directeur de la photographie pour la U.S.Navy pendant la Seconde Guerre mondiale. Il fut conservateur de la photographie au Museum of Modern Art de New York de 1947 à 1962. Il y organisa l'exposition photographique « The Family of Man ». Le catalogue est devenu un ouvrage de référence, une œuvre incontournable pour chaque bibliothèque.

Portrait, 1969.

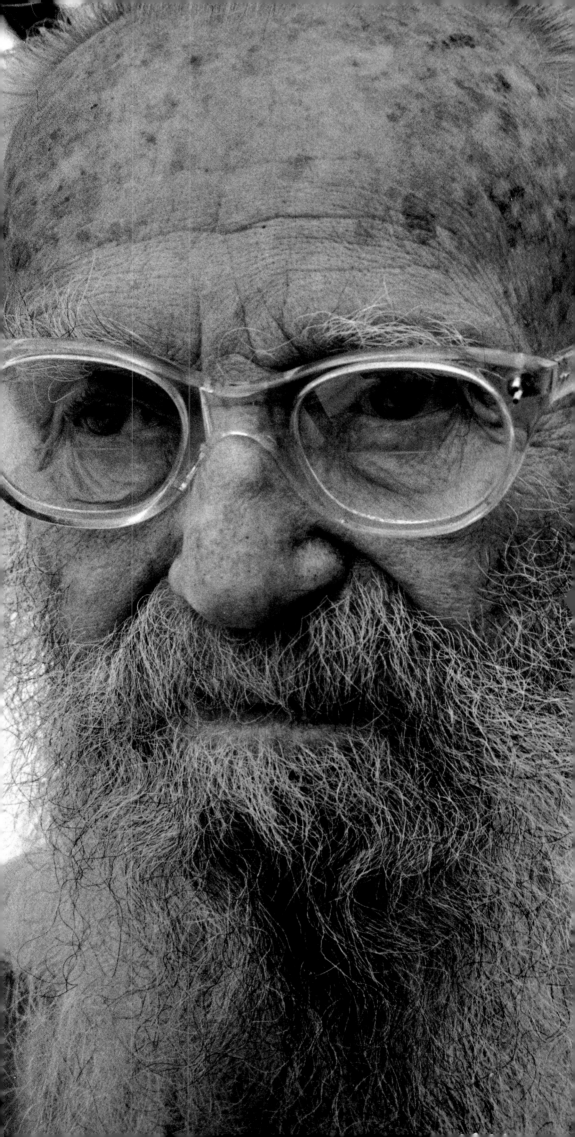

Steichen contributed to photography on a number of levels. It was a privilege for me to be invited to his home in 1969, at which time he was in his early nineties. I arrived sometime during the morning and was greeted at the door by his wife, Johanna, who ushered me into the living room, where the aging master was reading his newspaper. At his feet was sitting one of his two dogs, a mixed-breed terrier who had only three legs (the missing one having been lost in an unfortunate episode with a car). Steichen, ever the photographer, had named his three-legged dog Tripod.

Even in his nineties, Steichen was most candid and quite lucid, although somewhat frail. He took me around his house, proudly showing me some of the many awards he had received. He had started out as a painter – his paintings had been accepted in the Paris salon of 1901 – and afterwards become a photographer. He later became associated with the great Alfred Stieglitz in New York. After being published by Stieglitz in his journal *Camera Work,* he was involved in the founding of the »291« gallery with Stieglitz. In 1947 he became Curator of Photography at the Museum of Modern Art in New York. He later organized the Family of Man exhibition, the most widely attended photography exhibition ever.

He went on to work at the magazines *Vanity Fair* and *Vogue,* photographing fashion and doing portraits (at the same time that Man Ray was doing fashion photography for *Harper's Bazaar*). Steichen headed a photographic unit in World War II.

I had heard of the famous shadblow tree, the one

Steichen leistete auf vielen Gebieten Beiträge zur Fotografiegeschichte. Deshalb war es mir eine besondere Ehre, als er mich 1969 zu sich nach Hause einlud – er war damals schon Anfang neunzig. Ich traf am Vormittag ein; seine Frau Johanna öffnete mir die Tür und führte mich ins Wohnzimmer, wo der alte Meister die Zeitung las. Zu seinen Füßen lag einer seiner beiden Hunde, ein nicht ganz reinrassiger Terrier mit nur drei Beinen (das vierte war ihm bei einer unerfreulichen Begegnung mit einem Auto verlorengegangen). Der Fotograf Steichen hatte seinen dreibeinigen Hund kurzerhand »Tripod« genannt, was soviel heißt wie Dreifuß oder Stativ.

Trotz seines hohen Alters war Steichen geistig noch sehr rege und klar, wenn er auch recht gebrechlich wirkte. Er führte mich durch sein Haus und zeigte mir stolz einige der vielen Preise, die er erhalten hatte. Er hatte seine Karriere als Maler begonnen – seine Gemälde wurden 1901 im Pariser Salon ausgestellt – und war erst später zur Fotografie übergewechselt. Er schloß sich dem Kreis um den großen Alfred Stieglitz in New York an. Stieglitz publizierte einige seiner Bilder in seinem Magazin *Camera Work*, und Steichen half ihm bei der Gründung seiner Galerie »291«. 1947 wurde er Curator of Photography am New Yorker Museum of Modern Art. Die »Family of Man«-Ausstellung, die Steichen organisierte, wurde zur meistbesuchten Fotoausstellung aller Zeiten.

Später arbeitete er für die Modemagazine *Vanity Fair* und *Vogue*, in denen er auch Porträts veröffentlichte. (Zur gleichen Zeit machte Man Ray Mo-

Steichen a influencé la photographie à bien des niveaux. Ce fut un privilège pour moi que d'être admis chez lui en 1969, alors qu'il était âgé de 90 ans.

J'arrivai le matin et fus accueilli sur le seuil de la porte par Johanna, sa femme, qui m'introduisit dans le salon où le vieux maître lisait les journaux. Un de ses chiens, un terrier croisé, qui avait perdu une patte à la suite d'un malheureux accident de la circulation, se tenait à ses pieds. Steichen, incorrigible photographe, avait appelé son chien à trois pattes « Tripod » (trépied) !

Steichen était resté en dépit de son âge d'une belle candeur et très lucide, bien qu'ayant l'air fragile. Ce matin-là, il me fit faire le tour du propriétaire, me montrant au passage quelques-uns des nombreux prix reçus. Il avait débuté comme peintre – ses œuvres avaient été acceptées au salon de Paris de 1901 –, puis il était devenu photographe. Il s'associa plus tard au grand Alfred Stieglitz de New York. Après avoir été publié par Stieglitz dans sa revue *Camera Work*, il prit part à la fondation de la galerie « 291 » avec Stieglitz. En 1947, il fut nommé conservateur du département Photographie du musée d'Art moderne de New York et organisa « The Family of Man », une des expositions les plus visitées s'il en fut.

Il continua de travailler pour les magazines *Vanity Fair* et *Vogue*, photographiant la mode, exécutant des portraits (à la même époque, Man Ray faisait des photos de mode pour *Harper's Bazaar*). Steichen fut directeur de la photographie pour la U.S. Navy pendant la Seconde Guerre mondiale.

Steichen's Connecticut mailbox, 1969.

Steichens Briefkasten in Connecticut, 1969.

La boîte aux lettres de Steichen, Connecticut, 1969.

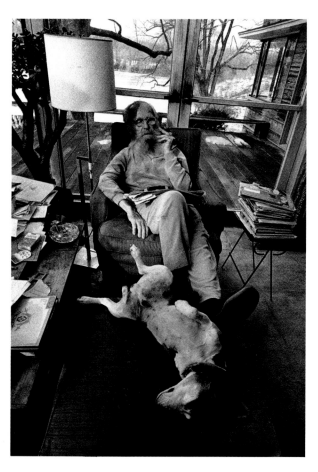

Portrait, 1969.

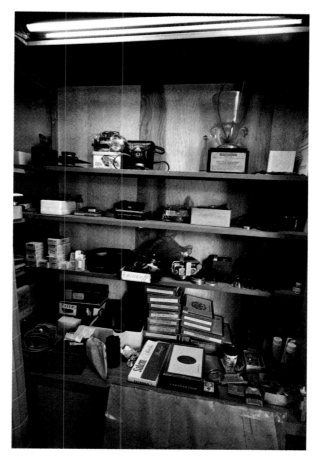

Steichen's hand
with a cigarette.

Steichens Hand mit
Zigarette, 1969.

La main de Steichen te-
nant une cigarette, 1969.

Steichen's equipment
shelves, 1969.

Steichens Regal für seine
Ausrüstung, 1969.

Les étagères équipées
de Steichen, 1969.

he had photographed over a number of seasons, and I asked him about it. He took me outside to his porch and proudly showed me the tree, which was still alive and well, its limbs winter-bare, on the other side of the pond.

I went walking with Steichen, accompanied by Tripod. I don't recall very much of our conversation, but I do remember what a wonderful day I had making portraits of one of photography's greatest living legends.

With his dogs in his bedroom. 1969.

Mit seinen Hunden im Schlafzimmer. 1969.

Avec ses chiens dans sa chambre. 1969.

defotos für *Harper's Bazaar*). Während des Zweiten Weltkriegs war Steichen Leiter einer Einheit der Luftbildaufklärung.

Ich hatte von der berühmten Felsenbirne gehört, die er über einen langen Zeitraum hinweg immer wieder fotografiert hatte. Als ich ihn danach fragte, ging er mit mir auf die Terrasse seines Hauses und zeigte sie mir voller Stolz; der Baum, offensichtlich noch voller Saft und Kraft, stand winterlich kahl auf der gegenüberliegenden Seite des Teiches.

Ich machte einen kleinen Spaziergang mit Steichen, und Tripod begleitete uns. Ich kann mich nicht mehr genau an unser Gespräch erinnern, aber ich erlebte einen wunderbaren Tag, als ich eine der größten lebenden Legenden der Fotografie auf Film bannen durfte.

J'avais entendu parlé du fameux « Shadblow Tree » qu'il avait photographié saisons après saisons, et je lui parlai de l'arbre. Il m'amena dehors, sous le porche, et me désigna fièrement l'arbre, toujours aussi vivant et beau, dont les branches hivernales s'étalaient de l'autre côté du bassin.

Nous continuâmes notre promenade accompagnés de Tripod. Je ne me rappelle pas précisément de notre conversation, mais je n'oublierai jamais ce jour merveilleux où je réalisai le portrait d'une des plus grandes légendes vivantes de la photographie.

Steichen with Tripod outside his home, 1969.

Steichen mit seinem Hund Tripod vor seinem Haus, 1969.

Steichen et Tripod devant la maison, 1969.

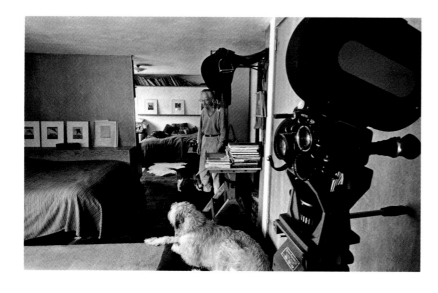

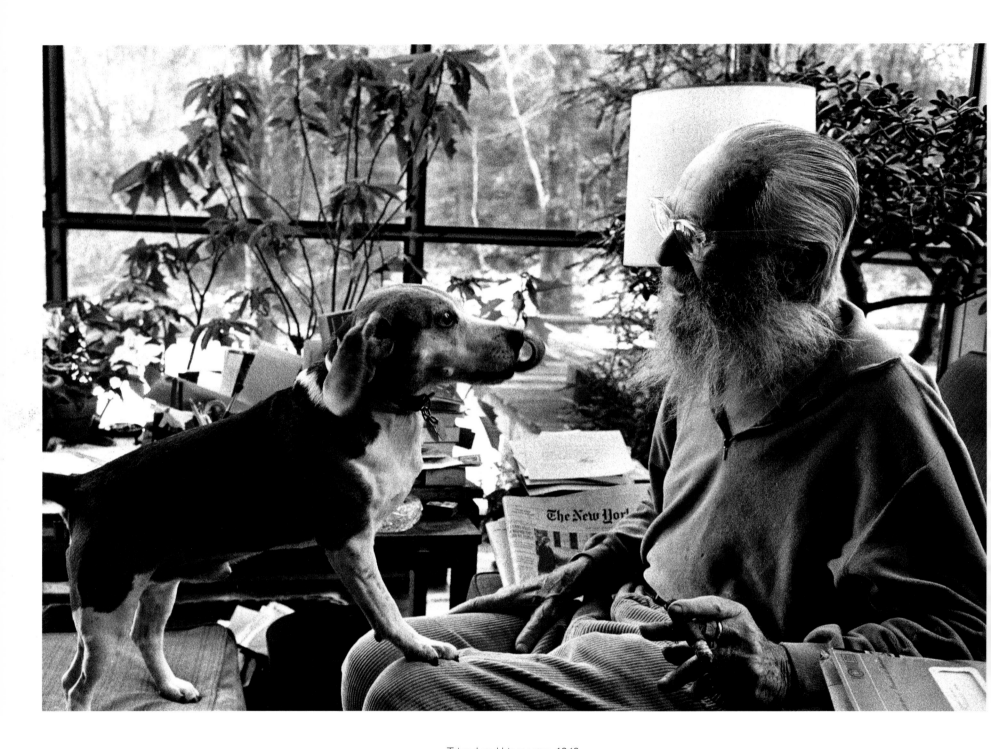

Tripod and his master, 1969.

Tripod und sein Herrchen, 1969.

Tripod et son maître, 1969.

Steichen looking toward shadblow tree which he proudly showed me, 1969.

Steichen betrachtet die Felsenbirne, die er mir voller Stolz gezeigt hat, 1969.

Steichen en train de contempler le « Shadblow Tree » qu'il me montre fièrement, 1969.

Steichen in his living
room, 1969.

Steichen in seinem
Wohnzimmer, 1969.

Steichen dans la
salle de séjour, 1969.

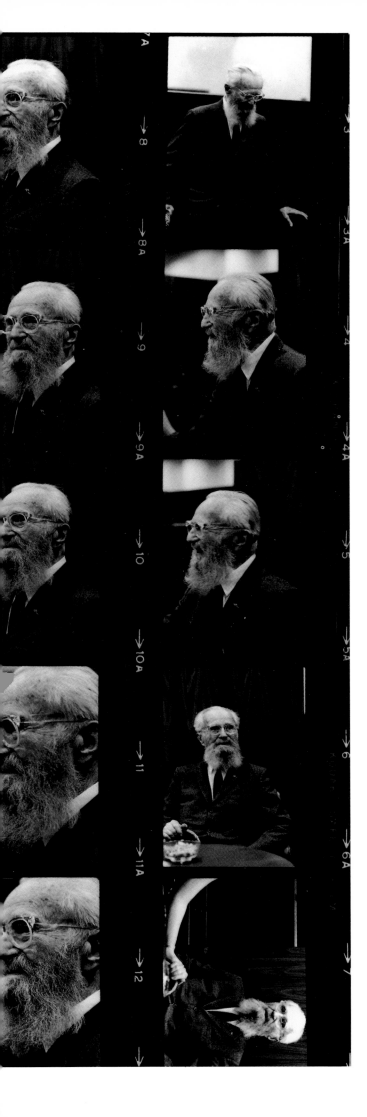

Contact sheet of Steichen. This contact sheet was one of two done from photographs I took at the Exchange National Bank of Chicago (now the LaSalle Bank) and was the group of photographs that was to become the genesis of this book and the photographs that Grace Mayer requested for the Steichen Archives at the New York Museum of Modern Art. (The Steichen photographs – plus the first photographs which I made in Paris of Man Ray – led Peter Bunnell to suggest this project.) 1969.

Kontaktabzug von Steichen aus einer Fotoserie, die ich in der Exchange National Bank of Chicago, der heutigen LaSalle Bank, gemacht hatte; Fotos, die den Grundstock für dieses Buch legten und die Grace Mayer für das Steichen- Archiv im Museum of Modern Art, New York, haben wollte. Die Fotos von Steichen sowie meine ersten Fotos von Man Ray haben Peter Bunnell bewogen, dieses Projekt vorzuschlagen. 1969.

Planche contact de Steichen. C'est l'une des deux planches de photographies que j'ai prises à la Exchange National Bank of Chicago, aujourd'hui LaSalle Bank. Ces photos sont à l'origine de cet ouvrage, et Grace Meyer les demanda pour les archives Steichen au Museum of Modern Art de New York. (Les photos de Steichen, ainsi que mes premières photos de Man Ray à Paris, sont à l'origine des suggestions de Peter Bunnell concernant ce projet). 1969.

△ ▷ Portrait, 1969.

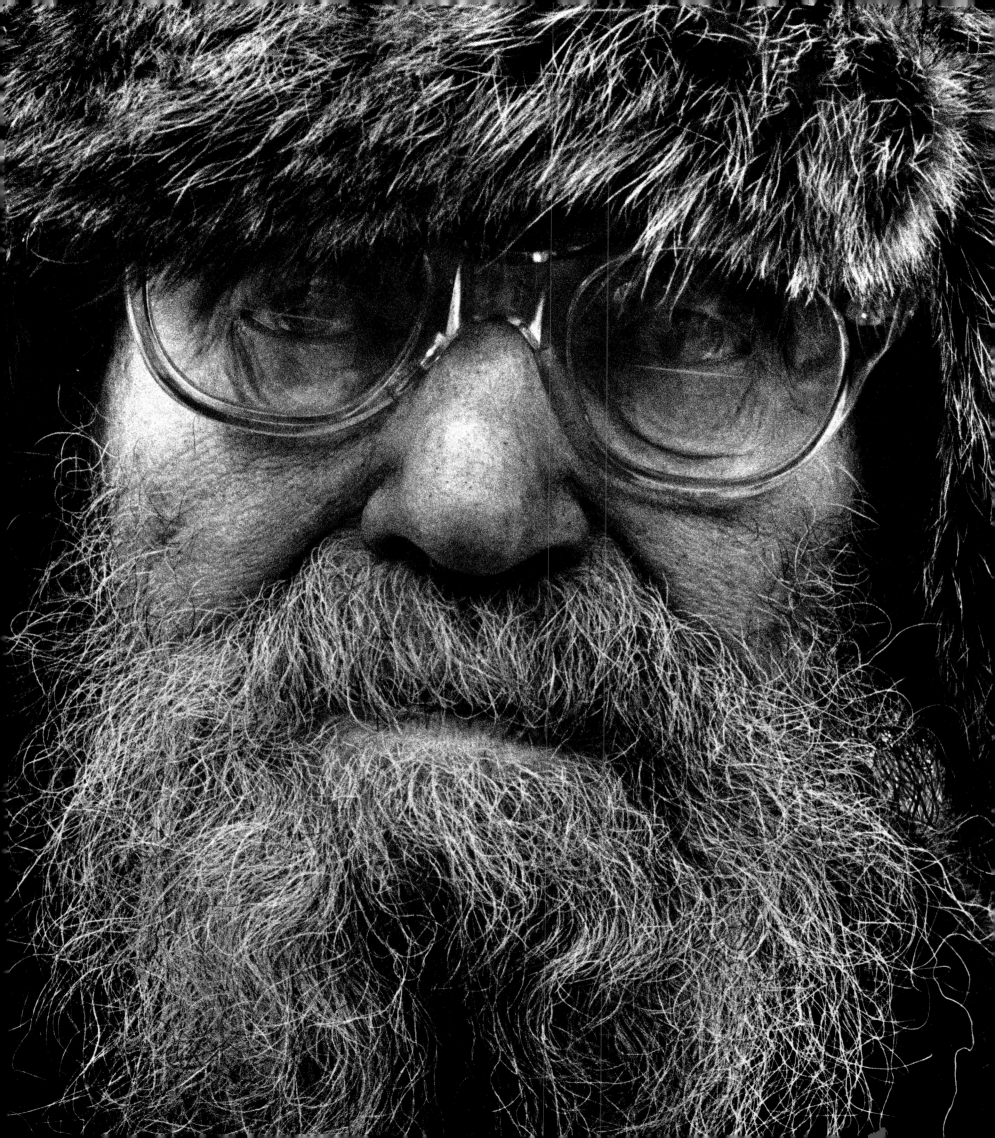

W. Eugene Smith

1918–1978. American.
Photojournalist, photographed World War II for *Life* in the
Pacific. His photography was daring and straightforward, showing
the hardships and horrors of war. Did many photo essays for
Life, including »Spanish Village.«

1918–1978. Amerikaner.
Fotojournalist, arbeitete während des Zweiten Weltkriegs als
Fotograf für *Life Magazine* und berichtete über den Krieg im
Pazifik. Seine Fotografie war mutig und direkt; er zeigte Härte
und Schrecken des Krieges. Unter seinen vielen Fotoessays für
Life ist »Spanish Village« besonders hervorzuheben.

1918–1978. Américain.
Reporter photographe ; il a photographié les événements de la
Seconde Guerre mondiale dans le Pacifique pour *Life Magazine*.
Ses photos sont provocantes, directes et montrent les difficultés
et les horreurs de la guerre. Il réalisa beaucoup de
reportages-photos pour *Life*, y compris « Spanish Village ».

Portrait, 1969.

On a very dark night, my taxi pulled up to a rather obscure doorway in Greenwich Village. Gene Smith's apartment over a storefront in New York City was where he always returned to after finishing an assignment – whether it was one he gave himself, like »Minamata,« or one he had done for *Life* magazine, such as »Country Doctor.« Both a humanitarian and a photographer, he had managed successfully to »marry« both of those pursuits while his real marriages fell apart.

He married in 1940 and had four children. But he was a tortured artistic soul whose emotions, perhaps, made it difficult for him to maintain a lifelong relationship with any woman.

Gene was expecting me that summer evening in 1969. That first meeting with Gene was the beginning of a strange relationship that was to go on for several more years.

I knew at the time I first met him that he had had difficulties with *Life* magazine – he insisted on having editorial control of his stories. When they denied him, he resigned on principle.

He was an honorable man with a cause. He went to Minamata in Japan to do a story on how the local factories caused the townspeople appalling physical harm with mercury which they released into the water supply. For the photographs he took, Gene Smith was brutally beaten by thugs hired by the factories.

I met him when he was bitter and deprived.

He wanted to talk, so we went to a »hole in the wall« pizza joint and spoke about pictures. He told me about the time he was on assignment for *Life* just before the invasion of Iwo Jima, and while on the command carrier learned of the invasion plans.

Gene's darkroom. His 4x5 enlarger on left and his 35mm enlarger near his head. 1969.

Genes Dunkelkammer. Links sein Vergrößerer für 10 × 15-cm-Abzüge, neben ihm der für 35-mm-Filme. 1969.

La chambre noire de Gene. Son agrandisseur 10×15 cm est à gauche, et celui pour les films de 35mm à côté de sa tête. 1969.

Eines Abends fuhr ich mit dem Taxi zu einem eher unansehnlichen Haus in Greenwich Village. Dort lag Gene Smiths Apartment über einem kleinen Laden, dorthin kehrte er von seinen Fototouren zurück. Er machte eigene Reportagen, wie »Minamata«, nahm aber auch Aufträge von *Life* an, wie »Country Doctor«. Er war in seinem Beruf zugleich Menschenfreund und Fotograf, und diese beiden Anlagen hatten sich bei ihm zu einer glücklichen Ehe zusammengefunden – während seine wirklichen Ehen weniger glücklich verliefen.

Er heiratete 1940 und wurde Vater von vier Kindern. Doch hatte er eine labile Künstlerseele, und das machte es ihm wohl sehr schwer, mit einer Frau eine lebenslange Bindung einzugehen.

An jenem Sommerabend des Jahres 1969 erwartete Gene mich in seinem Apartment. Diese erste Begegnung war der Anfang einer eigenartigen Freundschaft, die einige Jahre dauern sollte.

Ich wußte damals, daß er Schwierigkeiten bei *Life* hatte – er bestand auf voller redaktioneller Eigenverantwortung für seine Stories. Als man ihm das verweigerte, gab er seinen Job bei Life auf.

Er war ein Mann mit Stolz und Würde und hatte immer eine Mission. So ging er zum Beispiel nach Minamata, Japan, um eine Fotoreportage über die entsetzlichen Gesundheitsschäden der Bevölkerung zu machen, verursacht von der Verschmutzung des Trinkwassers durch die dortige Industrie. Seine Fotos hatten ein Nachspiel: Smith wurde von Schlägertypen, die von dieser Firma beauftragt worden waren, brutal zusammengeschlagen.

Als ich ihn traf, war er an einem Tiefpunkt angelangt, völlig verbittert.

Er wollte mit mir reden, also gingen wir zu einer Pizzeria und unterhielten uns über Fotos. Er erzählte mir von der Zeit kurz vor der Invasion von Iwo Jima; er machte zu dieser Zeit eine Reportage für *Life* und befand sich auf dem Kommandoschiff der Invasionstruppen, als er von der bevorstehenden Invasion hörte. Er versuchte den befehlshabenden Admiral zu überreden, ihn in einem Aufklärungsflugzeug mitfliegen zu lassen, und war sogar willens, sich von seinem Piloten erschießen zu lassen, falls

Il faisait nuit noire lorsque mon taxi ralentit avant de s'arrêter face à un sombre portail de Greenwich Village.

L'appartement de Gene Smith était situé au-dessus d'une boutique à New York. C'était son « repaire », là où il revenait toujours après un reportage tel que « Minamata », réalisé pour son propre compte, ou encore « Country Doctor », réalisé pour *Life*.

Philanthrope et photographe, il avait su marier ces deux activités tandis que ses propres mariages allaient à vau-l'eau. Marié en 1940, il eut quatre enfants. Mais il avait une âme d'artiste torturée et son monde émotionnel rendait probablement difficile une relation à long terme avec une femme.

Gene m'attendait ce soir d'été de 1969. Cette première rencontre fut le début d'une relation singulière qui se poursuivit plusieurs années. Il me dit, ce soir-là, qu'il avait eu des problèmes avec le magazine *Life*. Il insistait en effet pour garder le contrôle des éditoriaux de ses reportages, et quand *Life* refusa, il démissionna pour le principe.

C'était un homme d'honneur et fidèle à sa cause. Il s'était rendu à Minamata au Japon pour faire un reportage sur les terribles nuisances physiques endurées par les habitants, à cause du mercure déversé dans les réserves d'eau par les usines locales. Ses photos lui valurent d'être brutalement tabassé par des voyous à la solde des usines.

Je le rencontrai alors qu'il était amer, frustré. Comme il voulait parler, nous nous rendîmes dans une pizzeria et discutâmes photographie. Il me raconta l'époque où il faisait un reportage pour *Life* juste avant l'invasion de Iwô-Jima et comment il apprit le plan d'invasion alors qu'il était aux commandes du camion. Il essaya de conclure un marché avec l'amiral chargé de l'opération pour qu'il le laissât monter dans l'avion de reconnaissance, prêt à être abattu par le pilote au cas où il serait en danger d'être capturé.

Il débarqua en fin de compte à Iwô-Jima. Il m'expliqua qu'il avait caché cinq appareils photographiques dans l'île pour ne jamais prendre le risque de manquer de matériel en cas de destruction d'un ou plu-

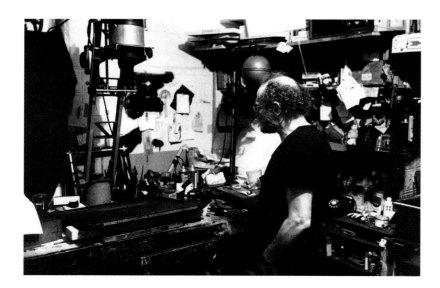

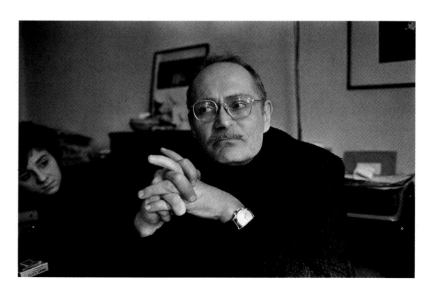

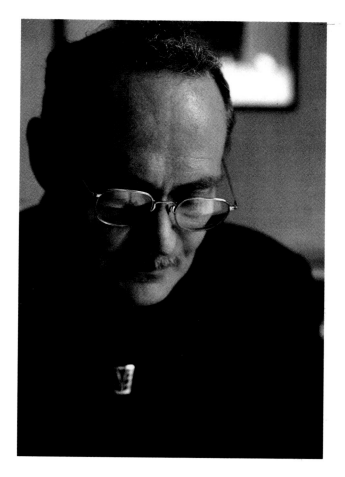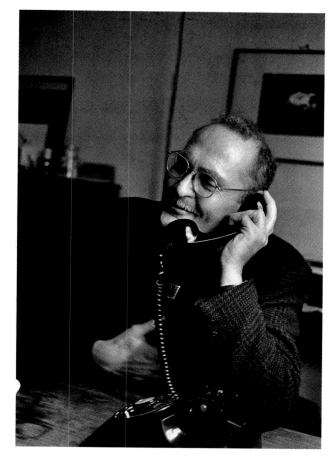

Portraits, 1969.

He tried to make a deal with the admiral in charge of the invasion to let him ride with a reconnaissance plane and was even willing, should it come to it, to be shot by the pilot rather than be captured.

He eventually landed on Iwo Jima. He told me he had five sets of cameras stashed around the island so he would always have equipment in the event any of his cameras were destroyed. Some of his most memorable photographs were made on that Pacific Island.

One of the most vivid memories was when Gene phoned me one day in tears. He said he needed a loan of $400 desperately, or he was »going to commit suicide.« I agreed, and in return he sent me a pawn ticket for his cameras. I still have that ticket!

Gene was a perfectionist. In fact, many of his prints were made from copy negatives, the reason being that his prints require so much work to make, such intricate burning and dodging, that he made a negative of the final print for purposes of repeatability.

My final parting with Gene took place after another of those phone calls. He asked me for a second loan, of several thousand dollars this time, which he needed in order to print his retrospective which was to be shown at the ICP (Institute for Concerned Photography) in New York.

I informed him that I was not in a financial position to loan him money. Upset, he said goodbye. And that was the last contact I had with probably the most brilliant photojournalist of our time.

die Mannschaft in Gefangenschaft geraten sollte.

Schließlich landete er auf Iwo Jima. Er erzählte mir, daß er fünf Kameras auf der ganzen Insel verteilt deponiert hatte, so daß er immer an eine neue Ausrüstung kommen konnte, falls eine seiner Kameras zerstört würde. Gene machte auf der Pazifikinsel Iwo Jima einige seiner eindrucksvollsten Aufnahmen.

Besonders lebhaft ist mir ein Tag in Erinnerung, als er mich unter Tränen anrief und klagte, daß er dringend 400 Dollar brauche, andernfalls würde er Selbstmord begehen. Ich schickte ihm das Geld und bekam einen Brief von ihm, in dem er mir seine Kameras als Pfand anbot. Diesen Brief verwahre ich noch heute.

Gene war Perfektionist. So stammen viele seiner Abzüge von Repronegativen, die er von Erstabzügen gemacht hat. In diesen Erstabzügen steckte nämlich so ungeheuer viel Arbeit, so viele Nachbelichtungen und Abwedelungen, daß er oft von seinen Erstabzügen noch einmal Repros machte, um das erste Ergebnis exakt wiederholen zu können.

Meine letzte Begegnung mit Gene bestand in einem weiteren Telefonanruf. Er bat mich nochmals um Geld – diesmal sollten es mehrere tausend Dollar sein, die er brauchte, um Abzüge für eine Retrospektive seines Werks im ICP (Institute for Concerned Photography) in New York entwickeln zu können.

Als ich ihm mitteilte, daß ich finanziell nicht in der Lage sei, ihm das Geld zu leihen, wurde er wütend und verabschiedete sich – für immer. Ich habe nie wieder etwas von dem womöglich genialsten Fotojournalisten unserer Zeit gehört.

sieurs de ceux-ci. Quelques-unes de ses photos les plus mémorables ont été faites dans cette île du Pacifique.

Un de mes souvenirs les plus marquants fut quand Gene me téléphona un jour, en larmes. Il me dit qu'il avait désespérément besoin d'un prêt de 400 dollars sans lequel il « allait se suicider ». Je fus d'accord et en échange il m'envoya un reçu de reconnaissance de dépôt en gage pour ses appareils. J'ai encore le reçu !

Gene était un perfectionniste. Beaucoup de ses épreuves ont été faites à partir de copies de négatifs, car elles demandaient un tel travail, de tels artifices compliqués brûlant le papier, qu'il tirait un négatif de la dernière épreuve dans le but de développer de nouveaux tirages.

Ma rupture finale avec Gene eut lieu à la suite d'un autre coup de téléphone. Il me demanda un nouveau prêt, de plusieurs milliers de dollars cette fois, dont il avait besoin pour imprimer sa rétrospective qui devait être montrée à l'ICP à New York. Je lui répondis que je n'étais pas en mesure financièrement de lui accorder un tel prêt. Bouleversé, il me dit « Good-bye ». Et ce fut le dernier contact que j'eus avec probablement le plus brillant reporter de notre temps.

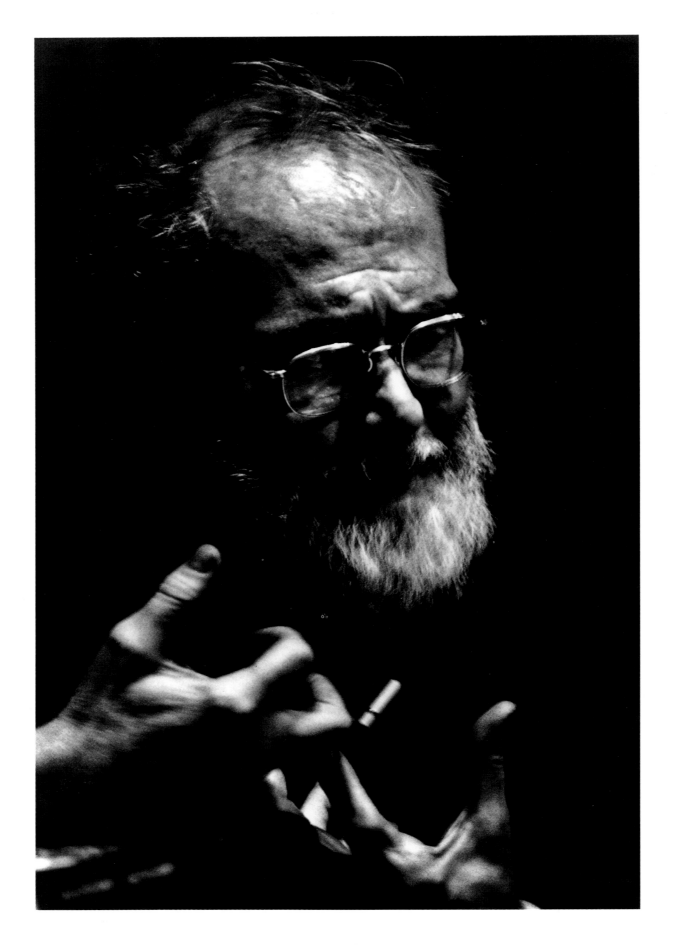

Portrait, 1969.

Gene Smith's front door. He had quotes written and pasted all over his apartment. He was vehemently against war, oppression and human exploitation and many of the quotes relate to those matters. 1969.

Gene Smiths Haustür. Er hatte überall in seinem Apartment Zitate an den Wänden. Gene war ein engagierter Gegner von Krieg, Unterdrückung und Ausbeutung, was in den Zitaten deutlich wird. 1969.

Gene Smith sur le pas de la porte. Il avait collé des citations dans tout l'appartement. Il était violemment opposé à la guerre, à l'exploitation humaine, à l'oppression, et beaucoup de ces citations se référaient à ces thèmes. 1969.

A cabinet with his graffiti, 1969.

Ein Schrank mit seinen Graffiti, 1969.

Un meuble contenant ses graffitis, 1969.

Gene Smith in his work room, 1969.

Gene Smith in seinem Arbeitsraum, 1969.

Gene Smith dans son atelier, 1969.

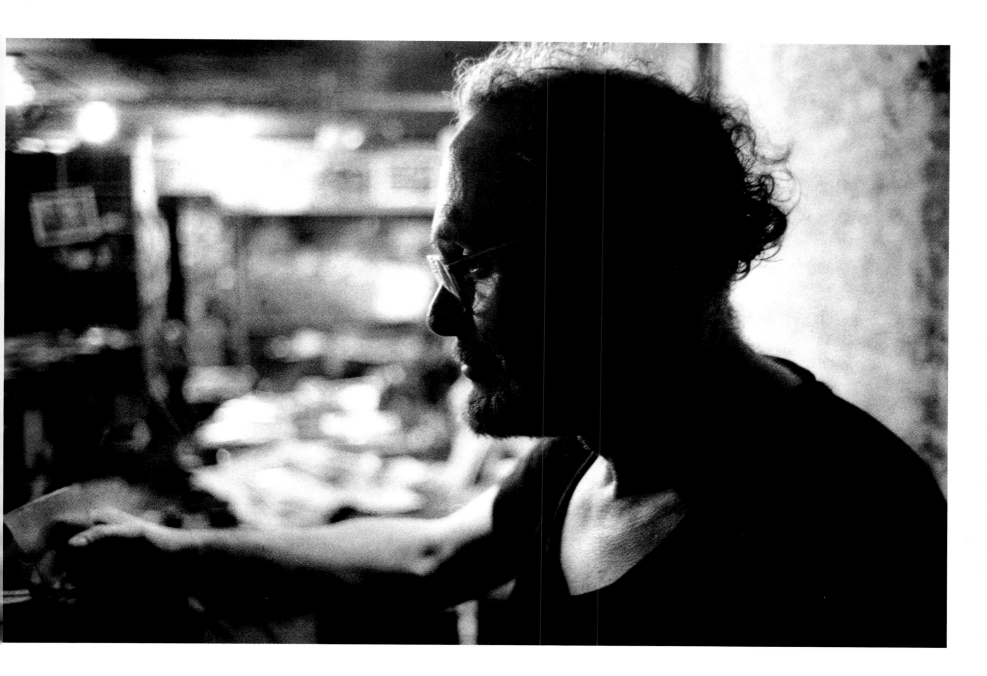

Portrait, 1969.

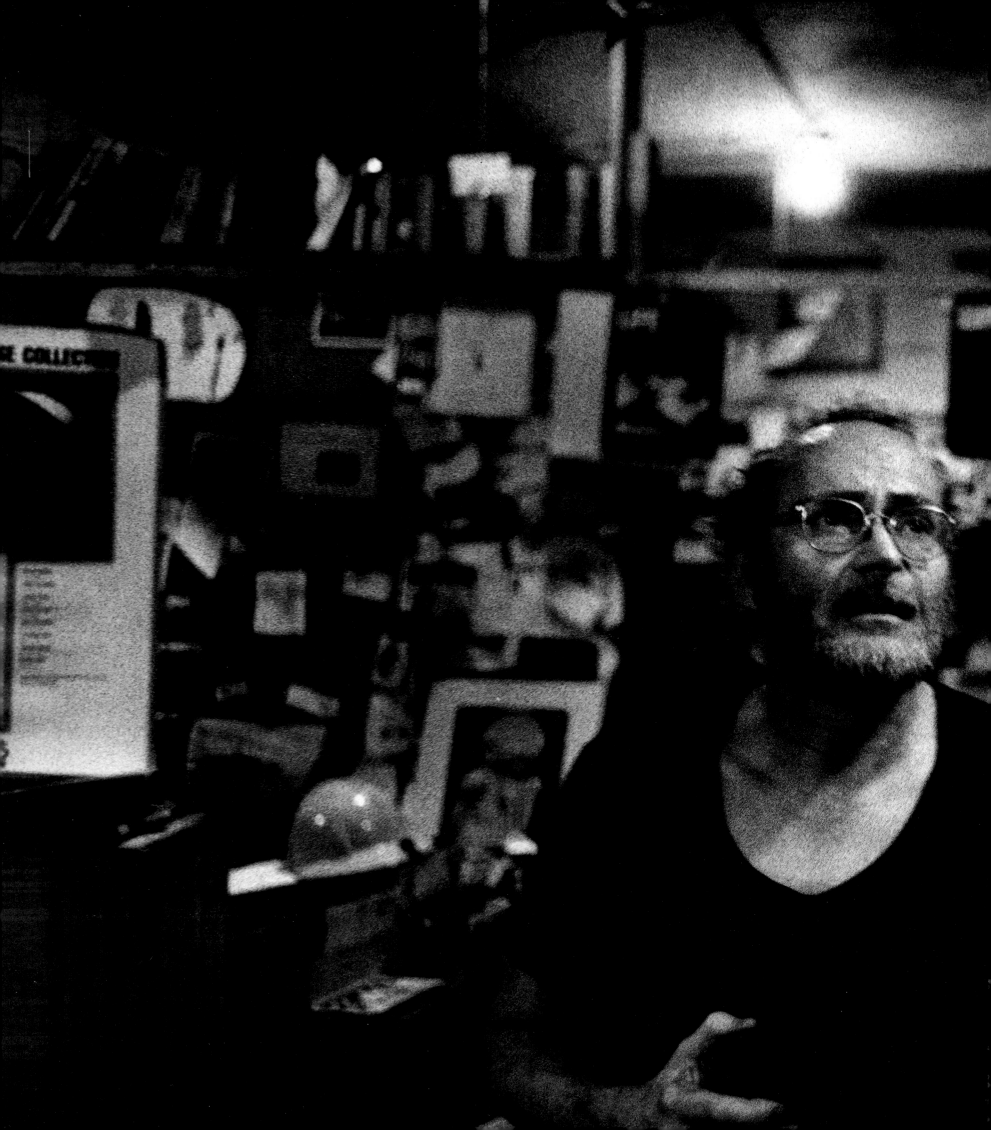

Gene Smith in his work room, 1969.
Gene Smith in seinem Arbeitsraum, 1969
Gene Smith dans son atelier, 1969.

Robert Frank

Born 1924. Swiss.
Came to the United States in 1974 where he received a
Guggenheim Foundation grant and with the money
photographed the seamier side of our nation, the photographs
culminating in a landmark book, *The Americans*.

Geboren 1924. Schweizer.
Kam im Jahre 1974 mit einem Guggenheim-Stipendium nach
Amerika, wo er die Schattenseiten der Vereinigten Staaten
fotografierte. Seine Fotos sind in einem maßstabsetzenden Buch
versammelt: *The Americans*.

Né en 1924. Suisse.
Il est venu aux États-Unis en 1974 où il reçut le prix de la
Guggenheim Foundation. Avec l'argent reçu, il photographia les
dessous sombres du pays. Ce travail fit l'objet du célèbre livre
The Americans.

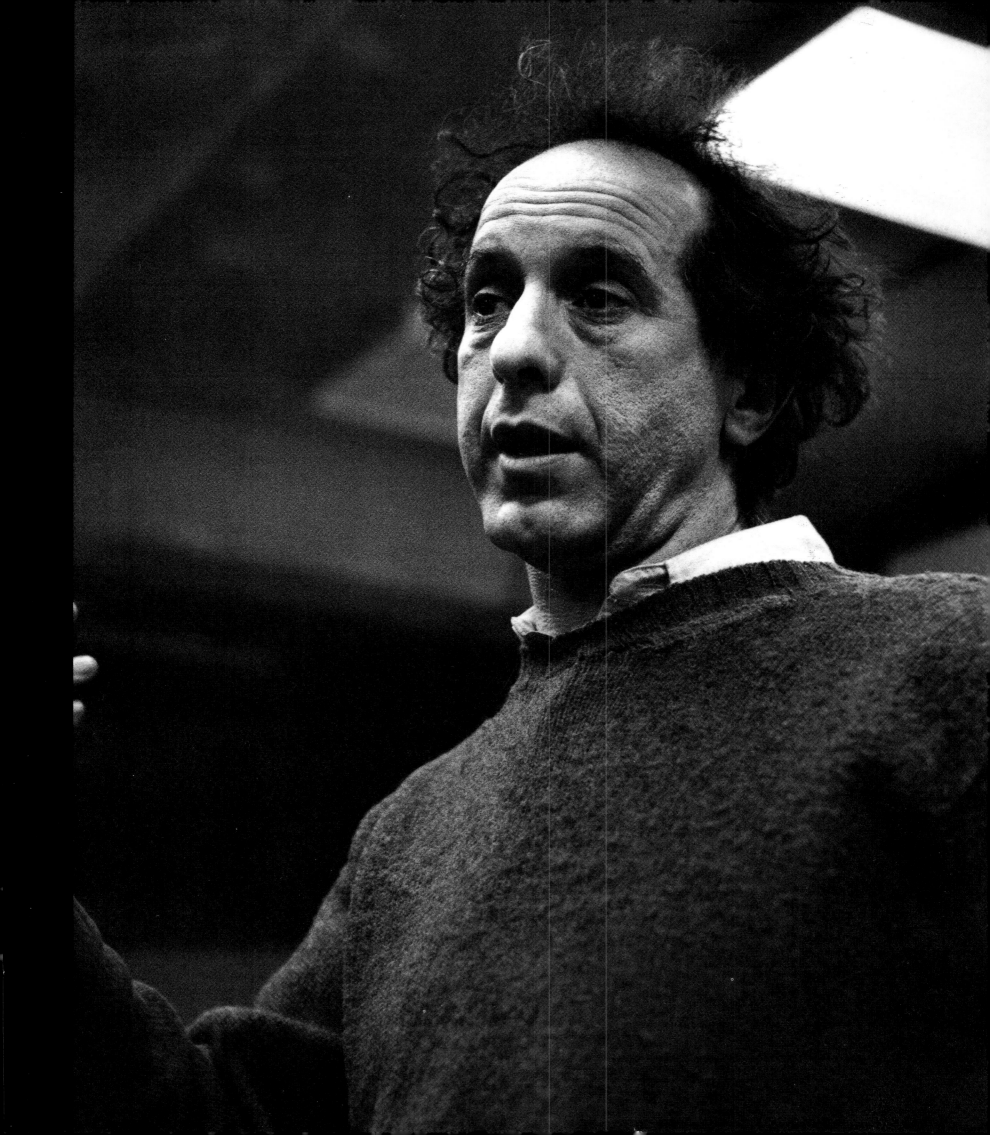

The opportunity to photograph this great legend came when I learned he was to deliver a lecture to the art and photography students at the University of Illinois, Circle Campus. Joe Jachna introduced Frank to me, and I told him about my project.

I photographed him being introduced and as he was speaking.

That evening he told of his experiences as a Swiss national travelling across the United States. He photographed total strangers in unlikely and sometimes forbidding places, such as cafés and bars, always with the hovering threat of someone turning angry or violent toward him when he pointed camera in their direction.

This transcontinental adventure of his culminated in his book *The Americans,* which has since become a 20th-century photography classic. The style he invented was so persuasive that, for many years, young photographers used the book as an encyclopedia of hard-edged visual reportage.

Die große Chance, diese Legende der Fotografie aufzunehmen, bot sich mir, als er für die Kunst- und Fotografiestudenten der University of Illinois, Circle Campus, einen Vortrag hielt. Joe Jachna stellte mich Frank vor, und ich erzählte ihm von meinem Projekt.

Ich fotografierte ihn bei diesem kleinen Gespräch und auch später, während seines Vortrags.

An jenem Abend berichtete er von seinen Eindrücken als Schweizer, der durch die USA reiste. Er hatte Menschen in ausgefallenen Situationen fotografiert, manchmal auch in solchen, wo das Fotografieren nicht erwünscht war, so daß er beständig fürchten mußte, daß jemand wütend oder sogar gewalttätig werden könnte, wenn er mit seiner Kamera zugange war.

Sein transkontinentales Abenteuer gipfelte in dem Buch *The Americans*, das bald zu einem Klassiker unter den Fotobüchern des 20. Jahrhunderts avancierte. Der Aufnahmestil, wie er in diesem Buch zum Ausdruck kommt, war jahrelang so überzeugend, daß junge Fotografen dieses Buch als eine Art Enzyklopädie der harten Fotoreportage betrachteten.

Ce fut à l'occasion d'une conférence, organisée pour les étudiants en art et en photographie sur le campus universitaire de l'Illinois, dont l'animateur était Robert Frank, que j'eus l'opportunité d'immortaliser ce grand nom de la photo. Jœ Jachna fit les présentations puis je lui exposai mon projet.

Je le photographiai alors qu'il était introduit auprès de l'assemblée et pendant qu'il faisait son exposé.

Il raconta ce soir-là son expérience de citoyen suisse voyageant à travers les États-Unis. Il avait pris des inconnus dans des lieux invraisemblables, des lieux où il était interdit de photographier, comme les cafés ou les bars, au risque d'encourir la colère ou de réveiller la violence des personnes vers lesquelles il dirigeait son objectif.

Le récit de cette aventure transcontinentale nous est raconté dans son ouvrage *The Americans*, devenu depuis un classique de l'histoire de la photographie du XX^e siècle.

Il créa et imposa un style unique et, pendant des années, les jeunes photographes se servirent de son livre comme de l'encyclopédie de la photographie contrasté.

Portrait, 1974.

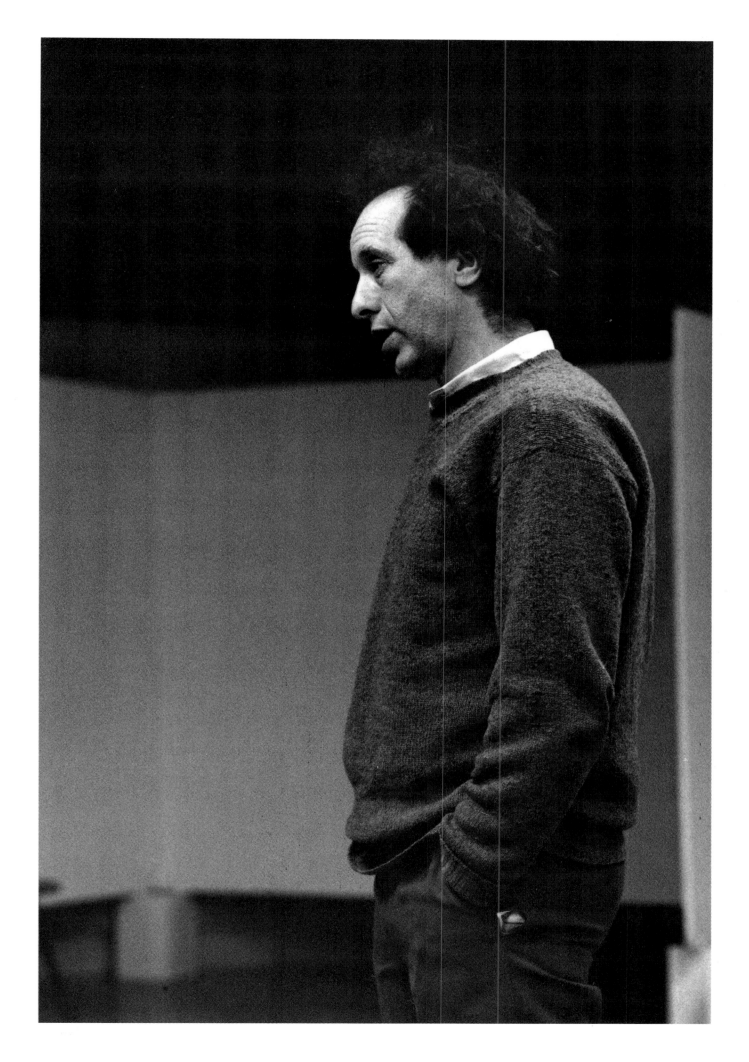

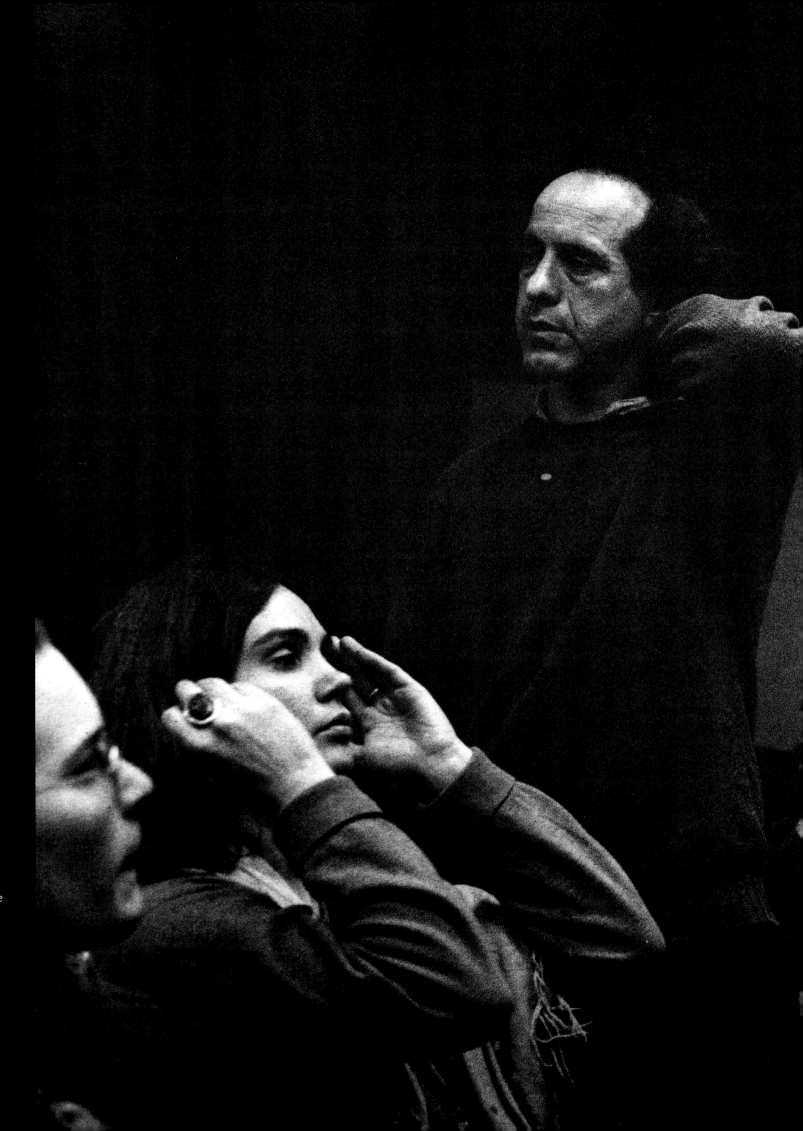

Robert Frank during his lecture at the University of Illinois, Chicago, Circle Campus, 1974.

Robert Frank bei seinem Vortrag an der University of Illinois, Chicago, 1974.

Robert Frank donnant une conférence sur le campus universitaire de l'Illinois, Chicago, 1974.

Berenice Abbott

1898–1992. American.
Became Man Ray's assistant in Paris. Portrait photographer.
Moved to New York in the late 1920s, where she photographed
the city and its skyscrapers. Did scientific photographs, e.g. the
results of movement, magnetism etc., in her later years.

1898–1992. Amerikanerin.
Abbott war eine Zeitlang Assistentin bei Man Ray in Paris.
Arbeitete als Porträtistin. Ende der zwanziger Jahre zog sie nach
New York, wo sie insbesondere die City mit ihren
Wolkenkratzern ablichtete. Sie machte später
naturwissenschaftliche Fotos, die z.B. die Motorik oder den
Magnetismus veranschaulichen.

1898–1992. Américaine.
Elle fut l'assistante de Man Ray à Paris. Photographe portraitiste,
elle s'installa à New York à la fin des années vingt et se mit à
photographier la ville et ses gratte-ciel. Elle réalisa plus tard des
photographies scientifiques sur la motricité, le magnétisme, etc..

Berenice with her cat, 1968.

Berenice Abbott mit ihrer Katze, 1968.

Berenice Abbott avec son chat, 1968..

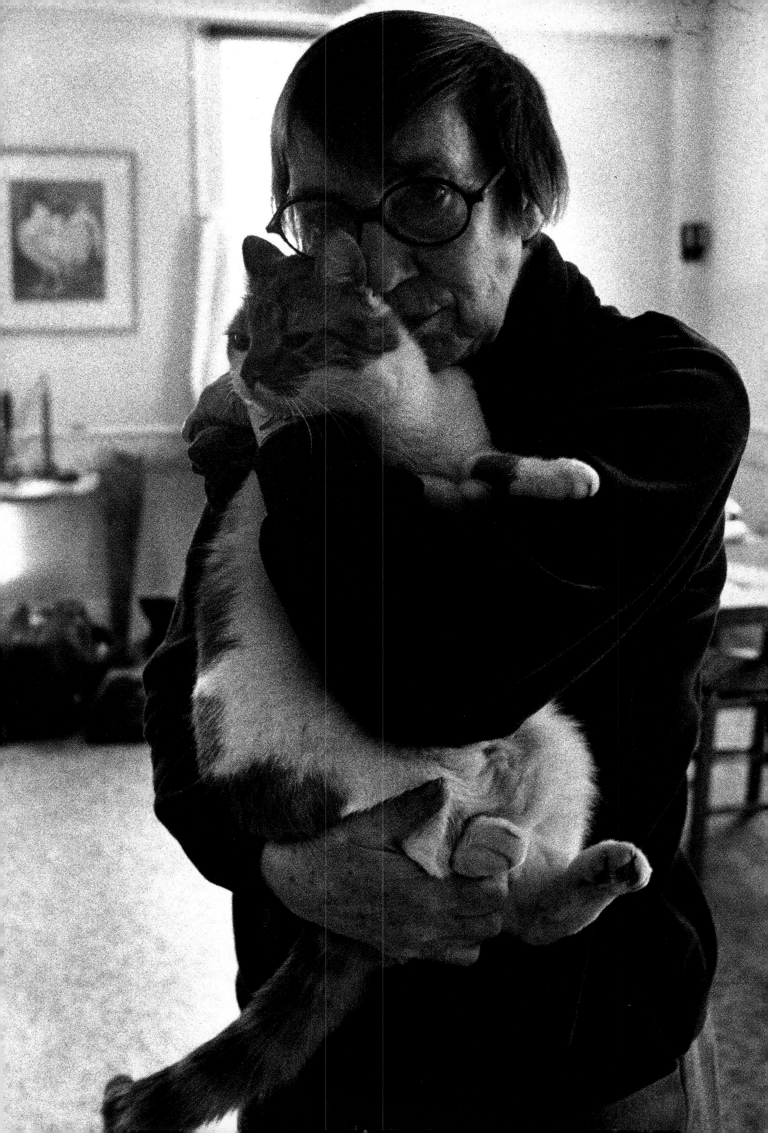

When my plane landed at Bangor, Maine, Berenice was there waiting for me. I had called her several weeks before and she had warmly agreed to meet me – though perhaps it was because she knew I was close to Man Ray, and she was curious to find out more about his life at that time. Berenice had been his assistant for two and half years in the late 1920s. She was bitter, feeling she had been overused and underpaid by Man Ray. But I sensed it was a love-hate feeling she had toward him.

She had been studying sculpture in Paris back then. However, as with most art students, she found herself in need of money, so she went to work for Man. In her words, she »took to photography like a duck takes to water,« and had to throw sculpture out the window. Thus began Berenice Abbott, photographer.

While working for Man Ray she become proficient in darkroom work, and she began doing portraits in her spare time. She told me: »He never once showed me how to take a picture! Never once! Not with lighting or anything else. In fact, I didn't want him to show me. This was a new adventure . . . and it turned out to be good!«

Berenice felt Man might have been envious of her abilities. Man never indicated any such thoughts to me. In fact, Man never criticized another artist's work in my presence. On a number of occasions I vividly remember him telling me: »All artists are sacred with retrospective vision!« – Meaning, it didn't matter whether or not one liked the work they were creating; whether painter, poet, or composer, the fact that one was creating work was worthwhile in and of itself.

During the time I spent with Berenice, she took me all through her house. Her studio/darkroom was in the attic. While we were up there she picked up an enormous wooden 8x10 camera and said: »I want to go back to New York someday and handhold this darn thing and photograph the city again. I can do it! I don't need a tripod! The pictures will be more interesting.«

Unfortunately, many who are steeped in the history of photography think of Berenice Abbott and Atget in the same sentence. While living in Paris and working for Man Ray, Berenice acquired the negatives and prints of Eugene Atget, the out-of-work actor who had photographed the streets, doorways, storefronts, houses, gardens, alleys and people of Paris to sell as artists' references. Later, he was to become recognized as one of the naïve artistic geniuses of photography's first century. Berenice, having willingly come into possession of Atget's work, became caretaker and curator of his archive.

I asked her why she had sublimated herself to Atget. She replied: »Well, I didn't mean to and I didn't want to. It is always easier to admire the dead than the living. People would come to see the Atget prints, and I was terribly glad they did. You know, I would give him everything. I sold what I could of my own work, but people wanted Atget!«

Als mein Flugzeug in Bangor, Maine, landete, wartete Berenice schon auf mich. Ich hatte sie einige Wochen zuvor angerufen, und sie war so freundlich gewesen, sich mit mir zu verabreden – vielleicht nur deshalb, weil sie wußte, daß ich ein Freund von Man Ray war, und weil sie wissen wollte, wie es ihm ging. Ende der zwanziger Jahre hatte Berenice zweieinhalb Jahre als Rays Assistentin gearbeitet. Mit Verbitterung erinnerte sie sich an diese Zeit, denn sie beklagte, daß sie bei Man Ray völlig überarbeitet und darüber hinaus noch unterbezahlt gewesen sei. Ich hatte allerdings das Gefühl, daß sie für Man Ray eine Art Haßliebe empfand.

Damals absolvierte sie in Paris eine Bildhauerausbildung. Aber wie die meisten Kunststudenten brauchte sie Geld, und so begann sie, für Man zu arbeiten. Da sie sich in der Fotografie so in ihrem Element fühlte wie der Fisch im Wasser, gab sie die Bildhauerei ganz auf. So begann das Leben der Fotografin Berenice Abbott.

Während ihrer Zeit bei Man Ray lernte sie alles über Dunkelkammertechnik. Schließlich griff sie selbst zur Kamera und machte in ihrer Freizeit Porträtaufnahmen. Sie erzählte mir: »Er hat mir nie was übers Fotografieren beigebracht. Nie! Kein Wort über das richtige Licht oder sonst etwas. Aber eigentlich wollte ich das auch gar nicht. Das Ganze war ein Abenteuer für mich, und letzten Endes war es gut!«

Berenice glaubt, daß Man Ray vielleicht neidisch auf ihr Talent gewesen ist. Man Ray hat mir gegenüber nichts dergleichen geäußert. Er hat sich in meiner Gegenwart eigentlich niemals kritisch über das Werk eines anderen Künstlers geäußert. Immer wieder betonte er: »Im nachhinein sind alle Künstler heilig!« – Seiner Meinung nach war es vollkommen egal, ob man die Werke der Künstler mag oder nicht; ganz gleich, ob jemand Maler, Dichter oder Komponist ist, die Tatsache, daß er künstlerisch tätig ist, stellt an sich schon einen Wert dar.

Als ich bei Berenice zu Besuch war, zeigte sie mir ihr ganzes Haus. Atelier und Dunkelkammer waren unter dem Dach. Sie hatte dort eine große hölzerne 8 x 10-Zoll-Kamera stehen. Sie sagte: »Eines Tages werde ich nach New York zurückgehen und die City mit diesem verdammten Ding frei aus der Hand fotografieren. Ich schaff' das schon! Ich brauch' kein Stativ! Die Fotos werden so viel aufregender.«

Leider nennen die meisten, die sich in der Geschichte der Fotografie auskennen, Berenice Abbott und Eugene Atget in einem Atemzug. Berenice erwarb nämlich, als sie für Man Ray in Paris arbeitete, die Negative und Abzüge von Atgets Werken; Atget hatte als arbeitsloser Schauspieler die Pariser Straßen, Toreinfahrten, Ladenfassaden, Häuser, Gärten, Gassen und Menschen fotografiert, um die Aufnahmen als Vorlagen an Maler zu verkaufen. Später wurde er als eines der naiven Genies der Frühzeit der Fotografie entdeckt, und da Berenice schon früh sein Werk erworben hatte, wurde sie Kuratorin von Atgets Archiven.

Quand mon avion se posa à Bangor dans le Maine, Berenice était là, à m'attendre. Je l'avais contactée par téléphone quelques semaines plus tôt et elle avait chaleureusement accepté de me rencontrer – la raison étant, peut-être, qu'elle me savait un intime de Man Ray et qu'elle était curieuse d'en savoir plus sur sa vie du moment. Berenice avait été son assistante pendant plus de deux ans à la fin des années vingt. Elle en gardait un souvenir amer ! Elle s'était estimée exploitée, sous-payée par lui. Malgré tout, je sentis que c'était un sentiment d'amour-haine qu'elle éprouvait à son égard.

A cette époque, elle étudiait la sculpture à Paris et, ayant besoin d'argent comme tous les étudiants, elle avait proposé ses services à Man. Selon ses propres termes, elle « *possédait* la photo, comme un canard *possède* l'eau ! », et n'avait plus qu'à jeter les sculptures par la fenêtre ! Berenice Abbott photographe était née.

Pendant qu'elle travaillait pour Man Ray, elle devint vraiment experte de la « chambre noire » et commença à réaliser des portraits durant ses loisirs. Elle me dit : « Il ne m'a jamais montré comment prendre une photo ! Jamais ! Ni comment utiliser les éclairages ou quoi que ce soit d'autre. Mais au fond, je ne voulais pas qu'il me montre. C'était une nouvelle aventure... qui se révéla excellente. »

Berenice me raconta que Man aurait été jaloux de son talent. Celui-ci n'a cependant jamais témoigné de pareilles pensées en ma présence. En fait, Man n'a jamais, devant moi, critiqué le travail d'un artiste. En de nombreuses occasions, je me souviens encore l'entendre me dire « rétrospectivement, tous les artistes sont sacrés ! » Ce qui signifiait qu'il importe peu que l'on aimât ou non leur œuvre ; qu'il s'agisse d'un peintre, d'un poète ou d'un compositeur, le fait de créer se suffisait à lui-même.

Pendant le temps que je passai avec Berenice, elle me fit faire le tour du propriétaire. Son studio-chambre noire se trouvait dans le grenier. Alors que nous étions là, elle se saisit d'un énorme appareil de bois 8x10 et me dit : « Je veux retourner à New York un de ces jours, tenir cette sacrée chose dans les mains et photographier la ville à nouveau. Je peux le faire ! Je n'ai pas besoin de trépied ! Les photos seront plus intéressantes. »

Malheureusement, nombreux sont ceux qui, passionnés d'histoire de la photographie, associent dans une même phrase Berenice Abbot et Atget. En effet, pendant son séjour à Paris et alors qu'elle travaillait pour Man Ray, Berenice se procura les négatifs et les épreuves d'Eugène Atget, cet acteur au chômage qui photographiait les rues, les portes, les devantures de magasins, les maisons, les jardins, les allées, et les gens de Paris... et vendait ces photos aux étudiants des beaux-arts cherchant des modèles. Plus tard, il allait être reconnu comme un génie de l'art photographique naïf, de ce qui fut le premier siècle de la photo. Berenice ayant pris possession du travail d'Atget, elle devint la gardienne et la conservatrice de ses archives.

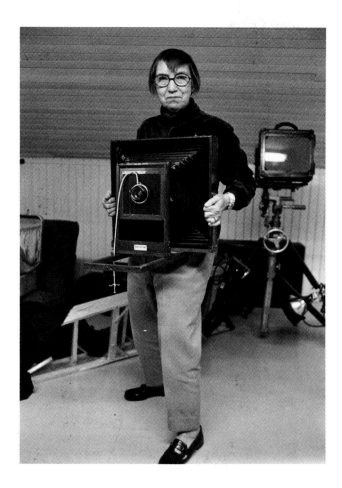 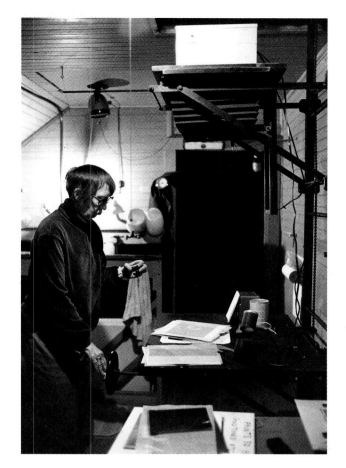

Berenice holding her 8x10-inch wooden view camera which she wanted to »hand hold« to photograph New York, 1968.

Berenice Abbott mit ihrer 8 x 10-Zoll-Kamera aus Holz, mit der sie frei aus der Hand Fotos von New York machen wollte. 1968.

Berenice tenant son appareil en bois de 8x10 pouces, dont elle voulait se servir pour photographier New York. 1968.

I think most art historians and photography curators agree that Berenice Abbott herself was one of the great people of the medium. It's left to our imaginations to ask if she would have been even greater, and done more work, if she had not backed herself into the corner of preserving Atget's place in history. A psychiatrist might say that she was in a prison of her own making, and herself possessed the key. But who can say how choices are taken in life?

I ran into Berenice many times after our first meeting; I always got a big hug.

Ich fragte sie, warum sie sich so hinter Atget versteckt habe. Sie antwortete: »Ich hatte das nicht vor und wollte das auch gar nicht. Aber es ist immer leichter, die Toten zu bewundern als die Lebenden. Die Leute kamen, um sich Atgets Arbeiten anzuschauen, und ich war froh, daß sie überhaupt kamen. Ich hätte alles für ihn getan. Von meinen eigenen Arbeiten verkaufte ich, was ich konnte, aber die Leute wollten Atget!«

Die meisten Kunsthistoriker und Kenner der Fotografie sind sich heute wohl einig, daß Berenice Abbott selbst zu den Großen der Fotografie zählt. Es bleibt unserer Spekulation überlassen, ob sie vielleicht noch bedeutender geworden wäre, noch mehr eigene Werke geschaffen hätte, wenn sie sich nicht so von ihrem Engagement für Atget hätte in Beschlag nehmen lassen. Atget verschaffte sie auf diese Weise einen angemessenen Platz in der Kunstgeschichte. Ein Psychologe würde vielleicht erklären, sie habe in einem selbstgewählten Gefängnis gesessen, zu dem sie den Schlüssel in der Hand hielt. Aber wer weiß schon zu sagen, wie Entscheidungen im Leben zustande kommen.

Ich bin Berenice nach diesem ersten Treffen noch häufig begegnet, und sie begrüßte mich immer sehr herzlich.

Berenice in her darkroom, 1968.

Berenice Abbott in ihrer Dunkelkammer, 1968.

Berenice dans sa chambre noire, 1968.

Je lui demandai la raison pour laquelle elle s'était ainsi sublimée dans le travail d'Atget. Elle me répondit : « Oh! je n'en ai eu ni l'intention ni le désir. C'est toujours plus facile d'admirer ce qui est mort que ce qui est vivant. Les gens venaient voir les épreuves et j'étais très heureuse qu'ils le fissent. Vous savez, j'aurais tout donné pour lui. Je vendais ce que je pouvais de mon propre travail, mais le public voulait Atget ! ».

Aujourd'hui, la plupart des historiens et conservateurs de la photographie reconnaissent en Berenice Abbot un grand nom du milieu. Aurait-elle été plus grande, aurait-elle accompli davantage encore, si elle ne s'était mise en arrière-plan afin de consacrer le nom d'Atget dans l'Histoire ? Un psychiatre dirait qu'elle était à la fois sa propre prison et la gardienne des clés. Mais la vie est une succession de choix !

Je suis bien souvent retourné auprès de Berenice; elle m'a, à chaque visite, serré sur son cœur.

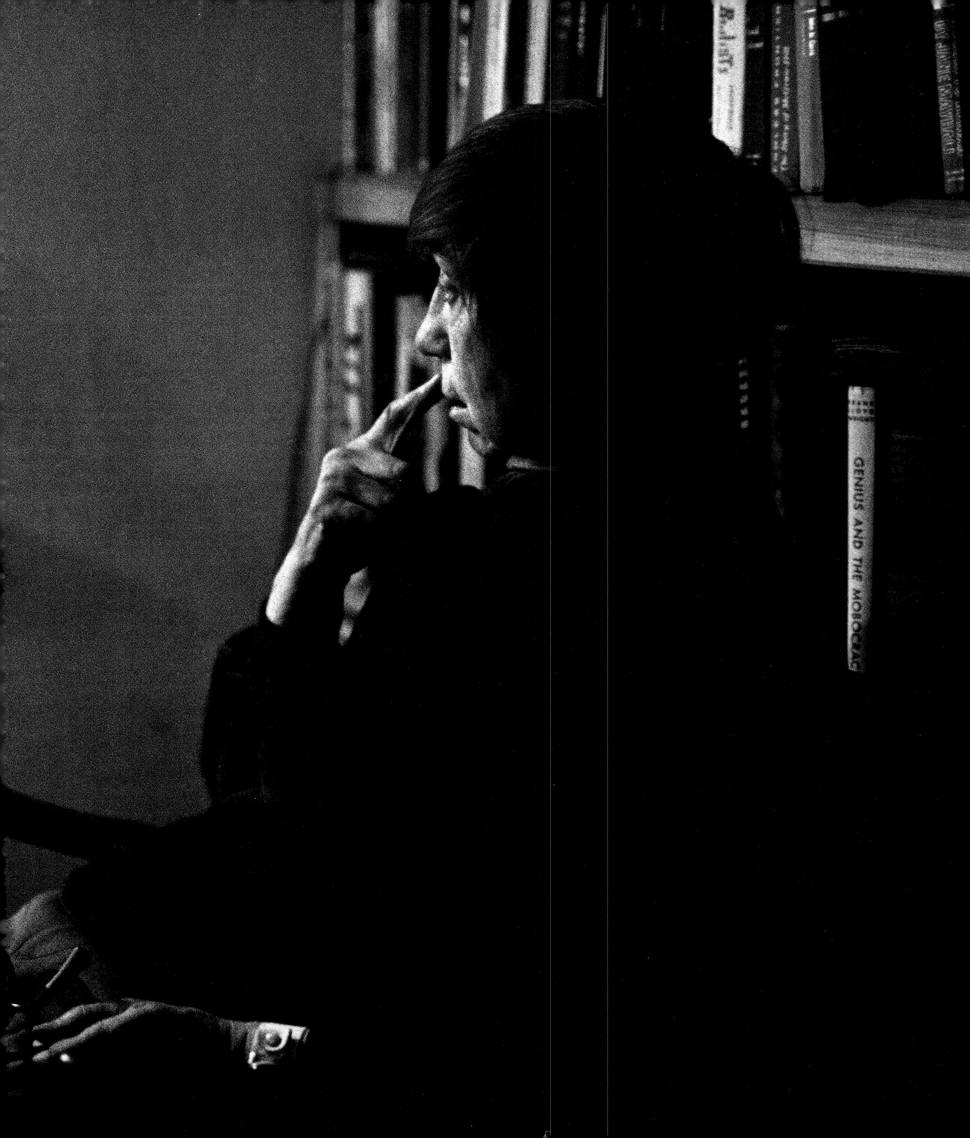

Manuel Alvarez Bravo

Born 1902. Mexican.
Photographer and film maker. Social documentarian of the
Mexican people. Some of his photographs are influenced by
Surrealism.

Geboren 1902. Mexikaner.
Fotograf und Filmemacher. Leistete einen wichtigen
fotografischen Beitrag zur Dokumentation der sozialen
Verhältnisse in Mexiko. In einigen seiner Arbeiten zeigt sich der
Einfluß des Surrealismus.

Né en 1902. Mexicain.
Photographe et cinéaste. Photographe à vocation sociale, il a
immortalisé le peuple mexicain. Quelques-unes de ses
photographies sont influencées par le surréalisme.

Portrait, 1970.

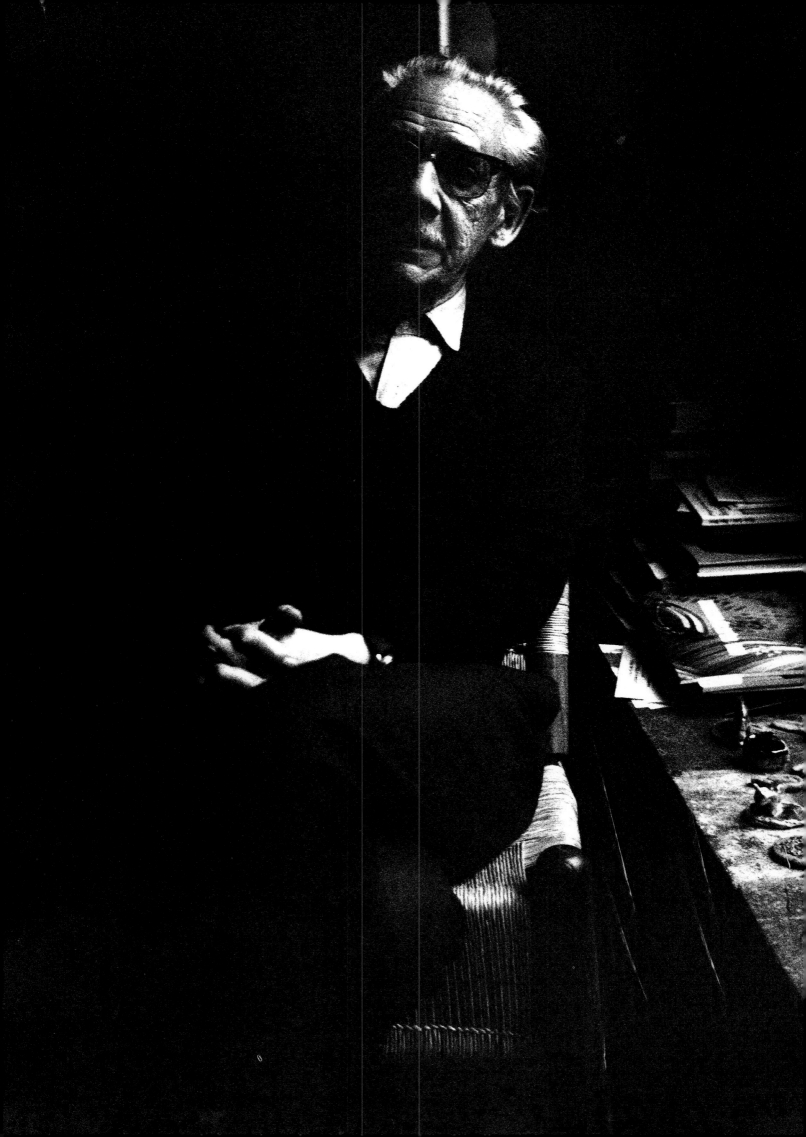

Bravo, one of the great photographers of this century, greeted me at the door of his modest home in Mexico. My visit to him was the briefest of any of the photographers I met in making the pictures for this book.

I also shot only one roll of film. I recall a sense of being confined to one tiny room with a slit of a window which permitted only a minuscule amount of light to illuminate his person. I had no tape recorder that day and I hardly recall whether Bravo spoke any English. I know no Spanish, so I suppose it was English or nothing.

I do remember that Bravo was extremely warm in his manner. During the session, his daughter came into the room while I was photographing her father. She has since become a photographer, but then she was still a loving child.

He took her in his arms; and that was the moment I was trying to capture on film.

Bravo, einer der großen Fotografen des 20. Jahrhunderts, begrüßte mich an der Tür seines bescheidenen Hauses in Mexiko. Es wurde der kürzeste Besuch, den ich für dieses Buch bei einem Fotografen machte.

Ich verschoß auch nur eine Rolle Film. Ich erinnere mich, daß ich den Eindruck hatte, auf einen winzigen Raum mit einem Fensterschlitz beschränkt zu sein, der als Beleuchtung für Bravo nur spärliches Licht ins Zimmer ließ. Ich hatte kein Tonband mitgebracht und weiß nicht einmal mehr, ob er Englisch sprach. Da ich aber kein Spanisch spreche, vermute ich mal, daß es Englisch war.

Bravo war sehr gutmütig und liebenswürdig. Während unserer Sitzung kam seine Tochter herein; ein reizendes Kind. Mittlerweile ist sie selbst Fotografin.

Er nahm sie in die Arme, und das war der Moment, den ich auf Film zu bannen versuchte.

Bravo, l'un des plus grands photographes de ce siècle, m'accueillit à la porte de sa modeste demeure à Mexico. Ma visite chez lui fut la plus brève de toutes celles faites chez les photographes pour réaliser cet ouvrage.

Je n'utilisai d'ailleurs qu'une seule pellicule. Je me souviens avoir pris les photos confiné dans une pièce minuscule, avec une fente en guise de fenêtre n'autorisant que très peu de lumière pour l'éclairage de sa personne.

Je n'avais pas de magnétophone ce jour-là et ne me souviens pas si Bravo parlait anglais. Je ne parle pas espagnol, je suppose donc que nous avons parlé anglais ou rien du tout.

Mais je me rappelle, par contre, qu'il fut très chaleureux. Pendant notre rencontre, sa fille entra dans la pièce au moment où je photographiai son père. Elle allait devenir à son tour photographe, mais en ce temps-là, elle n'était encore qu'une charmante enfant.

Il la prit dans ses bras, et ce fut le moment que je choisis pour capturer son image.

Bravo and daughter, 1970.

Bravo mit seiner Tochter, 1970.

Bravo et sa fille, 1970.

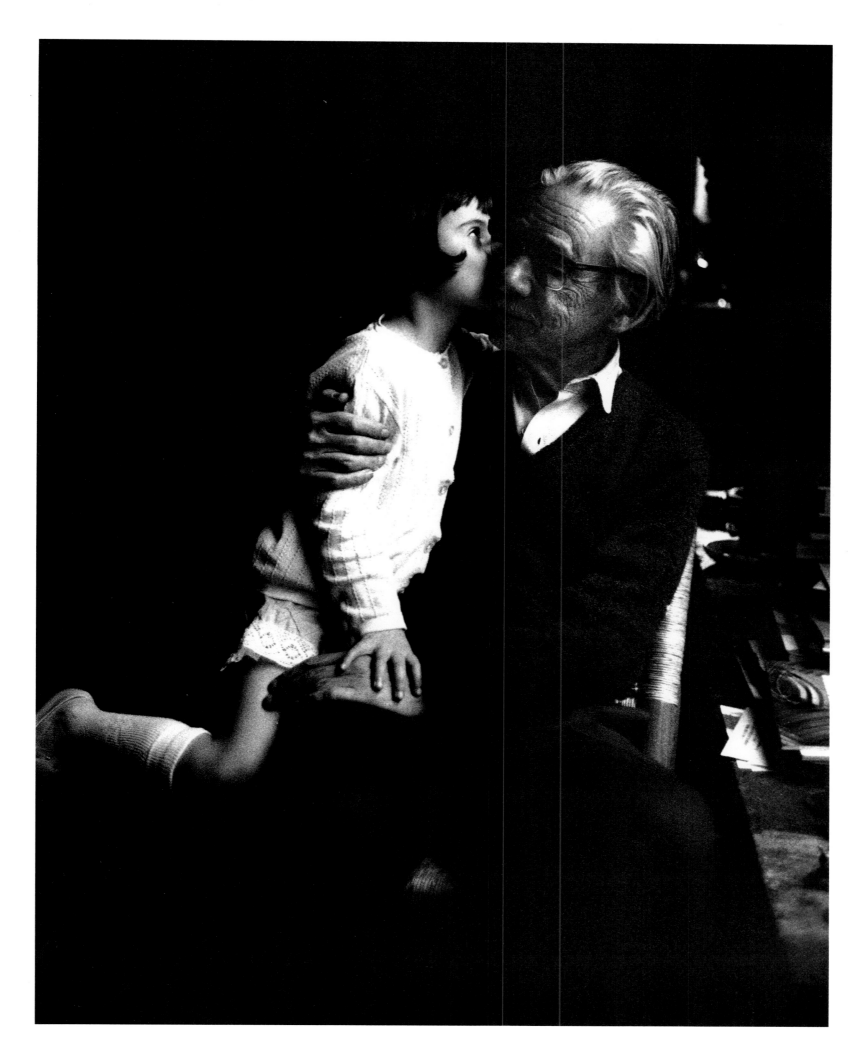

Harry Callahan

Born 1912. American.
Photographer and teacher. Photographed Eleanor, his wife, over
many years, doing portraits and nudes of her. Photographed
high-contrast street scenes and grasses.

Geboren 1912. Amerikaner.
Fotograf und Dozent. Berühmt für die Fotoserie von seiner Frau
Eleanor, die er über Jahre hinweg in Porträt- und Aktaufnahmen
immer wieder im Bild festhielt. Bekannt auch für kontrastreiche
Aufnahmen von Straßenszenen und Gräsern.

Né en 1912. Américain.
Photographe et chargé de cours. Il photographia Eleanor, sa
femme, au fil des années, exécutant portraits et nus de cette
dernière. Ses photos de scènes de rue et de pelouses riches en
contrastes sont également connues.

Portrait, 1968.

I went to Providence on a beautiful day just to photograph Harry Callahan.

I recall my camera shutter almost being louder than Harry. He is a very quiet man. I was received by him and his wife Eleanor at their home, and Harry graciously permitted me to photograph his home and his darkroom as well as himself. Our conversations turned mainly around mutual friendships and acquaintances, including his friend Aaron Siskind, and his affiliation with the Rhode Island School of Design. Harry, being very quiet, was self-conscious when I attempted to photograph him at home, so I suggested we leave and go out to lunch. We went to a local bar that Harry knew and that is where I made my favorite images of him.

We had lunch and Harry, seeming to know some of the locals, got into a number of conversations at the bar. He then suggested we go over to RISD (pronounced »Riz-Dee«) where he was scheduled to conduct a graduate seminar. I managed to make a few photographs at RISD, thanked Harry and went back home to Chicago.

I've had no subsequent personal contact with Harry Callahan, though I understand he is well, living in Atlanta, and still working – in fact, working every day – photographing in color.

Es war ein wunderschöner Tag, als ich nach Providence fuhr, um Harry Callahan zu fotografieren.

Ich hatte dabei das Gefühl, daß der Verschluß meiner Kamera lauter war als Harry; er ist ein sehr stiller Mensch. Er und seine Frau empfingen mich in ihrem Haus, und Harry erlaubte mir freundlicherweise, sein Heim, seine Dunkelkammer und ihn selbst zu fotografieren. Wir unterhielten uns hauptsächlich über gemeinsame Bekannte und Freunde, insbesondere über seinen besten Freund Aaron Siskind, sowie über seine Arbeit an der Rhode Island School of Design (RISD). Weil Harry ein zurückhaltender und bescheidener Mensch ist, war er recht verlegen, als ich ihn fotografierte; ich schlug deshalb vor, essen zu gehen. Wir gingen in ein Restaurant in der Nähe, das Harry vertraut war, und dort glückten mir meine Lieblingsbilder von ihm.

Während des Essens unterhielt sich Harry mit einigen Bekannten. Dann schlug er vor, zur RISD zu fahren, wo er ein Seminar halten sollte. Ich machte noch ein paar Fotos an der RISD, bedankte mich bei Harry und fuhr nach Chicago zurück.

An diesem Tag - der mir nur noch sehr vage in Erinnerung ist - war meine Hand ruhig, und meine Negative wurden gestochen scharf.

Ich habe Callahan danach nie mehr wiedergesehen, doch ich hörte, daß er jetzt in Atlanta lebt und arbeitet. Er macht vor allem Farbaufnahmen und fotografiert Tag für Tag.

Je me rendis à Providence par une belle journée, pour photographier Harry Callahan.

Je me souviens que l'obturateur de mon appareil faisait presque plus de bruit qu'Harry. C'était un homme extrêmement discret. Je fus accueilli chez eux par sa femme, Eleanor, et lui-même. Harry m'autorisa très gentiment à prendre des photos de leur intérieur, de sa chambre noire aussi bien que de lui-même. Notre conversation tourna principalement autour de relations ou d'amis communs, tel son meilleur ami Aaron Siskind et l'affiliation de ce dernier avec la Rhode Island School of Design (RISD). Harry étant très introverti et modeste, il était embarrassé quand je le photographiai, aussi je suggérai d'aller déjeuner quelque part. Nous nous rendîmes dans un bar-restaurant qu'Harry connaissait, et ce fut là que je pris de lui mes photos préférées.

Nous déjeunâmes, puis Harry, apparemment un habitué du bar, discuta avec des connaissances. Il proposa ensuite de nous rendre au RISD (prononcer « Riz-Di ») où il était attendu pour animer un séminaire d'étudiants diplômés. Je m'arrangeai pour prendre encore quelques photos au RISD, remerciai Harry et rentrai chez moi, à Chicago.

Bien que cette journée soit très floue dans mon esprit, Dieu merci, mes mains furent suffisamment habiles et réalisèrent des négatifs parfaitement nets !

Je n'ai plus revu Harry Callahan depuis, mais je sais qu'il va bien, qu'il vit à Atlanta et continue à travailler – en fait tous les jours –, en photographiant en couleur.

Callahan's darkroom, 1968.

Callahans Dunkelkammer, 1968.

La chambre noire de Callahan, 1968.

Harry Callahan at the Rhode Island School of Design where he taught, 1968.

Harry Callahan an der Rhode Island School of Design, an der er einen Lehrauftrag hatte. 1968.

Harry Callahan à la Rhode Island School of Design où il enseignait, 1968.

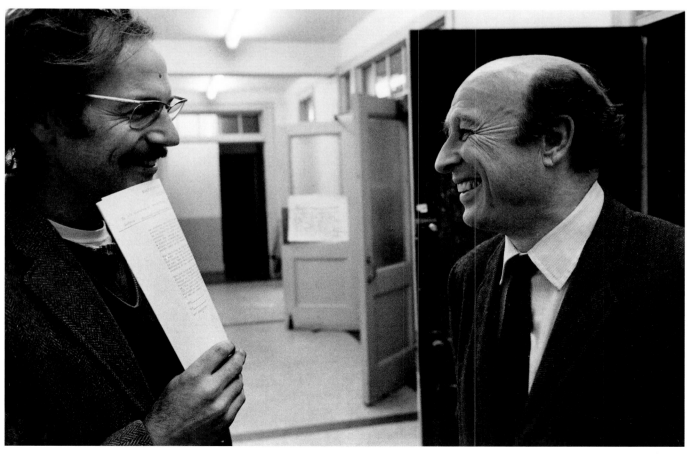

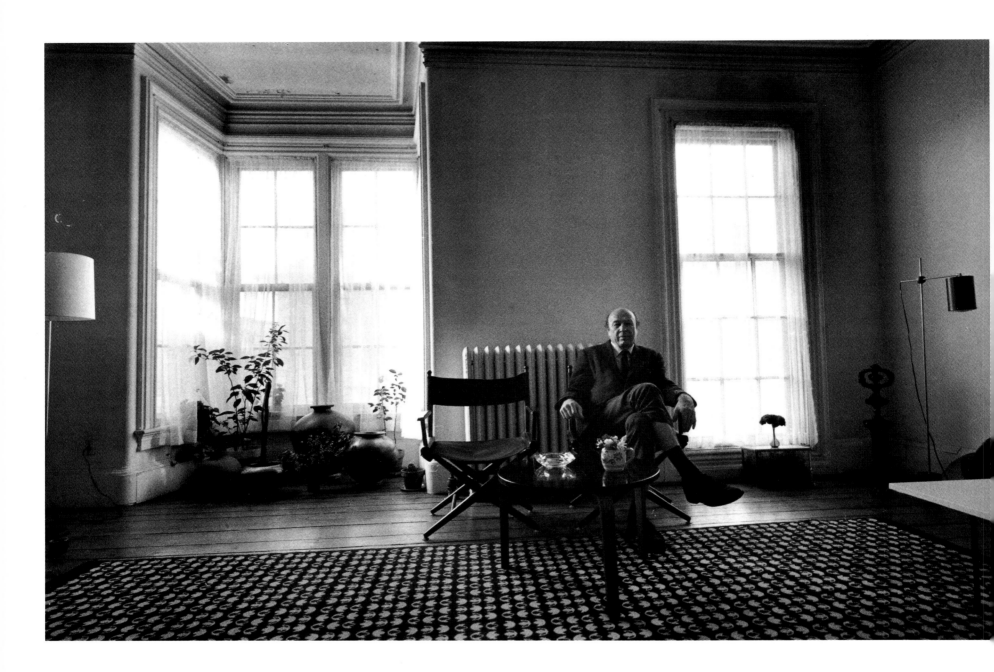

△ ▷ Callahan in his living room, 1968.

Callahan in seinem Wohnzimmer, 1968.

Callahan dans sa salle de séjour, 1968.

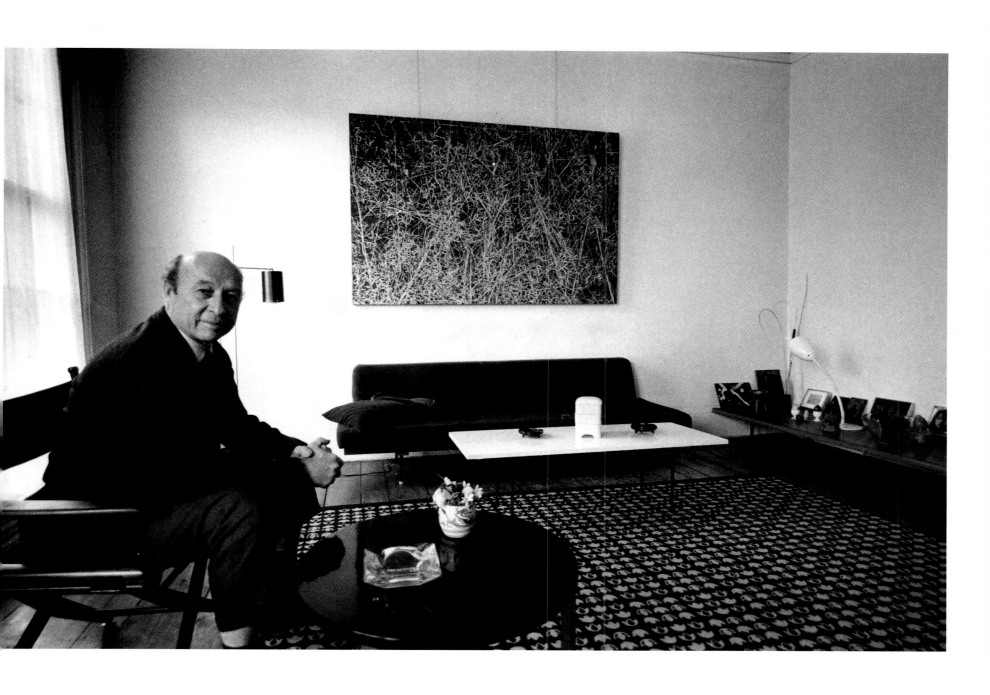

Callahan in his upstairs hallway, 1968.

Callahan in seinem Hausflur, 1968.

Callahan sur l'escalier du corridor, 1968.

Callahan walking in Providence, Rhode Island, 1968.

Callahan beim Spaziergang in Providence, Rhode Island, 1968.

Callahan se promenant dans Providence, Rhode Island, 1968.

△ ▷ At a pub in Providence, Rhode Island, 1968.

In einem Pub in Providence, 1968.

Dans un café à Providence, Rhode Island. 1968.

Callahan and an unnamed
colleague socializing
in a local pub, 1968.

Callahan und ein Kollege
beim Gespräch in einem
Pub, 1968.

Callahan et un collègue
discutant dans un café,
1968.

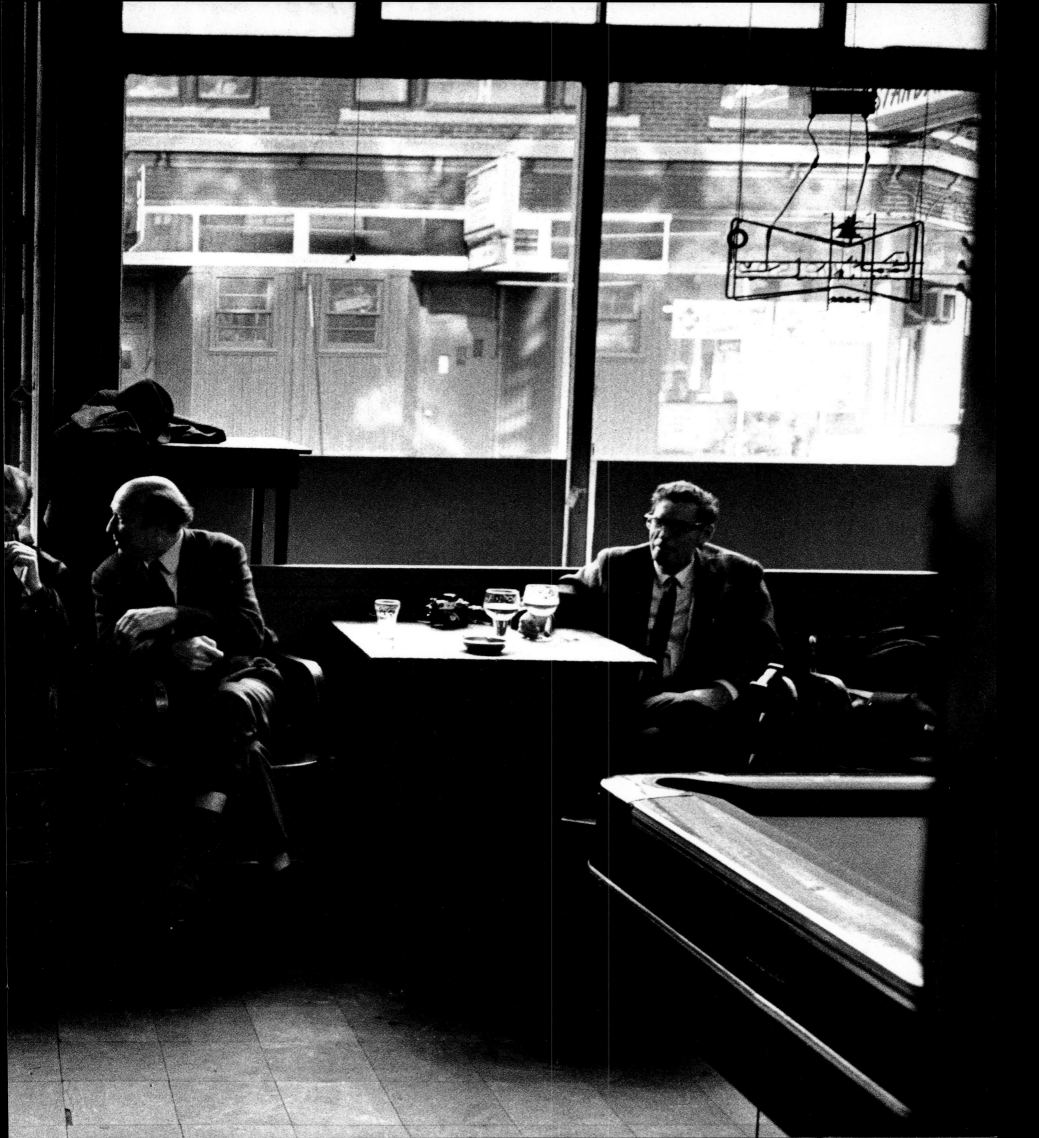

Aaron Siskind

1903–1991. American.
Photographer and teacher. His photographs were likened to
Abstract Expressionist paintings. He photographed the
deteriorating external surfaces of buildings and fences, e.g.
peeling paint. Taught at the Institute of Design, Chicago and the
Rhode Island School of Design.

1903–1991. Amerikaner.
Siskind war Fotograf und Dozent. Seine Fotografien werden oft
mit der abstrakten expressionistischen Malerei verglichen. Er
fotografierte Details von verfallenden Mauern oder von Zäunen,
zum Beispiel abblätternde Farbe. Er lehrte am Institute of Design
in Chicago und an der Rhode Island School of Design in
Providence.

1903–1991. Américain.
Photographe et chargé de cours. Ses photographies furent
souvent comparées à la peinture expressioniste abstraite. Il
photographia les dégradations extérieures d'immeubles, de
clôtures, comme par exemple les peintures écaillées. Il enseigna à
l'Institute of Design à Chicago et à la Rhode Island School of
Design.

Portrait, 1969–72.

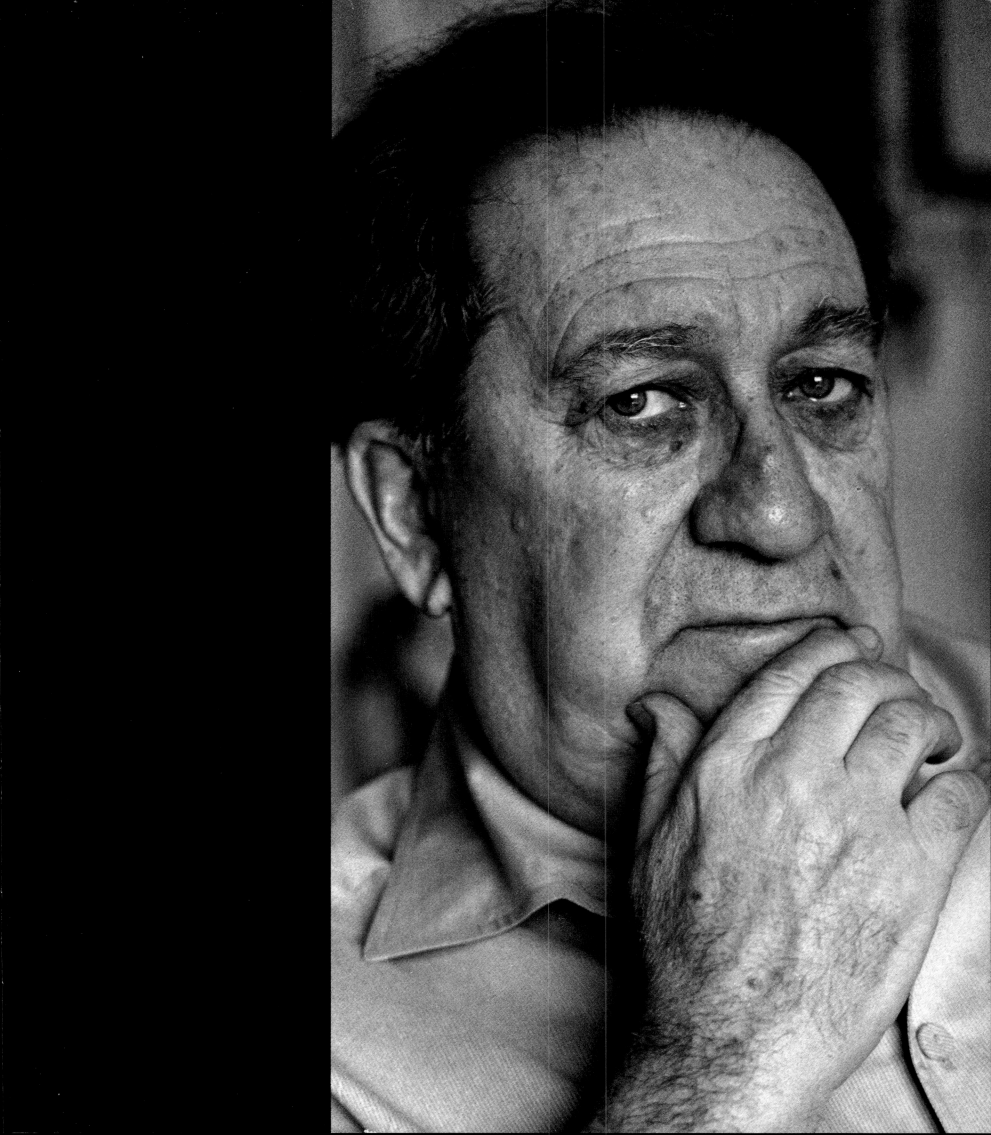

He was of medium height, broadly built. He spoke perfect »New Yorkese,« and he never missed a smartly turned woman's ankle passing within his view.

He taught photography in Chicago for many years and then moved on to the Rhode Island School of Design. When I learned Aaron was leaving Chicago and going on to work at RISD, I decided that I needed to seize the moment and photograph him at his long-time home while I still had the chance.

Aaron's work was very influential. His »Levitation« series of photographs of people hanging in space, his torn photographs of abstract pottery and of string, and, most importantly, his photographs of details of old buildings – peeling paint, peeling posters, crags, fissures, weathering, and decay – all contributed to Siskind being the transitional figure between photography and the Abstract Expressionist Painters, and one of the most »painterly« of all photographers.

Aaron war mittelgroß und breitschultrig. Er sprach ein perfektes New Yorkerisch und schaute allen hübschen Frauenbeinen in seiner Nähe mit Wohlgefallen nach.

Er lehrte viele Jahre lang in Chicago Fotografie und ging dann zur Rhode Island School of Design (RISD). Als ich hörte, daß Aaron Chicago verlassen und zur RISD wechseln wollte, beschloß ich, die Gelegenheit beim Schopf zu ergreifen, und ihn in seiner alten und gewohnten Umgebung zu fotografieren, solange es noch möglich war.

Aarons Arbeit war richtungsweisend. Seine Levitationsserie mit Fotos von Menschen, die frei im Raum schweben, seine zerrissenen Fotos von abstrakter Töpferkunst und Bindfaden, und insbesondere seine Fotos mit Details von alten Gebäuden – abblätternde Farbe, abblätternde Poster, Risse, verwitterte Steine und Verfall – all das machte Siskind zum Mittler zwischen Fotografie und abstrakter expressionistischer Malerei und zu einem der »malerischsten« Fotografen.

De stature moyenne et largement bâti, il s'exprimait en pur « new-yorkais » et n'aurait jamais manqué de remarquer une cheville bien faite lorsqu'il croisait une jolie femme.

Il enseigna la photographie à Chicago pendant des années, puis à la Rhode Island School of Design (RISD) par la suite.

Quand j'appris qu'Aaron quittait Chicago pour poursuivre son travail au RISD, je sentis que le moment était venu de saisir ma chance et de capturer son image.

Le travail d'Aaron eut une grande influence. « Lévitation », sa série de photos de gens suspendus dans l'espace, d'autres déchirées montrant des poteries et des cordes d'une façon abstraite, ou bien encore celles nous livrant les peintures écaillées des vieux immeubles, les affiches arrachées, les rochers à pic, les fissures, l'érosion, les ruines, c'est tout cela qui a contribué à faire de Siskind l'auteur de la transition entre la photographie et la peinture expressionniste abstraite d'une part, et le plus pictural des photographes d'autre part.

Portraits, 1969–72.

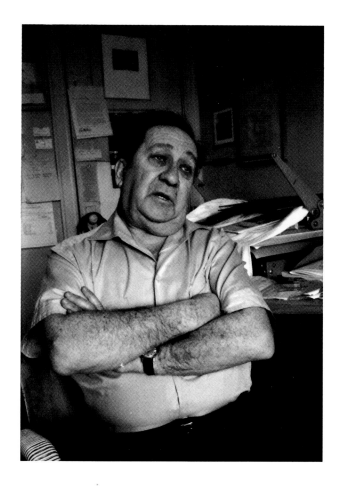

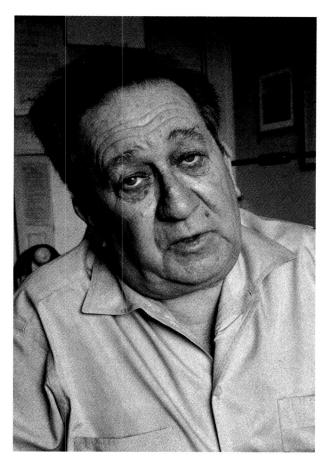

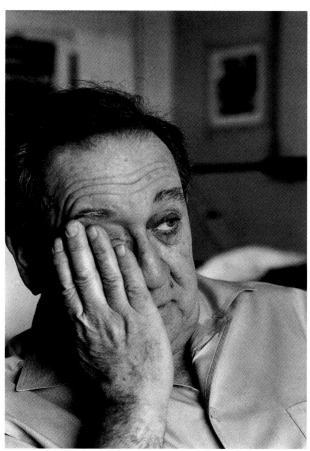

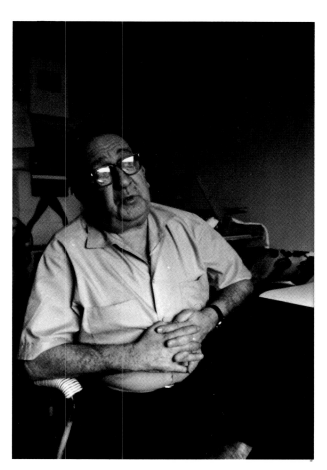

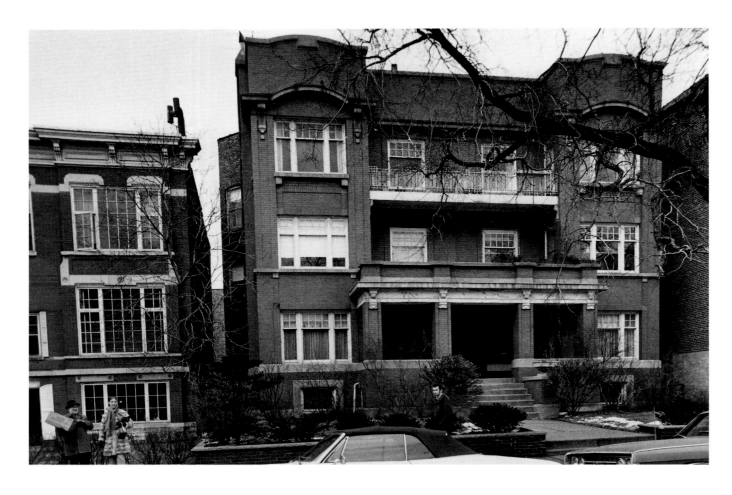

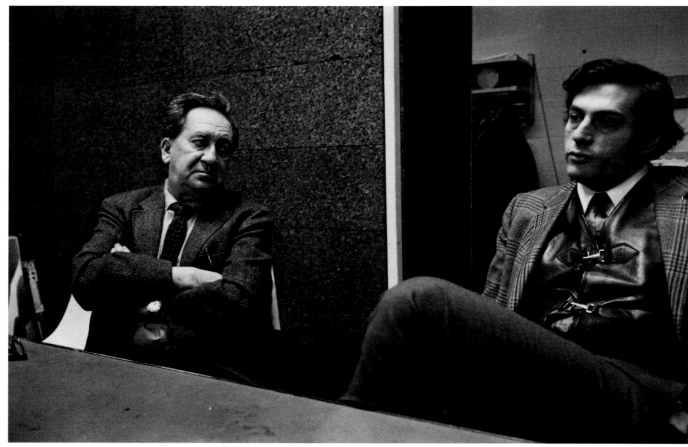

◁ The Chicago apartment where Siskind lived, 1969–72.

Siskinds Apartment in Chicago, 1969–1972.

L'appartement de Chicago, 1969–1972.

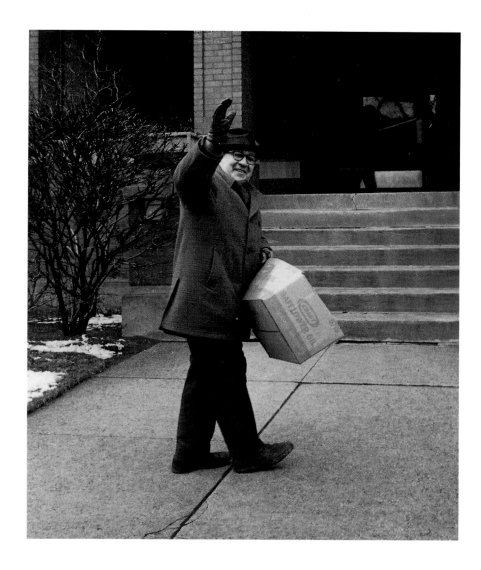

Waving goodbye to me,
1969–72.

Siskind winkt mir hinterher,
1969–1972.

Il me salue et prend
congé, 1969–1972.

Siskind outside his Chicago
apartment, 1969–72.

Siskind vor seinem Apartment
in Chicago, 1969–1972.

Siskind devant son
appartement, 1969–1972.

 Siskind with photographer Ben Fernandez at a seminar at the Institute of Design, Chicago. Fernandez later went on to photograph Martin Luther King and his movement and then became head of the photography department at the new School for Social Research in New York. 1969–72.

Siskind mit dem Fotografen Ben Fernandez bei einem Seminar am Institute of Design in Chicago. Fernandez dokumentierte später Martin Luther Kings Bürgerrechtsbewegung und wurde schließlich Leiter der Abteilung für Fotografie an der New School for Social Research in New York. 1969–1972.

Siskind avec le photographe Ben Fernandez lors d'un séminaire au Institute of Design de Chicago. Fernandez photographiera, plus tard, Martin Luther King et son mouvement, et sera à la tête du département Photographie à la New School for Social Research à New York. 1969–1972.

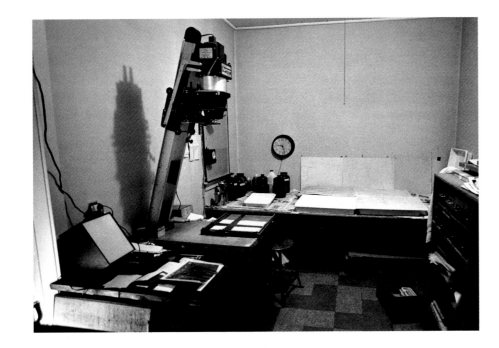

Siskind's darkroom, 1969–72.

Siskinds Dunkelkammer, 1969–1972.

La chambre noire de Siskind, 1969–1972.

Print boxes, 1969–72.

Schachteln mit Abzügen, 1969–1972.

Des boîtes d'épreuves, 1969–1972.

Siskind's desk, 1969–72.

Siskinds Schreibtisch, 1969–1972.

Le bureau de Siskind, 1969–1972.

In his work room at his Chicago apartment, 1969–72.

Im Arbeitszimmer seines Apartments in Chicago,
1969–1972.

Siskind dans l'atelier situé dans son appartement,
Chicago, 1969–1972.

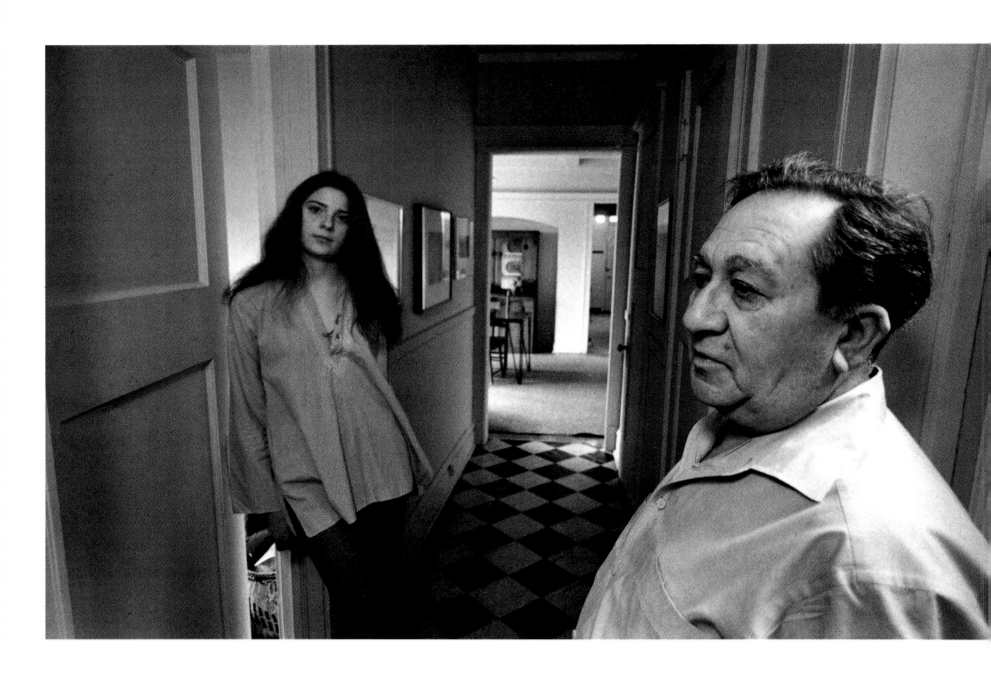

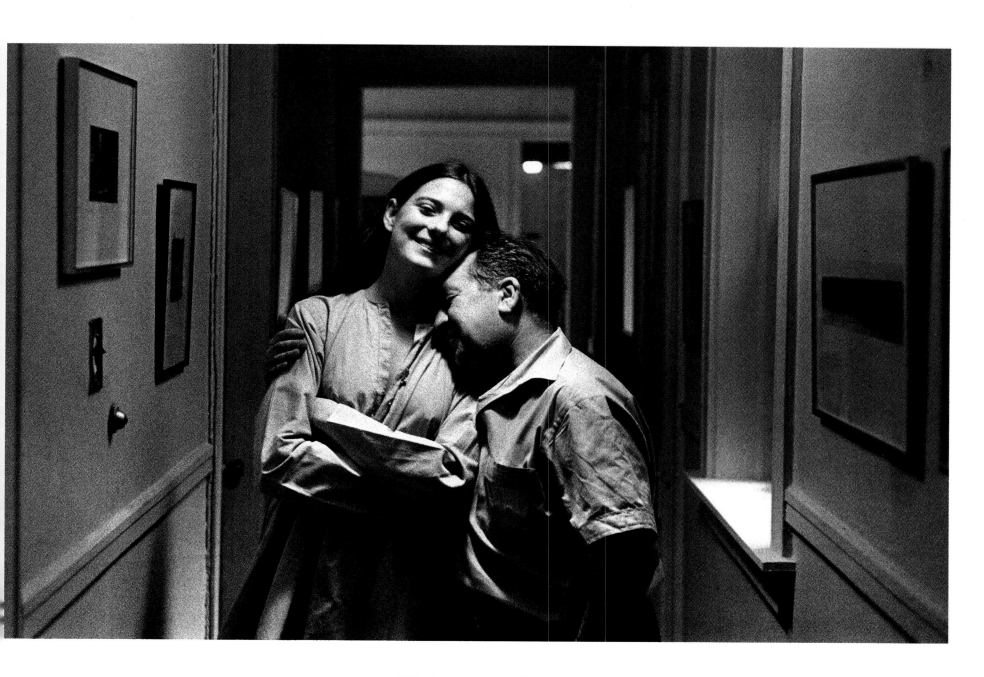

◁ △ With his stepdaughter, 1969–72.

Mit seiner Stieftochter, 1969–1972.

Siskind en compagnie de sa belle-fille, 1969–1972.

Arthur Siegel

1913–1978. American.
Photographer and teacher. Was a freelance photographer for
magazines (*Time, Life* and *Fortune*). His photograms remain
among his best known works. He was Chairman of the
Photography Department, Institute of Design, Chicago
(1971–78).

1913–1978. Amerikaner.
Fotograf und Dozent. Arbeitete als freier Fotograf für *Time, Life*
und *Fortune*. Besonders berühmt wurde er mit seinen
Fotogrammen. Von 1971 bis 1978 war er Leiter des Department
of Photography am Institute of Design in Chicago.

1913–1978. Américain.
Photographe, chargé de cours. Il fut photographe indépendant
pour les magazines *Time, Life* et *Fortune*. Ses photogrammes
sont les plus connus de ses travaux. Il fut directeur du
département Photographie de l'Institute of Design de Chicago
(1971–1978).

Arthur Siegel in a Chicago bookstore, 1978.

Arthur Siegel in einer Chicagoer Buchhandlung, 1978.

Arthur Siegel dans une librairie de Chicago, 1978.

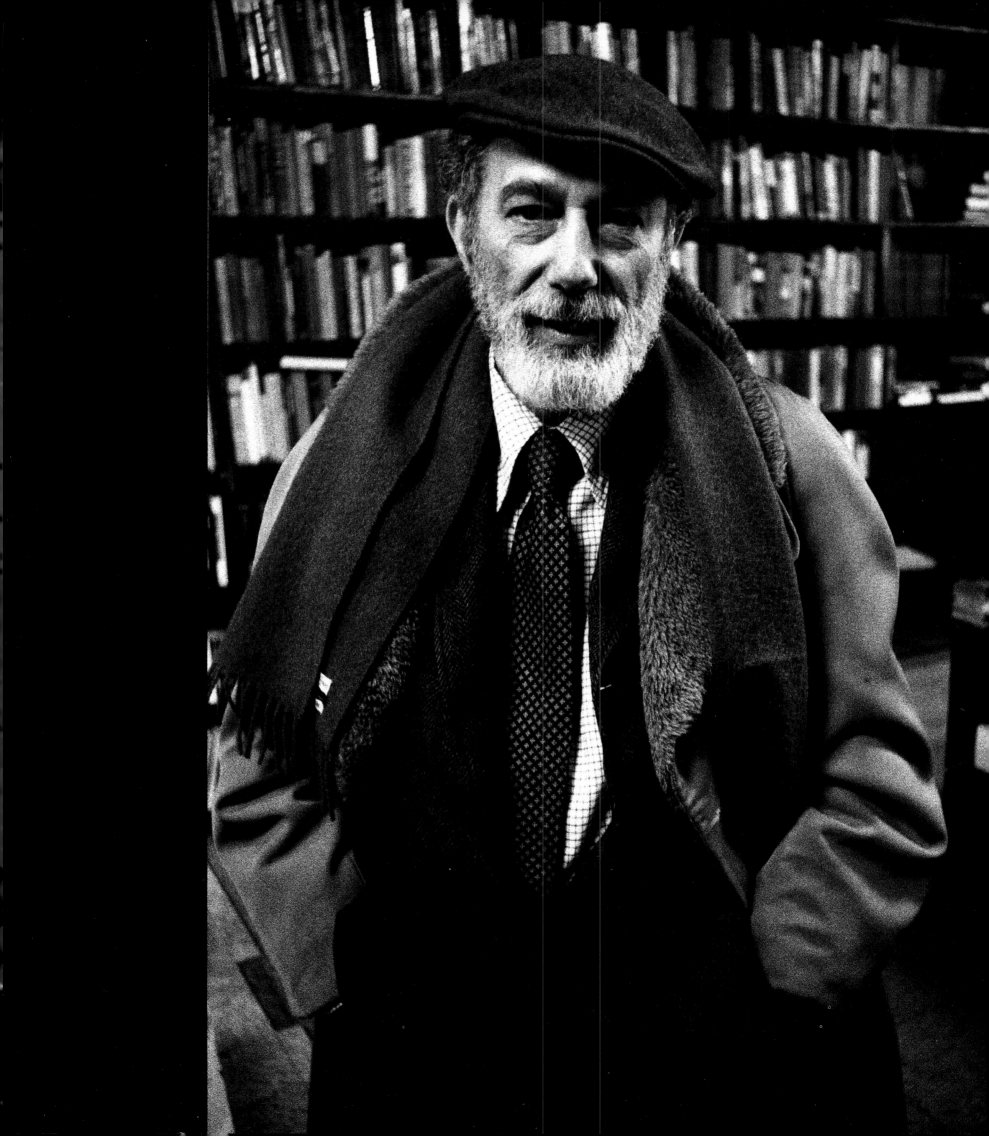

Every one of the great photographers I've known influenced me to some degree, but my friend Arthur Siegel helped to form my vision.

I was 21 years old. Having just graduated from law school, and waiting to take the bar exam, I took a job as an insurance adjuster for the company that handled the Lloyd's of London group. By that time, I had already photographed murders, fires, and a drowning as a freelance photographer, plus more than 600 weddings. But I still didn't consider myself a photographer. To me, at the time, a photographer either worked for the magazines – *Time, Life, National Geographic* or *Look* – or else was a full time staffer for one of the major metropolitan daily newspapers.

I met the Siegels when my supervisors assigned a claim to me, the injured party being one Irene Siegel who had slipped and fallen while in the hospital after giving birth to a child – Ezra, one of their sons. Immediately upon entering the Siegels' home, a small brownstone on Chicago's north side, I saw a Hasselblad camera perched on a shelf just inside the door and was greeted by a man who introduced himself as Arthur Siegel. I was awestruck! He worked for *Time!* Now *here* was a photographer! And there I was, in his home.

It was then that I asked him what, for me, probably became the most important photographic question I ever asked. I said: »Mr. Siegel, how can I become a photographer?« He looked me over, then took me over to his bookshelves which covered almost an entire wall of his living room – pointed to the books and said: »Just look at pictures!« I never forgot that admonition. As the years progressed, I gave up photography for almost 10 years in order to devote myself to the practice of law (in some ways a mistake), but I always continued to collect

Alle großen Fotografen, die ich kennengelernt habe, haben mich bis zu einem gewissen Grad beeinflußt, aber mein Freund Arthur Siegel hat meine künstlerische Sicht geformt.

Ich war 21 Jahre alt und hatte gerade mein Jura-Studium an der Universität abgeschlossen. In der Zeit bis zu meiner Rechtsanwaltsprüfung nahm ich einen Job als Versicherungssachverständiger für eine Gesellschaft an, die für Lloyd's of London tätig war. Ich hatte damals wie gesagt schon als freiberuflicher Fotograf Morde, Brände und eine Wasserleiche fotografiert – und außerdem zahllose Hochzeiten. Trotzdem betrachtete ich mich noch nicht als Fotograf. Für mich war ein Fotograf jemand, der entweder für Illustrierte arbeitete – etwa *Time, Life, National Geographic* oder *Look* – oder als Angestellter für eine der großen Tageszeitungen arbeitete.

Die Siegels traf ich, als ich den Auftrag bekam, mich mit dem Versicherungsfall einer gewissen Irene Siegel zu beschäftigen, die kurz nach der Geburt ihres Sohnes Ezra im Krankenhaus ausgerutscht und gestürzt war. Kaum hatte ich das rotverklinkerte Häuschen der Siegels im Norden Chicagos betreten, fiel mir eine Hasselblad auf einem Regal am Eingang auf, und der Mann, der mich begrüßte, stellte sich als Arthur Siegel vor. Ich war hingerissen! Er arbeitete für *Time,* ein Vollblutfotograf! Und ich in seiner Wohnung!

Damals stellte ich ihm meine wichtigste Frage über Fotografie: »Mr. Siegel, wie kann ich Fotograf werden?« Er musterte mich von oben bis unten, dann führte er mich zu seinen Bücherregalen und sagte: »Schauen Sie sich Bilder an, weiter nichts.« Diesen Rat habe ich nie vergessen. Viele Jahre später gab ich die Fotografie für fast zehn Jahre ganz auf und arbeitete als Rechtsanwalt – was sich in mancher Hinsicht als Fehler herausstellte –, aber

Chacun des grands photographes que j'ai connu m'a influencé d'une manière ou d'une autre, mais mon ami Arthur Siegel fut celui qui forgea ma vision.

J'avais 21 ans. Fraîchement diplômé de la faculté de Droit et dans l'attente de passer mon examen d'avocat, je pris un job de médiateur dans une compagnie d'assurances tenue par le groupe Lloyd's London. A cette époque photographe indépendant, j'avais déjà pris des incendies, des noyades, des malfaiteurs, et plus de 600 mariages ! Malgré cela je ne me considérais pas comme photographe. Pour moi, à cette époque, être photographe signifiait travailler pour le *Time, Life, National Geographic* ou encore *Look,* ou bien appartenir à plein temps à l'équipe d'un célèbre quotidien.

Je rencontrai les Siegel lorsque mes employeurs me chargèrent de régler un dossier dont la protagoniste et victime, une certaine Irene Siegel, avait glissé puis était tombée au cours d'un séjour à la maternité pour la naissance d'un de ses fils, Ezra. En entrant chez les Siegel, une petite maison en briques au nord de Chicago, j'aperçus immédiatement un appareil Hasselblad perché sur une étagère, et fus accueilli par un homme qui se présenta comme Arthur Siegel. J'étais très impressionné ! Il travaillait pour le *Time* ! Et j'étais là, chez lui.

Ce fut alors que je lui posai la question, pour moi essentielle : « Mr Siegel, comment puis-je devenir photographe ? » Il me regarda puis me montra les étagères qui couvraient pratiquement tous les murs du salon, pointa les livres d'un geste de la main et dit : « Regardez simplement les images ! ». Je ne devais jamais oublier cette exhortation ! Le temps passa. Une dizaine d'années durant, je délaissai la photographie pour me consacrer au droit (dans un

Arthur with my camera. This photograph and the others in this section captioned »at home« were taken shortly before Siegel's untimely death. Arthur knew he was fatally ill and invited me to his home for dinner. This was the last time I was to see my friend. 1978.

Arthur mit meiner Kamera. Dieses und andere Fotos habe ich kurz vor seinem Tod gemacht. Arthur wußte, daß er unheilbar krank war. Bei einem Abendessen habe ich meinen Freund zum letzten Mal gesehen. 1978.

Arthur avec mon appareil-photo. Cette photographie et d'autres ont été prises peu de temps avant la mort d'Arthur. Arthur se savait atteint d'un mal incurable et m'invita à dîner peu de temps avant qu'il ne s'éteigne. Ce fut la dernière fois que je le vis. 1978.

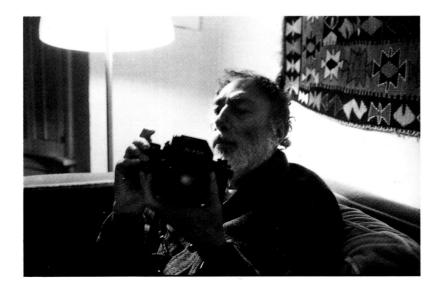

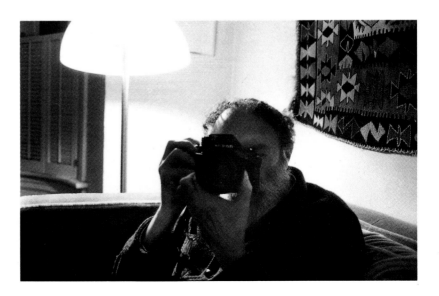

books and photographs – as I had done from the time I was fifteen.

During those years, I often would telephone Arthur to seek counsel and advice as to whether or not a certain acquisition was important for my collection. He was always available to me. After I began to photograph again in the late 1960s, we continued our friendship, which lasted until his death. He was enormously encouraging to me after seeing my own pictures of the great photographers and insisted that I keep careful notes of my meetings with them. He knew, I suppose, that someday this book would result from my project.

Arthur served for many years as the head of the Department of Photography at the Illinois Institute of Technology in Chicago, the successor to the New Bauhaus. Arthur was also a disciple of Moholy-Nagy; he had a close friendship with Aaron Siskind and Harry Callahan and was himself a brilliant critic of photographs. His opinions were well thought-out, and when he believed that one of the »great photographers« had gotten an overblown reputation, he was unmerciful in his own analysis of their achievement.

In October of 1976, the editor of *The New Art Examiner* telephoned me. He said: »Arnold, we're calling a dozen or so of Chicago's ›movers and shakers‹ in the arts and asking them what they would like to see in the arts in the New Year.« Thinking most photography schools a waste of a student's time, I glibly said I would like to close all the photography schools and to make all the former students go out onto the streets with their cameras to learn how to photograph.

The next edition of *The New Art Examiner* came out in December with my words quoted *in bold letters* above the mast-head. I was rather proud of myself – until several weeks later when I phoned to speak with Arthur. Irene answered the phone, and when she realized it was me said: »Don't ever call here again!« and slammed the receiver down! I had not considered that my good friend made his living teaching, and that, were my suggestions followed, Arthur would have been out of a job. With the passing of time, though, Irene forgave me.

Arthur will probably best be remembered as a great teacher of photography. But he was also an extremely fine photographer; his photograms are the works for which he will be best remembered. During his lifetime, Arthur was well recognized an educator.

All the years that I knew Arthur I enjoyed a wonderful friendship with him. I was invited to the Siegels' for dinner very near the time Arthur died of cancer. Irene had become a respected artist by that time, known for her meticulously executed drawings. The profile of Arthur with Irene in the background was taken at the time of that visit. I was in France when Arthur died, and will always regret that I couldn't return in time to attend his memorial service.

ich hörte nie auf, Fotos und Bücher zu sammeln – und das seit meinem 15. Lebensjahr.

Ich rief Arthur oft an und bat ihn um Rat bei Anschaffungen für meine Sammlung. Er nahm sich immer Zeit für mich. Als ich Ende der sechziger Jahre wieder zu fotografieren begann, blieb unsere Freundschaft bestehen; sie endete erst mit seinem Tod. Er machte mir sehr viel Mut, nachdem er meine Porträts der großen Fotografen gesehen hatte, und riet mir eindringlich, mir sorgfältig Notizen über meine Treffen mit ihnen zu machen. Wahrscheinlich ahnte er schon, daß meine Arbeit eines Tages in einem Buch münden würde.

Arthur arbeitete viele Jahre lang als Chef des Department of Photography am Illinois Institute of Technology in Chicago, dem Nachfolgeinstitut des legendären New Bauhaus. Arthur war auch ein Freund und Schüler von Moholy-Nagy, er war eng befreundet mit Aaron Siskind und Harry Callahan; man schätzte ihn als hervorragenden Fotokritiker. Seine Urteile waren immer wohlbegründet, und wenn er glaubte, daß einer der »großen Fotografen« überbewertet wurde, war er gnadenlos in seiner Analyse ihrer Leistungen.

Im Oktober 1976 rief mich der Herausgeber des Magazins *The New Art Examiner* an. Er sagte: »Arnold, wir machen gerade eine Telefonumfrage bei einem Dutzend der wichtigsten Persönlichkeiten in der Chicagoer Kunstszene. Wir wollen wissen, was sie sich für die Kunst im nächsten Jahr wünschen.« Da ich die meisten Fotoschulen für Zeitverschwendung halte, sagte ich frei heraus, daß ich gern alle Fotoschulen schließen und die Studenten mit ihren Kameras auf die Straße schicken würde, weil sie nur dort wirklich fotografieren lernen könnten!

Die nächste Ausgabe des *New Art Examiner* erschien im Dezember, und meine Worte standen fettgedruckt (!) über dem Impressum. Ich war recht stolz, zugegeben – bis ich einige Wochen später bei Arthur anrief. Irene kam ans Telefon: »Du brauchst dich bei uns nie wieder zu melden!« und knallte den Hörer auf die Gabel. Ich hatte völlig vergessen, daß mein guter Freund Arthur seinen Lebensunterhalt auch als Foto-Dozent verdiente und daß ich ihn mit meiner Idee hätte arbeitslos machen können. Nach einiger Zeit aber war Gras über die Sache gewachsen, und wir verstanden uns wieder gut.

Arthur wird als großer Lehrer der Fotografie wohl unvergessen bleiben. Aber er war auch selbst ein außergewöhnlicher Fotograf, und seine Fotogramme sind von hohem Rang. Unsere Freundschaft war wunderbar.

Kurz bevor Arthur an Krebs starb, war ich bei den Siegels zum Abendessen. Irene war zu diesem Zeitpunkt schon mit ihren akribisch genauen Zeichnungen bekannt geworden. Meine Fotoporträts von Arthur entstanden bei diesem Besuch.

Als Arthur starb, war ich in Frankreich, und noch heute schmerzt es mich, daß ich nicht rechtzeitig zu seiner Beerdigung zurückkehren konnte.

sens ce fut une erreur), mais je continuai à collectionner livres et photos, comme du temps de mes quinze ans.

Durant toutes ces années, je téléphonai souvent à Arthur pour recueillir ses conseils et son avis à propos d'éventuelles acquisitions importantes ou non pour ma collection. Il était toujours disponible pour moi. Je me remis à la photo dans les années soixante, mais notre amitié ne cessa jamais et se poursuivit jusqu'à sa mort. Après avoir vu des épreuves que j'avais faites de célèbres photographes, il m'encouragea vivement à conserver précieusement les notes de chacune de ces rencontres. Il eut, je pense, l'intuition qu'un jour ce livre serait l'aboutissement de mon projet.

Arthur resta de longues années à la tête du département Photo à l'institut illinois de Technologie de Chicago, le successeur du nouveau Bauhaus. Il était également disciple de Moholy-Nagy, ami intime de Aaron Siskind et Harry Callahan ; enfin, il était lui-même un brillant critique de photographie. Ses opinions étaient très respectées et, quand il sentait qu'un « grand photographe » jouissait d'une réputation surfaite, il se montrait sans pitié dans sa critique.

En octobre 1976, l'éditeur du magazine *The New Art Examiner* me téléphona. Il me dit : « Arnold, nous contactons actuellement une douzaine de ceux qui " font " l'art à Chicago pour leur demander ce qu'ils ont envie de voir dans l'année à venir. » Comme je pensais que les écoles de photographie ne sont pas autre chose que du temps perdu pour les étudiants, je proposai sans hésitation de toutes les fermer et d'envoyer les étudiants dans les rues armés de leurs appareils afin qu'ils apprennent vraiment à photographier !

La nouvelle édition du *New Art Examiner* sortit en décembre avec ces mots en gros titre. J'étais plutôt fier de moi, du moins jusqu'au jour où je voulus joindre Arthur au téléphone. Ce fut Irene qui décrocha et, lorsqu'elle réalisa qui j'étais, elle me dit : « N'appelle plus jamais ici ! », et me raccrocha au nez ! Je n'avais pas réalisé que mon ami enseignait la photographie et que si ma proposition avait été entendue, il se serait retrouvé sans travail ! Le temps arrangea les choses et Irene me pardonna.

On se souviendra sans doute mieux d'Arthur comme d'un professeur hors pair de la photographie. Mais il était également un photographe d'une grande finesse. Ses photogrammes sont les travaux qui ont le plus marqué. Lors de son vivant, il fut déjà reconnu comme un grand maître. Il était vraiment merveilleux. Toutes les années où je connus Arthur, j'appréciai sa merveilleuse amitié.

J'avais été invité à dîner peu de temps avant qu'Arthur ne meure d'un cancer. Irene était devenue une artiste respectée, connue pour la qualité de ses dessins. C'est au cours de cette visite que je dressai le profil photographique d'Arthur.

J'étais en France lorsque Arthur mourut, et je regretterai toujours de n'avoir pu l'accompagner jusqu'au bout.

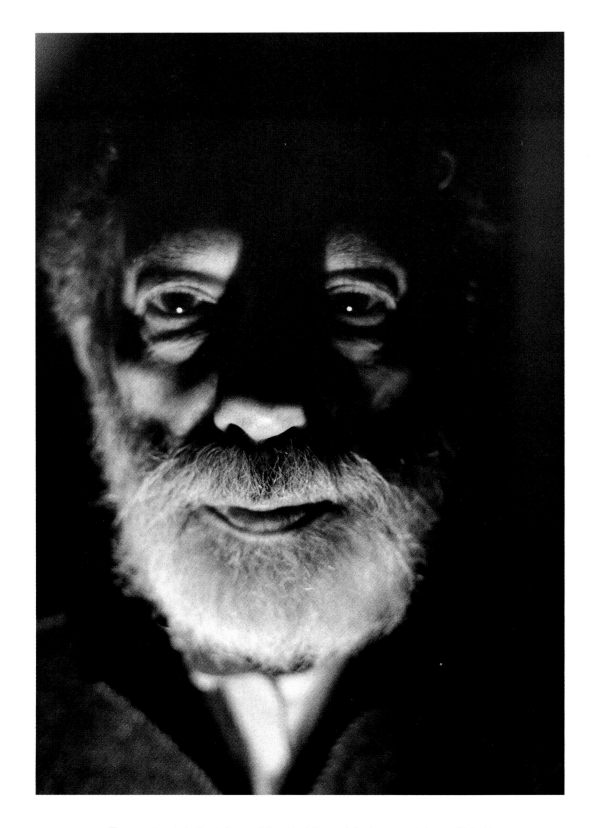

The evening at Arthur's home did not lack humor! Arthur, as only he could, held
candles near his face fully aware of the light and shadows they would cast and said:
»Look, I am the Ghost of Christmas Past« as he stared into my camera. 1978.

Es wurde viel gelacht an diesem Abend bei Arthur. Er hielt sich ein paar Kerzen vors Gesicht – er wußte
natürlich, was für einen Effekt Licht und Schatten auf seinem Gesicht haben würden, und sagte, frei
nach Dickens: »Ich bin der Geist der vergangenen Weihnacht«, und schaute dabei in meine Kamera. 1978.

On rit beaucoup chez Arthur ce soir-là ! Il approcha les bougies de son visage,
connaissant bien l'effet d'ombres et de lumières qu'elles produiraient et dit, citant
Dickens : « Regardez, je suis le fantôme du Noël passé », en fixant mon appareil. 1978.

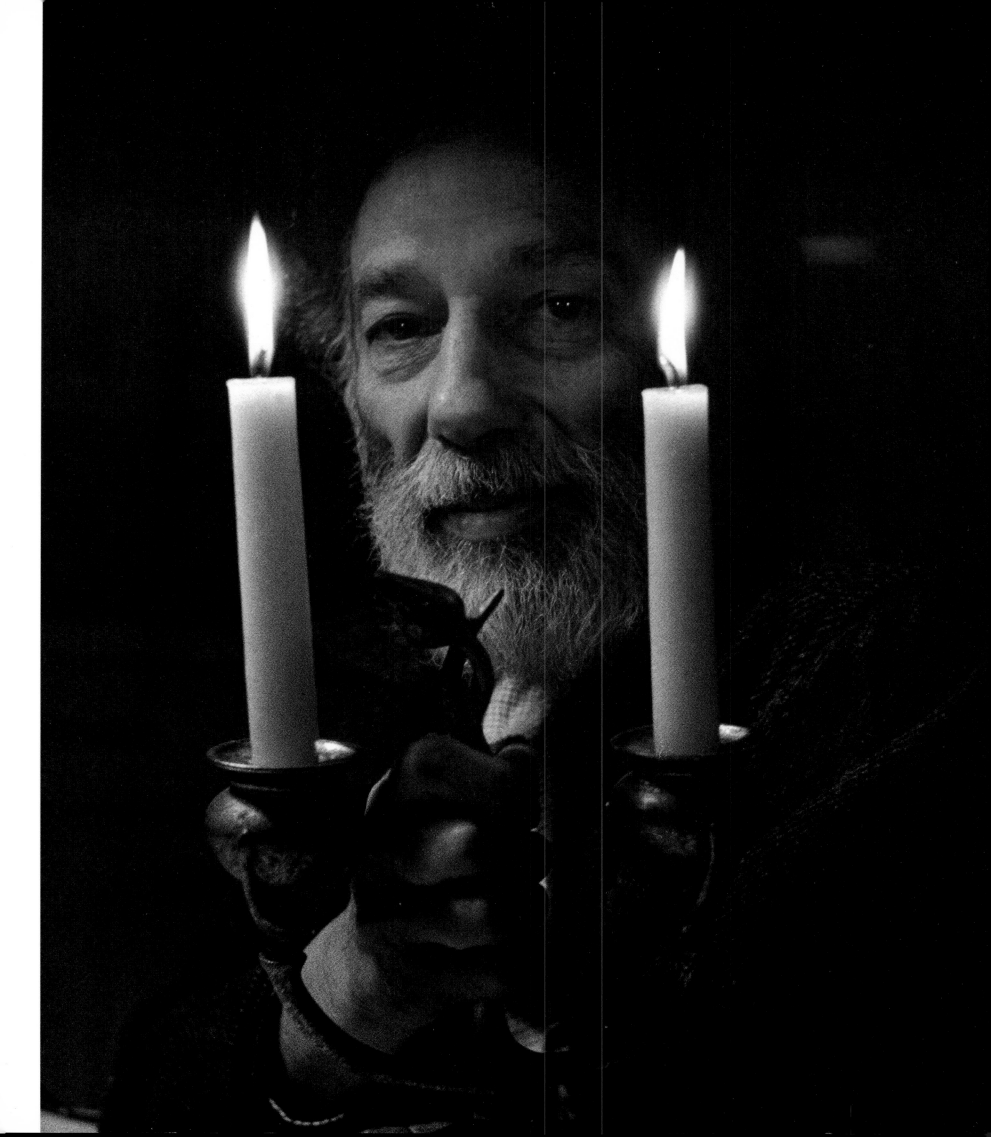

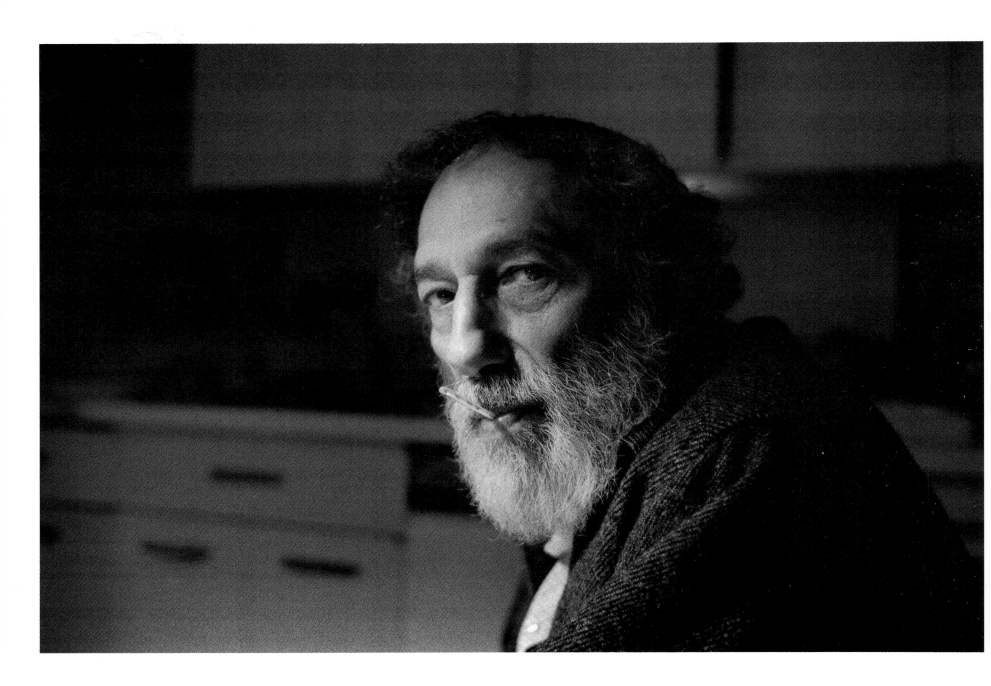

Arthur with thermometer, 1978.

Arthur mit einem Thermometer, 1978.

Arthur avec un thermomètre, 1978.

At home, 1978.

Zu Hause, 1978.

A la maison, 1978.

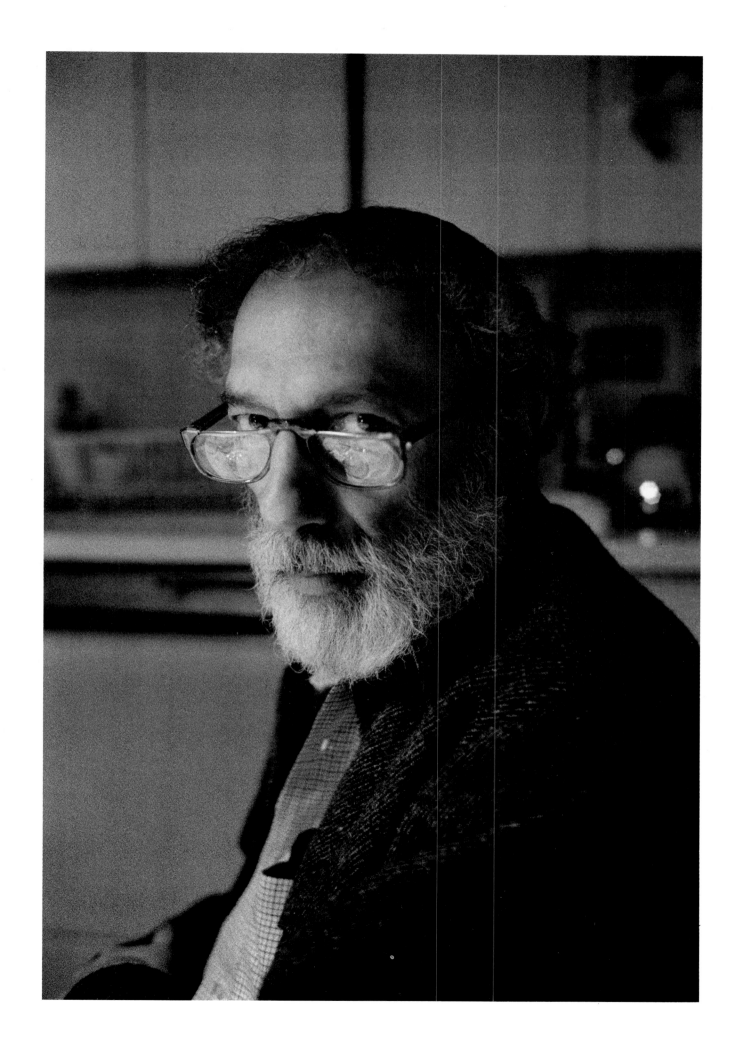

At home. We were having dinner at the Siegel home on W. Roslyn Place in Chicago; the front overhead light fixture lit his face. His wife Irene, herself a wonderful artist, is in the background. 1978

Abends bei Arthur. Er hatte uns in seine Wohnung am W. Roslyn Place in Chicago geladen. Die Lampe über ihm beleuchtet sein Gesicht. Seine Frau Irene, ebenfalls eine großartige Künstlerin, steht im Hintergrund. 1978.

A la maison. Lors d'un dîner chez les Siegel, place W. Roslyn à Chicago. La lampe au-dessus de lui éclaire son visage. Sa femme, Irene, une artiste merveilleuse, elle aussi, se tient au fond. 1978.

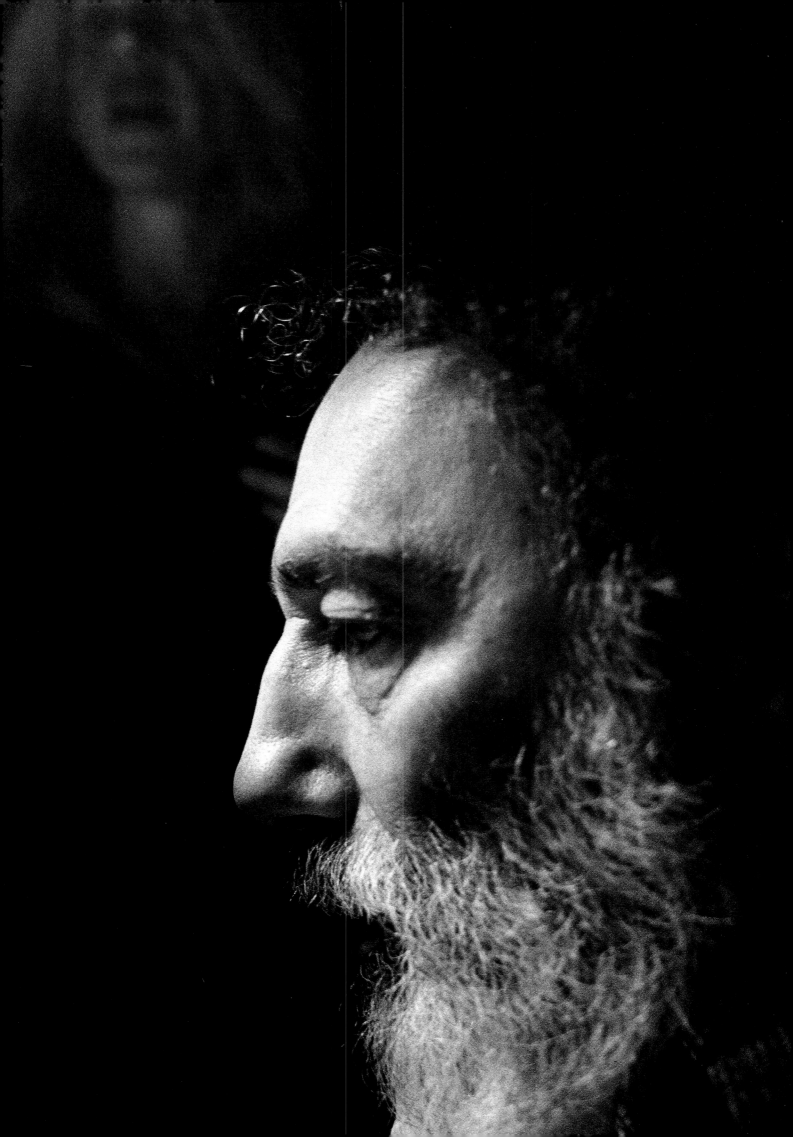

Beaumont Newhall

1908–1993. American.
Teacher, curator, historian, photographer. First Curator of Photography at the Museum of Modern Art, New York (1940) and later at George Eastman House (1958). Wrote his *History of Photography,* which remains a landmark text. Photographed during his early years, but put his cameras away so that he could devote most of his life to curating and writing about the history of photography.

1908–1993. Amerikaner.
Dozent, Museumskurator, Historiker, Fotograf. Er war der erste Curator of Photography am New Yorker Museum of Modern Art im Jahre 1940 und später am George Eastman House (1958). Schrieb eine Geschichte der Fotografie (*History of Photography*), noch heute ein Standardwerk. Arbeitete in jungen Jahren selbst als Fotograf, hängte die Kamera jedoch an den Nagel und widmete sein Leben der Museumsarbeit und dem Schreiben über Fotografie.

1908–1993. Américain.
Chargé de cours, conservateur, historien, photographe. D'abord conservateur de la Photographie au Museum of Modern Art à New York (1940) puis à la George Eastman House (1958). Il écrivit son *Histoire de la Photographie* qui demeure un ouvrage de référence. D'abord photographe, il mit son appareil de côté pour se consacrer aux expositions puis à la rédaction de l'histoire de la photographie.

Beaumont in his work room, Santa Fe, 1980.

Beaumont in seinem Arbeitszimmer in Santa Fe, 1980.

Beaumont dans son atelier, Santa Fe, 1980.

He was »Beau« to all his friends. To list them all – if it were possible – would fill every space in this book, for no one was more respected, better loved, or gentler than Beau.

I first met him in 1950. I was 17 years old and a member of the Jackson Park Camera Club in Chicago. At that time, I was known in the club as a young free-lancer. Alden Scott Boyer, who had made a fortune making perfume after the Depression, had built several different collections. He was giving one to a museum, and pressed me into service to take some photographs as a record. I arrived in the morning as requested, at an old bank building near 23rd and Wabash on Michigan in Chicago. There, floor to ceiling, were books and albums all relating to photography that Mr. Boyer had collected during his lifetime. It was on that occasion that I was introduced by Mr. Boyer to one Beaumont Newhall, who was acquiring the collection for the George Eastman House in Rochester, New York. Little did I know then that this was to become part of the foundation of Kodak's famous collection. I made three negatives of Mr. Boyer and Mr. Newhall with my 4x5 Speed Graphic.

Boyer also collected calliopes, and I recall that he had a number of these 6-foot-plus marvels lining the walls of the room where his photographic collection was kept. When I asked if they were in working order, he flipped a switch and the room was filled with the sounds of circus music – cymbals, drums, and pipe organ!

I next saw Beaumont some years later during the gestation of a show he was curating at the Museum of Modern Art. Knowing of my personal photograph collection, he visited me in Chicago. I agreed to make a number of loans for the show.

I next saw Beau when he borrowed a number of 19th-century books from me, books which were illustrated with orginal tipped-in photographs, for the landmark show of such works held at the Grolier Club in New York.

We collaborated several times after that, especially on the last edition of his *History of Photography*.

Ill seine Freunde nannten ihn »Beau«. Es waren so viele, daß eine Namensliste dieses Buch füllen würde. Er wurde einfach von allen geliebt – und es gab wohl niemanden, der liebenswürdiger war als Beau.

Ich begegnete ihm 1950 das erste Mal. Ich war damals 17 Jahre alt und Mitglied des Jackson Park Camera Club in Chicago, wo ich als »freier Fotograf« geführt wurde. Alden Scott Boyer hatte nach der Weltwirtschaftskrise ein Vermögen mit Parfüm verdient und nebenbei verschiedene Kunstsammlungen aufgebaut. Eine davon wollte er einem Museum stiften, und er hatte mich engagiert, die Übergabezeremonie zu fotografieren. Das ganze fand in einem alten Bankgebäude unweit Ecke 23. Straße und Wabash in Chicago statt. In einem Raum, vollgepackt bis unter die Decke, befanden sich alle Bücher und Kataloge zum Thema Fotografie, die Mr. Boyer im Laufe seines Lebens gesammelt hatte; und dort stellte mich Mr. Boyer einem gewissen Beaumont Newhall vor, der die Sammlung für das George Eastman House in Rochester erworben hatte. Natürlich hatte ich damals noch keine Ahnung, daß dies der Grundstein zu der berühmten Kodak-Sammlung werden sollte. Ich machte drei Aufnahmen von Mr. Boyer und Mr. Newhall mit meiner 4 x 5-Speed Graphic.

Boyer sammelte auch Dampfpfeifenorgeln, und einige von diesen mindestens zwei Meter großen Wunderwerken standen in dem Raum der Fotosammlung. Als ich fragte, ob sie noch funktionierten, betätigte er einen Schalter, und prompt war der Raum erfüllt mit Zirkusmusik mit Becken-, Trommel- und Orgelklängen.

Das nächste Mal sah ich Beaumont einige Jahre später, in der Vorbereitungsphase für eine Ausstellung am Museum of Modern Art in New York, für die er als Kurator zuständig war. Da er von meiner eigenen Fotosammlung gehört hatte, besuchte er mich in Chicago, und ich überließ ihm einige Leihgaben für seine Ausstellung.

Bei unserer nächsten Begegnung kam Beaumont, um sich einige Bücher aus dem 19. Jahrhundert von mir auszuleihen, die mit eingeklebten Originalfotos

Il était « Beau » pour tous ses amis. Les nommer tous, à condition que ce fût possible, remplirait chaque espace de ce livre, tant personne n'était plus respecté, aimable ou mieux aimé que Beau.

Je le rencontrai pour la première fois en 1950. J'avais 17 ans et j'étais membre du Jackson Park Camera Club de Chicago. A cette époque, j'étais connu pour être le plus jeune des photographes indépendants. Alden Scott Boyer, qui avait fait fortune dans les parfums après la grande crise, avait réuni diverses collections. Comme il exposait dans un musée, il m'avait demandé de faire quelques photos afin de perpétuer l'événement. J'arrivai le matin comme convenu devant une vieille banque située non loin de la 23e rue et Wabash on Michigan à Chicago. Là, du sol au plancher, se trouvaient des albums, des livres – tous consacrés à la photographie –, que M. Boyer avait collectionnés tout au long de sa vie. Ce fut à cette occasion qu'il me présenta à Beaumont Newhall, qui avait acquis la collection pour le George Eastman House à Rochester (New York). J'étais loin de m'imaginer que cette dernière serait la base de la célèbre collection de Kodak. Je fis trois négatifs de MM. Boyer et Newhall avec mon 4x5 Speed Graphic.

Boyer collectionnait aussi les orgues à vapeur (les *calliopes*), et je me souviens d'un certain nombre de ces merveilles hautes de deux mètres, accrochées au mur de la pièce où se tenait la collection. Alors que je lui demandai s'ils étaient en état de fonctionner, il tourna un interrupteur et la pièce fut remplie de sons de musique de cirque, de cymbales, de percussions et d'orgue !

Je rencontrai Beaumont pour la seconde fois quelques années plus tard durant les préparatifs d'une exposition de photos au Museum of Modern Art, dont il était le conservateur. Connaissant l'existence de ma collection personnelle, il me rendit visite à Chicago. Je fus d'accord pour lui prêter un certain nombre de photos en vue de cette exposition. Je le revis encore lorsqu'il m'emprunta quelques livres du XIXe siècle qui étaient illustrés avec des photogra-

◁ ▽ Santa Fe, 1980.

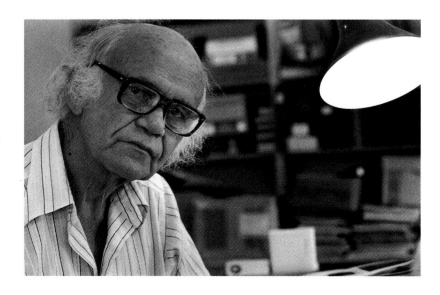
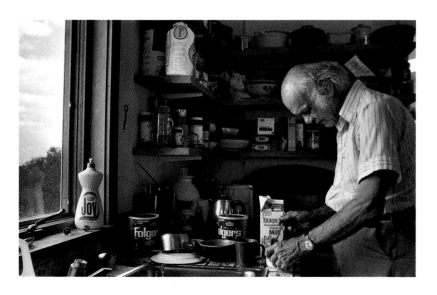

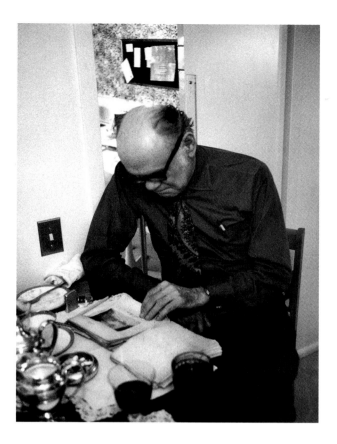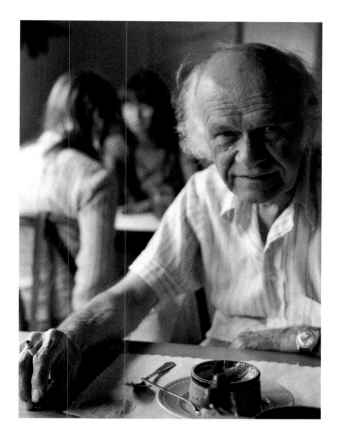

In my Chicago apartment, examining an album of English photographs from my collection; this album is the one referred to by Beaumont in his *History of Photography*, which he subsequently revised. c. 1973.

Newhall beim Betrachten eines Bildbandes mit englischen Fotos aus meiner Sammlung in meinem Apartment in Chicago, um 1973. Beaumont erwähnt dieses Buch in seiner Geschichte der Fotografie, die er später umschrieb.

A mon appartement à Chicago vers 1973. En train d'examiner un album de photographies anglaises appartenant à ma collection. Cet album est mentionné par Beaumont dans son *Histoire de la Photographie* qui fut plus tard révisée.

Beaumont was also the guest speaker that evening at the Grolier Club. He spoke about the history of photography and the photographically illustrated book. He spoke and spoke and spoke; people coughed – throats were cleared – but he went on and on. Beaumont was a walking encyclopedia of the history of photography, and when he spoke, he would not stop until he had told his audience everything.

I last saw him when I visited him at his home in Santa Fe, New Mexico. We reminisced about many of our mutual photographer friends who had passed on. He proudly showed me some of the photographs he had made during his earlier days as a photographer.

I didn't yet have a publisher for this book, but I asked him if he would write the introduction whenever I eventually found one. He agreed without hesitation. To everyone's loss, he died before it happened.

illustriert waren; er brauchte die Bücher für die bedeutende Buch-Ausstellung im Grolier Club in New York.

Auch später arbeiteten wir noch einige Male zusammen, insbesondere bei der letzten Ausgabe seiner *History of Photography*.

Beaumont hielt auch den Eröffnungsvortrag zur Ausstellung im Grolier Club. Er sprach damals über die Geschichte der Fotografie und über die Entwicklung des fotografisch illustrierten Buches. Er redete und redete und redete, die Leute begannen sich zu räuspern, zu hüsteln, aber er hörte einfach nicht auf. Beaumont war eine wandelnde Enzyklopädie der Fotografiegeschichte, und wenn er einen Vortrag hielt, hörte er nicht eher auf, bis er »alles« gesagt hatte.

Ich sah ihn zum letzten Mal bei einem Besuch in seinem Haus in Santa Fe. Wir versanken in Erinnerungen an gemeinsame verstorbene Freunde. Voller Stolz zeigte er mir einige Fotos, die er als ganz junger Fotograf gemacht hatte.

Ich hatte damals noch keinen Verleger für dieses Buch, aber ich fragte ihn, ob er eventuell die Einführung schreiben wolle. Ohne zu zögern, stimmte er zu. Daß er starb, bevor es dazu kam, ist unser aller Verlust.

Santa Fe, 1980.

phies originales numérotées, à l'occasion d'une exposition sur cette époque marquante, organisée par le Grolier Club à New York.

Nous collaborâmes bien des fois encore, particulièrement pour la dernière édition de son *Histoire de la Photographie*.

Beaumont fut également invité, lors de cette soirée au Grolier Club, à faire un exposé. Il parla de l'histoire de la photo et du livre illustré photographiquement. Il parla, parla, parla, les gens toussaient, les gorges s'éclaircissaient, mais il poursuivait encore et encore. Beaumont était une encyclopédie vivante de l'histoire de la photo, et quand il parlait, il ne trouvait la paix qu'après avoir informé son audience sur tout ce qu'il savait.

Je le vis pour la dernière fois lors d'une visite que je lui fis chez lui, à Santa Fe, au Nouveau-Mexique. Nous évoquâmes nos nombreux amis photographes disparus. Il me montra fièrement quelques-unes des photos qu'il avait faites au tout début de sa vie de photographe.

Je ne connaissais pas encore l'éditeur du présent livre, mais je lui demandai s'il accepterait d'en écrire l'introduction. Il accepta sans hésitation. Il disparut avant, et c'est une perte pour nous tous.

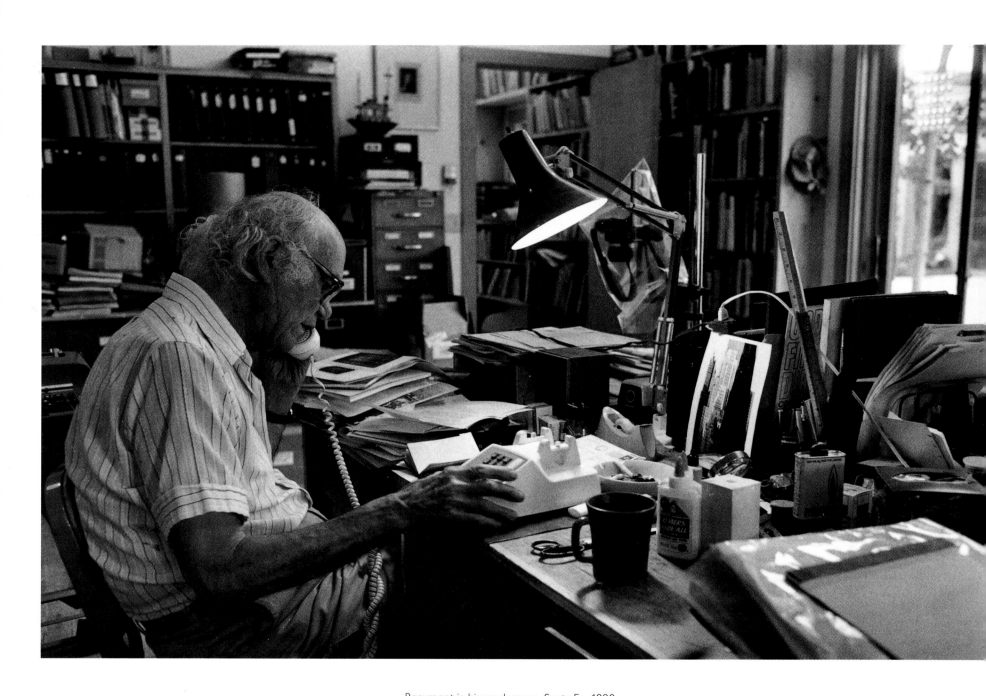

Beaumont in his work room, Santa Fe, 1980.

Beaumont in seinem Arbeitszimmer in Santa Fe, 1980.

Beaumont dans son atelier, Santa Fe, 1980.

In his kitchen, Santa Fe, 1980.

In seiner Küche in Santa Fe, 1980.

Dans la cuisine, Santa Fe, 1980.

△ ▷ Beaumont with Alden Scott Boyer, inventorying Boyer's donation
to the George Eastman House in Rochester, New York, 1950.

Beaumont mit Alden Scott Boyer bei der Inventarisierung von Boyers
Schenkung an das George Eastman House in Rochester, New York, 1950.

Beaumont avec Alden Scott Boyer, faisant l'inventaire de la
collection de Boyer au George Eastman House, 1950.

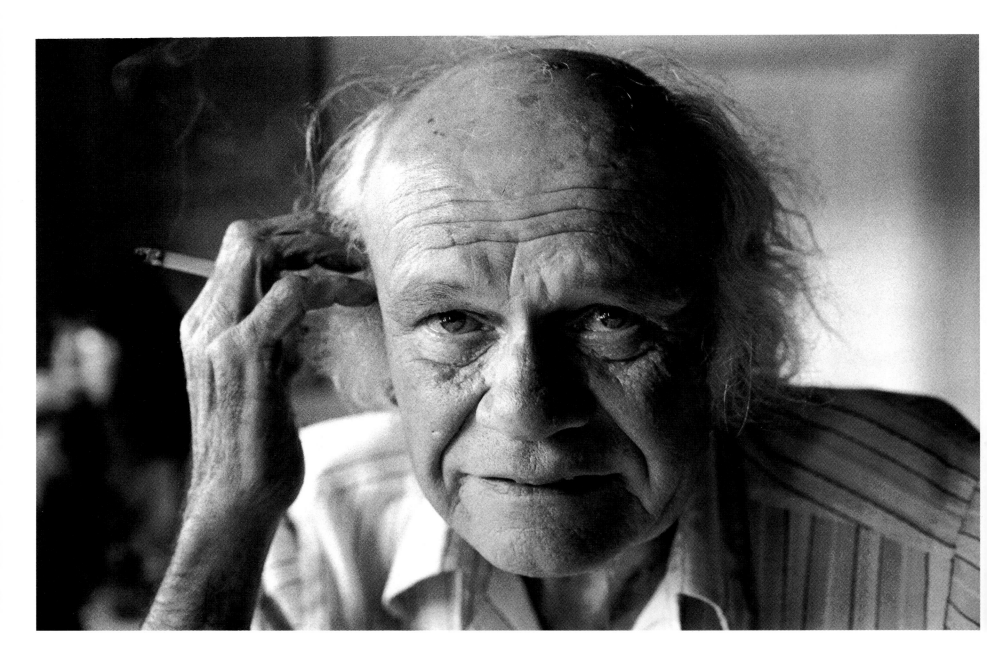

△ ▷ Portrait, 1980.

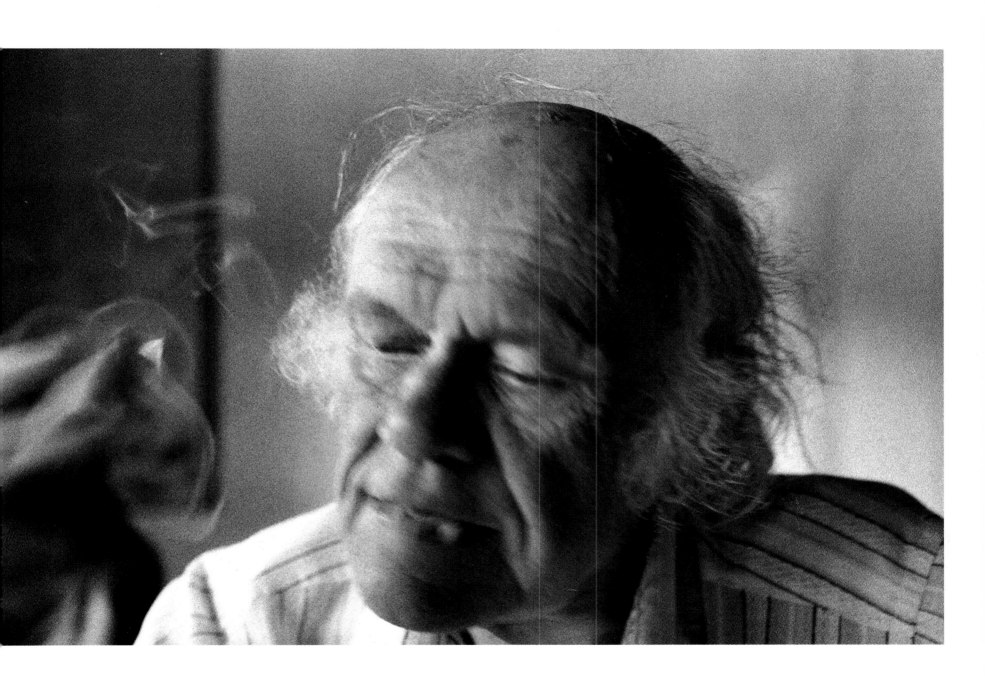

Beaumont on the phone in his workroom, Santa Fe, 1980.

Beaumont am Telefon in seinem Arbeitszimmer in Santa Fe, 1980.

Beaumont au téléphone dans son atelier, Santa Fe, 1980.

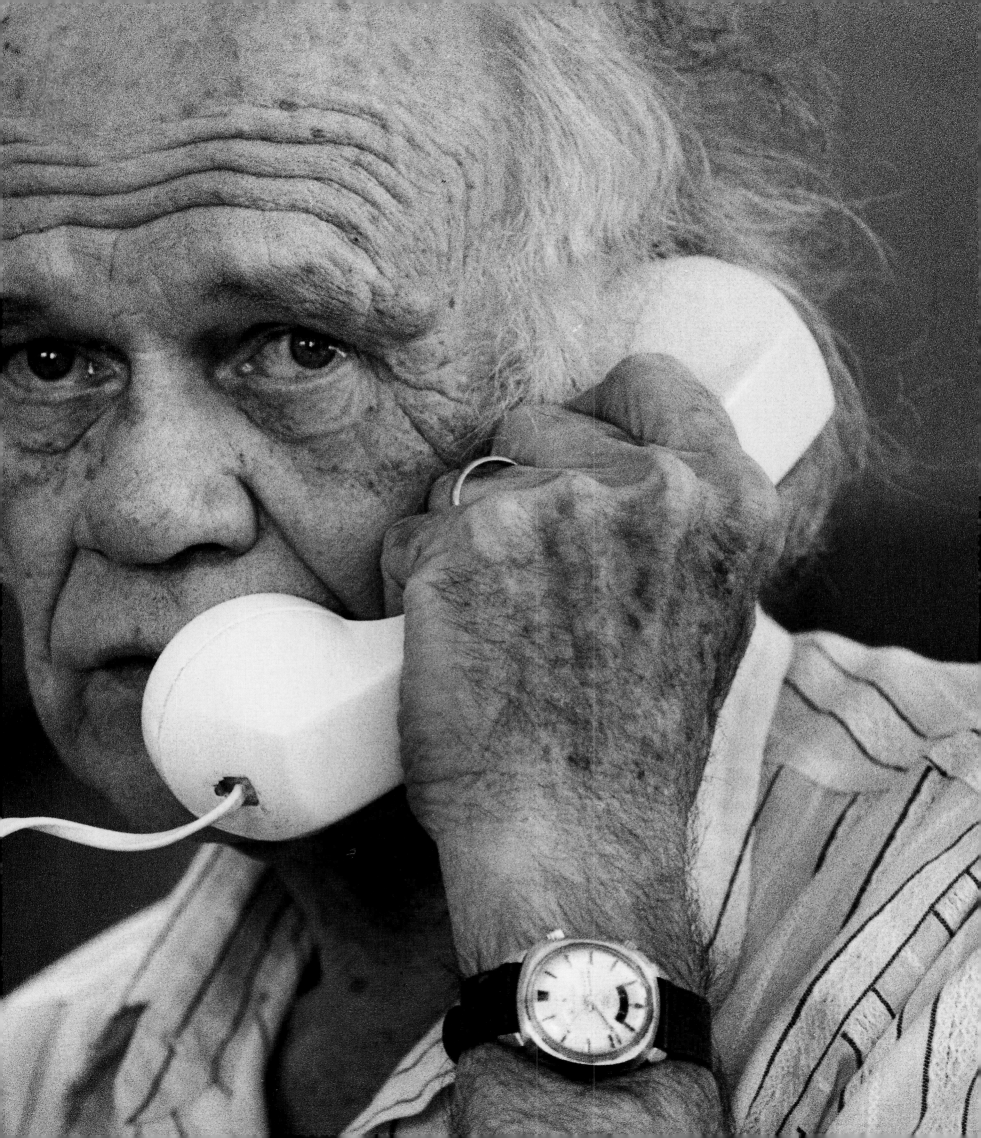

Minor White

1908–1976. American.
Photographer and teacher. Himself a mystic, his photographs are
a reflection of him and are abstract in nature. He helped found
the photographic magazine, *Aperture*.

1908–1976. Amerikaner.
Fotograf und Dozent. Er war Mystiker, und auch seine
abstrakten Fotos haben eine übersinnliche Dimension. White
war Mitbegründer des Fotomagazins *Aperture*.

1908–1976. Américain.
Photographe et chargé de cours. Mystique, ses photos sont un
reflet de lui-même et ont une qualité abstraite. Il prit part à la
création du magazine *Aperture*.

Portrait, 1970.

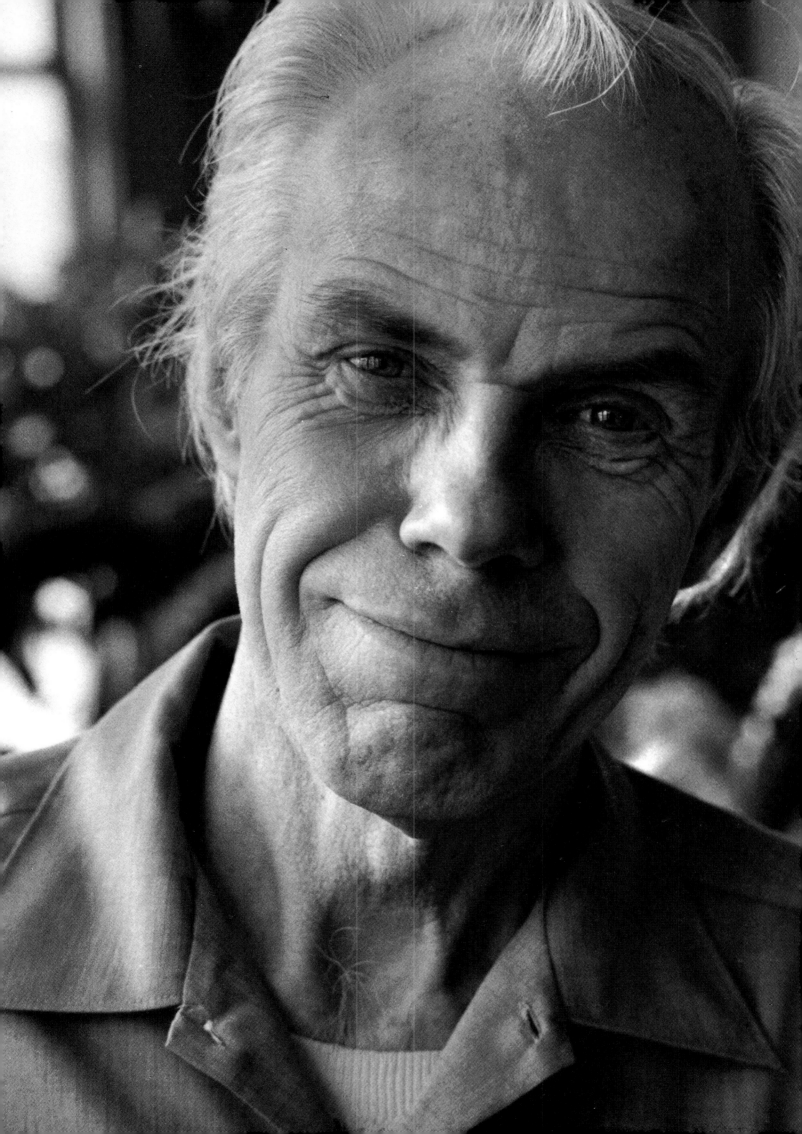

Minor White was the photographer, teacher and »seer« who started *Aperture* magazine. Many people think of Minor as a mystic. This mysticism was not only reflected in his images, which were almost abstract, but in the entire manner in which he lived.

I met him only once, the day I flew to Boston to photograph him. In his kitchen Minor had a food processor which he used to make himself a vegetable vitamin drink. Upstairs was a spacious meditation room where Minor could retire for his periods of prayer, which he practiced on a daily basis.

I remember him being so quiet and private that I almost felt uncomfortable in his presence.

Minor White war der Fotograf, Lehrer und Visionär, der das Magazin *Aperture* ins Leben rief. Es gibt viele, die Minor für einen Mystiker halten. Sein Mystizismus schlug sich nicht nur in seinen Aufnahmen nieder – sie sind nahezu abstrakt –, sondern in der ganzen Art und Weise seines Lebenswandels.

Ich bin ihm nur ein einziges Mal begegnet und zwar, als ich nach Boston flog, um ihn zu fotografieren. In seiner Küche hatte Minor eine Saftpresse, mit der er sich Vitamindrinks aus Gemüse machte. Oben war ein großer Meditationsraum, in den sich Minor regelmäßig zu den Gebetszeiten zurückzog.

Er war so still und zurückhaltend, daß ich mich in

Minor White est le photographe, maître et « prophète » qui fut à l'origine du magazine *Aperture*. Beaucoup de gens le définissent comme un mystique. Ce mysticisme ne se reflète pas seulement dans ses images, qui sont presque abstraites, mais aussi dans sa manière de vivre.

Je ne l'ai rencontré qu'une seule fois, le jour où je pris l'avion pour Boston, dans le but de le photographier.

Dans sa cuisine, Minor avait un robot électrique dont il se servait pour se préparer des boissons vitaminées à base de légumes. A l'étage se trouvait une vaste salle de méditation où Minor se retirait pour sa pratique journalière. Je me souviens qu'il

A detail of his library, 1970.

Minor's Bibliothek, Detail, 1970.

Un détail de sa bibliothèque, 1970.

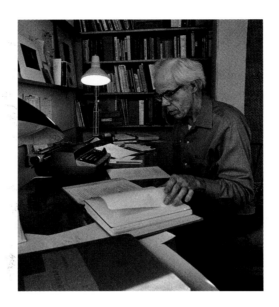

Minor working at his desk, 1970.

Minor an seinem Schreibtisch, 1970.

Minor à son bureau, 1970.

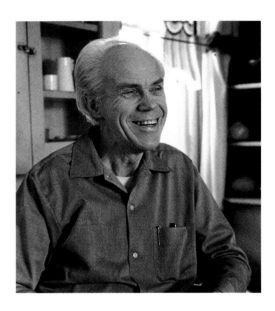

Portrait, 1970.

Aperture published a major book of his photographs entitled *Mirrors, Messages and Manifestations*. The book contained abstract photographic images which were reflective of all of the work he had done up until that time, consisting mostly of »dreamscapes« from his own mind.

As sometime happens when I photograph certain people, I feel that with Minor White, I almost became a sort of medium to his presence. While walking in his garden I made certain photographic images that I felt he might have made; not trying to mimic his style, but as an effort to see the way he saw. That day was a strange one for me, because several of the images that I made of Minor had a certain mystical quality – specifically that image where he is in his meditation room standing in a sea of light.

That is the photograph which for me best describes Minor White.

seiner Gegenwart beinahe ein wenig unwohl fühlte.

Aperture brachte mit dem Band *Mirrors, Messages and Manifestations* ein bedeutendes Buch seiner Fotos heraus; die abstrakten Fotoimpressionen spiegeln sein gesamtes Schaffen bis zu dieser Zeit wider, das vor allem aus »Dreamscapes« bestand, aus Traumlandschaften seiner Seele.

Manchmal habe ich beim Fotografieren das Gefühl, daß ich in die Haut des anderen schlüpfe; so war es auch bei Minor White; mir war, als sei ich das Medium für seine Gegenwart. In seinem Garten machte ich eine Reihe von Fotos, von denen ich das Gefühl hatte, er hätte sie auch so gemacht; dabei versuchte ich nicht, seinen Stil nachzuahmen, sondern nur, so zu sehen, wie er sah. Es war ein absonderlicher Tag für mich, weil einige der Aufnahmen, die ich von Minor gemacht hatte, von mystischer Qualität waren – vor allem das Bild, wo er in seinem Meditationsraum steht, umgeben von einem Meer aus Licht.

Das ist das Foto, das Minor White meiner Meinung nach am besten charakterisiert.

était tellement calme et secret que je ressentis presque de la gêne en sa présence.

Aperture publia un ouvrage majeur contenant ses photographies : *Mirrors, Messages and Manifestations*. Dans ce livre, on retrouve ces photos abstraites qui ont marqué l'ensemble de son œuvre de l'époque – en un sens une série de rêveries reflétant son propre esprit.

Comme cela arrive quelquefois quand je photographie certaines personnes, je devins en quelque sorte le médium de Minor White. Dans son jardin, je fis un certain nombre de photos qui auraient pu être *ses* photos. Non pas que j'essayai de singer son style, non, mais plutôt de voir les choses comme lui les voyait. Cette journée fut vraiment étrange pour moi, certainement en raison d'une photo que je fis, d'une certaine qualité mystique, précisément celle prise dans la salle de méditation alors qu'il se tenait dans un océan de lumière.

C'est pour moi la photo qui décrit le mieux Minor White.

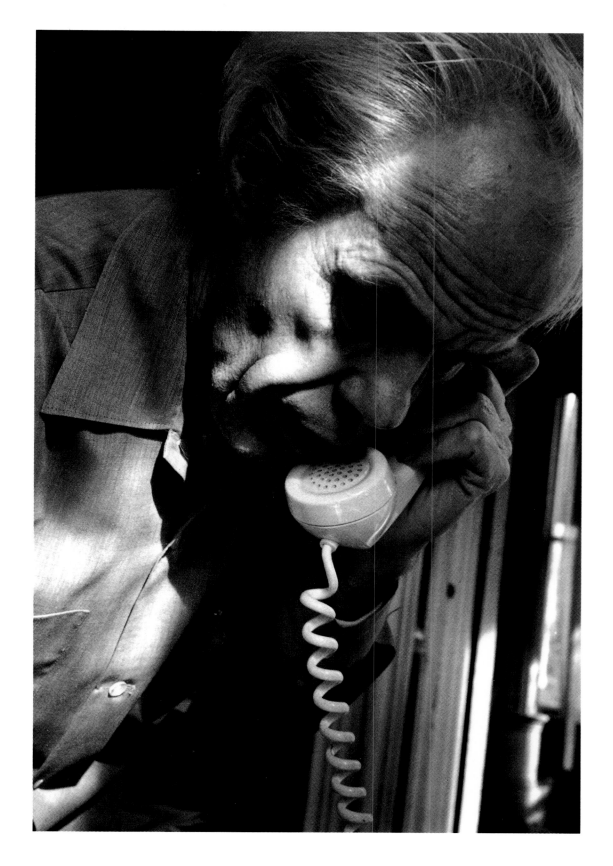

Portrait, 1970.

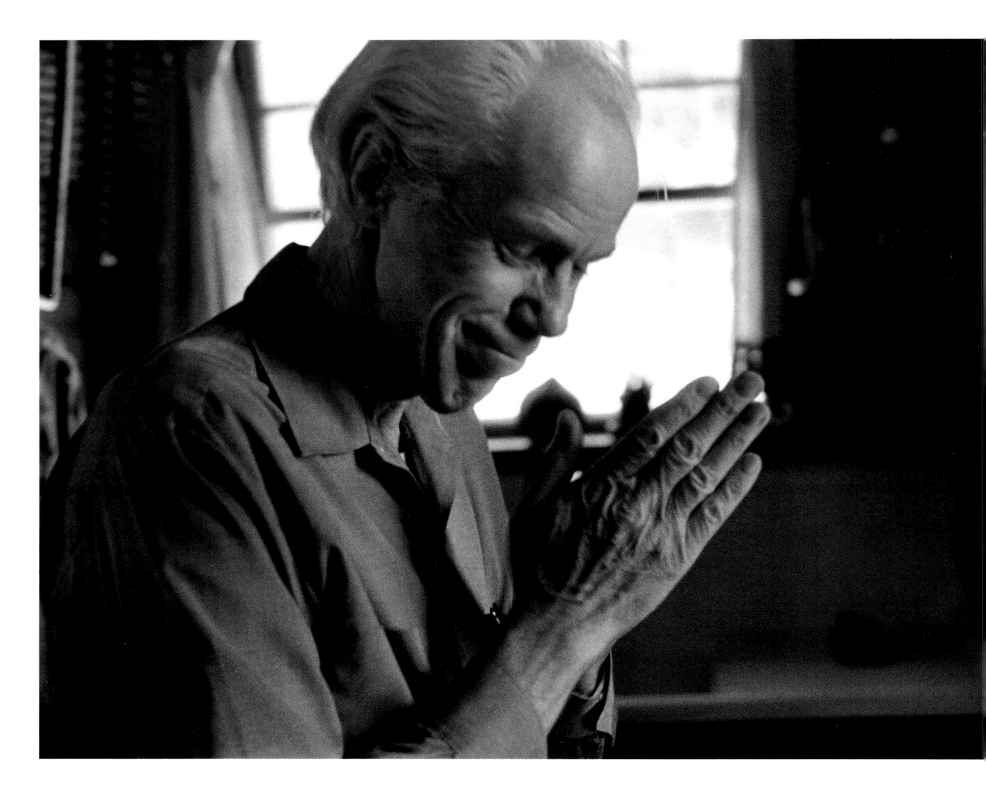

Minor White meditating, 1970.

Minor White bei der Meditation, 1970.

Minor White en train de méditer, 1970.

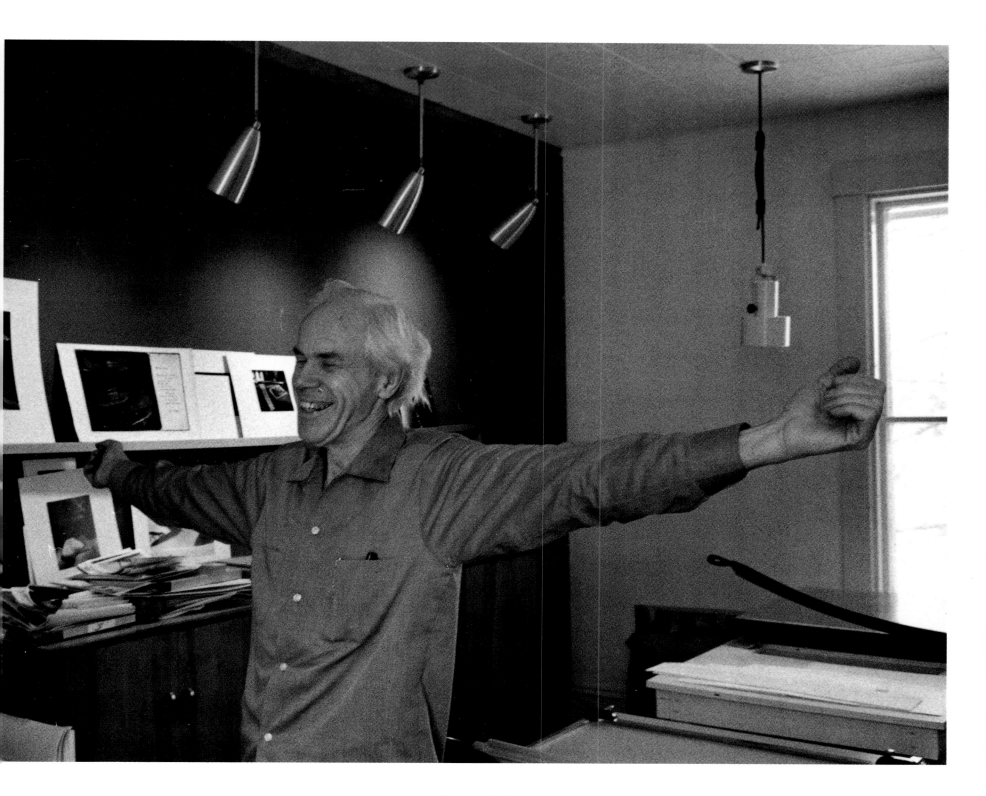

Portrait, 1970.

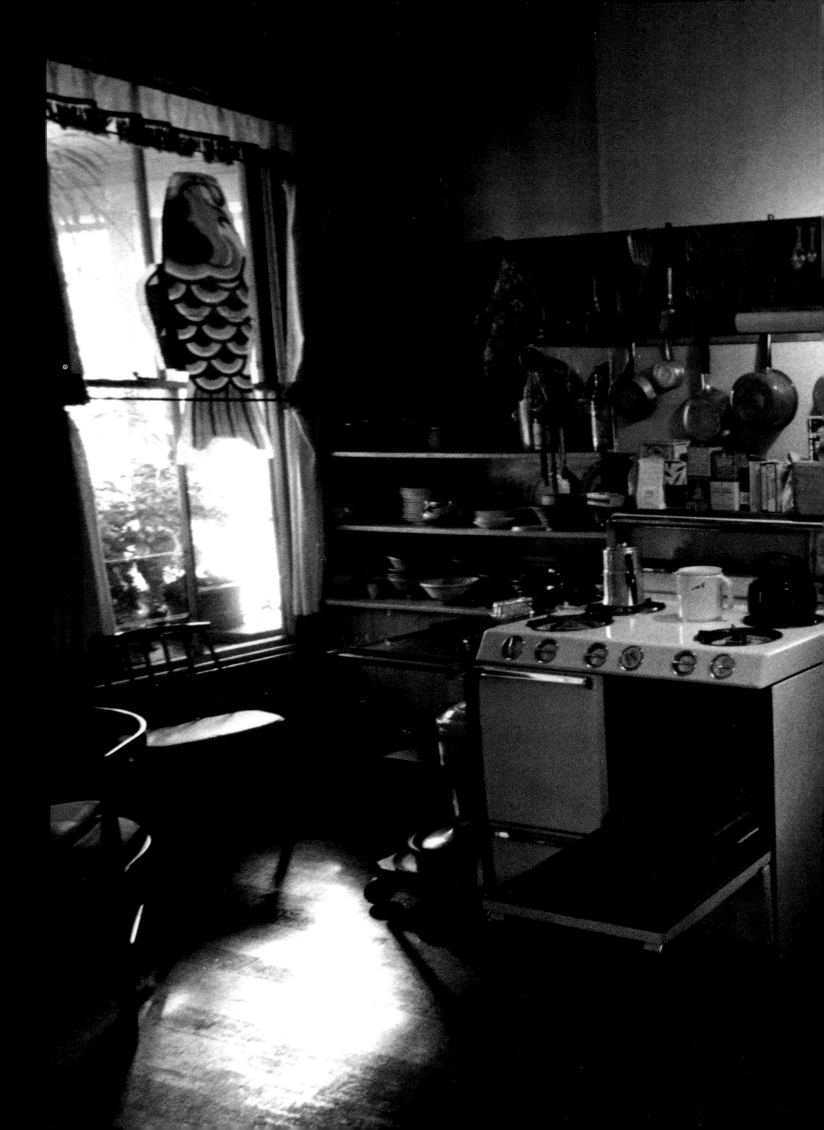

Minor in his kitchen preparing his »healthy« vegetable juice drink. He offered me a sample to taste. I remember it as being terrible! 1970.

Minor in seiner Küche bei der Herstellung eines »gesunden« Gemüsesaftes. Er gab mir ein Glas zum Kosten. Es schmeckte scheußlich, zugegeben. 1970.

Minor White dans sa cuisine en train de préparer une « saine » boisson à base de légumes. Il me proposa de la goûter. Ce fut épouvantable ! 1970.

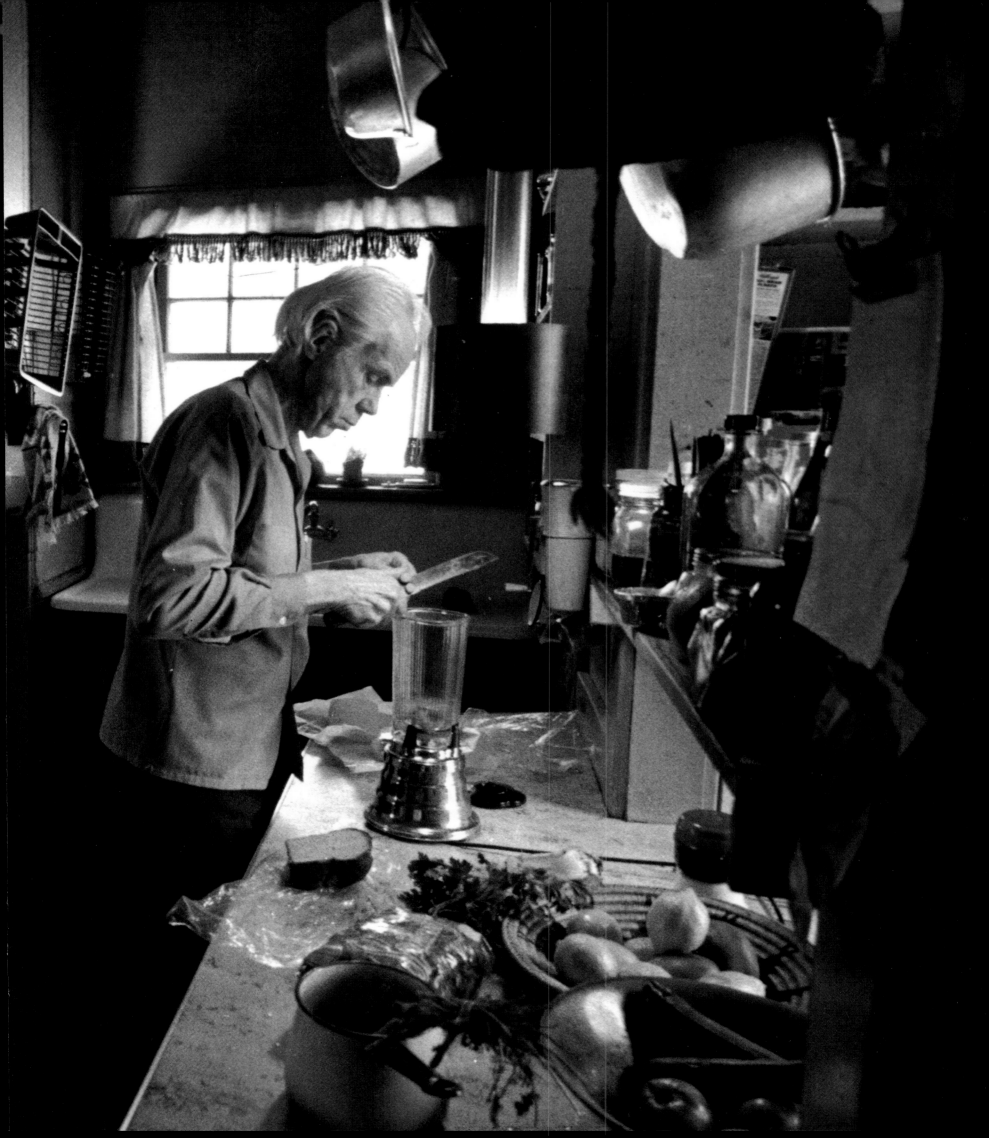

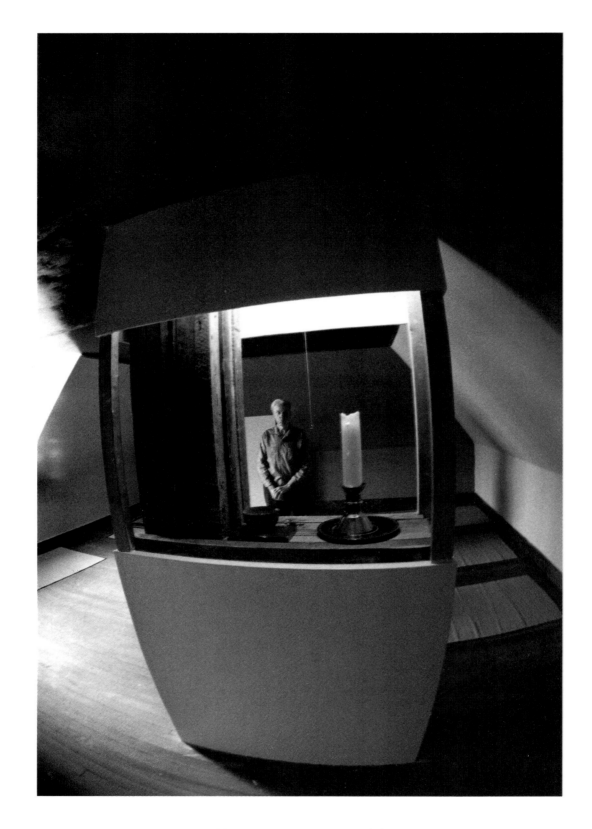

△ ▷ Minor in his meditation room, 1970.

Minor in seinem Meditationszimmer, 1970.

Minor dans sa salle de méditation, 1970.

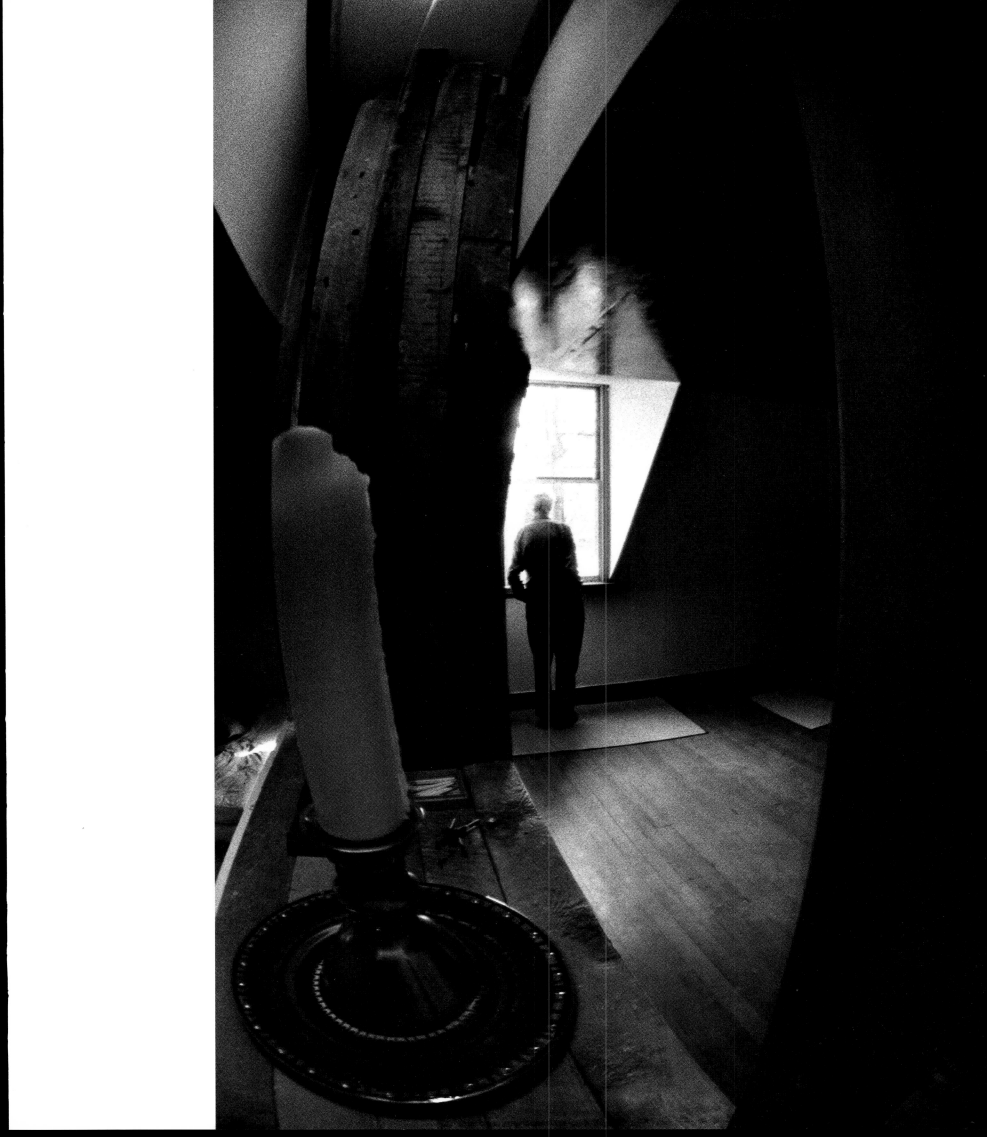

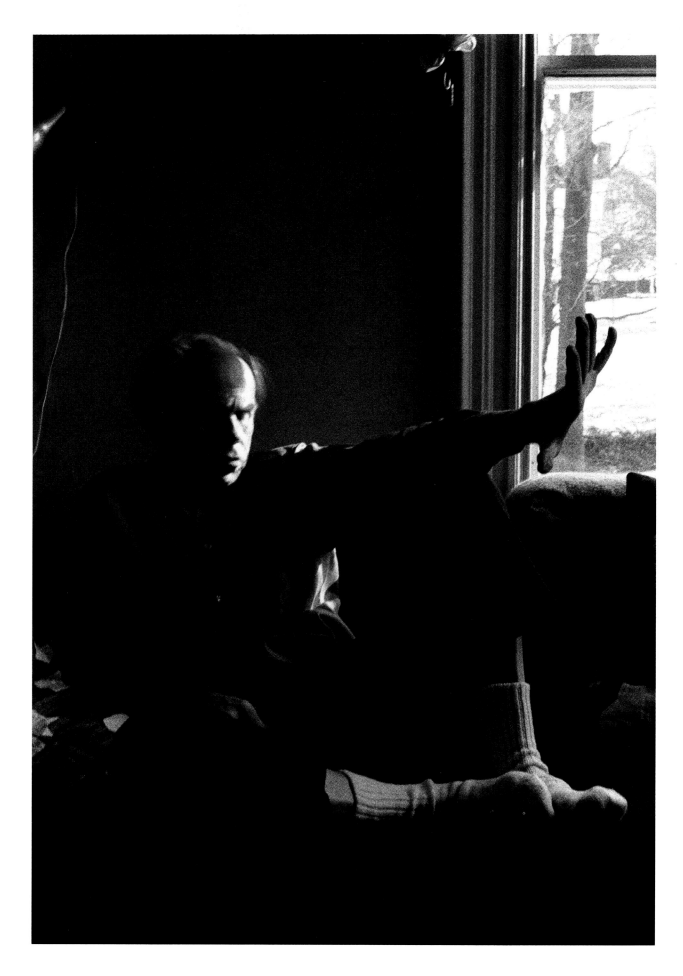

Minor in his sitting room conversing with the author, 1970.

Minor im Gespräch mit mir in seinem Wohnzimmer, 1970.

Minor dans le salon bavardant avec l'auteur, 1970.

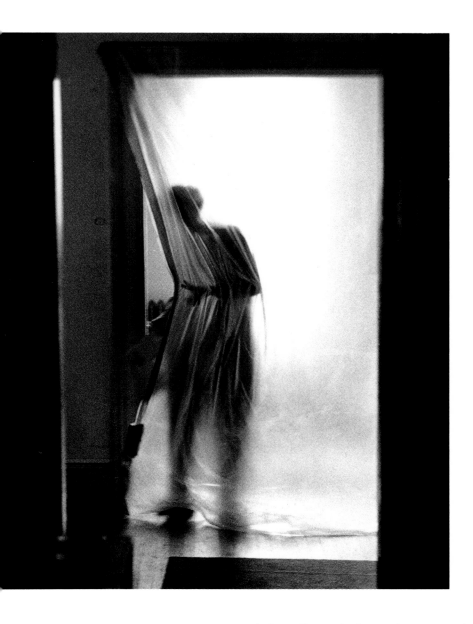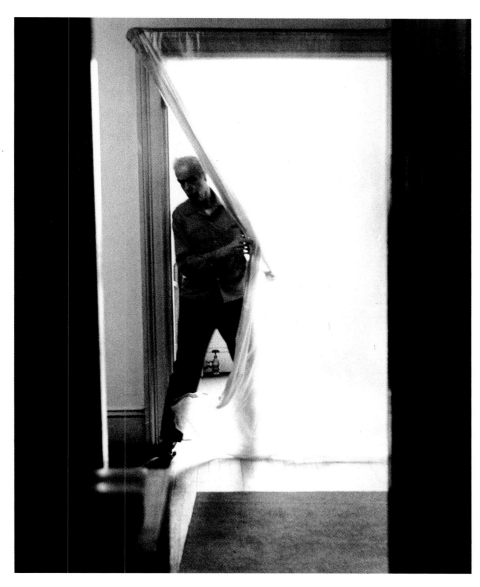

A piece of heavy plastic served to separate the kitchen from the rest of Minor's house. I saw
Minor as a very mystical figure and the photographs taken that day convey the same feeling in retrospect. 1970.

Ein dicker Plastikvorhang trennte Minors Küche vom Rest der Wohnung. Minor war ein sehr
geheimnisvoller Mensch, und die Fotos, die ich an diesem Tag machte, vermitteln etwas davon. 1970.

Un lourd rideau de plastique séparait la cuisine des autres pièces. Je reconnus en Minor
White une qualité mystique, et, des photos prises ce jour là, il émane cette même impression. 1970.

Arthur Rothstein

1915–1985. American.
Photographer with the Farm Security Administration 1935–40;
Director of Photography, *Look* magazine, 1946–71.

1915–1985. Amerikaner.
Arbeitete für die Farm Security Administration von 1935 bis
1940; war von 1946 bis 1971 Director of Photography beim
Magazin *Look*.

1915–1985. Américain.
Photographe pour la Farm Security Administration de 1935 à
1940. Directeur de la photographie à *Look Magazine*, de 1946 à
1971.

Portrait, 1977–78.

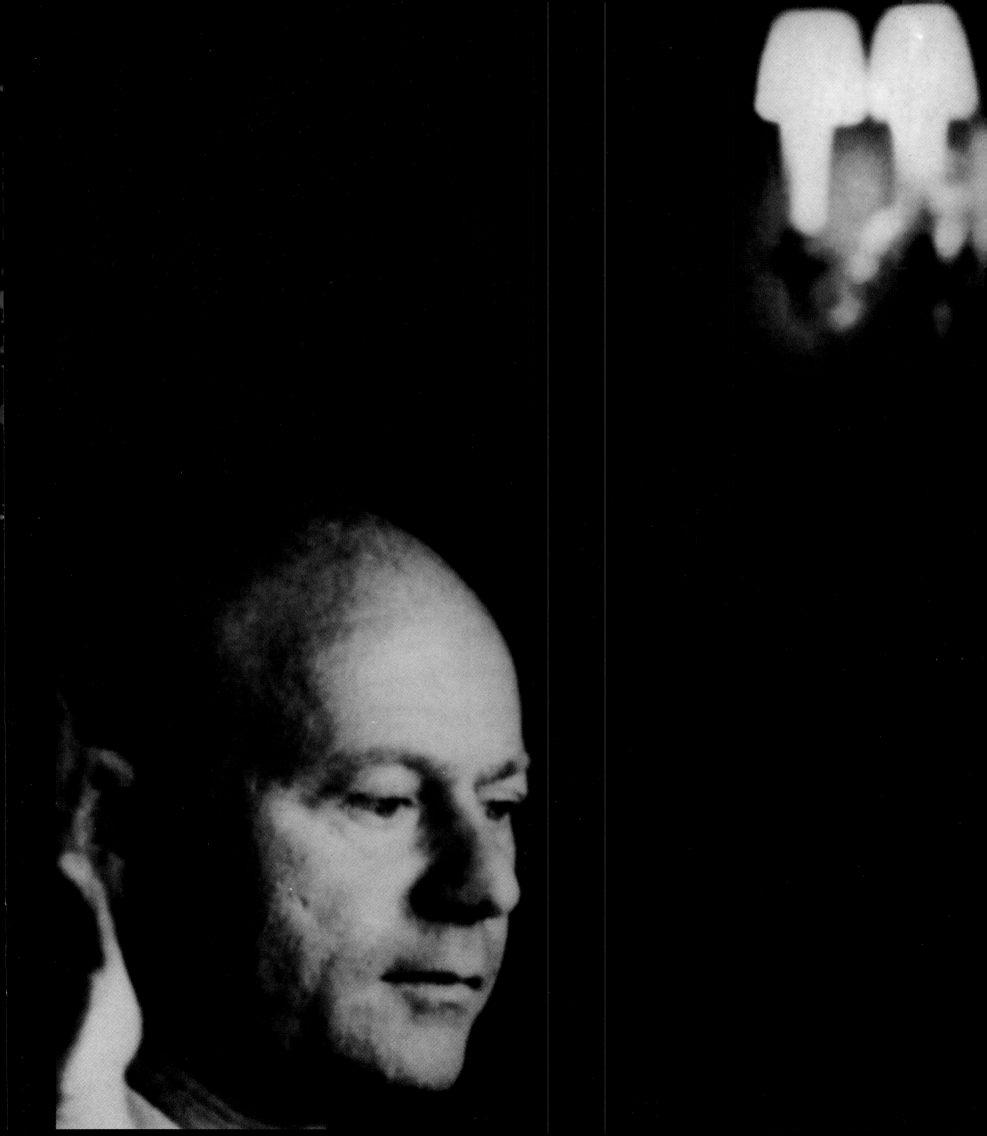

I first interviewed Arthur Rothstein in December 1968 at his home in New Rochelle, New York. I had met him a year before when I attended a color photography workshop conducted by Arthur and Phillip Harrington, who both worked at *Look* magazine as photographers.

At the time of the interview, Arthur was the head photographer at the magazine. He had limited his own assignments to things that personally interested him. In addition to his being a photojournalist, he was an extremely accomplished food photographer, and his food pictures were frequently published in *Look*. He was best known, however, for his work with the Farm Security Administration, the organization that photographically recorded the poverty of the Depression in America from 1929 to the mid-1930s. His most famous photograph is the one he made of a farmer and his son walking bent over in a dust storm.

During my interview with Arthur, he told me that the dust storm photograph was instrumental in causing the passage of soil conservation legislation in the United States.

Arthur was prouder of his family than he was of himself. He was short but strong looking, a balding man with a perpetual smile and a New Yorker's speech. During a dinner at his home, which his wife

At his home, New Rochelle, New York, 1977–78.

Zu Hause in New Rochelle, New York, 1977–1978.

Chez lui à New Rochelle, New York, 1977–1978.

Mein erstes Interview mit Arthur Rothstein machte ich im Dezember 1968 in seinem Haus in New Rochelle. Ich hatte ihn ein Jahr zuvor bei einem Workshop über Farbfotografie kennengelernt, den Arthur und Phillip Harrington geleitet hatten; die beiden arbeiteten damals als Fotografen für *Look*.

Als ich das Interview machte, war Arthur gerade Cheffotograf bei *Look*, so daß er sich die Freiheit nehmen konnte, nur noch das zu fotografieren, was ihn interessierte. Ich sollte hier vielleicht hinzufügen, daß Arthur nicht nur ein guter Fotojournalist war, sondern auch ein ausgezeichneter Gourmet-Fotograf; seine kulinarischen Fotos wurden häufig in *Look* veröffentlicht.

Berühmt wurde er jedoch durch seine Arbeit für die Farm Security Administration, jene amerikanische Behörde, die die Armut in Amerika während der Weltwirtschaftskrise von 1929 bis Mitte der dreißiger Jahre fotografisch dokumentieren ließ. Sein wohl berühmtestes Foto ist das Bild eines Farmers und seines Sohnes, die gebeugt durch einen Sandsturm gehen.

Während meines Interviews mit Arthur berichtete er mir, daß dieses Foto sehr viel dazu beigetragen habe, daß die amerikanische Regierung Gesetze zum Schutz des Bodens vor Erosion erließ.

Arthur war ganz besonders stolz auf seine Familie. Er war von kleiner Statur, kräftig und fast glatzköpfig. Er hatte ein freundliches Lächeln und sprach mit New Yorker Akzent. Wir aßen bei ihm zu Hause zu Abend – seine Frau Grace hatte gekocht –, und er erzählte vor allem von seinen talentierten

Je réalisai ma première interview d'Arthur Rothstein en décembre 1968 chez lui à New Rochelle (New York). Je l'avais rencontré un an plus tôt au cours d'un atelier sur la photographie en couleurs, mené par Arthur et Phillip Harrington, qui travaillaient au magazine *Look* comme photographes. Au moment de l'interview, Arthur était à la tête des photographes du magazine. Il avait limité sa tâche aux sujets qui l'intéressaient personnellement. Il faut ajouter qu'en plus de sa fonction de reporter photographe, il réalisait de superbes photos de cuisine fréquemment publiées dans *Look*.

Il était très connu, quoi qu'il en soit, pour son travail avec la Farm Security Administration, une organisation chargée de rassembler les documents photographiques sur l'indigence et la misère lors de la grande dépression des années trente en Amérique. Sa photo la plus célèbre est celle d'un fermier et son fils marchant courbés dans une tourmente de poussière.

Au fil de cette interview avec Arthur, il me dit que cette photo, la tourmente de poussière, avait été l'instrument qui avait contribué au passage de la législation sur la conservation des sols aux États-Unis.

Arthur était plus fier de sa famille que de lui-même. Il était petit mais il se dégageait de lui une impression de force. Il était chauve, souriait toujours et parlait avec l'accent new-yorkais. A l'occasion d'un dîner que sa femme, Grace, avait préparé, Arthur passa une bonne partie de la soirée à me vanter les mérites de ses enfants merveilleux et

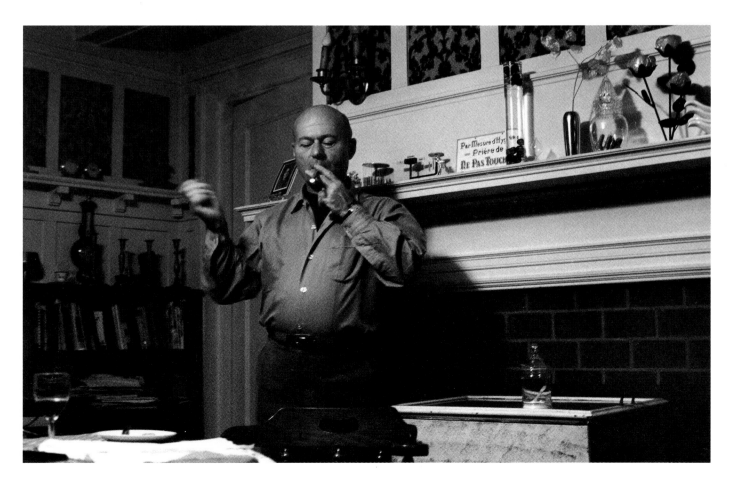

Grace had prepared, Arthur spent much of the evening telling me about his wonderful and talented children. One was a musician, and another an artist. I recall most vividly him telling me about his 15-year-old daughter and her successful dress design business – she designed, made, and sold prom dresses to her fellow students. Arthur, with immense pride, showed me an album of many of the dresses she had made.

Later that evening we got down to what were, for me at least, more serious matters. Arthur had written two books on photojournalism, and was considered an expert on the subject. He told me of a lecture he had given the previous week on the subject of photojournalism and made a point of telling me what he felt were the three most important things that are necessary for a photojournalist to keep in mind.

First, he or she must anticipate the moment – be ready to photograph an event when it is happening, and always have the camera loaded with enough film.

Second, the photograph must be believable. It should be a faithful and honest representation of the event. It must not be phoney. (Imagine what he would think of some of the computer-manipulated news photos of today!)

Third, it must have significance. He named as examples the photograph of the *Hindenburg*, taken as it crashed and burned, and his own dust storm photograph.

I then broached the subject of television and what its impact might be on the survivability of magazines such as *Look* or *Life*. His response was that there would always be need for magazines. He thought these magazines would change with the times and would, of necessity, have to become more specialized, but he felt sure that magazines would survive.

He was only partially right. *Look* is gone. *Life* is a shadow of its former self; and many other magazines that were on the newsstand at that time are now but a memory. But he was right in saying that the magazines would become more specialized.

We spoke about pictures that evening and he gave me a print of his famous dust bowl photograph – printed from the original negative which he said had been destroyed some years earlier. For years he had been making prints of the image from a copy negative.

I saw Arthur only on rare occasions after that evening.

Kindern. Eines war Musiker, das andere bildender Künstler. Mir ist noch ganz deutlich in Erinnerung, wie er mir von seiner fünfzehnjährigen Tochter erzählte, die schon erfolgreich als Modeschöpferin arbeitete – sie entwarf, nähte und verkaufte Ballkleider an ihre Mitschülerinnen. Voller Stolz zeigte mir Arthur ein Album mit vielen ihrer Kleiderentwürfe.

Später am Abend sprachen wir dann von Dingen, die – mir jedenfalls – wichtiger waren. Arthur hatte zwei Bücher über Fotojournalismus geschrieben und galt als Experte auf diesem Gebiet. Er berichtete mir von einem Vortrag, den er eine Woche zuvor zum Thema Fotojournalismus gehalten hatte, und erklärte mir, welches seiner Meinung nach die drei wichtigsten Grundregeln für einen Fotojournalisten sind.

Erstens soll er in der Lage sein, »den entscheidenden Moment vorherzusehen« – um im richtigen Augenblick den Auslöser zu drücken; dazu muß er immer genug Film in der Kamera haben.

Zweitens soll das Foto »glaubwürdig« sein, eine wahrheitsgetreue und objektive Darstellung eines Geschehens. Es darf auf keinen Fall gestellt wirken. (Man überlege sich einmal, was Arthur von den heutigen Computer-manipulierten Nachrichtenfotos halten würde!)

Drittens soll ein Foto »bedeutsam« sein. Als Beispiele nannte er mir das Foto von der Explosion des Zeppelins »Hindenburg« und sein eigenes Foto von dem Sandsturm.

Ich lenkte unser Gespräch dann auf das Thema Fernsehen und auf die Frage, ob der Fernsehkonsum eventuell Illustrierte wie *Look* oder *Life* zurückdrängen könne. Seine Antwort lautete, daß es immer einen Bedarf nach Illustrierten geben werde. Er glaubte, daß solche Zeitschriften sich ihrer Zeit anpassen und zwangsläufig immer mehr spezialisieren würden. Für ihn stand fest: »Die Illustrierten werden überleben.«

Er sollte nur teilweise recht behalten: *Look* wurde eingestellt, und *Life* ist heute nur noch ein Schatten ihrer selbst; und viele andere Illustrierte, die man damals noch an den Kiosken kaufen konnte, gehören heute der Erinnerung an. Recht hatte Arthur aber mit seiner Voraussage, daß sich die Illustrierten stärker spezialisieren würden.

Wir sprachen an jenem Abend auch noch über Fotos, und er schenkte mir einen Abzug von seinem berühmten Sandsturmfoto – er stammte vom Originalnegativ, das einige Jahre zuvor verlorengegangen war; er hatte Abzüge seitdem nur noch von einem kopierten Negativ herstellen können.

Nach diesem Besuch sah ich Arthur Rothstein nur noch wenige Male.

talentueux. L'un était musicien, un autre artiste. Je me souviens encore de ce qu'il me dit à propos de sa fille alors âgée de quinze ans et de ses célèbres talents de créatrice de mode. Elle dessinait, fabriquait et vendait des tenues de bal à ses collègues étudiantes. Arthur, avec une immense fierté, me montra un album de photos des vêtements qu'elle avait faits.

Plus tard dans la soirée, nous sommes revenus, pour moi du moins, à des sujets plus sérieux. Arthur était l'auteur de deux livres concernant le reportage photographique et était considéré comme un expert en la matière. Il me parla d'une conférence qu'il avait donnée une semaine plus tôt sur ce sujet et insista sur les trois points qui lui semblaient essentiels et que tout reporter photographe devait garder en tête :

Premièrement, « il ou elle devait anticiper le moment », être prêt(e) à photographier l'événement quand il survenait, et veiller à ce que l'appareil soit chargé en permanence.

Deuxièmement, « la photographie devait être digne de foi ». Elle devait être une fidèle et honnête représentation de l'événement. Elle ne devait pas être factice. (Mieux vaut ne pas s'imaginer ce qu'il aurait pensé aujourd'hui de ces photos manipulées, réalisées sur ordinateur !).

Troisièmement, « ça devait avoir un sens ». Il prit en exemple les photographies du Hindenburg, lorsqu'il s'écrasa et prit feu, et ses propres photos de la tourmente de poussière.

J'abordai ensuite le sujet de la télévision et de son impact sur la survie de magazines comme *Look* ou *Life*. Il répondit qu'on aurait toujours besoin de magazines. Il pensait que ces magazines évolueraient avec le temps, et devraient, par nécessité, se spécialiser, mais ajouta que les magazines survivraient.

Il n'eut que partiellement raison. *Look* a disparu. *Life* est le fantôme de lui-même ; beaucoup d'autres magazines qu'on trouvait à l'époque dans les kiosques ne sont plus que des souvenirs. Mais il avait raison en disant que les magazines deviendraient plus spécialisés.

Nous parlâmes encore de photos ce soir-là et il me fit cadeau d'une copie de sa fameuse *Tourmente de poussière* reproduite d'après le négatif d'origine, lequel était détruit depuis quelques années. Il me dit avoir tiré des épreuves de cette photo plus tard, d'après une copie du négatif.

Je ne le revis qu'en de rares occasions après cette soirée.

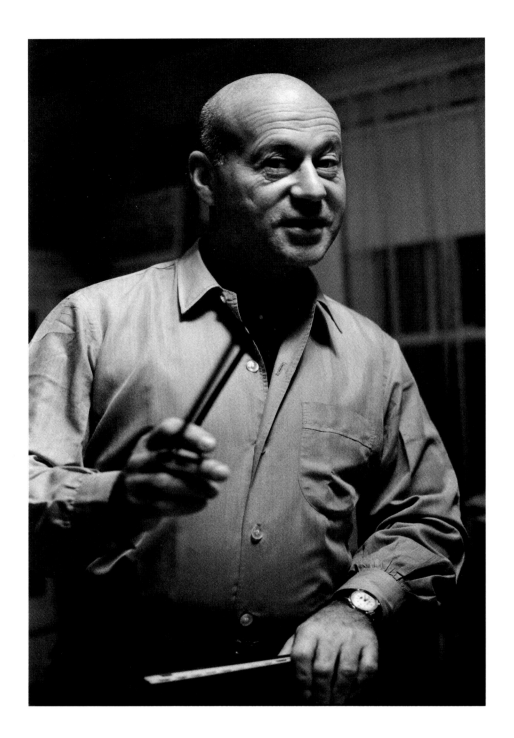
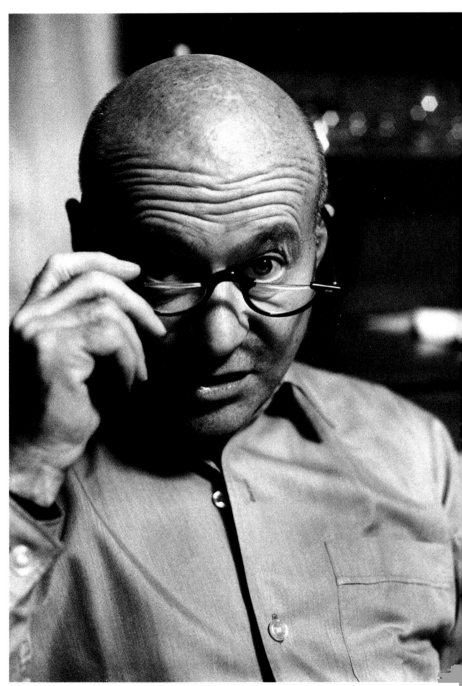

Arthur during a conversation with the author at the Rothstein home, New Rochelle, New York, 1977–78.

Arthur im Gespräch mit dem Autor in Rothsteins Wohnung in New Rochelle, New York. 1977–1978.

Arthur pendant une conversation avec l'auteur chez les Rothstein, à New Rochelle, New York. 1977–1978.

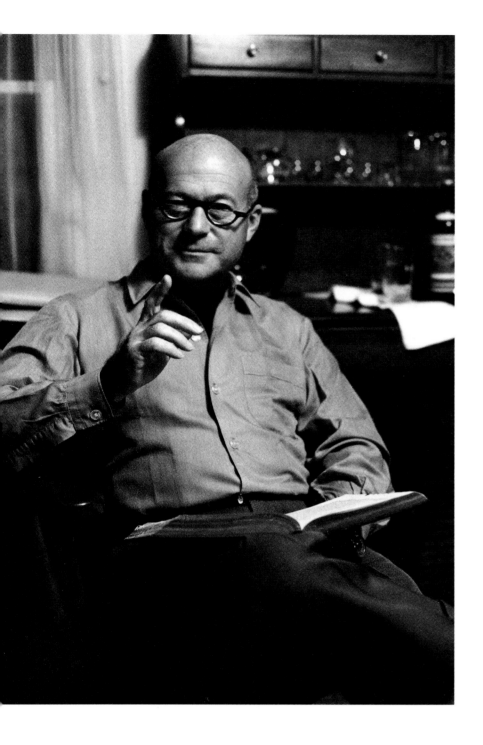
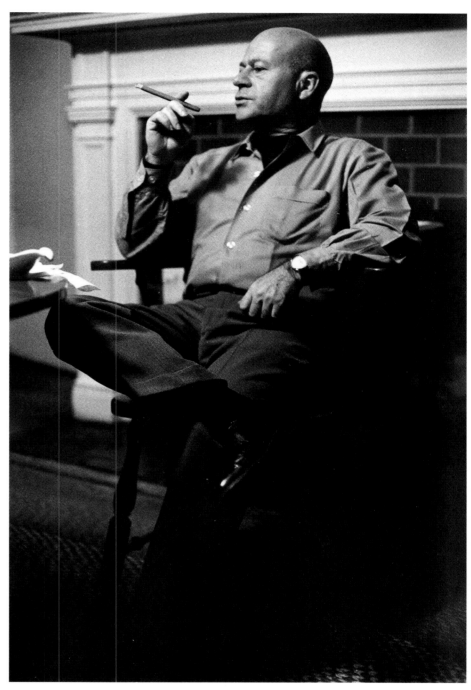

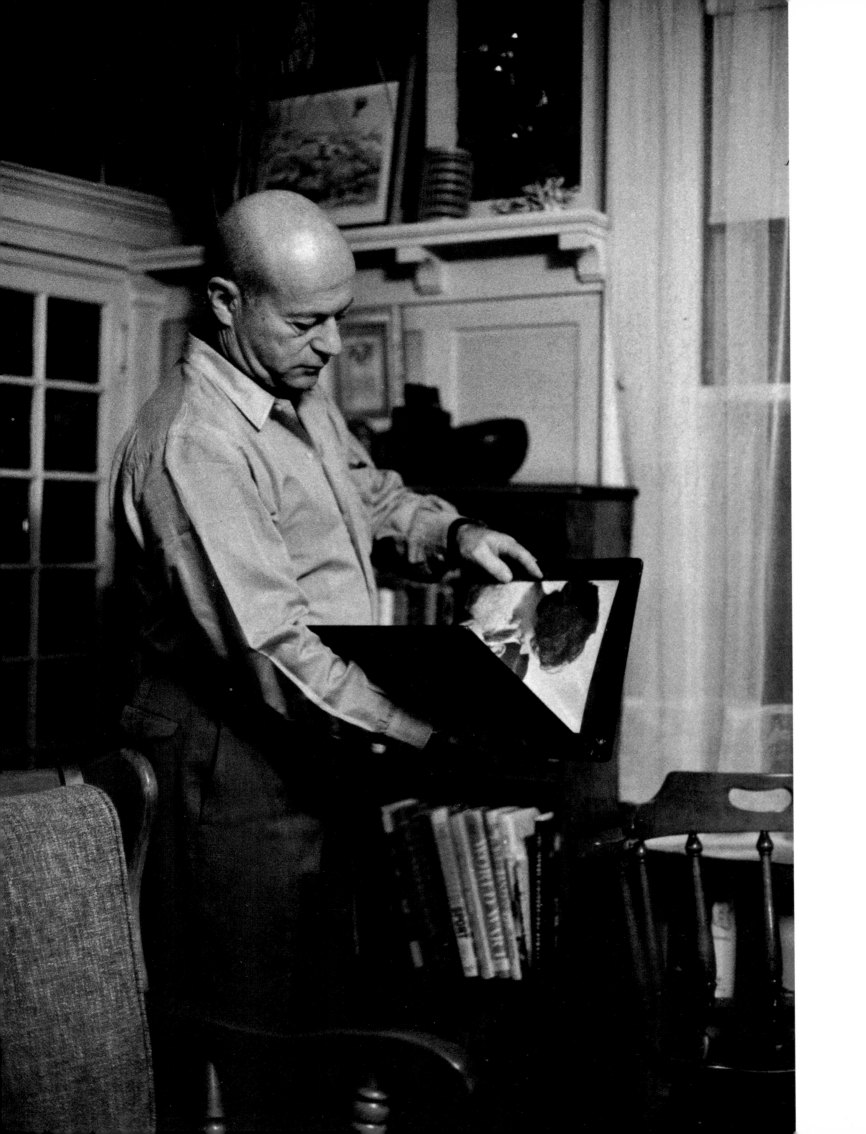

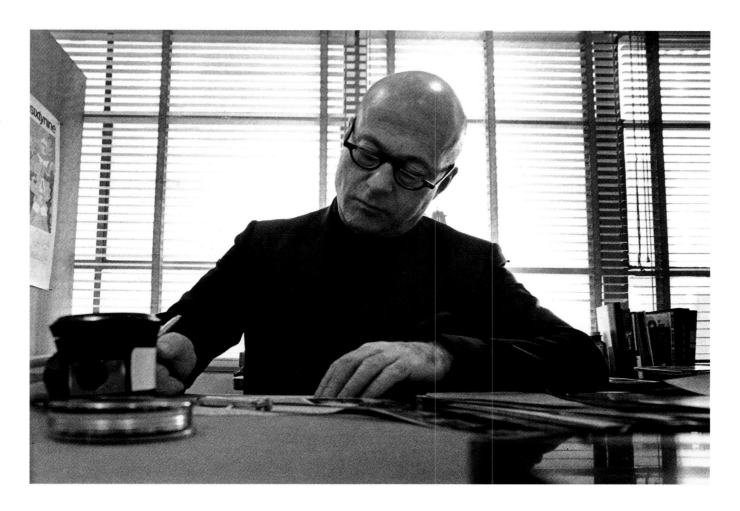

Arthur at his desk at *Look* magazine, New York, 1977–78.

Arthur in seinem Büro bei *Look* in New York, 1977–1978.

Arthur dans son bureau à *Look Magazine*, New York, 1977–1978.

At home with his daughter's portfolio, 1977–78.

Zu Hause, mit der Mappe seiner Tochter, 1977–1978.

A la maison avec le portfolio de sa fille, 1977–1978.

Arnold Newman

Born 1918. American.
Best known for his carefully conceived portraits of famous
musicians, artists and statesmen.

Geboren 1918. Amerikaner.
Bekannt für seine Porträts von berühmten Musikern, Künstlern
und Staatsmännern.

Né en 1918. Américain.
Très connu pour ses portraits raffinés de musiciens célèbres,
d'artistes et hommes d'État.

Portrait, 1995.

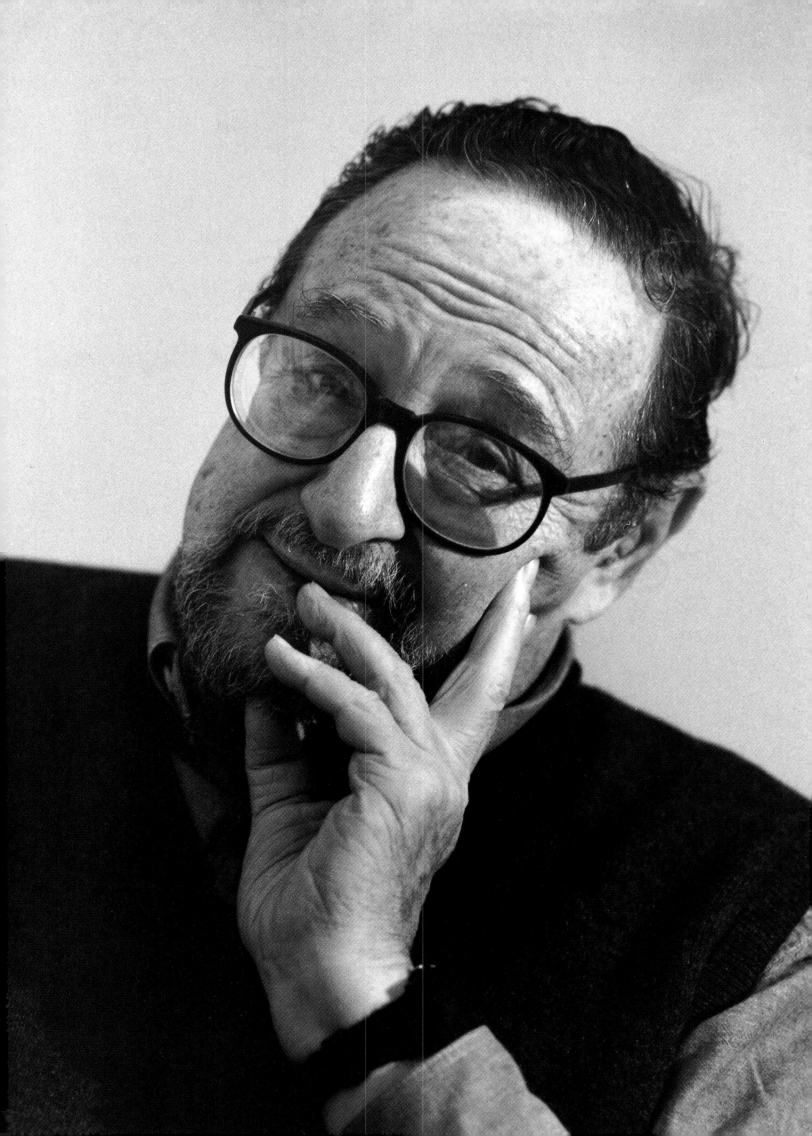

Eighteen years ago, Arnold Newman phoned me to say that he had been assigned by *Fortune* magazine to photograph me. I agreed; he did; and that was my first meeting with this master portraitist, who had started out as a painter and then took up photography to earn a living.

He arrived promptly with his assistants, meeting me in the basement vault at the American National Bank of Chicago. He set up a table, took some of my books out of the vault, carefully arranged me, my books, his lights, his tripod – metered – shot – and was finished in less than 30 minutes! I remember it vividly, as I was going through a divorce at the time. My mind was full of thoughts about my personal problems, although I tried not to divulge that to Arnold.

Our paths have crossed many times since then – Arnold always aware of my project and me always intending to photograph him. Initially, I would say, »Arnold, I need to photograph you!« – that was the first few years. Then when we'd meet, he'd say: »Arnold, when are you going to photograph me?« We even got as far as having a »date« for the event last year only to have it cancelled because he had just returned from the Middle East, where he was photographing Yassir Arafat. He came back jet-lagged, tired, and feeling generally awful, so I suggested postponing the session yet again.

It finally took place at the beginning of this year. I arrived in New York for the event, and phoned him. He sounded terrible – he said he was getting sick – but he agreed to let me come around anyway. He warned me, however, that he »would be difficult.« Undaunted, I told him I'd be over anyway.
I arrived at the studio as scheduled and was

Photos: Arnold in his studio on the Upper West side, New York, 1995.

Fotos: Arnold in seinem Atelier auf der Upper West Side von New York, 1995.

Photos: Arnold dans son studio du Upper West Side de New York, 1995.

Vor achtzehn Jahren rief mich Arnold Newman an und sagte mir, daß er von *Fortune* den Auftrag erhalten habe, mich zu fotografieren. Ich erklärte mich gerne bereit, und so kam er vorbei; es war meine erste Begegnung mit diesem Meisterporträtisten, der als Maler begonnen hatte und später zur Fotografie wechselte, um sich seinen Lebensunterhalt zu verdienen.

Er kam bald mit seinen Assistenten; wir trafen uns im Tresorraum der American National Bank of Chicago. Er stellte einen Tisch auf, nahm ein paar Bücher aus meinem Tresor, arrangierte mich und meine Bücher sorgfältig, regulierte die Studiolampen, schnell die Kamera aufs Stativ, scharfstellen – auslösen – fertig. Das ganze dauerte keine halbe Stunde. Ich hatte zu der Zeit mit meiner Scheidung zu tun und war in Gedanken nur bei meinen privaten Problemen, versuchte das aber vor Arnold zu verbergen.

Unsere Wege haben sich seither noch mehrfach gekreuzt – Arnold wußte von meinem Buchprojekt, und ich hatte immer vor, ihn zu fotografieren. Anfangs sagte ich zu ihm: »Arnold, ich muß dich unbedingt noch fotografieren.« Das war während der ersten paar Jahre. Später kehrte sich das um, und er sagte: »Arnold, wann wirst du mich fotografieren?« Letztes Jahr hatten wir sogar schon einmal einen Termin vereinbart, doch fiel der leider wieder ins Wasser, weil Arnold kurz zuvor von einem Fototermin mit Yassir Arafat aus dem Mittleren Osten zurückgekehrt war; er war so müde und erschöpft, daß ich vorschlug, den Termin zu verschieben.

So wurde unser Treffen erst zu Beginn dieses Jahres Wirklichkeit. Ich flog nach New York und rief ihn an. Er klang schrecklich – er hatte eine Grippe in den Knochen –, aber er war dann doch so freundlich, mich zu empfangen. Aber er warnte mich, daß er »schwierig« sein würde.

Das schreckte mich nicht, und ich machte mich auf den Weg.

Ich erschien also pünktlich in seinem Atelier, wo mich einer seiner Assistenten begrüßte. Arnold kam zu mir und sagte, er fühle sich schauderhaft. Ich

Arnold Newman me téléphona, il y a de cela 18 ans, pour m'expliquer qu'il était chargé par *Fortune Magazine* de me prendre en photo. Je fus d'accord et c'est ainsi que je rencontrai pour le première fois ce maître portraitiste, qui avait débuté comme peintre, puis s'était mis à la photo pour gagner sa vie.

Nous avions prévu de nous retrouver dans la chambre forte, située au sous-sol de l'American National Bank de Chicago. Il arriva rapidement suivi de ses assistants, installa une table, sortit du coffre quelques-uns de mes ouvrages, puis il m'arrangea soigneusement ainsi que mes livres et son trépied, il vérifia l'éclairage, évalua la distance et prit la photo. Tout fut emballé en une demi-heure ! Je me souviens que c'était à l'époque de mon divorce, que j'avais l'esprit occupé par ce problème et toutes sortes de pensées dues à ma situation personnelle, tout en essayant de n'en rien laisser paraître. Nos chemins se sont croisés, depuis, en bien des occasions, et à chacune d'elle Arnold me parlait de mon projet et moi de mon intention de le prendre en photo. Au tout début, dans les premières années, je lui disais : « Arnold, j'ai besoin d'une photo de vous. » Par la suite, chaque fois que nous nous rencontrions, il me répétait : « Arnold, quand allez-vous me prendre en photo ? » Nous étions même allés jusqu'à prendre rendez-vous l'année dernière, rendez-vous que nous avions dû annuler parce qu'il rentrait du Moyen-Orient, où il avait photographié Yasser Arafat, et qu'il était assommé à cause du décalage horaire, épuisé, dans un état épouvantable. Je proposai donc encore une fois de reporter la séance.

Elle put enfin avoir lieu au début de cette année. Je lui téléphonai à mon arrivée à New York et les choses se présentèrent plutôt mal : il me dit qu'il était malade, mais il accepta malgré tout gentiment que je vienne, m'avertissant que « ça ne serait pas facile ». Je ne me laissai pas ébranler par la situation et lui dis que j'arrivai.

Je vins au studio à l'heure prévue et fus accueilli par l'assistant d'Arnold, qui lui-même arriva très vite en se plaignant d'être vraiment mal dans sa peau. Je

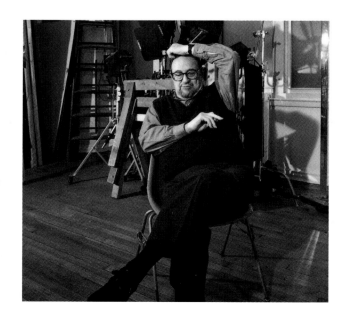
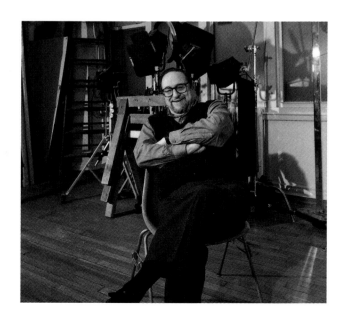

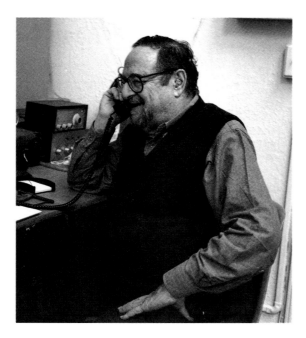 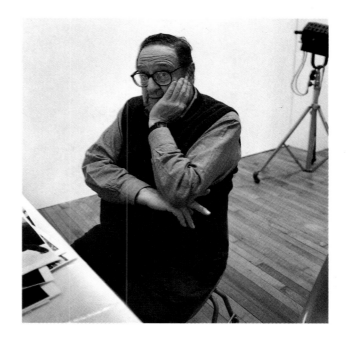

greeted by Arnold's assistant. Arnold promptly appeared, complaining of feeling lousy. I suggested photographing him in his home, which was just across the street from the studio, but he rejected the idea because Gus, his wife, was there recovering from the flu. We spoke about lighting, and about the spectacular light banks in his studio. He said he preferred quartz lighting to strobe, and offered me whatever I wanted to use. I chose two quartz lights – bounced – and went to work. I like my photographs of faces to be direct, and it was hell getting him to look into the lens. I kept the session brief, because I could see he was not well.

Then Gus walked in. My cameras set aside, the three of us talked of children and families and of mutual friends (of which there were a number). The conversation soon turned to the business of photography, and I was surprised to learn that even with his abilities and reputation, he sometimes had the same problems the rest of us had getting assignments. He told me about the declaration of one friendly art director, who had told him he didn't think Arnold would want a particular job – because it was »only« for three days at $5,000 a day!

This vignette of Arnold would not be complete without saying that in addition to his being a great photographer, he is also a great teacher. A number of his former assistants, having been schooled by a dedicated master, have gone on to become successful professionals. In addition, Arnold's name appears often on the faculty list of the most important photographic workshops in America. He has devoted endless days over the years to teaching others.

Warm, very bright, and a great visual artist – I finally have Arnold on film.

schlug vor, ihn zu Hause zu fotografieren, denn er wohnte gleich gegenüber. Das wollte er nicht, weil seine Frau, Gus, sich noch nicht ganz von einer Grippe erholt hatte. Wir sprachen über Fragen der Beleuchtung und über die großartigen Scheinwerferreihen in seinem Atelier. Er sagte, er ziehe Quarzlampen dem Stroboskoplicht vor, ich solle aber nehmen, was ich wolle. Ich wählte zwei Quarzlampen und einen Reflektor und machte mich an die Arbeit. Ich liebe sehr direkte Porträts, aber es war fast unmöglich, Arnold dazu zu bewegen, in die Kamera zu sehen. Da ich merkte, daß es ihm nicht gut ging, machte ich es kurz.

Dann kam Gus herein.

Ich legte meine Kameras beiseite, und wir drei unterhielten uns eine Weile über die Kinder, die Familie und gemeinsame Freunde – wir haben einige.

Bald drehte sich das Gespräch um die Arbeit des Fotografen, und ich war überrascht zu hören, daß Arnold trotz seiner Fähigkeiten und seiner Reputation manchmal ebenso große Schwierigkeiten hat, Aufträge zu bekommen, wie wir normalsterblichen Fotografen. Er erzählte mir die Geschichte von einem befreundeten Art Director, der ihm einmal einen Job gar nicht erst angeboten hatte, weil er geglaubt hatte, Arnold würde ihn sowieso ablehnen – es ging »nur« um drei Tage zu einem Tagessatz von 5.000 Dollar!

Um diese Vignette über Arnold abzurunden, muß ich noch erwähnen, daß er nicht nur ein großer Fotograf, sondern auch ein bedeutender Dozent ist. Einige seiner früheren Assistenten sind nach ihrer Ausbildung bei diesem hingebungsvoll arbeitenden Meister selbst erfolgreiche Profi-Fotografen geworden. Arnolds Name steht oft auf der Liste der Dozenten der wichtigsten Fotoworkshops in den USA. Ungezählte Tage seines Lebens hat er schon für die Lehre geopfert.

Der freundliche, intelligente Arnold Newman, der großartige Künstler – endlich habe ich ihn fotografieren dürfen.

proposai de le photographier à son domicile situé dans la rue avoisinante, mais il refusa parce que sa femme, Gus, se trouvait là et se remettait d'une grippe.

Nous parlâmes des éclairages et de son extraordinaire rampe de spots. Il me dit qu'il préférait l'éclairage à quartz pour les flashes et m'offrit d'utiliser ce que je souhaitais. Je choisis deux éclairages à quartz, et me mis au travail. J'aime photographier les visages directement de face et j'eus un mal fou à l'amener à fixer l'objectif. J'écourtai la séance sentant qu'il n'allait pas bien du tout. Puis Gus fit son apparition.

Je mis mon appareil de côté et nous discutâmes tous les trois des enfants, de la famille, de nos nombreux amis communs. La conversation s'orienta bientôt sur l'aspect financier de la profession, et je fus surpris d'apprendre qu'en dépit de son talent et de sa réputation, Arnold avait parfois, comme nous tous, des difficultés pour obtenir des contrats. Il me raconta qu'un directeur artistique, au demeurant amical, ne lui avait pas proposé un certain travail, parce que le cachet était, pour trois jours, « seulement » de 5 000 dollars par jour !

Arnold n'était pas seulement un grand photographe, il était également un grand professeur. Beaucoup de ses anciens assistants ont profité de son charisme, poursuivi leur carrière et sont devenus de talentueux photographes professionnels. Soulignons encore que son nom apparaît très souvent sur la liste des universités qui dispensent les plus importants cours de photographie aux États-Unis. Arnold aura consacré une grande partie de sa vie à enseigner, à faire profiter les autres de son génie.

Chaleureux, très intelligent et grand maître de l'image, je tenais, enfin, mes photos d'Arnold.

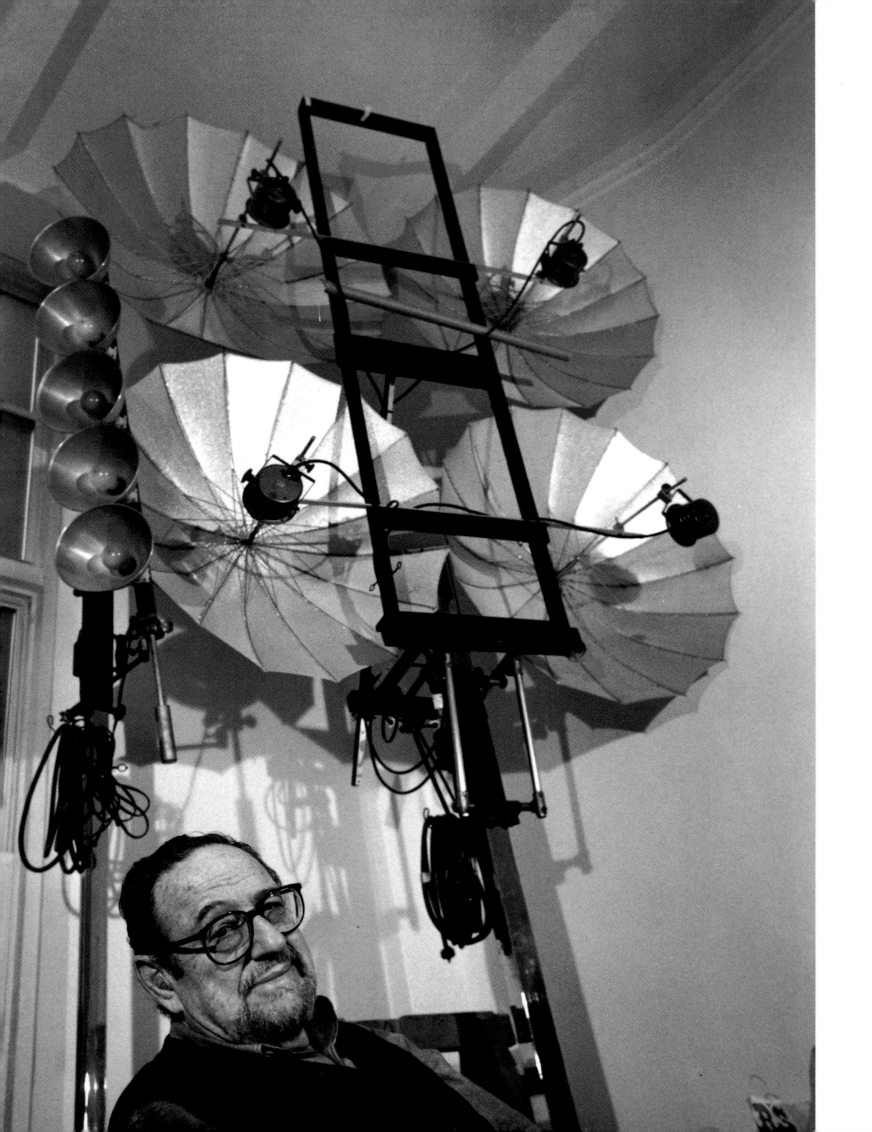

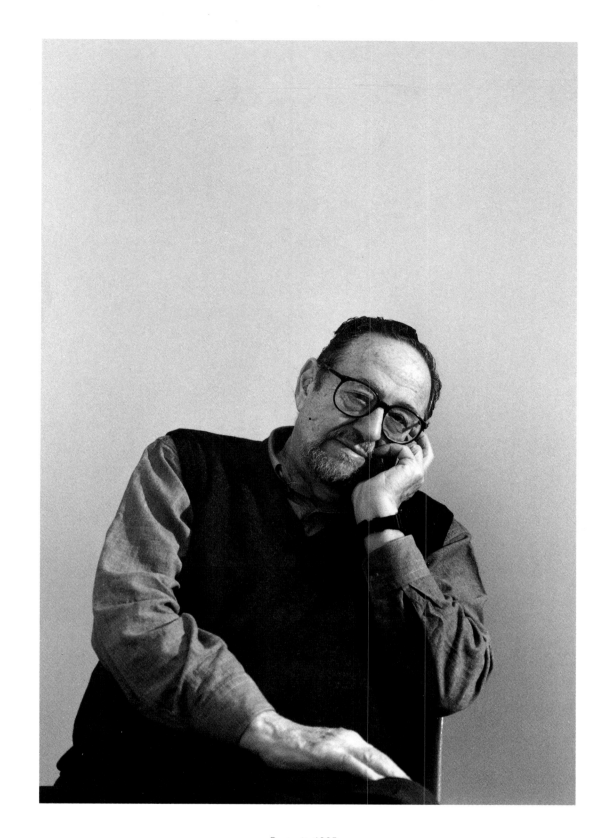

Portrait, 1995.

Arnold with his light setup, 1995.

Arnold mit seinen Fotolampen, 1995.

Arnold, dans son studio, installant ses éclairages, 1995.

Lee Friedlander

Born 1934. American.
Photographer of city landscapes and people. His photographs
often have a mysterious and subtle content. Close friend of
Garry Winogrand.

Geboren 1934. Amerikaner.
Fotografierte Stadtlandschaften und Personen. Seine Fotos
wirken oft geheimnisvoll und ätherisch. Er war ein guter Freund
von Garry Winogrand.

Né en 1934. Américain.
Photographe de la ville et des gens. Du contenu de ses photos
émane souvent une qualité subtile et mystérieuse. Ami très
proche du regretté Garry Winogrand.

Lee at the automobile show, McCormick Place, Chicago, 1974.

Lee bei der Automobil Show am McCormick Place, Chicago, 1974.

Lee lors d'un salon automobile, place McCormick, Chicago, 1974.

Whenever I think of Lee, my mind recalls one of my early meetings with him. He was wearing a beanie on his head – with a propeller attached!

Lee Friedlander, contrary to that picture, is as serious, purposeful, thoughtful and intelligent as anyone I've ever met.

I was introduced to Lee by Garry Wingrand while Garry was in Chicago. The two of them were best friends. Lee had come here with his wife, Maria, and their children, and was staying in a small motel on LaSalle Street near the downtown area.

There, Lee photographed me wearing some awful white shoes, sitting by a table-lamp. This photograph, much to my embarrassment, appeared in a book of Lee's portraits published several years ago.

I attended a lecture Lee gave at the Art Institute of Chicago a number of years ago. He showed a great many slides of his work – most of them having a pole, a line – something – which bisected the frame. Some unwary student in the audience asked Lee: »Why do you often show bisecting forms?« Lee replied: »I'm not aware that I do.«

I've seen Lee and Maria a number of times since. On one of the most unusual and pleasant of those occasions, I was sitting in the lobby of the Regent Hotel in Hong Kong, when, much to my surprise, Lee and Maria suddenly walked in. Lee was in the Hong Kong area to receive an honor for his photographs, one of the many awards he's been given over the years.

Wenn ich heute an Lee denke, erinnere ich mich immer an unsere erste Begegnung. Er trug ein Damenhütchen und darauf – einen Propeller!

Auch wenn diese Szene etwas anderes suggerieren könnte – Lee Friedlander ist einer der ernsthaftesten, zielstrebigsten, nachdenklichsten und intelligentesten Menschen, die ich kenne.

Garry Winogrand machte mich mit Lee in Chicago bekannt. Lee und Garry waren sehr eng miteinander befreundet. Lee war mit seiner Frau Maria und seinen Kindern nach Chicago gekommen; sie wohnten in einem kleinen Hotel in der LaSalle Street, unweit vom Stadtzentrum.

Dort machte Lee ein Foto von mir, auf dem ich scheußliche weiße Schuhe trage und neben einer Tischlampe sitze. Sehr zu meinem Ärger erschien dieses Foto vor einigen Jahren in einem Buch mit Lees Porträts.

Vor einigen Jahren besuchte ich einen Vortrag, den Lee am Art Institute of Chicago hielt. Dabei zeigte er viele Dias, die er von seinen Fotos aufgenommen hatte – die meisten waren von einem Mast, einem Draht oder sonst etwas in zwei Hälften geteilt. Ein kecker Student im Publikum fragte: »Warum sind Ihre Bilder formal oft zweigeteilt?« Lee erwiderte trocken: »Das ist mir noch gar nicht aufgefallen.«

Ich habe Lee und Maria später noch einige Male gesehen. An die schönste und ungewöhnlichste dieser Begegnungen erinnere ich mich noch gut: Ich saß in der Lobby des Regent Hotel in Hongkong, als plötzlich Lee und Maria hereinkamen. Lee war nach Hongkong gekommen, um eine der vielen Auszeichnungen für seine Fotos entgegenzunehmen.

Chaque fois que je pense à Lee, je me souviens de notre première rencontre. Il portait une calotte vissée sur le crâne sur laquelle était attachée une hélice !

Cependant, contrairement à cette description, Lee est l'une des personnes les plus sérieuses, les plus réfléchies et les plus intelligentes que j'ai rencontrées.

Je fus présenté à Lee, pendant qu'il séjournait à Chicago, par Garry Winogrand. Lee et Garry étaient très liés. Lee était venu avec sa femme, Maria, et leurs enfants, et ils étaient descendus dans un petit motel situé rue LaSalle dans le centre-ville. Lee me photographia (je portais d'affreuses chaussures blanches) assis à une table surmontée d'une lampe. Cette photographie, à ma grande confusion, parut dans le livre de portraits de Lee publié il y a quelques années.

Je me rendis à une conférence que Lee donna, il y a de cela plusieurs années, à l'institut d'Art de Chicago. Il montra un grand nombre de diapositives de son travail, la plupart montrant un mât, une ligne, quelque chose qui divisait le cadrage. Un étudiant demanda imprudemment à Lee: « Pourquoi montrez-vous si souvent des formes coupées en deux ? » Lee répliqua : « Je ne m'en rends pas compte. »

Depuis, j'ai revu Lee et Maria en bien des occasions. Mais l'une d'elle fut particulièrement inattendue et sympathique. J'étais assis dans le vestibule de l'hôtel Regent à Hong-Kong, quand, à ma plus grande surprise, je vis entrer Lee et Maria. Lee était à Hong-Kong pour recevoir un prix, un parmi tous ceux qu'il reçut au fil des années.

Lee in my living room, Chicago, 1974. Lee would often avoid being photographed by covering his face.

Lee in meinem Wohnzimmer in Chicago, 1974. Lee hielt sich immer die Hände vors Gesicht, wenn er nicht fotografiert werden wollte.

Lee dans ma salle de séjour, Chicago, 1974. Lee évitait souvent d'être photographié en se cachant le visage.

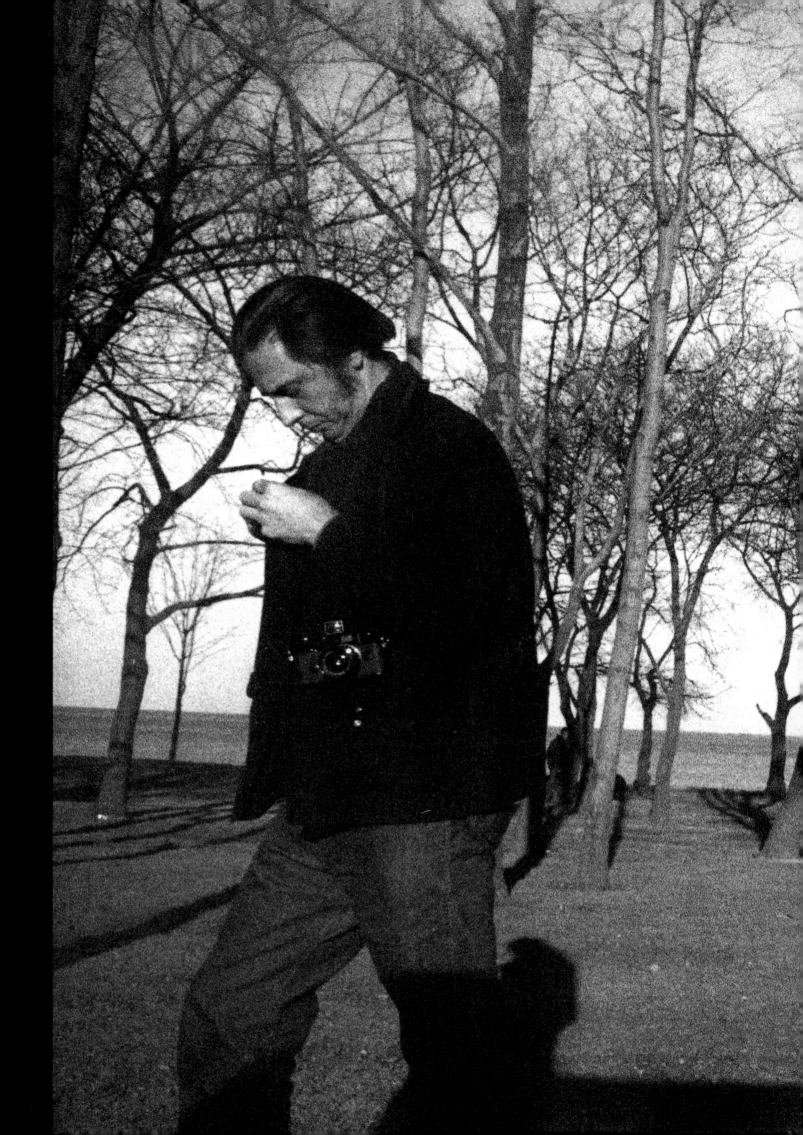

Lee walking near the
lake, Chicago, 1976.

Lee beim Spaziergang am
Ufer des Lake Michigan, 1976.

Lee sur les rives du
Lac Michigan, 1976.

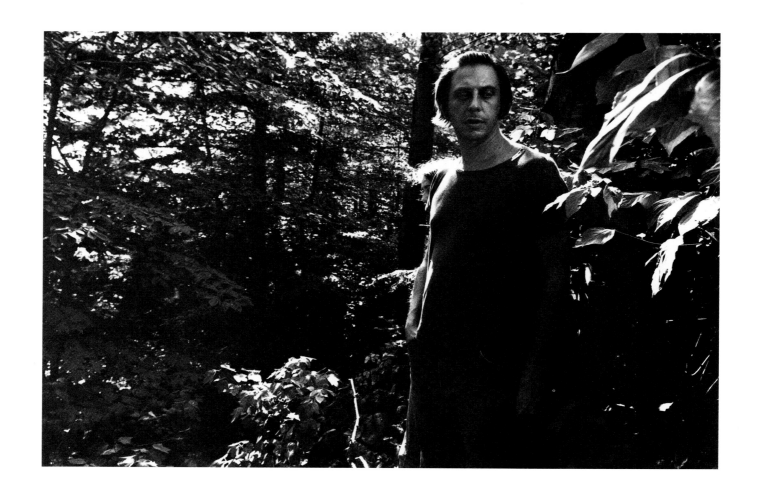

Lee in his garden and with Garry Winogrand and Carole Kismarec at his home, New York, 1976.

Lee in seinem Garten und mit Garry Winogrand und Carole Kismarec vor seiner New Yorker Wohnung, 1976.

Lee dans son jardin et avec Garry Winogrand et Carole Kismarec chez lui à New York, 1976.

Carole, Lee and Garry in Lee's garden, 1976.

Carole, Lee und Garry in Lees Garten, 1976.

Carole, Lee et Garry dans le jardin de Lee, 1976.

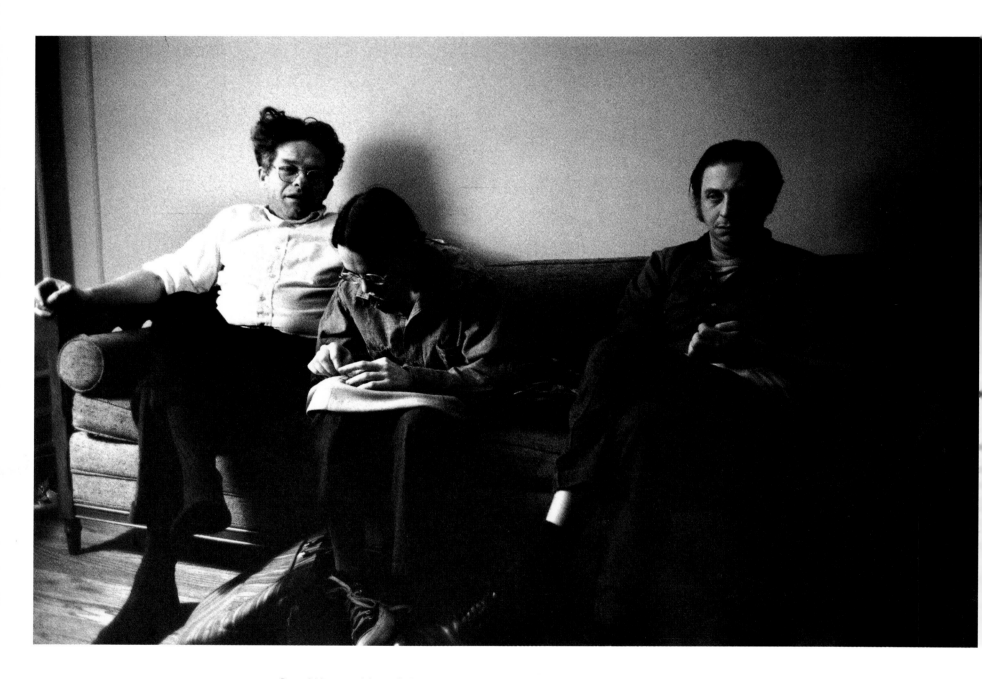

△ ▷ Garry Winogrand, his wife Eileen Hale and Lee Friedlander in Garry's Chicago apartment, 1976.

Garry Winogrand, seine Frau Eileen Hale und Lee Friedlander in Garrys Apartment in Chicago, 1976.

Garry Winogrand, sa femme, Eileen Hale et Lee Friedlander dans l'appartement de Garry à Chicago, 1976.

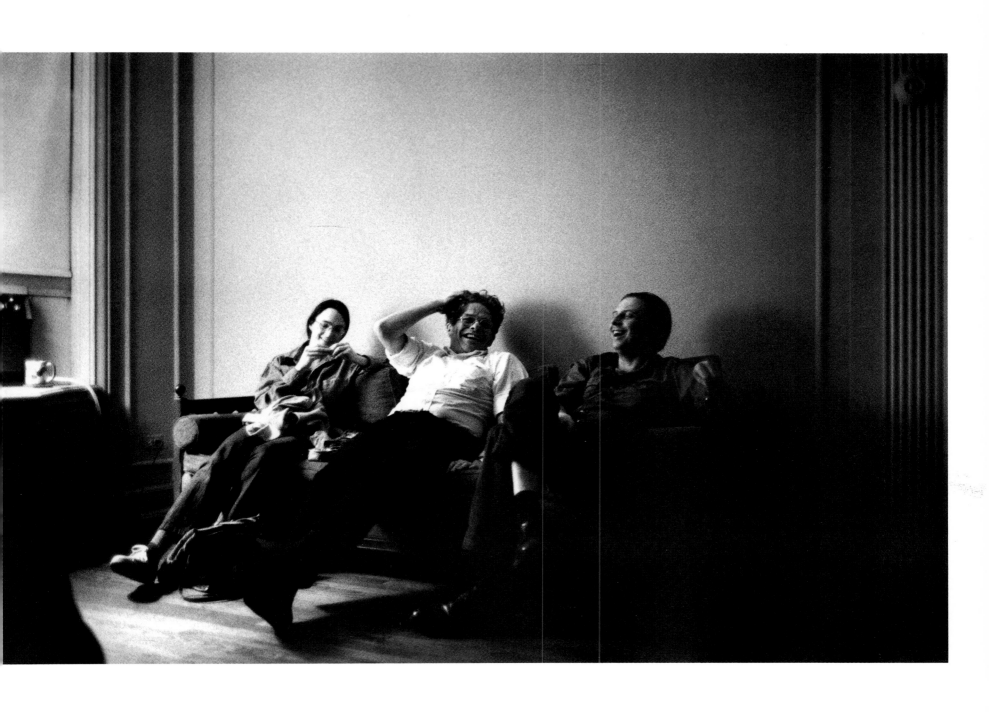

Garry Winogrand

1928–1984. American.
One of the creators of »street photography«. A social
documentarian, he was never without his camera.

1928–1984. Amerikaner.
Er war einer der Erfinder der »Street Photography«, einer
fotografischen Richtung, die eine engagierte Dokumentation der
gesellschaftlichen Verhältnisse betrieb.

1928–1984. Américain.
L'un des créateurs de la « photographie de rue ». Il a fourni
beaucoup de documents sur la condition sociale de son pays et
ne se déplaçait jamais sans son appareil.

Garry on a Chicago bus, 1971.

Garry in einem Chicagoer Bus, 1971.

Garry dans un bus à Chicago, 1971.

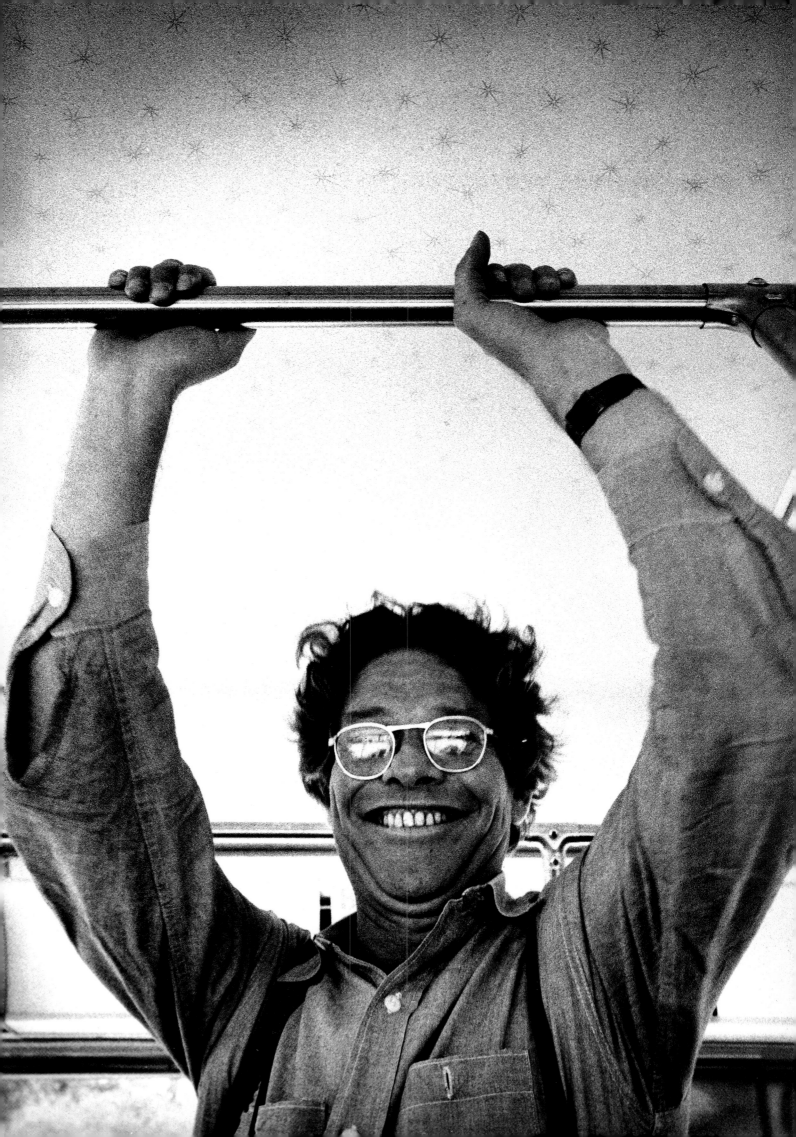

He called himself a »photo-junkie.« And he was. I don't ever remember seeing Garry when he didn't have his Leica M with its 28mm lens either over his shoulder, up to his eye, or in his right hand with the thin leather camera strap wrapped securely around his palm.

Garry came to Chicago around 1970 to be artist in residence at one of the Universities here. I really can't recall just how we met – but by coincidence (or fate), he ended up leasing an apartment not 75 feet from my door.

During the couple of years he spent here, Garry and I would see each other almost on a daily basis, Saturdays, Sundays, and evenings included. He soon became my closest friend.

Garry photographed constantly, wherever he might be. He is generally referred to as a »street photographer.« In his personal work, he had spent his early years on the streets and in the parks of New York, »immortalizing.«

That word or its various permutations will forever hold special memories for me. I was already well into my project, the subject matter of this book, when Garry and I first met. At that time, Garry was already famous. Not only was he a superb photographer, but he was also very smart – he had an uncanny ability to sucker me into carrying his packages, so his own hands would be free to photograph. Or he'd get me to drive him around in my car, so he could sit in the front seat, with his head out the window, photographing women in cars next to us and yelling: »You've just been immortalized!«

Now, I can be photographing on the street

Er nannte sich einen »Foto-Junkie«, und das war er auch. Ich habe ihn, glaube ich, niemals ohne seine Leica M mit ihrem 28-mm-Weitwinkel gesehen – entweder hatte er sie über der Schulter hängen, oder er schaute durch den Sucher, oder er hielt sie in der rechten Hand und hatte das dünne Lederband fest um die Hand gewickelt.

Garry kam um 1970 als »artist in residence« an eine der Universitäten von Chicago. Ich kann mich nicht mehr genau erinnern, wie wir uns kennenlernten, aber es war ein Zufall (oder das Schicksal), das uns zusammenführte: Er mietete ein Apartment, das keine zwanzig Meter von meinem entfernt lag.

Während der beiden Jahre, die Garry hier verbrachte, sahen wir uns fast täglich, auch an den Wochenenden. Er wurde bald zu meinem besten Freund.

Garry fotografierte, wo er ging und stand. Allgemein nennt man ihn einen »Straßenfotografen«. Die Anfangsjahre seiner Karriere hatte er auf den Straßen und in den Parks von New York verbracht, »um sie zu verewigen«.

Das Wort »verewigen« und Garrys verschiedene grammatische Abwandlungen dieses Begriffs werden mir immer im Ohr bleiben und mich immer in ganz besonderer Weise an Garry erinnern. Als ich ihn traf, war mein Buchprojekt schon recht weit fortgeschritten und Garry schon ein berühmter Mann. Er war nicht nur ein ausgezeichneter Fotograf, sondern auch ein geriebener Bursche. Er hatte die Gabe, mir beim Einkaufen seine Sachen in die Hand zu drücken, so daß er selbst die Hände zum Fotografieren frei hatte. Oder er schaffte es, sich

Il s'appelait lui-même le « drogué de la photo ». Et il l'était ! Je ne me souviens pas avoir vu Garry sans son Leica M avec ses lentilles de 28mm, soit sur l'épaule, soit devant les yeux, ou bien dans la main droite, la fine lanière entortillée dans la paume de la main par sécurité.

Garry vint à Chicago dans les années soixante-dix pour être « artiste résident » dans l'une des universités d'ici. Je ne peux me souvenir comment nous nous sommes rencontrés, mais par une coïncidence (ou le destin) il loua finalement un appartement à moins de vingt mètres de chez moi.

Durant les deux années qu'il passa ici, Garry et moi nous vîmes presque tous les jours, samedis, dimanches et soirées y compris. Il devint bientôt mon meilleur ami. Garry photographiait à tout instant et partout. On se réfère généralement à lui comme étant le « photographe de rue ». Il avait passé les premières années de sa carrière dans les rues et les parcs de New York pour les « immortaliser ».

Ce mot et toutes ses variations évoqueront à jamais dans ma mémoire des souvenirs particuliers. J'étais déjà très engagé dans mon projet, le sujet de ce livre, quand Garry et moi nous rencontrâmes. A cette époque, Garry était déjà célèbre. Ce n'était pas seulement un photographe formidable, il était également très malin et avait une habileté diabolique pour m'entraîner avec lui et me faire porter son chargement, de façon à avoir les mains libres pour photographier. Ou encore, il me demandait de l'emmener à travers Chicago en voiture, il s'asseyait alors à côté de moi, la tête sortie par la fenêtre,

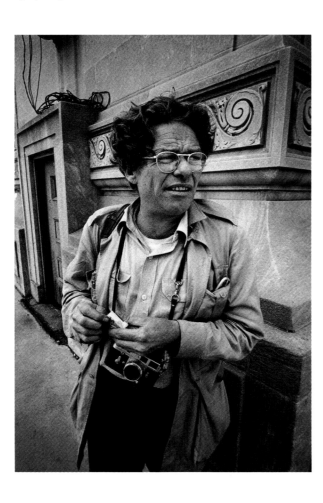

Garry, Chicago, 1974.

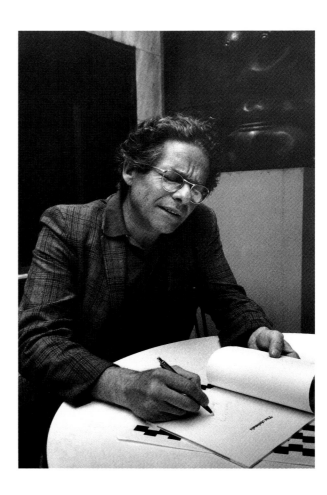

Garry signing a copy of his book, 1971.

Garry signiert sein Buch, 1971.

Garry signant un exempla de son livre, 1971.

Garry photographing an anti-Vietnam war parade, Chicago, 1974.

Garry beim Fotografieren einer Demonstration in Chicago, 1974.

Garry en train de photographier une manifestation contre la guerre du Viêt-nam à Chicago, 1974.

anywhere in the world, and not a day goes by when I do not think of Garry yelling that phrase in his broad New York accent.

In addition to my »immortalizing« the great living photographers of my time, I also had to earn a living, so I practiced law for some 27 years as a litigator with a specialty in medical law. My cases required me to do a certain amount of travel, generally within the state. On several occasions, Garry accompanied me on these trips.

On one of these occasions I was in the court clerk's office in Joliet, Illinois. There was Garry! »Immortalizing« away! Photographing me at the counter – in the halls – everywhere! Yet I've never even seen those photographs. Garry would shoot at least two rolls of film, and as many as ten rolls, each and every day of his life. He also would wait for months before he would even develop any – which he would do only every so often. In the interim, huge numbers of rolls of exposed, undeveloped film would accumulate. In fact, at his death, he left more than 7,000 undeveloped rolls of exposed 35mm black-and-white film that he had shot. This film was developed after his death and some of the pictures were added to the retrospective exhibit and book of his life's work.

That work and that show has, of course, raised the question as to how Garry would have edited it had he been alive to do so.

How Garry made prints was even more interesting. He had a Leitz Focomat enlarger. He would expose several hundred different negatives one after another onto sheets of enlarging paper, and store all of the exposed but undeveloped paper until a later time when he would develop the prints – *en masse*. When I asked him why he didn't de-

von mir durch Chicago chauffieren zu lassen; er saß dann neben mir, streckte den Kopf aus dem Fenster, fotografierte Frauen in den Autos neben uns und rief ihnen zu: »Sie sind soeben verewigt worden!« Wenn ich heute fotografiere, ganz gleich wo auf dieser weiten Welt, muß ich immer wieder an Garry denken, der diesen Satz in seinem breiten New Yorker Akzent in die Welt hinausgeschrien hat.

Da ich mich aber nicht nur der Verewigung der größten Fotografen unseres Jahrhunderts widmen konnte, sondern auch meinen Lebensunterhalt verdienen mußte, arbeitete ich 27 Jahre lang als Jurist auf dem Spezialgebiet medizinischer Rechtsfragen. Gelegentlich mußte ich bei meinen Fällen auch auf Reisen gehen, meist aber innerhalb des Bundesstaates, in dem ich lebte. Garry begleitete mich auf mehreren solcher Reisen.

Besonders erinnere ich mich an die Ereignisse im Büro des Gerichtsschreibers in Joliet. Garry war dabei und widmete sich unentwegt der »Verewigung«. Er fotografierte mich am Schalter des Gerichtsbediensteten – in den Fluren und Sälen des Gerichtsgebäudes, einfach überall! Doch habe ich diese Fotos nie gesehen. Garry verschoß nämlich jeden Tag mindestens zwei Filme, manchmal sogar bis zu zehn Rollen. Meist wartete er mehrere Monate, ehe er die belichteten Filme entwickelte – er ging nur hin und wieder in die Dunkelkammer, und so sammmelten sich bergeweise belichtete, noch unentwickelte Filme an. Als Garry starb, hinterließ er über 7000 unentwickelte Schwarzweißfilme im Kleinbildformat. Dieses Material wurde nach seinem Tod entwickelt und einige Aufnahmen gingen in die große Retrospektive und den Katalog zu seinem Lebenswerk ein.

Natürlich stellte sich dabei die Frage, wie Garry diese Aufnahmen wohl verarbeitet hätte, wenn er noch âm Leben gewesen wäre.

Garrys Methode, Abzüge zu entwickeln, war schon ungewöhnlich. Er besaß ein »Focomat«-Vergrößerungsgerät von Leitz. Damit machte er Hunderte großformatiger Abzüge und legte dann das belichtete, aber noch nicht entwickelte Papier beiseite; die Abzüge entwickelte er oft erst später – alle zusammen. Ich fragte ihn einmal, warum er sie

photographiant les femmes des voitures d'à côté en criant à tue-tête : « Vous venez d'être immortalisée ! ». Dorénavant, quand je prends une photo dans n'importe quelle rue du monde, je ne peux m'empêcher de penser à Garry hurlant cette phrase avec son terrible accent new-yorkais.

En plus « d'immortaliser » les grands noms de la photographie de mon époque, je devais également gagner ma vie. Je le fis pendant quelques vingt-sept années comme avocat spécialisé dans le droit médical. Mes dossiers entraînaient un certain nombre de déplacements, généralement à l'intérieur de l'État. Je me souviens qu'en plusieurs occasions, Garry m'accompagna dans ces voyages. Il me revient encore en mémoire cet épisode où je me trouvais dans le bureau du greffier à Joliet. Garry s'y trouvait aussi, m'« immortalisant » à qui mieux mieux, au comptoir, dans le hall, partout ! Jusqu'à présent, je n'ai jamais vu ces photos.

Garry utilisait deux à dix pellicules par jour. Puis il attendait des mois avant d'en développer une seule. Ce qui rendait l'événement rare. Entre temps, un nombre impressionnant de négatifs et de pellicules s'entassaient un peu plus chaque jour. A sa mort, il laissa plus de 7000 bobines non développées en 35mm noir et blanc tirées au fil des jours. Elles ont été tirées après sa mort et quelques photos ont été ajoutées à l'exposition de sa rétrospective et au livre consacré à sa vie de photographe.

Cette rétrospective, bien sûr, souleva la question de savoir comment Garry l'aurait organisée s'il avait été en vie.

Mais la façon dont Garry développait est encore plus intéressante. Il avait un agrandisseur, un Leitz Focomat. Il exposait plusieurs centaines de négatifs différents l'un après l'autre sur des planches de papier photo et conservait tous les négatifs exposés mais non développés pour plus tard. Quand je lui demandai pourquoi il ne développait pas ses épreuves au fur et à mesure, afin de garantir une qualité constante, il répondit : « Je n'ai plus besoin de faire ça. Je l'ai tellement fait. Je sais parfaitement ce que je fais et en général j'obtiens de très bonnes photos. » Et il avait raison. Ça marchait.

Garry était merveilleux avec ses enfants, c'était un

velop his prints one at a time as they were made, in order to ensure a consistent quality, he responded:

»I don't have to. I've done this so much, I know what I'm doing, pretty well, and I generally get a good print most of the time.« And he was right – he did.

Garry was wonderful with children and was also an intensely loving father, always in close contact with his son and daughter from his first marriage. When he was in Chicago, he was already divorced from his first wife and was living with Eileen, who later became his second wife. Garry spent many evenings at my house, philosophizing about the world and the arts and cradling a glass containing an inch or so of Scotch.

I learned a great deal about photography from Garry. I once asked him why he sometimes would hold his camera on an angle, not keeping a level horizon. He responded that when he made a »pick-cha,« he always set up a problem he had to solve, a situation of »contention« – and therefore he felt free to compose his frame as he saw fit, for each sit-

Garry playing with David Crane. His son Ethan appears in the last two frames and is photographing me. 1971.

Garry spielt mit David Crane. Auf den letzten beiden Bildern erkennt man Ethan, der mich fotografieren will. 1971.

Garry jouant avec David Crane. Son fils Ethan apparaît dans les deux dernières photos en train de me photographier. 1971.

nicht sofort nach der Belichtung entwickelte, um sich z.B. der Qualität des Ergebnisses zu vergewissern. Er antwortete: »Weil es unnötig ist. Ich mache diese Arbeit schon so lange, daß ich genau weiß, was ich tue; ich kriege fast immer gute Abzüge.« Und das stimmte, sie waren fast immer tadellos.

Garry konnte wunderbar mit Kindern umgehen und war ein guter Vater; er hielt engen Kontakt mit seinem Sohn und seiner Tochter aus erster Ehe. Während seiner Zeit in Chicago war er bereits von seiner ersten Frau geschieden und lebte mit Eileen zusammen, die er später heiratete. Garry verbrachte viele Abende in meiner Wohnung, er philosophierte über Gott und die Welt – und die Kunst; dabei schwenkte er ein Glas, das zwei Finger breit mit Scotch gefüllt war.

Von Garry lernte ich viel über Fotografie. Einmal fragte ich ihn, warum er seine Kamera gelegentlich schräg statt waagerecht halte. Er antwortete, daß er sich bei einem Bild [er sagte auf New Yorkerisch »pick-cha«] immer ein Problem aufgebe, eine Aufgabe, die es zu lösen gelte, eine »Auseinandersetzung«, die es zu gewinnen gelte – deshalb nehme er sich die Freiheit, den Bildrahmen so zu gestalten, wie er es für die jeweilige Situation angemessen finde (ein schwieriges, aber ästhetisch brillantes Konzept). Bei Schnappschüssen auf der Straße, so erzählte er mir, ging er meist direkt auf die Person zu, die er fotografieren wollte, und drückte dann blitzschnell ab. Seine Art, auf die Menschen zuzugehen, schuf die »Auseinandersetzung« – sie mußten sich mit ihm auseinandersetzen. Oft foto-

père très tendre, très proche de son fils et de sa fille issus d'un premier mariage. Quand il habitait Chicago, il était déjà divorcé de sa première femme et vivait avec Eileen, qui deviendrait plus tard sa seconde épouse.

Garry passa de nombreuses soirées chez moi, philosophant à propos du monde et de l'art en remuant son verre de scotch.

J'en appris beaucoup sur la photo grâce à lui. Un jour, je lui demandai pourquoi il tenait de temps en temps son appareil dans un angle, en ne gardant pas la ligne d'horizon. Il répondit que quand il faisait une « pick-cha » (picture), il devait toujours résoudre le problème du moment, relever un défi, et c'est pourquoi il se sentait libre de créer un cadre approprié à son regard, pour chacune des opportunités qui se présentait (un concept difficile mais esthétiquement brillant). Il continua en m'expliquant que lorsqu'il photographiait dans les rues, il lui était très souvent arrivé de se précipiter tout d'un coup en face de son sujet, qu'il prenait en un instant. Cette façon de faire créait une émulation, le sujet étant provoqué. Comme les personnages étaient souvent pris au moment où ils se rendaient compte de sa présence, l'événement en lui-même déclenchait une nouvelle dynamique, une interaction du sujet avec l'appareil et le photographe. Il devint un maître de ce style, et ceux d'entre nous qui ont été amenés à le voir travailler comprennent mieux la façon dont cette dynamique survient quand nous photographions.

Garry avait un sens de l'humour merveilleux et une bonne dose de fantaisie. Je l'ai souvent observé

Garry playing with David Crane, Chicago;
Eileen Hale is on far right, 1971.

Garry spielt mit David Crane; ganz rechts:
Eileen Hale. 1971.

Garry en train de jouer avec David Crane à Chicago.
Eileen Hale est au fond à droite. 1971.

uation as it occurred (a difficult but aesthetically brilliant concept). He further told me that when he photographed on the streets, he frequently would quickly get directly in front of his subject and photograph them in an instant. His manner would create this contention – the subject having to contend with him. As they would often be photographed the instant they became aware of his presence, that in itself would create a new dynamic – the interaction of the subject with the camera and the photographer. He became the master of this photographic genre, and those of us who got to watch him work – and knew why – have a better understanding of the way those dynamics occur when we work ourselves.

Garry had a wonderful sense of humor and was possessed of a great amount of whimsy. Often when I was with him I found him joking with a child – he would point to one of his upper front teeth and tell the child he had a ticklish tooth. The child would often touch it – and Garry would laugh. The child, terribly amused, would do it a number of times and Garry would always laugh.

Garry died of cancer, much too young. After his death, a memorial service for him was held at the Ethical Culture Center on Central Park West. I flew in that morning in the middle of one of the most intense snow and sleet storms New York had seen for years. The Center was filled to overflowing, with all of the world's photographers who were in New York at the time in attendance.

After the service, a small group of Garry's friends, including Lee Friedlander (perhaps Garry's oldest and closest friend), Todd Pappageorge, John Szarkowski, and myself, all went to Garry's favorite Chinese restaurant on Columbus Avenue to remember him. I believe it was Lee who said that the lousy day was Garry's revenge. We all loved him, and we still miss him.

grafierte er Leute genau in dem Augenblick, in dem sie ihn entdeckt hatten, und das allein erzeugte schon eine neue Dynamik – die Interaktion des Subjekts mit der Kamera und dem Fotografen. In dieser Aufnahmetechnik brachte er es zu wahrer Meisterschaft, und wer ihm einmal bei der Arbeit zuschauen durfte – und wußte, worauf es ankam –, verstand besser, wie solche dynamischen Prozesse in unserer Arbeit zustande kommen.

Garry hatte einen wunderbaren Sinn für Humor und konnte herrlich schrullig sein. Oft habe ich ihn beobachtet, wie er mit Kindern herumalberte – einmal erzählte er einem Kind, daß einer seiner Schneidezähne kitzlig sei, und zeigte mit dem Finger darauf. Das Kind berührte den Zahn, und Garry fing an zu kichern. Das Kind fand das sehr lustig und berührte den Zahn immer wieder.

Garry starb, viel zu jung, an Krebs. Die Trauerfeier fand im Ethical Culture Center in der Nähe von Central Park West statt. Ich flog an jenem Morgen nach New York; es herrschte einer der schlimmsten Schnee- und Eisstürme, die die Stadt seit Jahren erlebt hatte. Im Center drängten sich Fotografen aus aller Welt.

Nach der Feier gingen Garrys engste Freunde, darunter Lee Friedlander (vielleicht Garrys engster und ältester Freund), Todd Pappageorge, John Szarkowski und ich, in Garrys Lieblingslokal, ein Chinarestaurant auf der Columbus Avenue. Ich glaube, es war Lee, der behauptete, daß das lausige Wetter Garrys Rache gewesen sei. Wir haben ihn alle sehr geliebt, und wir vermissen ihn.

s'amusant avec des enfants. Une fois, il montrait une de ses dents de devant à l'enfant, lui racontant qu'il avait une dent chatouilleuse. L'enfant touchait alors la dent à plusieurs reprises et Garry éclatait de rire. L'enfant, fou de bonheur, recommençait sans fin et Garry riait à chaque fois !

Garry fut emporté bien trop jeune par un cancer. On fit un office à sa mémoire au Ethical Culture Center à Central Park Ouest. Je pris l'avion le jour où New York connût une des plus violentes tempêtes de neige jamais vues depuis des années. Le Centre culturel débordait, envahi par le monde de la photographie présent à New York au moment de l'office.

Après cette cérémonie, un petit groupe d'intimes de Garry, avec notamment Lee Friedlander (sans doute son meilleur et son plus vieil ami), Todd Pappageorge, John Szarkowski et moi-même, se rendit en son souvenir dans le restaurant chinois préféré de notre ami disparu, sur la Colombus Avenue.

Je crois que c'est Lee qui ajouta que ce temps de chien était la revanche de Garry.

Nous l'aimions tous et il continue de nous manquer.

Garry playing with my son David. His son Ethan and daughter Laurie look on. 1971.

Garry spielt mit meinem Sohn David. Seine Kinder, Ethan und Laurie, schauen zu. 1971.

Garry en train de jouer avec mon fils, David. Son fils Ethan et sa fille Laurie les regardent. 1971.

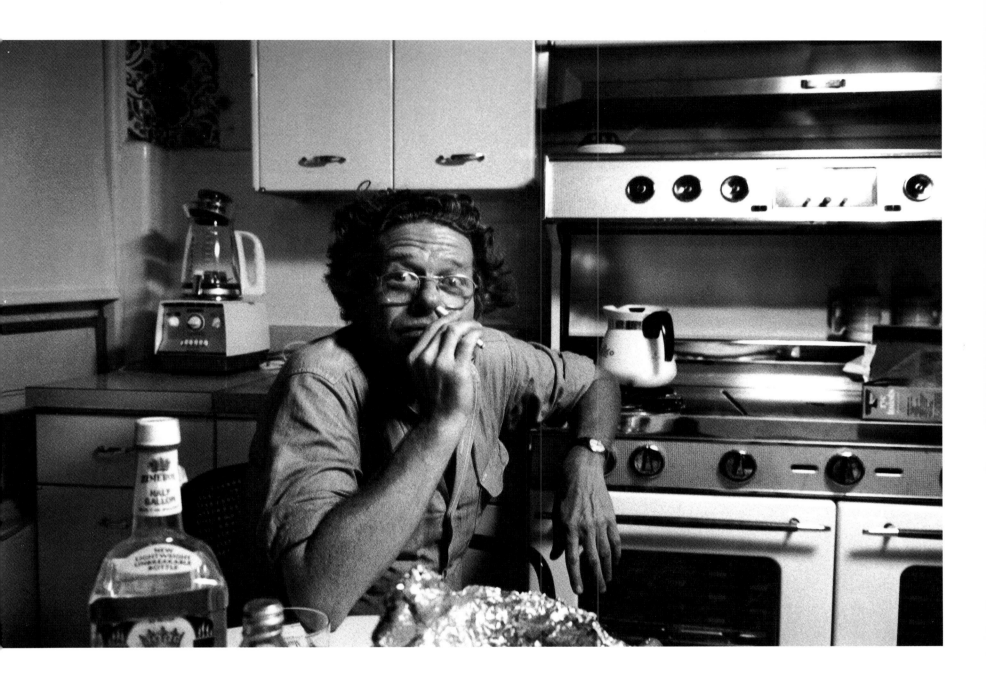

In the author's kitchen. Another Winogrand pose! 1971.

In meiner Küche, Winogrand hat sich wieder in Positur geworfen. 1971.

Dans la cuisine de l'auteur, 1971. Une autre « pose » de Garry !

◁ Garry frequently invited his students from I.D. (the Institute of Design at the Illinois Institute of Technology) over to his Chicago apartment on a weekend. Here he is with a group of them; his son, Ethan, is standing in the doorway. 1971.

Garry lud seine Studenten vom Institute of Design am Wochenende oft zu sich nach Hause ein. Hier unterhält er sich mit einigen seiner Studenten; sein Sohn Ethan steht im Türrahmen. 1971.

Garry invitait fréquemment ses étudiants de l'Institute of Design pour le week-end, dans son appartement à Chicago. On le voit ici en leur compagnie. Son fils Ethan est dans l'encadrement de la porte. 1971.

Always playful – Garry would sometimes suddenly go into his own »poses« as I photographed him, 1971.

Garry hatte immer den Schalk im Nacken – manchmal stellte er sich in Positur, wenn ich ihn fotografierte, 1971.

Toujours en train de s'amuser, Garry se mettait de temps en temps à « poser » quand je le photographiais, 1971.

Garry on State Street, Chicago. This shows how he typically would
do his street photography – nonchalantly looking forward, his camera in
one hand suddenly rising to capture »the moment.« 1971.

Garry in der State Street, Chicago. Dieses Foto zeigt etwas von seiner typischen Arbeitsweise,
wenn er auf der Straße fotografierte: Er stand immer ganz nonchalant herum, hielt die Kamera
wie zufällig in der Hand und riß sie dann plötzlich hoch, um den »richtigen Augenblick« festzuhalten. 1971.

Garry sur la State Street à Chicago. Cette photographie montre précisément la façon dont il
réalisait ses photos de rues : il attendait tranquillement, l'appareil dans une main,
le moment où tout à coup il capturerait « l'instant ». 1971.

▷ Garry photographing an anti-Vietnam war parade, Chicago, 1974.

Garry beim Fotografieren einer Demonstration in Chicago, 1974.

Gary en train de photographier une manifestation contre la guerre du Viêt-nam à Chicago, 1974.

Yet another Winogrand pose! 1971.

Garry wieder mal »in Positur«, 1971.

Garry Winogrand pose à nouveau ! 1971.

Garry and Ethan, New York City, 1971.

Garry und Ethan in New York City, 1971.

Garry et Ethan, à New York, 1971.

Garry in front of the
Museum of Science and
Industry, Chicago, 1971.

Garry vor dem Museum
of Science and Industry,
Chicago. 1971.

Garry face au musée de
la Science et de l'Industrie,
Chicago. 1971.

Henri Cartier-Bresson

Born 1908. French.
Photojournalist. Cofounder of the Magnum picture agency. His most important book, *The Decisive Moment*, was published in 1952. His photographs gained worldwide acclaim due to his brilliant ability to compose each frame. Has given up photography and now devotes his time to painting.

Geboren 1908. Franzose.
Fotojournalist. Mitbegründer der Bildagentur »Magnum«. 1952 wurde sein wichtigstes Buch *The Decisive Moment* veröffentlicht. Seine Fotos erhielten weltweite Anerkennung. Hat die Fotografie aufgegeben, um sich nun ganz der Malerei zu widmen.

Né en 1908. Français.
Photographe. Cofondateur de l'agence Magnum. Son livre le plus important, *L'Instant décisif*, a été publié en 1952. Sa brillante capacité à composer les cadrages fit louer ses photographies dans le monde entier. A abandonné la photographie et se consacre aujourd'hui à la peinture.

HENRI CARTIER-BRESSON ~ by Rudolf Blane

He appeared at the very instant he had said he'd meet me – at the Hôtel d'Angleterre, 44 Rue Jacob, on the *rive gauche* in Paris. A somewhat short, bespectacled, slender, quick man, he had Leica no. 1,000,000 with a 50mm lens hanging from his neck, and a dark brown, hard-leather case measuring about 3×7×8 inches, containing 35mm and 90mm lenses and film, hanging from his shoulder.

This description of him is important, for I have no photographs to accompany this particular vignette!

He spoke perfect English – he was a true gentleman – but took pride in his refusal to be photographed. There are photographs of him, but most were taken either early in his career or »stolen« when he was unaware.

His rationale is that he is better able to make the type of pictures he makes if he is an anonymous face in the crowd.

As an alternative, I asked if I could just photograph his camera with the special serial number (a gift from the manufacturer). But he refused that request also!

I phoned Henri in November of 1994 on one of my trips to Paris. He answered the phone and the following conversation ensued.

»Hello, Henri, Arnold Crane, from the United States.«

Henri Cartier-Bresson (speaking very rapidly): »I am not involved in photography any longer. I am a heart patient and my doctor doesn't want me to do too much. I am painting now.«

»You've given up photography and you're making paintings . . .?«

»I will paint you. I will paint you nude. *You* will be nude, not me! I will paint your head!«

»Henri, I've finished my project, and you are the only one missing . . .«

Henri (interrupting): »I do not wish to be photographed. I will paint you! Good-bye!«

. . . and he hung up!

Several people, aware that I knew Henri's address in Paris, suggested that I lie in wait across the street from his home armed with a long lens, *à la* paparazzi. But that I refuse to do. Thus, in his case, I can offer you only my memories.

One last story, told to me by David Travis, Curator of Photography at the Art Institute of Chicago:

»One day in Paris, Cartier-Bresson was lurking in a dark doorway on a narrow street, sketch pad and conté crayon in hand, making sketches of the day. At the same time, as chance would have it, Edouard Boubat was doing the same thing just across the way.

They see each other at the same time and leave their respective lairs to say hello to each other.

As they shake hands, each says to the other, in unison, ›I guess we're the last of the photojournalists.‹«

Er erschien pünktlich um die verabredete Zeit bei mir, im Hôtel d'Angleterre in Paris, 44 Rue Jacob, am linken Seineufer. Er war ein etwas kleingewachsener, schlanker, agiler Mann mit Brille. Eine Leica mit der Seriennummer »1.000.000« und einem 50-mm-Objektiv baumelte um seinen Hals, und über seiner Schulter hing eine dunkelbraune Hartledertasche, in der er seine 35-mm- und 90-mm-Objektive und Reservefilme aufbewahrte.

Das mußte ich beschreiben, denn ich habe leider keine Fotos von Henri, die ihn mit seiner Ausrüstung zeigen.

Er sprach perfektes Englisch – ein echter Gentleman –, aber er blieb kategorisch bei seiner Weigerung, sich fotografieren zu lassen. Es gibt zwar Fotos von ihm, doch die meisten stammen aus seinen jüngeren Jahren oder sind sozusagen Diebesgut, sie wurden heimlich gemacht.

Er begründete seine Weigerung damit, daß er die Fotos, die er gern macht, leichter machen kann, wenn die Leute sein Gesicht nicht kennen.

Ich fragte ihn, ob ich denn vielleicht seine Kamera mit der originellen Seriennummer (ein Geschenk des Herstellers) fotografieren dürfe – aber auch das ließ er nicht zu.

Ich rief Henri im November 1994 während einer Paris-Reise an: »Hallo Henri, hier spricht Arnold Crane aus Amerika.«

Henri Cartier Bresson, in gehetztem Tonfall: »Ich mache keine Fotos mehr. Ich habe ein Herzleiden, und der Arzt hat mir verboten, zu hart zu arbeiten. Ich male nur noch.«

»Sie haben aufgehört zu fotografieren und malen nur noch ...«

»Ich werde Sie malen. Ich werde Sie nackt malen. *Sie* werden nackt sein, nicht ich! Ich werde Ihren Kopf malen!«

»Henri, mein Buch ist so gut wie fertig, nur Sie fehlen noch ...«

Henri unterbricht mich: »Ich will nicht fotografiert werden. Ich werde Sie malen! Auf Wiedersehen!«

... dann legte er auf.

Einige Leute schlugen mir vor, mich mit einem Teleobjektiv in der Nähe seiner Wohnung auf die Lauer zu legen, wie die Paparazzi. Aber ich weigere mich aus prinzipiellen Gründen, so etwas zu tun. Deshalb kann ich hier nur mit meinen Erinnerungen an diesen Mann dienen.

Eine Geschichte möchte ich allerdings noch erzählen. Dick Travis, Curator of Photography am Art Institute of Chicago, hat sie mir berichtet:

Cartier-Bresson lag eines Tages in einem dunklen Hauseingang in einer kleinen Pariser Gasse auf der Lauer, Block und Zeichenstift in der Hand; er machte sich Skizzen. Zufällig saß auf der gegenüberliegenden Straßenseite Edouard Boubat und machte sich ebenfalls Skizzen.

Sie blicken auf, sehen einander und kommen aus ihren Höhlen, um sich zu begrüßen.

Sie reichen sich die Hände und sagen beide gleichzeitig und absolut unisono: »Wir sind wohl die letzten Fotojournalisten.«

Il se présenta à l'instant précis où il avait fixé l'heure de notre rencontre, à l'hôtel d'Angleterre, 44 rue Jacob, rive gauche, à Paris. Je vis un homme plutôt petit, d'apparence svelte, vif et qui portait des lunettes.

Il transportait avec lui un Leica n° 1 000 000 équipé d'un objectif de 50 mm suspendu à son cou et une mallette en cuir marron foncé, contenant des objectifs de 35 et 90 mm et des pellicules, suspendue à l'épaule.

Cette description est très importante étant donné que je n'ai aucune photo pour l'étayer.

Il m'autorisa gentiment à l'accompagner durant cette journée.

Il s'est exprimé dans un anglais parfait, en véritable gentleman, mais mit un point d'honneur à ne pas se laisser photographier.

Les photos que nous avons de lui ont soit été prises au début de sa carrière, soit volées dans un moment d'inattention. Il expliqua que c'est pour lui plus facile de respecter son style quand il reste un visage anonyme.

Je lui ai demandé, en compensation, si je pouvais photographier son appareil sur lequel était gravé un numéro de série spéciale (cadeau du fabricant), mais il s'y refusa aussi !

Lors d'un passage à Paris en novembre 1994 je lui téléphonai et voici en bref le résumé de notre conversation :

« Hello Henri, Arnold Crane des États-Unis »

Henri (parlant très vite): « Je ne m'occupe plus de photographie, je suis malade du cœur et mes docteurs ne veulent pas que je me fatigue. Je me suis mis à la peinture. »

« Vous avez abandonné la photo et vous faites de la peinture...? »

« Je vais vous peindre. Je vous peindrai nu. *Vous* serez nu, pas moi ! Je vais peindre votre portrait ! »

« Henri, j'ai terminé mon projet et vous êtes le seul qui manquez... »

Henry (m'interrompant) : « Je ne veux pas être photographié. Je vais vous peindre. Au revoir. »

Et il raccrocha.

Je connaissais son adresse, bien sûr, et certains ont suggéré que je me poste dans sa rue muni d'un zoom à la façon des paparazzi, ce que bien entendu, par principe, je refusai. C'est pourquoi je ne puis vous offrir que mes souvenirs.

Voici une dernière anecdote que m'a raconté David Travis, conservateur du département Photographie au Art Institute de Chicago :

Un jour, à Paris, Cartier-Bresson se tenait dans une rue étroite, dissimulé dans l'encadrement d'un portail sombre, muni d'un bloc et d'un crayon, croquant des scènes de la rue. Par hasard, au même moment, Edouard Boubat faisait la même chose de l'autre côté de la rue.

Ils se reconnurent simultanément et quittèrent leurs places respectives pour se saluer puis, alors qu'ils se serraient la main, chacun dit à l'autre à l'unisson : « Je crois que nous sommes les derniers reporters. »

Epilogue · Epilog

Man Ray and Arnold Crane.

Man Ray und Arnold Crane.

Man Ray et Arnold Crane.

Walker Evans talking with Arnold Crane.

Walker Evans mit Arnold Crane im Gespräch.

Walker Evans parlant avec Arnold Crane.

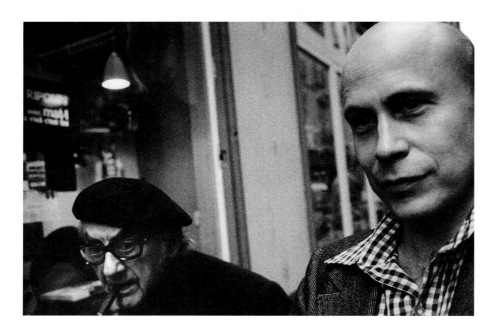

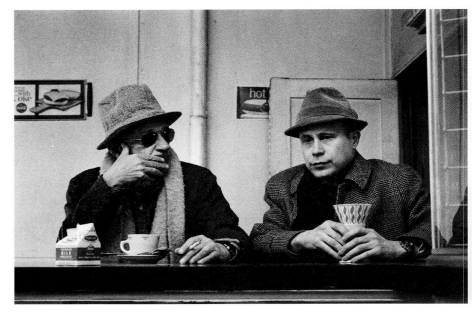

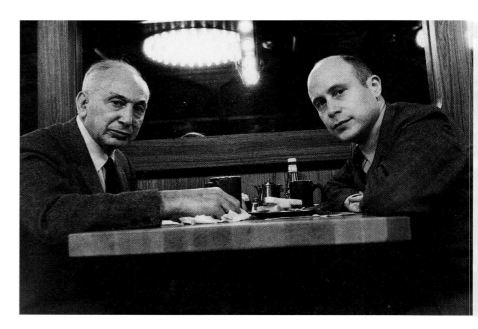

Paul Strand and Arnold Crane.

Paul Strand und Arnold Crane.

Paul Strand et Arnold Crane.

André Kertész with Arnold Crane.

André Kertész mit Arnold Crane.

André Kertész avec Arnold Crane.

Ansel Adams and
Arnold Crane.

Ansel Adams und
Arnold Crane.

Ansel Adams et
Arnold Crane.

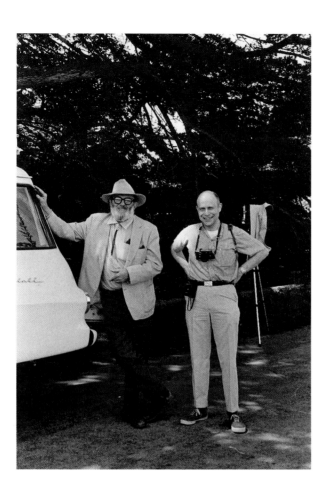

Robert Doisneau
and Arnold Crane.

Robert Doisneau
und Arnold Crane.

Robert Doisneau
et Arnold Crane.

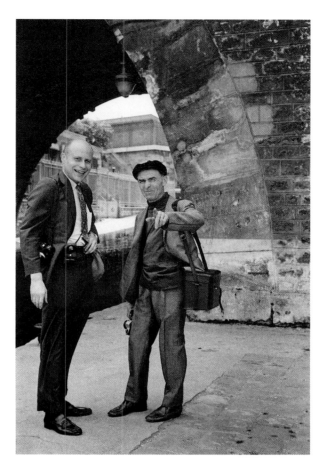

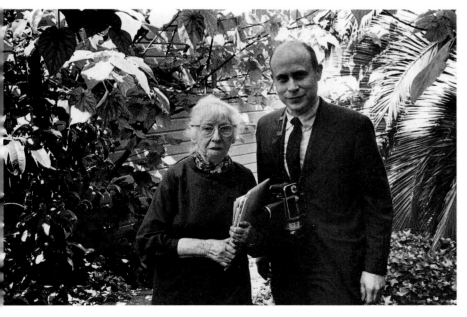

Imogen Cunningham with Arnold Crane in the garden.

Imogen Cunningham mit Arnold Crane im Garten.

Imogen Cunningham et Arnold Crane dans le jardin.

Garry Winogrand and Arnold Crane with friends.

Garry Winogrand und Arnold Crane in fröhlicher Runde.

Garry Winogrand et Arnold Crane avec des amis.

Acknowledgements

I wish to thank Peter Bunnell, currently of Princeton University, for suggesting this project and for his help in furthering its progress. Without his assistance I would not have been able to gain access to the lives and homes of many of the photographers included in this book.

My thanks to Mary Beth Brown, my friend, who some ten years ago said to me: »Arnold, when you finally do your book, I'll help you!« When I eventually got my contract for this book and phoned Mary Beth, she was there for me – and has been every day since, totally organizing me and my negatives and prints. She has been my loyal »muse« in putting this book together, helping me in its design and its editing. This book would not exist in its final form without her.

To the staff at the Ritz Carlton's »Greenhouse« in Chicago, who served me tea and desserts during my weeks of writing the text, and to Stephan Hershkowitz, who did the same in the wonderful lounge at the Stanhope Hotel in New York, where I finished my manuscript and wrote all of the captions.

To Robin and Renee Beningson and Joseph Coplin of Antiquarian Ltd. in New York, who would feed me oversized lunches and who gave me use of their phones and fax machine and who humored me during my writing anxieties while I was in New York.

To Mike Johnston, my text editor, who was able to clarify the sometimes convoluted sentences in my original manuscript.

To Lupe Kalter, who typed the manuscript and who creatively interpreted my handwriting (which to most is indecipherable!)

To my friend Anthony JP Meyer, of the Oceanic Art Gallery bearing his name on the Rue des Beaux-Arts in Paris. Anthony was the catalyst for this book; it was he who, after he saw the photographs, introduced me to Ludwig Könemann, publisher of Anthony's own book on *Oceanic Art*.

To my former secretary, Barbara Tucibat, for her tireless devotion and endless help in organizing my life and my time, enabling me to practice law and photograph the people in this book – two full-time professions practised during the same years.

To my wife Cynthia for her help, suggestions and understanding during the production and editing of this book.

And lastly to my son David, with whom I shared some of those early precious moments with Man Ray, Garry Winogrand and some of the others, who have been the subjects of my camera.

Danksagung

Ich möchte mich bei Peter Bunnell von der Princeton University für die Idee zu diesem Buch bedanken – und dafür, daß er mich auch bei der Produktion unterstützt hat. Ohne seine Hilfe wären mir gewiß die Türen zu Leben und Wohnung vieler Fotografen verschlossen geblieben.

Danken möchte ich meiner Freundin Mary Beth Brown, die mir vor ungefähr zehn Jahren einmal sagte: »Arnold, wenn du dein Buch eines Tages schreiben wirst, dann werde ich dir dabei helfen.«

Als ich den Vertrag für dieses Buch in der Tasche hatte, rief ich Mary Beth an, und sie ist seither jeden Tag an meiner Seite gewesen – sie hat meine Tagesabläufe organisiert, meine Negative und Abzüge geordnet; sie war meine Muse beim Schreiben und hat mir beim Layout und beim Korrekturlesen geholfen. Ohne sie hätte das Buch nicht seine jetzige Gestalt.

Danken möchte ich auch den Angestellten des Greenhouse im Ritz Carlton Chicago, die mich in den Wochen des Schreibens mit Tee und Kuchen versorgten; auch Stephen Hershkowitz bin ich zu Dank verpflichtet, der mich in der Lounge des Stanhope-Hotel in New York gleichermaßen versorgte.

Dank auch an Robin und Renée Beningson sowie Joseph Coplin von Antiquarian Ltd. in New York, die mir riesengroße Lunches besorgten und mir ihre Telefone und Faxgeräte zur Verfügung stellten. Wenn ich beim Schreiben nicht weiterkam, haben sie mich wieder aufgemuntert.

Dank auch an Mike Johnston, meinen Lektor, der meine gelegentlich ins bandwurmartige ausufernden Sätze straffte und viel zu ihrer Klarheit beitrug.

Weiterhin sei Lupe Kalter gedankt, die das Manuskript tippte und in der Lage war, meine Handschrift zu lesen, was schon eine Kunst für sich ist.

Schließlich möchte ich mich bei meinem Freund Anthony JP Meyer bedanken, dem Inhaber der gleichnamigen Galerie für Ozeanische Kunst auf der Rue des Beaux-Arts in Paris. Anthony war gewissermaßen der Katalysator für dieses Buch; als er die Bilder gesehen hatte, machte er mich mit dem Verleger Ludwig Könemann bekannt, der Anthonys Buch über ozeanische Kunst herausbrachte.

Besonderer Dank gilt auch meiner früheren Sekretärin, Barbara Tucibat, für ihr Engagement und ihre Hilfe, mein Leben und meine Zeit zu organisieren und es mir so zu ermöglichen, als Rechtsanwalt zu arbeiten und die hier vorgestellten Menschen zu fotografieren – zwei Vollzeitbeschäftigungen, die ich zur gleichen Zeit ausgeübt habe.

Meiner Frau Cynthia danke ich für ihre Unterstützung, ihre Vorschläge und ihr Verständnis während der Arbeit an der Zusammenstellung und Veröffentlichung dieses Buches.

Und schließlich danke ich meinem Sohn David, mit dem ich einige kostbare Augenblicke mit Man Ray, Garry Winogrand und manchen anderen erleben durfte, die vor meiner Kamera gestanden haben.

Remerciements

Je tiens à remercier ici :
Peter Bunnell, qui est actuellement à l'université de Princeton, pour m'avoir inspiré ce projet, et pour son aide constante tout au long de sa réalisation. Sans cette aide, je n'aurais pas eu accès à de nombreux photographes figurant dans cet ouvrage.

Mary Beth Brown, mon amie, qui me dit il y a de cela dix ans « Arnold, quand tu te décideras enfin à faire ton livre, je t'aiderai ». Quand j'obtins finalement mon contrat, je lui téléphonai, elle fut là et resta chaque jour depuis. Elle prit en charge l'organisation de mon travail : négatifs, épreuves, etc., m'aidant dans la conception et l'édition. Sans son aide, ce livre n'existerait pas dans sa version finale.

L'équipe du Ritz Carlton « Greenhouse » à Chicago, qui me servit du thé, m'offrit des desserts durant les semaines consacrées à la rédaction de mes textes, et Stephan Hershkowitz, qui fit la même chose dans le merveilleux salon du Stanhope Hotel à New York où j'achevai mon manuscrit et où j'écrivis toutes les légendes.

Robin et Renee Beningson et Joseph Coplin de l'Antiquarian Ltd. à New York, qui me servirent des déjeuners pantagruéliques et m'autorisèrent l'accès aux téléphones et aux fax. Leur humour a su me distraire de mes anxiétés d'écrivain pendant que j'étais à New York.

Mike Johnston, mon rédacteur, qui s'est montré capable de faire surgir des phrases claires à partir d'un texte original parfois bien sinueux.

Lupe Kalter, qui a tapé le manuscrit et a su lire mon écriture pourtant indéchiffrable.

Mon ami Anthony JP Meyer, de la Galerie d'Art océanien. Il fut le catalyseur de ce livre. Après avoir vu les photographies, il m'introduisit auprès de Ludwig Könemann qui a édité le livre d'Anthony sur l'art océanien.

Mon ancienne secrétaire, Barbara Tucibut, pour sa dévotion totale et son aide continuelle pour organiser ma vie et mon temps, qui m'a permis de me consacrer à la loi et de photographier les gens présents dans ce livre – deux professions exercées à plein temps tout au long des mêmes années.

Ma femme Cynthia pour son aide, ses suggestions et sa compréhension durant la rédaction et la préparation de ce livre.

Enfin, mon fils David, avec qui j'ai partagé de précieux moments au début de nos rencontres avec Man Ray, Garry Winogrand et quelques autres qui ont été les sujets de mon appareil.

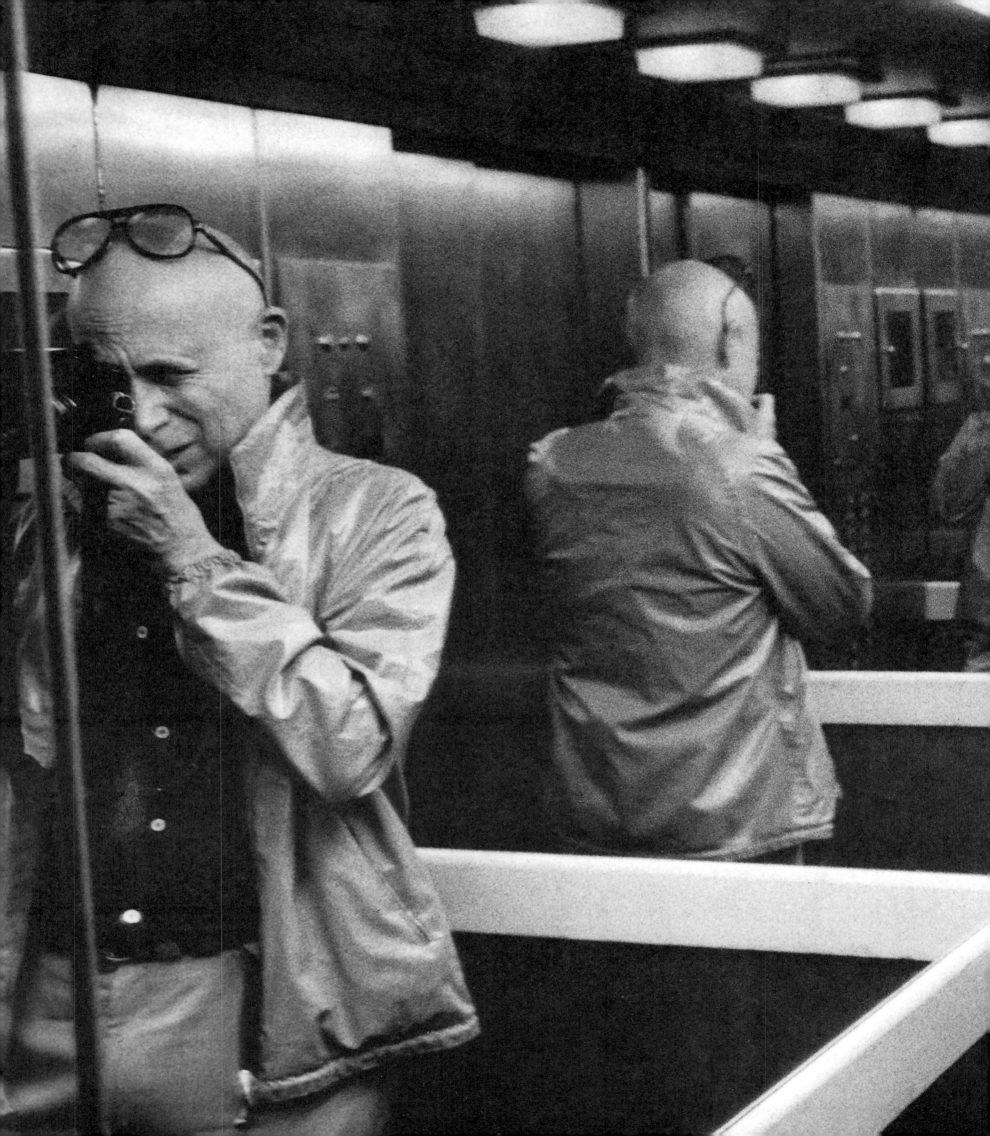